CANADIAN ART

FROM ITS
BEGINNINGS
TO 2000

CANADIAN ART

FROM ITS
BEGINNINGS
TO 2000

ANNE NEWLANDS

FIREFLY BOOKS

A FIREFLY BOOK

Published by Firefly Books Ltd. 2000

First Printing 2000

U.S. Cataloging-in-Publication Data is available.

Canadian Cataloguing in Publication Data

Newlands, Anne, 1952 –
 Canadian art : from its beginnings to 2000

Includes index.
ISBN I-55209-450-2

I. Art, Canadian – History. I. Title.

N6540.N48 2000 709'.71 C00-930879-2

Published in Canada in 2000 by
Firefly Books Ltd.
3680 Victoria Park Avenue
Willowdale, Ontario M2H 3KI

Published in the United States in 2000 by
Firefly Books (U.S.) Inc.
P.O. Box 1338, Ellicott Station
Buffalo, New York 14205

Produced by
Bookmakers Press Inc.
12 Pine Street
Kingston, Ontario K7K IWI
(613) 549-4347
tcread@sympatico.ca

Colour Separations by
Quadratone Graphics Ltd., Toronto

Printed and bound in Canada by
Friesens
Altona, Manitoba

FRONT COVER:
Lawren S. Harris, *Algoma Hill*,
1920; oil on canvas; 117.0 cm x 137.1 cm;
Collection of the University Health Network;
Photo by National Gallery of Canada

BACK COVER:
Kenojuak Ashevak, *The Enchanted Owl*,
1960; stonecut; 38.5 cm x 58.2 cm;
Printed by Eegyvudluk Pootoogook (1931-);
Canadian Museum of Civilization, image #S99-10062

THE CANADA COUNCIL | LE CONSEIL DES ARTS
FOR THE ARTS | DU CANADA

The Publisher acknowledges the financial support of the Government of Canada through the Book Publishing Industry Development Program for its publishing activities.

For my children Andrew and Martha

CONTENTS

CONTENTS

PREFACE

"Artistic expression is a spirit, not a method, a pursuit, not a settled goal, an instinct, not a body of rules."

— *Foreword, Group of 7 Exhibition of Paintings, exhibition catalogue, Art Gallery of Toronto, 1922*

The opportunity to compile a selection of works of art that would reflect the enormously diverse history of Canadian art was both a privilege and a daunting prospect, a marvellous and humbling journey of discovery through our astoundingly rich visual culture from its beginnings to 2000, a timescape as vast as the land itself. The challenge of devising a definition of art which would encompass this complexity was magnified by the fact that our first artists, Inuit and First Nations, did not have words in their languages for art. For the First Nations, art was an integral part of everyday life. It could include the embellishment of household objects and clothing or the creation of objects that fulfilled the needs of sacred rituals. Rather than trying to reconcile these differences, I embraced them, recognizing that definitions of art have changed and evolved over the years. Art has meant different things to different people and always will.

In selecting only 300 artists from among the tens of thousands who have been documented, I was interested in capturing highlights of artistic production by our finest artists, from the past and the present and across our hugely varied geography. In every region, I have tried to present an example of the early work by Inuit and First Nations artists, tracing the continuity of production by these artists and by those of European descent, who made their first appearance in Quebec City in the 1600s, through to the end of the second millennium. I have endeavoured to include a variety of media, and while oil on canvas surely dominates this book, I have tried to acknowledge country-wide innovations in native art made on and from the land, as well as those in sculpture, photography and installation art. While new technologies are recognized, I restricted my selection to works whose essences could be apprehended through the still images of a book. The variety of subjects reflects the infinite artistic diversity brought to the timeless themes of the figure, portraits, landscapes, beliefs, abstraction, fears, dreams and rituals. Lastly, I generally gave preference to works in public collections in the hope that readers may someday have the opportunity to see the real thing.

The arduous challenge of selecting artists was compounded by the equally formidable task of choosing a single image to represent an artist's prolific career. While the works featured are often typical of an artist's production, it is important to see these not as a summing up but, rather, as a glimpse into a lifetime of creative expression. To lend relief to this system, it was decided that some artists who were much loved by Canadians or who had excelled in a variety of media would be represented by two images. You will find 26 such cases throughout the book.

In the accompanying text, I have concentrated on the visual quality of the work and on the artist's use of the language of art as an intrinsic conveyor of meaning. Whether the decision was to work with rock, hide, canvas, wood, steel or videotape, the artist's choice of materials speaks volumes about context and intention. Similarly, the visual elements of colour, line, shape and texture are all powerfully expressive tools.

The artists are arranged alphabetically, which removes them from predictable associations and chronological relationships and frees them from the standard linear narrative of traditional art histories. On these pages, art and artists forge new connections that raise fresh questions and invite renewed consideration of their distinct individuality. The alphabetical structure allows you to make your own syntax, creating your own map through the vibrant visual heritage established by Inuit and native artists as well as artists of European descent. Finally, there are multiple narratives, which offer a complex interweaving of shared histories and distinct identities that, like the strands of a braid, create a fibre whose beauty and strength come from its intertwinement.

Artists spend entire lifetimes creating work, probing the depths of human experience, the splendour and intensity of which cannot be apprehended at a single glance. Looking at art is an active and creative process that demands opening oneself to new worlds and new ways of seeing. Looking at art takes time and promises the patient viewer an odyssey of exalted riches and adventures. Through their labours, artists invite us to travel into their hearts, their minds and their dreams, taking us to places that, without them, we could not even imagine. *Anne Newlands*

"Who of us knows just why we do what we do, much less another's whys, or what we're after? Art is not like that; cut and dried and hit-at like a bull's eye and done for a reason and explained away by this or that motive. It's a climbing and a striving for something always beyond."

— *Emily Carr, from* Hundreds and Thousands: The Journals of An Artist. *Toronto: Irwin Publishing, 1966*

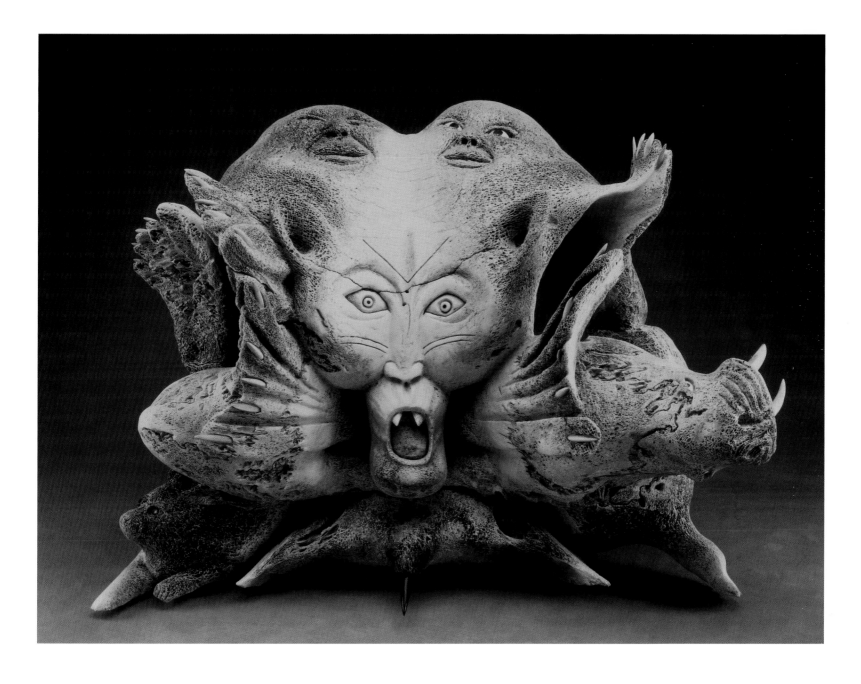

Respecting the Circle

Manasie AKPALIAPIK

1989; whalebone, ivory, dark grey stone, antler, baleen, rust stone, horn; 52.0 cm x 71.4 cm x 40.0 cm;
Art Gallery of Ontario; Photo by Dieter Hessel, Toronto

(1955-)

Capitalizing on the intricate and unpredictable forms of nature, Manasie Akpaliapik releases a wide-eyed shouting wolf from the smooth, dense centre of a whalebone. Above the animal's pointed ears, one moon head grimaces and the other offers a glazed smile. A fanlike shape fringed with sharp ivory claws descends to frame the wolf's head; from its base a diving bird emerges and, to the left, a cautious rabbit. As we move around the work, human hands appear, and on the other side, the moon-creatures return, screaming silently from their angry mouths, while a solemn owl warns us to keep our distance. In completing the circle, we are reminded of the integration of human and animal nature in Inuit cosmology. "Everything in the world is connected," says Manasie, "people and the animals and the entire food chain. When you disturb the circle, the chain, you disturb everything."

In his adult life, Manasie has focused on reclaiming the Inuit culture denied him as an adolescent in a residential school in Iqaluit. Following the tragic death of his wife and two children in a house fire in 1980, Manasie moved to Montreal and later to Toronto. From time to time, he returns to his native Arctic Bay, where contact with Inuit traditions fuels his art and his desire to perpetuate Inuit culture through his sculpture. "I feel the only way we can preserve the culture," he said, "is if people can see it."

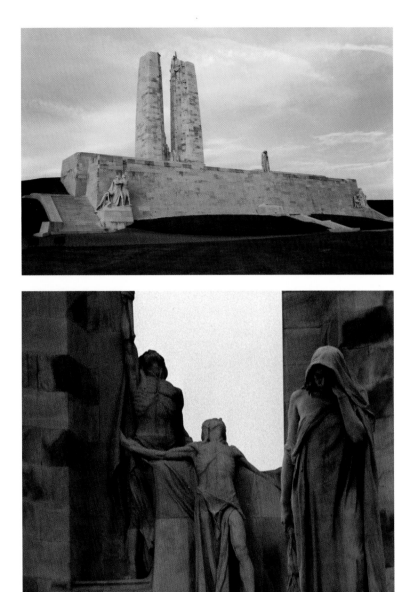

Walter ALLWARD

Canada "Bereft," Vimy Ridge Memorial

(1876-1955)

1936; limestone; H: 37.3 m, W: 62.9 m, D: 36.5 m; Vimy Ridge, France; Photos courtesy Public Works and Government Services Canada; Real Property Services for Parks Canada; Heritage Conservation Program

On July 26, 1936, Canada's prime minister, William Lyon Mackenzie King, and France's president, Albert Lebrun, gathered with thousands of veterans and spectators to witness King Edward VIII unveil Walter Allward's *Vimy Ridge Memorial*, a towering monument honouring the loss of more than 60,000 Canadians in the First World War. Located near the town of Arras, France, the memorial rises over 37 metres from its base on the ridge taken by the Canadians in a definitive battle against the Germans in April 1917.

In the centre, the solitary sculpture of a woman, her head bent heavily with grief and her body draped like a figure from antiquity, is the eloquent symbol of "Canada bereft." She holds the palm of martyrdom and gazes solemnly over the former battlefields, now green farmland. Behind her, a suite of figures scales the twin towers, their bodies weary with anguish and sorrow, and below, on a base that spans over 60 metres, mourning figures flank the list of names engraved in the stone.

Born in Toronto, Allward was already well established as a sculptor of monuments when he submitted his designs for *The Vimy Memorial* in 1921. Upon winning the competition and after much searching, he selected limestone from a quarry near Sarajevo as his material. For more than 15 years, Allward and a veritable fleet of stone carvers made manifest his greatest contribution to Canadian memorial sculpture.

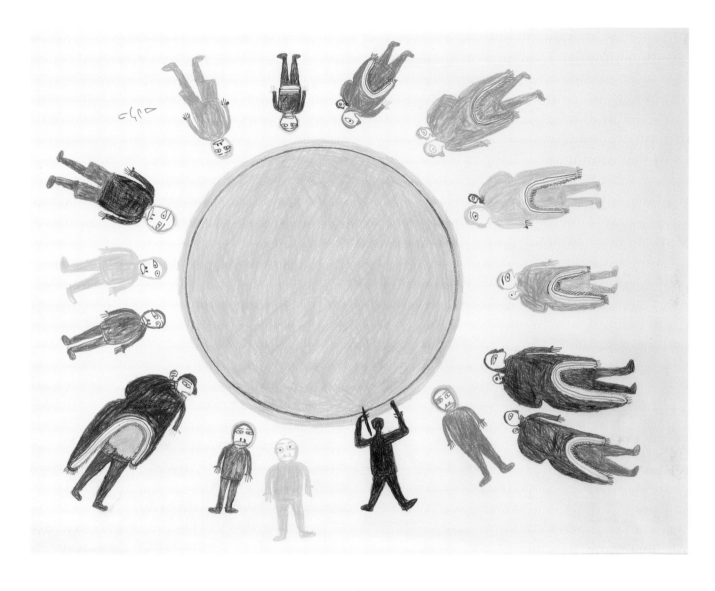

Drum Dance Luke ANGUHADLUQ

1970; coloured pencil and graphite on wove paper; 48.3 cm x 61.0 cm; Art Gallery of Ontario; (1895-1982)
Gift of Samuel and Esther Sarick, 1998; Photo by Carlo Catenazzi/AGO

In Inuit life, communal dances and songs as well as celebrative and religious ceremonies are performed to the hypnotic beat of the skin drum. For Luke Anguhadluq, a powerful camp leader and a hunter of considerable prowess, the depiction of the drum dance, along with his many images of the hunt and fishing, reflected the dominant memories of his life on the land in the Back River area of the Keewatin region of Nunavut.

Often sitting on the floor to draw and rotating the paper as he defined each of the figures assembled for the event, Anguhadluq captured the circular movement of the drummer, whose instrument becomes the giant yellow centre from which the men facing us and the women in profile radiate like beams from the sun. Anguhadluq's characteristically bold drawing style and distinctive use of colour embody the essence of community, central to Inuit life.

Anguhadluq moved into Baker Lake at the age of 73 and began to make art as a source of income. Encouraged by artists Jack and Sheila Butler, who had been hired by the federal government in 1969 to establish a print shop at Baker Lake, Anguhadluq went on to become a most prolific draughtsman. He supplied drawings for over 70 prints published in the Baker Lake print collections from 1970 until his death in 1982.

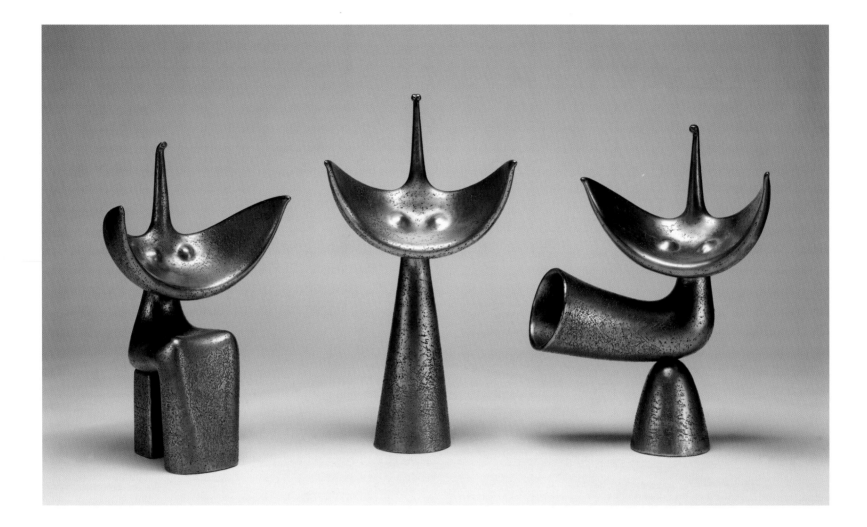

Louis ARCHAMBAULT

Moon Maids: Queen; Vertical; Frivolous

(1915-)

1955; bronze; H: 70.0 cm, 64.0 cm, 61.5 cm; W: 37.0 cm, 49.5 cm, 37.5 cm; D: 24.5 cm, 26.5 cm, 24.5 cm;
The Montreal Museum of Fine Arts; Gift of the artist in memory of his wife, Mariette; Photo by Brian Merrett/MMFA

Three imaginary figures with cone-shaped bodies sit, stand and leap, throwing their crescent-moon arms up in joy while their long, skinny necks and nozzlelike heads remain elegantly erect. Inspired by the dreamlike imagery of Surrealism, Louis Archambault devised hybrid creatures—part woman, part geometry—that suggest a futuristic interpretation of the classical "three graces."

Archambault graduated from the École des beaux-arts in Montreal in 1939, and in 1940, he began mak-ing sculptures out of clay in the studio he shared with Charles Daudelin. He later became associated with Alfred Pellan and the Prisme d'yeux—a group of art-ists who were interested in exploring an imaginative ap-proach to the figure. In 1948, he signed the group's manifesto, which called for an art "liberated from all contingencies of time and place [and] from restrictive ideology." In 1951, Archambault's welded-steel *Iron Bird* was included in an international sculpture exhibi-tion in London, England. That same year, he travelled throughout Europe studying contemporary and ancient sculpture. He was particularly attracted to African, Byzantine and Etruscan art, whose sense of humanity was manifest through a geometric simplification. Rec-ognized as a leader in the field of modern sculpture, Archambault was the first sculptor to represent Canada at the Venice Biennale in 1956, in which *Moon Maids*, along with other of his works, was shown.

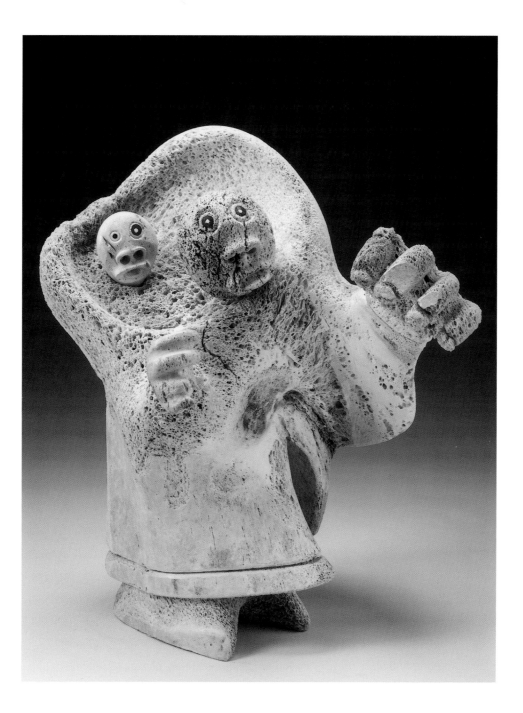

The Coming and Going of the Shaman

Karoo ASHEVAK

c. 1973; whalebone, antler and stone; 38.5 cm x 27.0 cm x 29.5 cm;
National Gallery of Canada; Public Trustee for the Northwest Territories; Estate of Karoo Ashevak

(1940-1974)

Here, Karoo Ashevak adapted the image of an Inuit mother and child (and the attending metaphor of teaching and growing) to illustrate the transfer of powers from an old shaman to a novice. According to a friend of the artist, Karoo explored a symbolic use of materials in this work, carving the large head and hands of the old shaman, with his diminishing strength, in the fragile, more porous part of the whalebone, while the small head and hand of the less knowledgeable apprentice are carved from denser whalebone. The unpaired eyes of both the shaman and the student manifest Karoo's understanding of a shaman's attributes.

Karoo was born near Taloyoak (formerly Spence Bay), in the Kitikmeot region of Nunavut, and lived on the land until 1968, when he moved into Taloyoak. In the five short years before he and his wife died in a house fire, Karoo produced over 250 sculptures, largely in whalebone. As stone was not readily available, the lighter whalebone was flown in by charter plane from nearby Arctic sites. Capitalizing on its irregular organic form and inspired by dreams and spiritual beliefs, Karoo created imaginative sculptures whose uncanny proportions and frequently whimsical nature appealed to collectors from as far away as New York City. An exhibition there in 1973 was an unqualified success and served to increase Karoo's popularity in Canada.

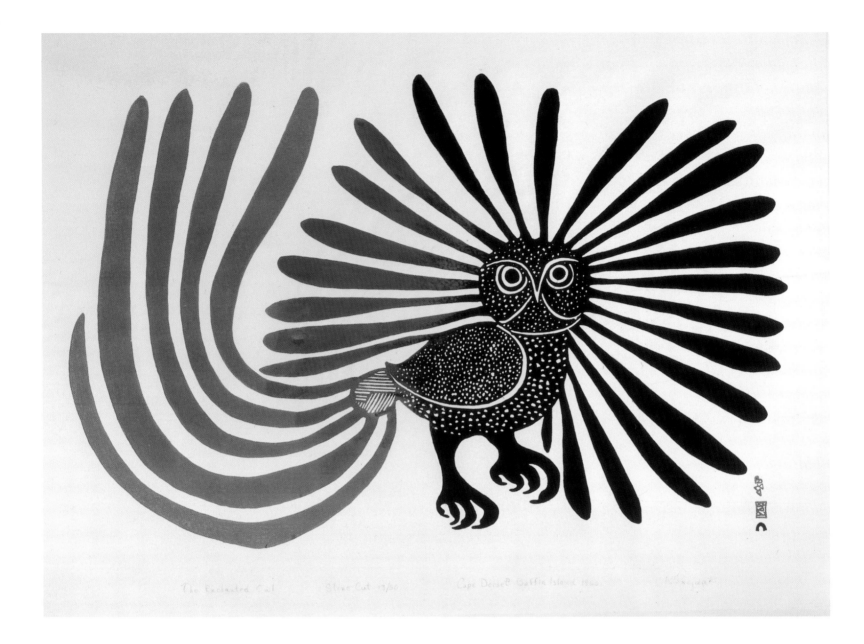

The Enchanted Owl Stone Cut 17/50 Cape Dorset Baffin Island 1960

Kenojuak ASHEVAK

The Enchanted Owl

(1927-) 1960; stonecut; 38.5 cm x 58.2 cm; Printed by Eegyvudluk Pootoogook (1931-); Canadian Museum of Civilization, image #S99-10062

Kenojuak Ashevak's enchanted owl, whose head feathers spin out like the rays of the sun and whose tail sweeps up joyously, is one of the most famous images in Inuit art. In 1970, to commemorate the centennial of the Northwest Territories, it was reproduced on the six-cent postage stamp. Although birds are a dominant subject in her art, Kenojuak has said that she draws without preconceived ideas: "I may start off at one end of a form not even knowing what the entirety of the form is going to be; just drawing as I am thinking, thinking as I am drawing…I try to make things which satisfy my eye, which satisfy my sense of form and colour." While birds in their many imaginative permutations frequently emerge when she begins to draw, their simple forms and potential for abstract elaboration are suited to Kenojuak's intent "to make something beautiful, that is all," rather than to tell a story or to depict a particular event.

Kenojuak began to draw with pencil on paper in the late 1950s, while she was living on the land along the south shore of Baffin Island. Her sense of graceful form and fluid design was already developed in the shapes and patterns she used to decorate skin bags and clothing for her family. As the first woman to provide drawings for the Cape Dorset printmaking co-operative established by James Houston in 1959, Kenojuak became the most prolific of artists, supply-

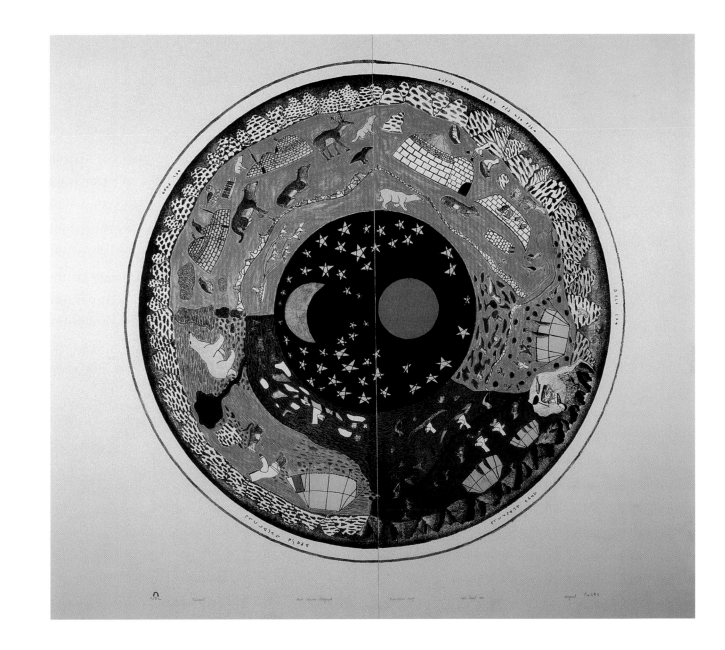

Nunavut (Our Land)

1992; hand-coloured lithograph; 120 cm x 134 cm; Printed by Pitseolak Niviaqsi (1947-); Canadian Museum of Civilization, image #S99-135

ing thousands of bold drawings, more than 188 of which have been issued as prints.

Awaiting the birth of her ninth child, Kenojuak moved into Cape Dorset in 1966 so that her children could attend school. She soon expanded her approach to drawing and printmaking and began to produce sculptures and paintings. In all media, her work shows the interconnectedness of humanity and nature and, in some cases, verges on abstraction, as birds and ani-

mals become intertwined in complex patterns. In the late 1980s, Kenojuak started to explore landscapes.

She was commissioned in 1992 by the Department of Indian Affairs and Northern Development to produce a work to commemorate the signing ceremony for the Tungavik Federation of Nunavut Settlement Agreement in Iqaluit in 1993. Unusual for its narrative structure, *Nunavut (Our Land)* is a round lithograph. In the centre of the Inuit universe, the

sun and the moon reign eternal throughout the changing seasons, overseeing the cycle of life on the land, where igloos give way to snow tents and ice melts to water for kayaking and fishing. The distant mountains circle the land, declaring the homeland for Inuit of the eastern Arctic.

In appreciation for her great gift to Canadian art, Kenojuak was appointed a Companion of the Order of Canada in 1982.

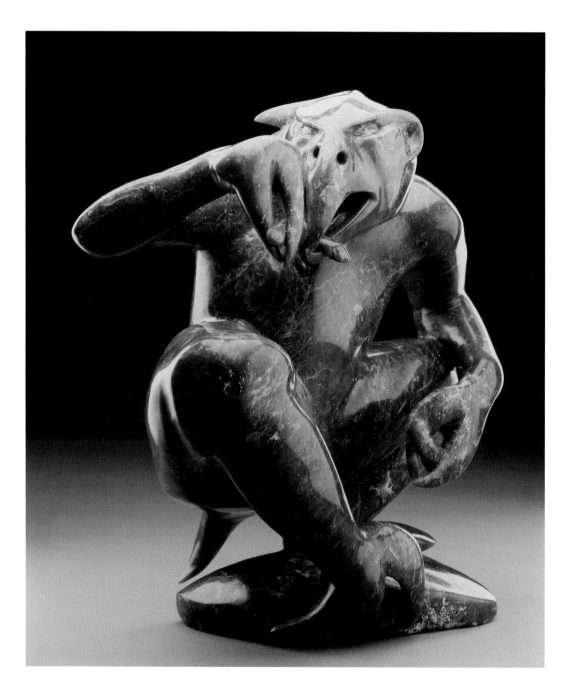

Kiawak ASHOONA

Bird Creature

(1933-)

1990; light green stone; 49 cm x 45 cm x 22 cm; National Gallery of Canada

Squatting on powerful human legs supported by claw-like feet, the Bird Creature purposefully consumes a sliver of fish. With its hunched-over stance and thrusting elbows, the beast exudes energy and a sinister aura that is enhanced by the downward thrust of its sharp beak and narrow eyes. Kiawak Ashoona employs a stone the colour of seaweed in the sun, deftly combining precisely executed detail with a complex pose delivered from the weight and density of the

hard, brittle local serpentine. Despite the malevolent demeanour of this imaginary animal, Kiawak, a devout Christian, insisted: "I don't want to have anything to do with evil spirits. And when I carve weird-looking creatures, this has nothing to do with shamans."

Kiawak, the son of graphic artist Pitseolak Ashoona and the brother of Qaqaq Ashoona, began carving in the late 1940s, while he was living on the land with his family. Endowed with both a lively

imagination and expert carving skills, he exhibited in London, England, in 1953 to critical acclaim.

In the early 1960s, he embarked on a series of elaborate fantasy creatures whose inventiveness was matched by his desire to challenge the limitations of the stone. Over Kiawak's long and prolific career, his work has evolved from the monolithic solidity of his early sculptures to the dynamic openness of pieces such as this.

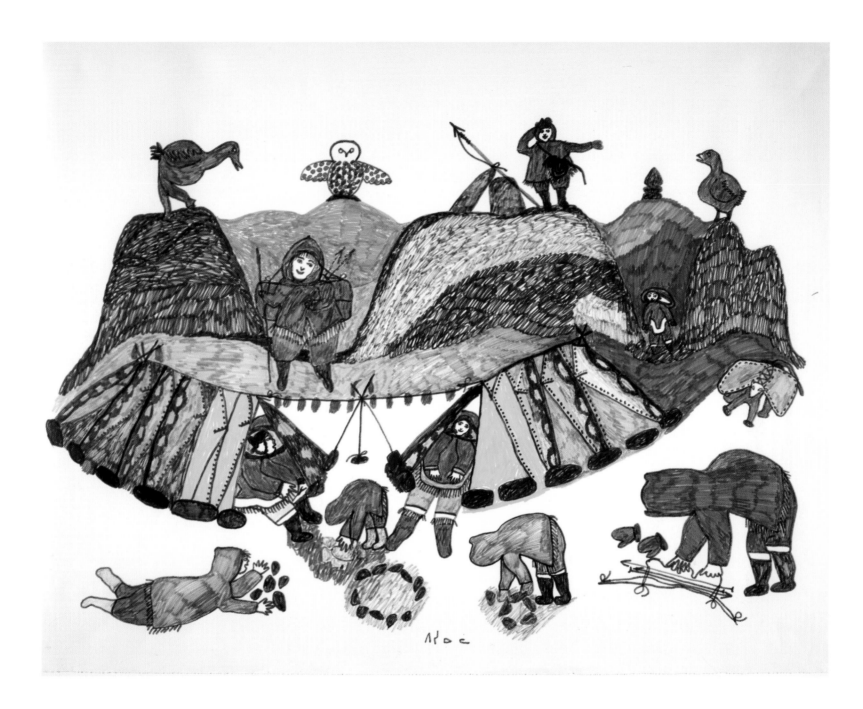

Summer Camp Scene

Pitseolak ASHOONA

1974; felt pen on wove paper (watermark: "RIVES"); 50.8 cm x 65.6 cm; National Gallery of Canada;
Gift of the Department of Indian Affairs and Northern Development, 1989

(1904-1983)

Drawing on her memories of growing up on southern Baffin Island, Pitseolak Ashoona renders a rare moment of relaxation from a woman's perspective. The women, with their signature *amauti*, or parkas, smile and chat in the opening of a summer sealskin tent, while children play and men carrying bows and arrows return from the hunt. Even the wildlife seems to be enjoying the day, striking almost comical poses that contribute to the feelings of joy. Pitseolak's skil-

ful use of the felt-tip pen captures the textures of life, with different strokes distinguishing the varied surfaces of rock, tundra and caribou clothing. "The old life was a hard life, but it was good," she once said. "It was a happy life."

Pitseolak was a widow with young children to support when James Houston introduced her to drawing in the early 1960s, after she moved to Cape Dorset. Houston established an artists' workshop that would

become one of the most important printmaking centres in the Arctic. Pitseolak supplied thousands of drawings, more than 200 of which were released as prints between 1960 and 1981. A book of her early recollections—"the things we did long ago before there were white men"—entitled *Pictures Out of My Life*, was published in 1971. In 1977, she received the Order of Canada for her outstanding contributions to Canadian art.

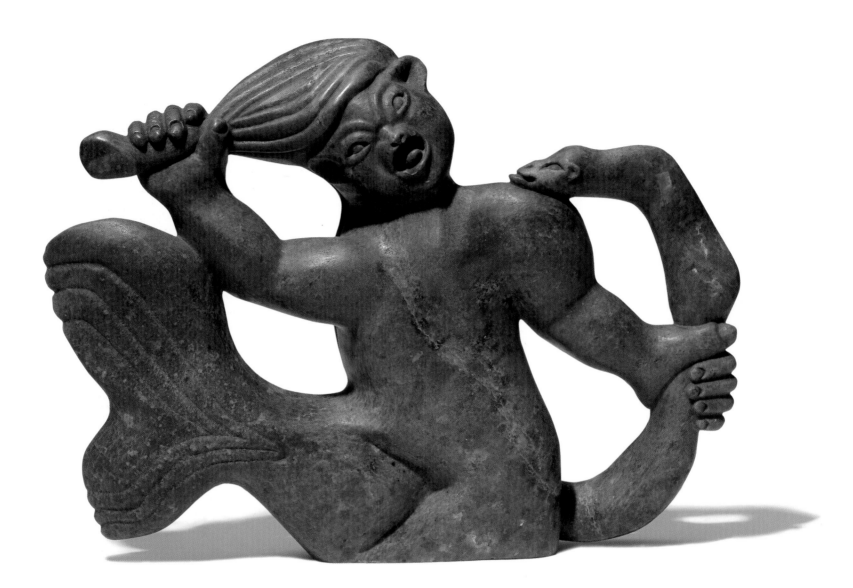

Qaqaq ASHOONA

(1928-1996)

1962; stone; 22.1 cm x 29.5 cm x 6.3 cm; Winnipeg Art Gallery; The Ian Lindsay Collection;
Acquired with funds donated by the Volunteer Committee to the WAG; Photo by Ernest Mayer/WAG

In a sculpture whose rounded organic forms and sinuous lines echo the watery home of this important Inuit spirit, Qaqaq Ashoona summons the powers of the sea goddess herself. Known by a variety of names throughout the Arctic, Taleelayuk, Nuliayuq or Sedna, as she is most often called, was the guardian of both land and sea animals and was therefore frequently invoked for a successful hunt. In portraying Taleelayuk and the serpent in the hard, green serpentine stone of

Cape Dorset, Qaqaq adopts Taleelayuk's most familiar form as part human, part animal. Here, she is an angry goddess, her mouth open in a rage as she pulls at her tresses and mercilessly squeezes a snake in her other hand. It was the shaman's responsibility, through soul travel, to appease the angry goddess by combing and braiding her hair, thereby restoring order.

Qaqaq, a son of Pitseolak Ashoona and brother of Kiawak Ashoona, was introduced to carving in the

early 1950s by his mother's cousin Kiakshuk. Having mastered the art of the hunt in his struggle to survive on the land, Qaqaq preferred to carve while living outside settled communities such as Cape Dorset, finding his inspiration in Inuit beliefs and traditions.

"I get the idea for a carving from the stone," he said. "Before I start carving, I just look at it for a while—sort of draw it with my eyes to see what I will carve."

24

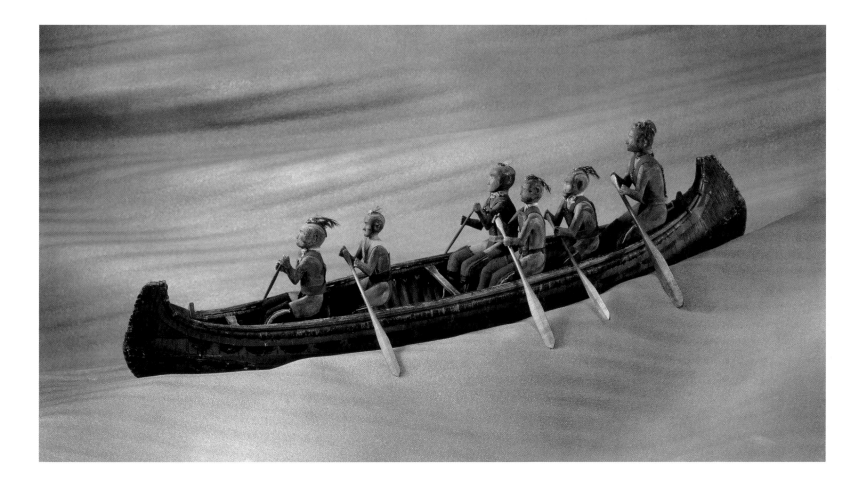

Model Canoe

Jean-Baptiste ASSIGINACK

1815-1827; birchbark canoe with carved and painted wooden figures dressed in woollen cloth, feathers, tanned skin; L: 94 cm, W: 21 cm, H: 19 cm; Canadian Museum of Civilization, image #S89-1735

(1768-1866)

An anonymous early-19th-century manuscript, which refers to the details of this scaled-down Algonkin/ Great Lakes Indian fur-trade canoe, reports that its maker, Jean-Baptiste Assiginack, "occasionally amuses himself in performing works of this kind…at the request of his friends, who wish to send them as Curiosities to Europe." A renowned orator and chief of the Odawa Nation, Assiginack had fought for the British during the War of 1812.

When constructing the nearly one-metre-long canoe, Assiginack employed the materials and tools used to make a full-sized, lake-worthy canoe: birchbark, wood, tree roots and pine or spruce gum mixed with animal fat and pulverized charcoal to prevent the canoe from leaking. Each of the six (originally seven) wooden figures is carved from a single piece of wood and is said to represent an individual, known to the artist, who had participated in a war-party expedition. While paddlers

would normally sit lower in the canoe, Assiginack's decision to have them perch on the thwarts allows us to appreciate the meticulous attention paid to the colourful clothing, the feather headdresses and the moccasins worn by one of the paddlers. Each figure has pierced ears and red and black designs painted on its face, head and torso. The fidelity to detail renders this work invaluable to ethnologists, but for the artist, it immortalized friendships and bygone adventures.

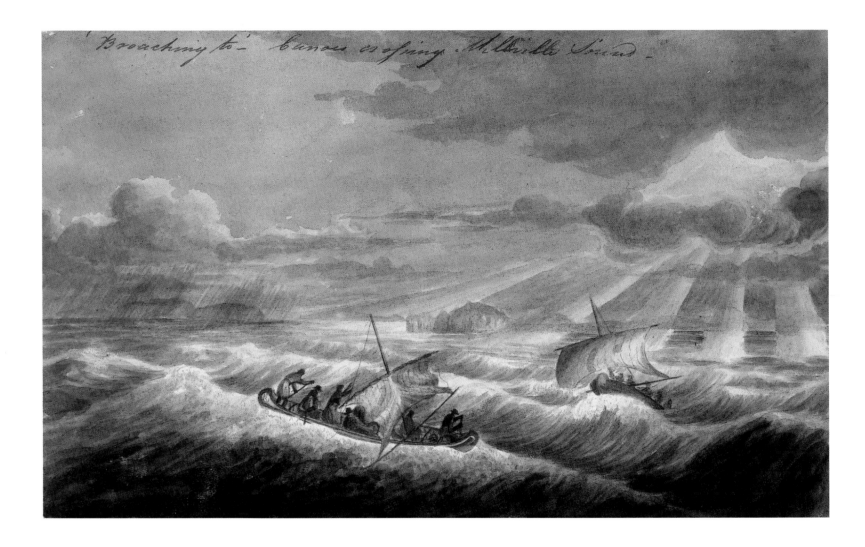

'Broaching to' – Canoes crossing Melville Sound –

George BACK

Broaching to,–Canoe crossing Melville Sound

(1796-1878)

August 1821; watercolour/from Sketchbook II; 11.1 cm x 18.3 cm; National Archives of Canada/C-141501

Despite exhaustion, near starvation and wet, frigid weather, George Back kept a detailed diary and sketchbook of his heroic voyage with Lieutenant John Franklin on his first overland Arctic expedition to the Coppermine River (1819-22). Today, that record sheds fascinating light on the experience. In his diary entry for August 23, 1821, Back relates the hazardous circumstances and the curious beauty to be observed in a crossing of Melville Sound: "When we were about mid-channel, a sudden squall came on—it rained hard —and the rays of the sun...cast a beautiful yellow tinge over the white foam of the dark green sea. We were admiring this spectacle with delight when a huge wave...broached our canoe and we narrowly escaped sinking." In this sketch, executed on terra firma, Back contrasts the shimmering light of the sun against the stormy grey sea and depicts the vulnerability of the canoes about to be engulfed by the raging water.

Unlike other naval officers, who learned their artistry in British military academies, Back is said to have acquired his while he was a French prisoner of war from 1809 to 1814. Although it was his versatility as an artist that secured his position with Franklin in 1819 and again in 1825 to Great Bear Lake and the Arctic coast, it was Back's singular accomplishments as an explorer on these and later expeditions that earned him a knighthood in 1839.

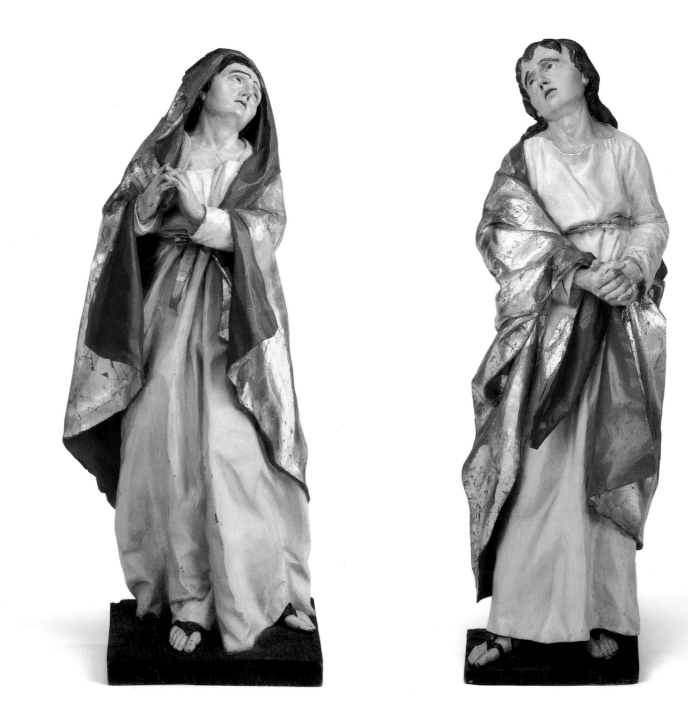

The Virgin and Saint John

François BAILLAIRGÉ

1797; polychromed and gilded white pine; H: each approximately 137 cm; National Gallery of Canada

(1759-1830)

The two sculptures shown here were originally part of a Crucifixion scene commissioned in 1794 by the parish church of Saint-Jean-Port-Joli, Quebec, on the south shore of the St. Lawrence River. When we look at the works today, we must imagine the sculpture of the crucified Christ upon which these figures gazed. The mournful Virgin leans to the right, her hands clasped in prayer and her sorrowful eyes cast upward toward her dying son. Saint John completes the narrative, leaning to the left with an expression of anguish and despair. François Baillairgé has transformed the rigidity of wood into near life-sized figures that breathe with vitality, whose garments fold and sway around their bodies with a naturalism charged with both theatricality and emotion. The use of a limited palette of flesh tones, red, white and gold is in concert with the restrained use of colour characteristic of the neoclassical style that Baillairgé would have admired during his studies at the Académie royale in France.

Multitalented, like the other members of his family with whom he frequently collaborated, Baillairgé was also a painter, an architect, a teacher and a sculptor of ships' figureheads. His dedication to fine craftsmanship and design can still be seen in the execution of complex interiors for over 30 churches in the province of Quebec.

27

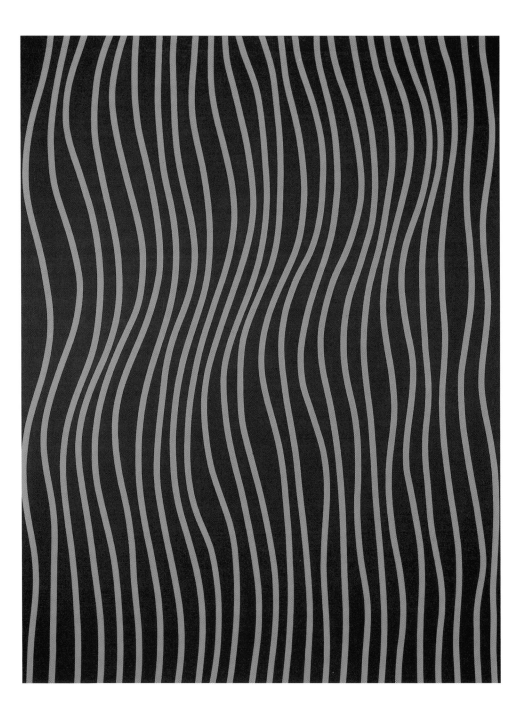

Marcel BARBEAU

(1925-)

1964; acrylic on canvas; 203.6 cm x 152.7 cm; National Gallery of Canada

Against a violet-blue background, sinuous yellow lines create an undulating vertical pattern like a current in a river, exciting an optical vibration which gives the impression that the painting, at one moment concave and the next convex, is energized with life and swaying before us. The artistic trajectory of Marcel Barbeau has been similarly dynamic—in a process of constant change and productivity in a variety of media over the span of his long and prolific career.

From 1942 to 1947, Barbeau studied at the École du meuble in Montreal, where he adopted a spontaneous approach to abstraction, then being explored by the artists associated with Paul-Émile Borduas and the Automatistes. He signed the *Refus global* in 1948, thereby joining the group's cry for a new social and artistic order following the war. In 1959, Barbeau abandoned the gestural techniques and "accidental" dream-inspired imagery promoted by the Automa-

tistes. As he pursued the nature of space in painting, his work became more structured and geometric. In 1962, his encounter in Paris with the work of Victor Vasarely, a pioneer in the Op Art of the 1960s, opened the door for Barbeau's own exploration of powerful optical effects. "I am an intuitive painter," he said in 1966. "I don't have a particular theme that I pursue. I sense a certain approach or attitude to follow, rather than having a clear, defined strategy."

Whale Song #10 Anne Meredith BARRY

1989; oil on canvas; 185.4 cm x 125.1 cm; Art Gallery of Newfoundland and Labrador; The Scott Meredith Barry Memorial Collection (1932-)

From her studio window in a small outport on New-foundland's southern shore, Anne Meredith Barry studiously observed the graceful movements of the whales and contemplated their fragile plight and threatened environment. After extensive research into their anatomy and habitat, she decided how she wanted to portray them: "as gentle leviathans who have existed since the dawn of time, who are singing a song we do not understand and who are, in the long run, probably headed for extinction." To address the whales' ancient and primeval character, Barry turned away from academic traditions and employed a delib-erately rough drawing style, applying the colours flatly to give a sense of the power and weight of nature. "I decided to do these paintings almost as petroglyphs," she explained, "white lines crudely incised into wet black gesso." In *Whale Song #10*, the whales dive and surface from ominous dark waters, creating cir-cular movement and emitting colourful sounds into the glorious yellow and aqua light of the sky.

A native of Toronto and a graduate of the Ontario College of Art in 1954, Barry has lived in Newfound-land since 1987. Although she admires the work of artists as varied as Matisse, Gauguin, Canada's Pater-son Ewen and a number of Japanese painters, Barry derives her greatest inspiration from her relationship with nature amid the rugged beauty of Newfoundland.

29

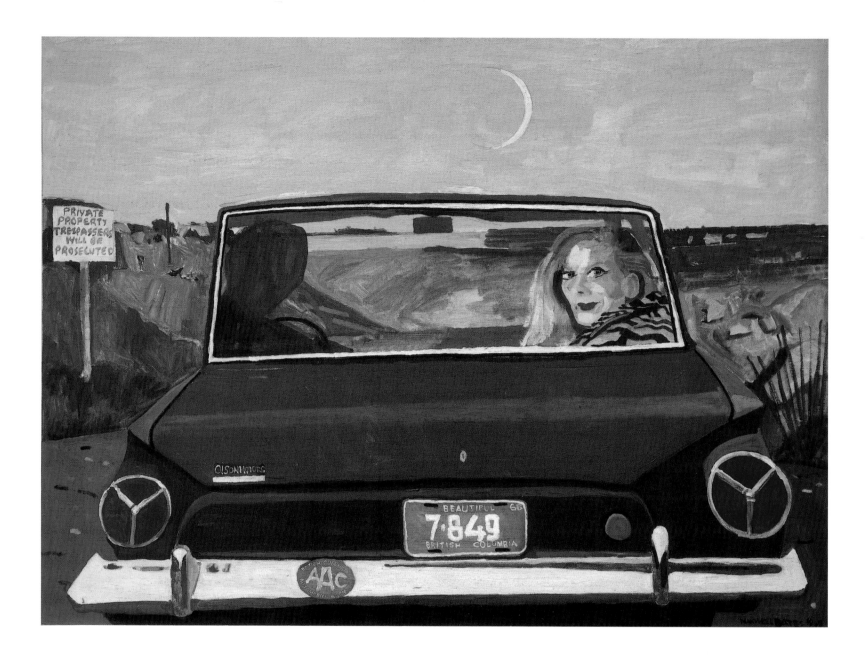

Maxwell BATES

(1906-1980)

Beautiful B.C.

1966; oil on canvas; 91.0 cm x 121.9 cm; Vancouver Art Gallery; Siwash Auction Funds VAG 68.15; Photo by Jim Gorman

Maxwell Bates based the title of this painting on a promotional magazine of the 1960s called *Beautiful B.C.*, in which the photography was intended to depict an idealized vision of West Coast nature. Here, a blue car frames our image of the passengers inside: A blonde woman dressed in a tiger-skin coat gazes at us from the back of the car, while her partner, by the steering wheel, is lost in shadow. As the pale moon rises over the beach and the sea, Bates takes a satirical stance:

glamour and technology impede our view of nature.

Bates began his artistic career as an apprentice in his father's architecture firm in Calgary, Alberta, and he studied art there for a year. Seeking exposure to more avant-garde styles, he lived in England from 1931 to 1939, where he continued to paint and to practise architecture. Bates joined the British Army in 1938 and was sent to France. Captured in 1940, he spent the next five years in a German prison camp, the

memories of which he later published in *A Wilderness of Days*. Although he returned to his father's firm in 1946, Bates continued his education as an artist. He studied at the Brooklyn Museum School in 1949 with exiled German artist Max Beckmann, whose expressionistic and sometimes brutal depictions of the human figure strengthened Bates's enduring admiration for the incisive observations and biting graphic commentary of Honoré Daumier and Edgar Degas.

Bagged Rothko Iain BAXTER and Ingrid BAXTER, N.E. Thing Company Ltd.

1965; inflated vinyl and cotton flock; 169 cm x 156 cm x 2 cm (uninflated); (1936-)
National Gallery of Canada; Gift of Yves and Germaine Gaucher, Montreal, 1994 (1938-)

In the rebellious 1960s, artists questioned definitions of art and the authority of the art market. In Vancouver, the influential writings of Canada's internationally acclaimed communications theorist Marshall McLuhan were of particular interest to Iain and Ingrid Baxter, whose attention to McLuhan's famous dictum "the medium is the message," coupled with his analysis of the "processing and packaging of information," had a direct impact on their art.

Iain Baxter abandoned his work as a painter in 1965 and explored notions of packaging, drawing on the use of plastic and the North American obsession with everyday "bagging." In one work, he "bagged" the entire contents of an apartment. A series of "bagged" landscapes, using vinyl filled with air and water to portray the various elements, offered a cushioned vision of nature. Works of art introduced to mass culture through magazines could also be pack-

aged. In *Bagged Rothko*, a large vinyl rectangle, inflated and stuffed, mimics the palette and composition of paintings by American artist Mark Rothko. By appropriating Rothko's trademark composition, Baxter humorously mocks the preciousness of the art object, the notion of the creative genius and the elitism of the art market.

In 1966, Baxter and his wife founded the N.E. Thing Company (art could now be "anything!").

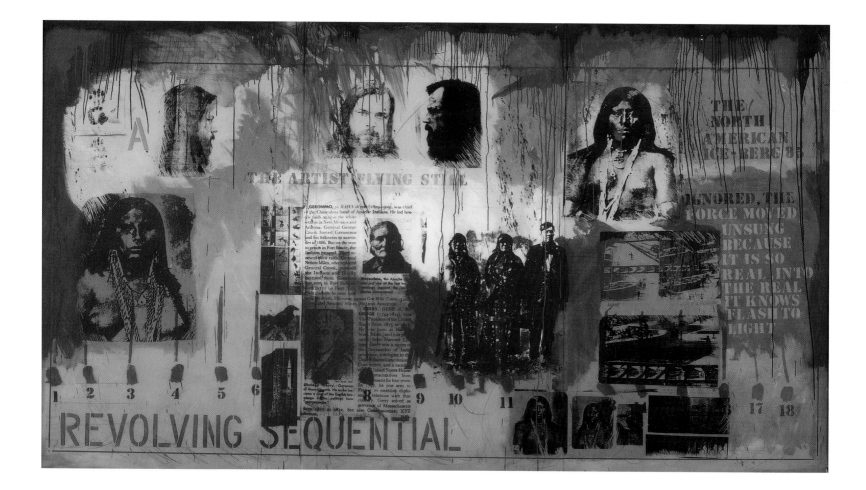

Carl BEAM

The North American Iceberg

(1943-)

1985; acrylic, photo-serigraph and graphite on Plexiglas; 213.6 cm x 374.1 cm; National Gallery of Canada

The title of this work is a reference to The European Iceberg, an exhibition held at the Art Gallery of Ontario in 1985 that presented contemporary European art little known to North Americans. Adapting this notion of marginalization to contemporary native experience on this continent, Carl Beam employed silkscreen images and text on Plexiglas using the technique of photo transfer popular with American artists such as Robert Rauschenberg.

Here, Beam combines encyclopedia texts and a photograph of Geronimo—the Apache chief from the American Southwest—with pictures of Indians dressed as Europeans. Flanking these, 19th-century portraits contrast with mug-shot-style self-portraits of Beam. The words "The Artist Is Flying Still" link the self-portraits to film stills of an eagle, its actions likewise imprisoned by the camera. While the images are thematically related and disclose an obvious criticism of the forced assimila-

tion of the native peoples, the chaotic arrangement of the texts combined with the erratic use of colour, gestural brushwork and dripping suggest a story whose complex narrative has yet to be unravelled. "My guides," said Beam, "have been the wise men of traditions who interpret reality and get hold of meaningful things."

An Ojibwa from Manitoulin Island, Beam studied art at both the University of Victoria and the University of Alberta.

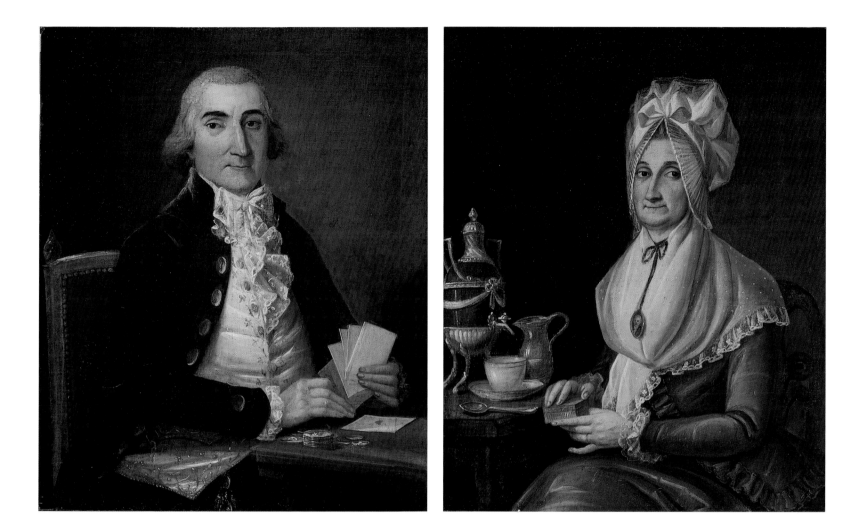

Eustache-Ignace Trottier dit Desrivières/
Madame Eustache-Ignace Trottier dit Desrivières,
née Marguerite-Alexis Mailhot

François BEAUCOURT

1793; oil on canvas mounted on fibreboard; 79.5 cm x 63.8 cm / 79.9 cm x 64.1 cm; Musée du Québec; Photo by Patrick Altman/MQ (1740-1794)

These paintings are among the earliest examples of Canadian portraits of individuals accompanied by attributes that reflect their status in society. On the left, M. Trottier, a prosperous Montreal merchant, sits proudly in a red-back chair, dressed fashionably in a dark green coat with gold buttons and an embroidered white silk waistcoat, an elegant ruffle of lace at his throat. His wry, confident smile and look of good fortune are reflected in his hand, the ace of

hearts already played and the stack of nearby coins.

Smiling with polite reserve, Marguerite Mailhot turns toward an imaginary centre to face her husband. With a miniature painting of her son fastened around her neck, she is stylishly attired in a blue dress and jacket that are softened by the scarf on her shoulders and a white bonnet, which was routinely worn indoors. An elegant samovar echoes the blue of her dress and affirms her participation in the genteel rit-

ual of tea preparation befitting the aspirations of her class. The small gold box in her hands probably contains tea, a precious commodity. That the couple chose François Beaucourt to paint their portraits further mirrors their good taste. Quebec-born and initially educated by his artist father, Beaucourt could boast the prestige of academic training in France— the only other 18th-century Quebec artist besides François Baillairgé to have been able to do so.

33

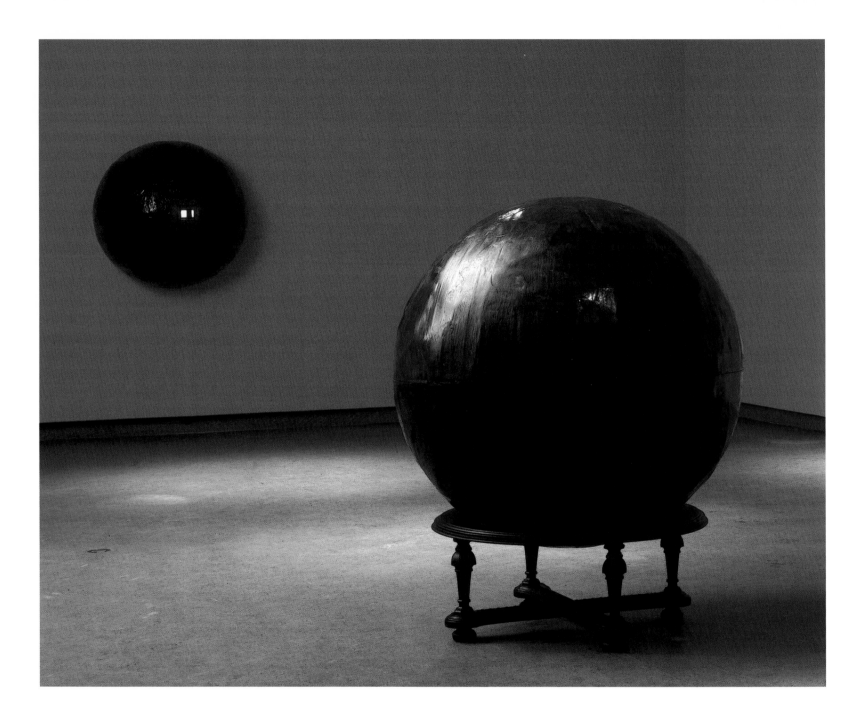

Lance BELANGER

<div style="text-align: right">Neo-Lithic Tango</div>

(1956-)

1994-1995; sphere: veneers and wax on wood structure; D: 120 cm;
Photo courtesy Ottawa Art Gallery; Collection of the artist; Photo by Louis Joncas

While visiting a museum in the Dominican Republic in the late 1980s, Lance Belanger saw stone spheres made by the Taino, the first indigenous culture to be encountered and annihilated by Europeans in the late 15th century. For Belanger, a member of the Maliseet Nation who grew up on the Tobique Indian Reserve in New Brunswick, the spheres symbolize the survival of native American cultures, despite 500 years of colonization.

In his own work, Belanger has used contemporary materials other than stone to construct spheres of various sizes—"neolithic spheres"—that evoke the solemn ancientness and mysterious volumetric simplicity of the originals. As Belanger has explained, "The point has been to spread these objects around the world in galleries and specific sites as part of a topographical mapping process that reinforces the resilience of this hemisphere's original inhabitants."

In linking his neolithic spheres with the tango, a dance that demands the constant negotiation of position, Belanger alludes to a Western cultural system within which to explore native identity. The tango is also about movement, and while the shape of the ancient spheres suggested movement, their great weight arrested it, a contradiction that the artist sees as analogous to the struggle to assert native identity. Belanger studied Indian art at the Saskatchewan Indian Federated College in Regina from 1977 to 1979.

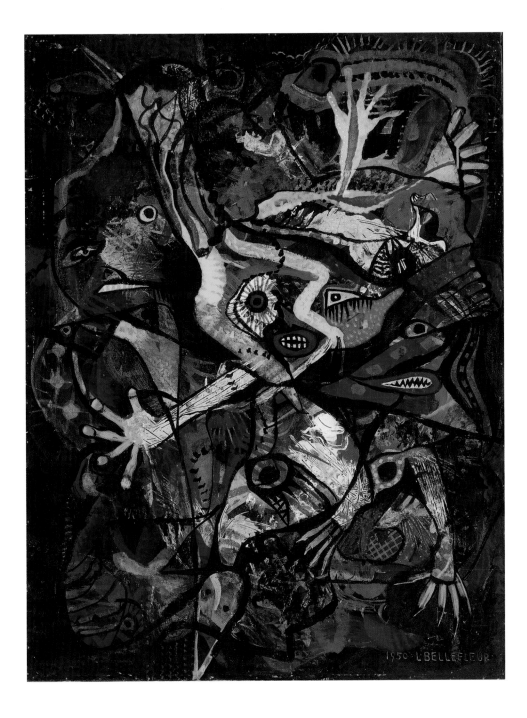

Dance of the Drowned

Léon BELLEFLEUR

1950; oil on canvas; 81.3 cm x 60.2 cm; National Gallery of Canada

(1910-)

A red eye and a crying mouth stare out at us from the centre of the canvas, as a single white arm beckons with a helpless open palm. The rest of the body is lost in a frenzy of overlapping shapes and colours from whose chaos more grim faces emerge, identified by gaping eyes, clenched mouths and spiky hands grasping for each other in the midnight waters of the dance of the drowned. "I paint by instinct," said Léon Bellefleur in 1953, "without philosophical or pictorial reason-ing. It's a world I invent poetically and in exaltation."

Bellefleur studied at the École des beaux-arts in Montreal, and in the early 1940s, he became ac-quainted with artists associated with Paul-Émile Borduas and Alfred Pellan, whose explorations of Sur-realist theories promoted an approach to art inspired by dreams and the subconscious. Bellefleur also ad-mired the work of Swiss artist Paul Klee, whose sim-plified and whimsical compositions reflected his own enthusiasm for children's art. In it, Bellefleur saw a freshness and spontaneity of expression that many 20th-century artists also wished to recover. In his "Plea for the Child," first published in 1947, Belle-fleur championed the child's natural inclination to reverie, "the way of mystery and the infinite…Only those who have retained or rediscovered the ability to dream, to play, to feel moved and to pursue an ideal can hope to make their life a great and splendid thing."

35

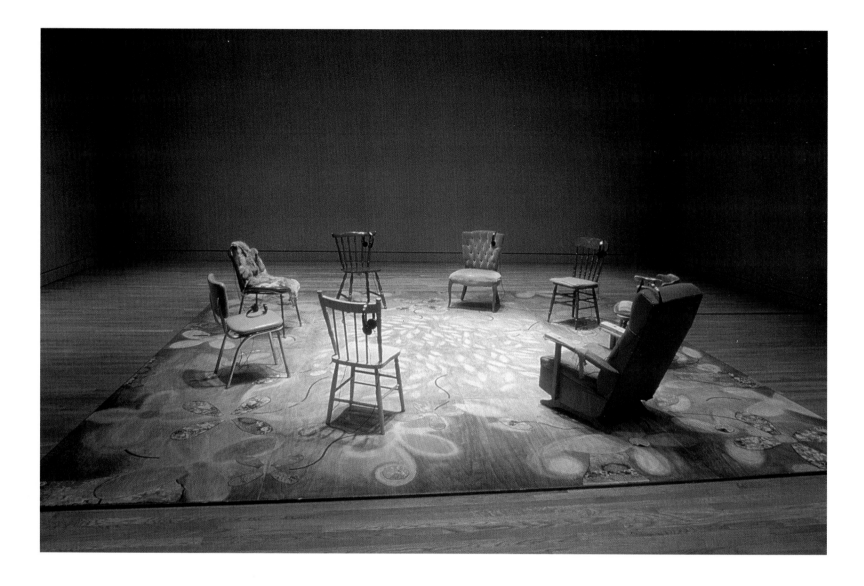

Rebecca BELMORE

Mawu-che-hitoowin: A Gathering of People for Any Purpose

(1960-) 1991; mixed-media installation; dimensions vary; Collection of the artist

In this work, Rebecca Belmore arranged a group of chairs in a circle on a carpet of flowered linoleum and equipped each chair with a headset, thereby inviting us into the community of women who donated the seven chairs and whose seven voices are recorded on the audiotapes. Sitting on their chairs, we listen to their stories and personal experiences, which have been forgotten, neglected and disregarded by standard archives and histories but are rich with memories of the fami-

lies and children these women cherished. While the individuality of the voices is symbolized by the singularity of each of the chairs, the circular arrangement evokes the continuity of tradition, the life cycle and sacred circles, implying the security and sharing in traditional communities where people gathered as equals for any purpose.

Belmore is Ojibwa, grew up in Upsala, Ontario, and studied at the Ontario College of Art. In her varied ex-

pression as a painter and performance and installation artist, the recollections of her own female relatives have had a powerful impact on her art and on the assertion of her native identity. "I have with me the influence of my *Kokum* [grandmother] and my mother," she said. "I can see their hands at work. Hands swimming through the water, moving earth and feeling sky: warm hands. I can see their hands touching hide, cloth and bead, creating colour beauty: working hands."

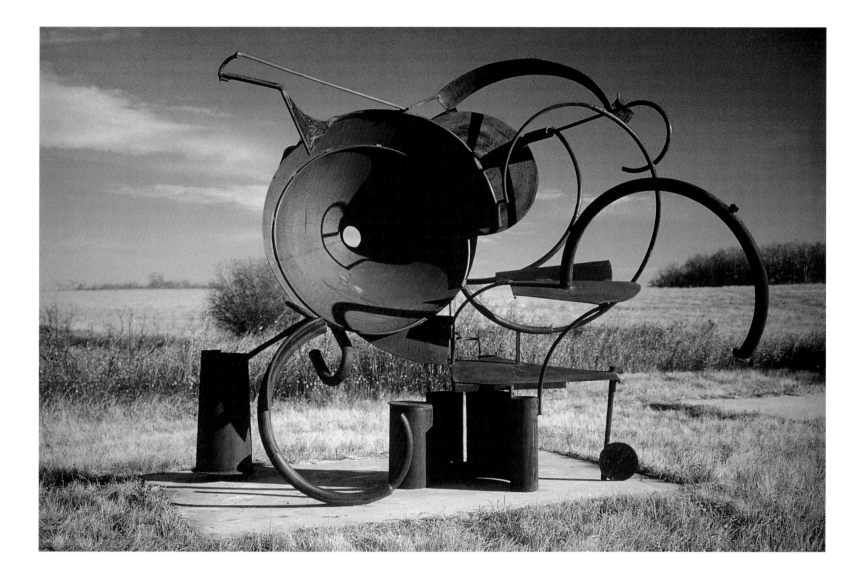

Portrait of the Painter

Douglas BENTHAM

1989-1990; steel, rust, paint and wax; 228.5 cm x 249.0 cm x 183.0 cm; Collection of the artist

(1947-)

In *Portrait of the Painter*, a dancing calligraphy of curving lines springs out from a central cone that appears independent of its base of cylinders and flat metal planes. With its open, expansive energy, Douglas Bentham's sculpture seems to denounce the inherent heaviness of the metal materials, producing a lyrical abstract choreography that defines space without completely filling it with traditional volume. Bentham's titles, which he assigns only after completing the sculptures, are not literal descriptions but evocative cues to a work's essence. "I continue to be challenged by the potential of pictorial sculpture," he has explained, "that is, sculpture which extends into and encompasses space…We know that inspired art embraces the ambiguous and the equivocal. I hope this is the 'content' which sustains my art."

Born in Rosetown, Saskatchewan, Bentham studied at the University of Saskatchewan. His encounter with American sculptor Michael Steiner in 1969 and British artist Anthony Caro in 1977 at the Emma Lake workshop consolidated his commitment to abstract metal sculpture that is open and linear rather than monolithic. Influenced by the freedom and spontaneity of abstract expressionist painting, Bentham makes no attempt to disguise the nature of his materials or their method of assemblage. Welding, bolts and screws animate the surfaces and joints, making evident the artist's process.

Alexandre BERCOVITCH

Petroushka

(1891-1951)

c. 1948; oil on canvas; 207.5 cm x 474.3 cm; National Gallery of Canada; Gift of Jack Gordon, Montreal, 1990

Alexandre Bercovitch's Ukrainian origins, his apprenticeship in a Kherson monastery, where he learned to paint icons, and his experience as a designer of sets and costumes for his local Yiddish theatre together set the stage for this large painting. In the centre of a pre-Lenten panorama that spans over four metres, the ghostly pale figure of the Russian legend embraces his ballet partner and turns in surprise, fearful of being felled by the "blackamoor" with the raised sabre. In the foreground, musicians, clowns and puppeteers entertain the colourfully masqueraded crowds enjoying the celebrations of the Butter Week fair held in St. Petersburg. In creating this composition, Bercovitch combined his childhood memories of Petroushka seen in travelling puppet shows with the interpretation of the character in Sergei Diaghilev's 1911 ballet of the same name.

While Bercovitch's association with the world of Russian theatre and ballet was exciting and enriched by contact with choreographers such as Léon Bakst, his career as an artist was thwarted by the social and political turmoil of the country. In 1926, Bercovitch and his family immigrated to Canada, where he became active with the Montreal arts community, designing theatre sets, painting and establishing himself as an influential teacher at the YWHA. He was commissioned in 1946 to paint *Petroushka* for a hotel mural in Ste-Agathe, Quebec.

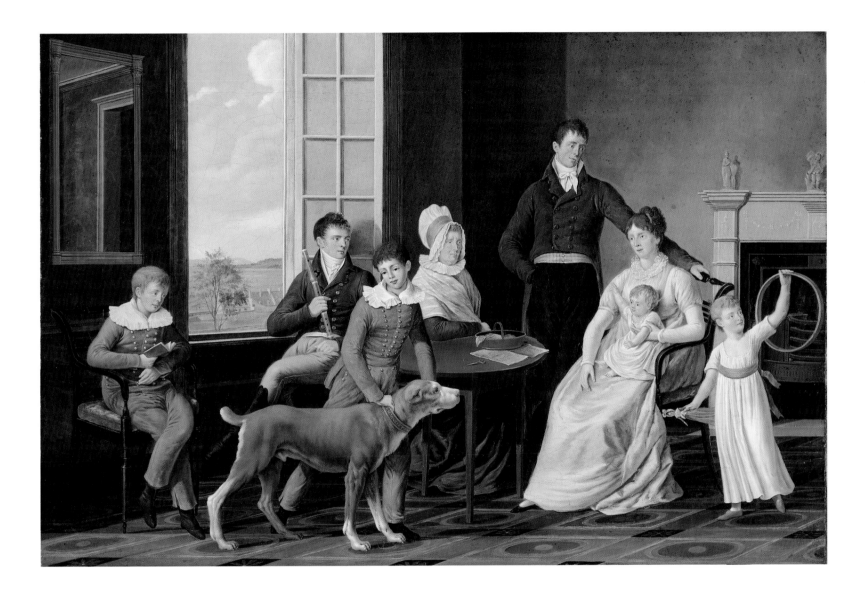

The Woolsey Family

William BERCZY

1809; oil on canvas; 59.9 cm x 86.5 cm; National Gallery of Canada; Gift of Major Edgar C. Woolsey, Ottawa, 1952

(1744-1813)

With the poise and restraint of a classical frieze, members of the Woolsey family gather in their Quebec City drawing room, suspended in quiet conversation. The soft pastel tones of their clothing are echoed by the refined Regency interior decoration and confirm the affluence of John William Woolsey, a wealthy Quebec merchant, auctioneer and broker. An inscription written by Woolsey on the back of the canvas identifies the sitters: Woolsey stands behind his wife and forms the apex of a triangle that includes their four children, his mother and his brother-in-law, who is holding a flute. Birth and death dates record the ill fortune and sickness that would soon diminish the family ranks.

The enterprising William Berczy was born in Germany and worked as a painter and an architect before coming to Canada, via the United States, as an immigration agent. First settling in York in 1794, he moved to Montreal in 1805, where his talents as a portrait painter, a church decorator and an architect were highly esteemed. In 1808, John Woolsey commissioned Berczy to paint this portrait for 80 pounds—a hefty sum, given that Woolsey's rent was 55 pounds per year. The dog, whose collar bears the family name, was painted free of charge. Completed after the artist undertook a year of preparatory sketches, the painting is considered one of the triumphs of Berczy's career.

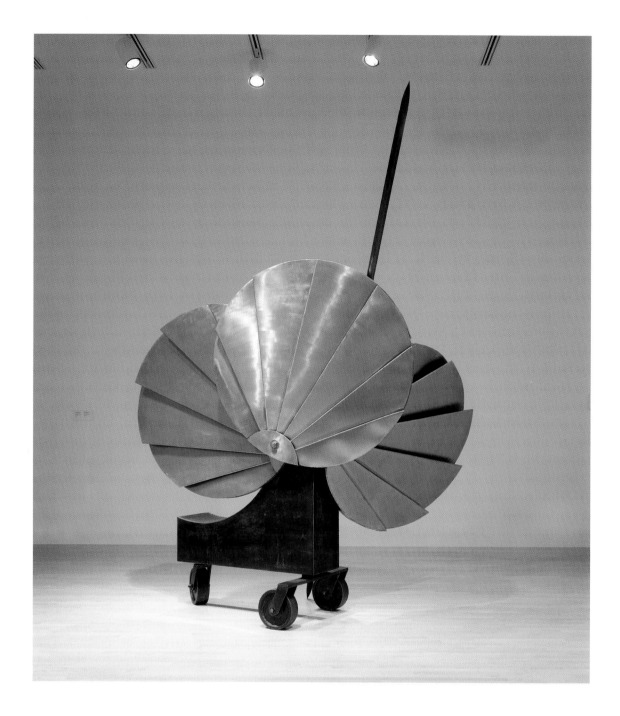

Liliana BEREZOWSKY

Boaz

(1944-)

1989; stainless steel, steel; 324 cm x 236 cm x 175 cm; National Gallery of Canada

Three pleated fanlike shapes sit atop a heavy metal chassis supported by three metal wheels, creating opposition between the coarse industrial character of the "wagon" and the silvery quality of the brushed stainless steel that shimmers like ironed silk. On the other side, a long, pointed pole, like a giant knitting needle or a huge lance, adds an element of aggression and danger to the work, conspiring with the dark humour of this rather incongruous object. Is it a toy? A vehicle? An incomplete machine? Its purpose, as much as its title, remains a mystery. Drawn by the tensions provoked by these polarities, Liliana Berezowsky explains, "As a whole, the sculpture embodies a number of contradictions and dichotomies…although nonfunctional, the piece alludes to function…to issues of purpose and use. References to male/female, to reality/myth and [to] questions of public/private as well as pleasure/danger, desire/doubt are some of the issues engendered by the work."

Born in Kraków, Poland, Berezowsky grew up in Toronto and studied at the University of Toronto and, later, at Concordia University in Montreal. Descended from a long line of eastern European blacksmiths, Berezowsky recognizes the importance of both collective and personal history, and in her work, she explores notions of opposition rooted in her heritage, where tradition was questioned by modernism and mysticism challenged by rationalism.

40

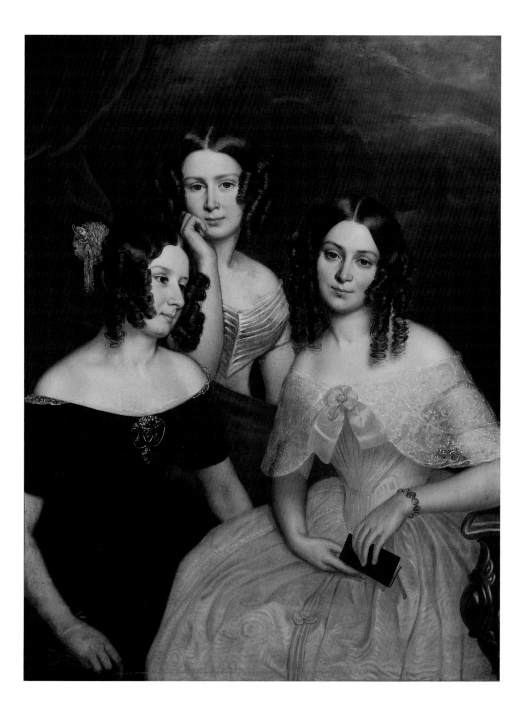

The Three Robinson Sisters George Théodore BERTHON

1846; oil on canvas; 112.1 cm x 83.8 cm; on loan to the Art Gallery of Ontario (1806-1892)
by Mr. and Mrs J. B. Robinson, 1944; Photo by Carlo Catenazzi/AGO

Three 19th-century graces gather in their finery for a portrait that will be a surprise gift to their parents. Augusta, the eldest, dressed in black velvet, looks demurely to the side, while the younger sisters—Louisa in white silk and Emily in pink—agreeably meet our gaze. With their porcelain skin, silky brown curls and sartorial splendour, the three exude the gentility and reserve befitting their station as the daughters of eminent Chief Justice Sir John Beverley Robinson. The portrait was presented to the girls' parents in April 1846, on the day of Louisa and Emily's double wedding. It had been commissioned by the three sisters' husbands, all members of the Toronto ruling class and all related to influential persons whose portraits had also been painted by George Berthon. In a letter to Berthon, Robinson wrote: "Our dear little girls are, as we think, faithfully and characteristically portrayed."

The son of a court painter to Napoleon Bonaparte, Berthon was born in Vienna and immigrated to Toronto in 1844, bringing with him his neoclassical training, as displayed in this skilfully composed portrait. He rapidly established himself as the preferred portraitist of Canada West's most powerful citizens and, soon after his arrival, was commissioned to paint the portrait of the formidable Bishop John Strachan (Augusta's father-in-law). In 1845, he did a portrait of Chief Justice Robinson himself.

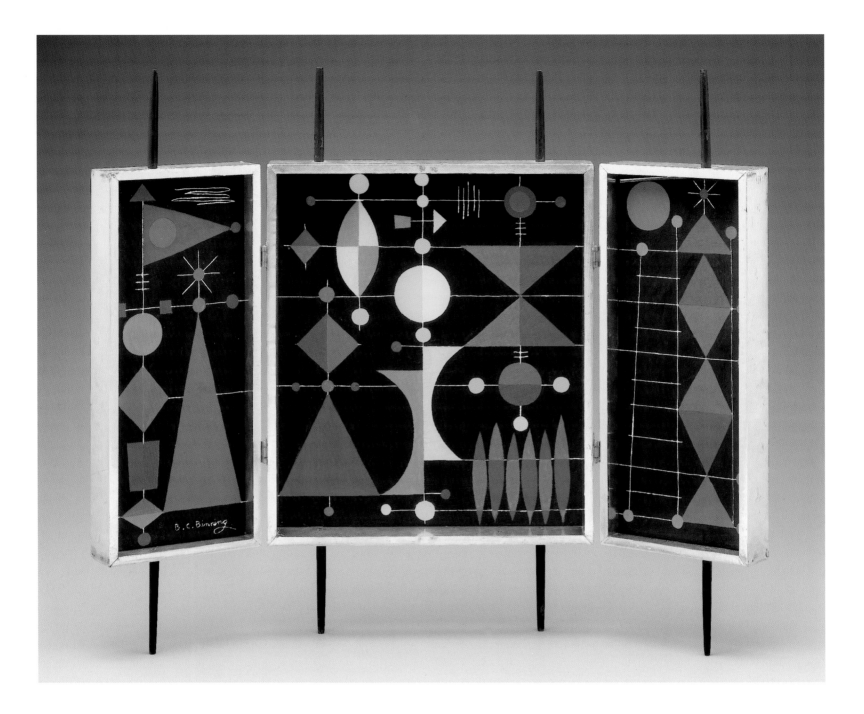

Bertram Charles BINNING

Mariners' Triptych for Night Navigation

(1909-1976)

c. 1955; tempera on composition board and wood; triptych open: 57.3 cm x 67.2 cm x 4.8 cm;
Vancouver Art Gallery Women's Auxiliary Provincial School Scheme VAG 65.11; Photo by Teresa Healey

Recalling the 15th-century religious triptychs he had seen on his visit to Siena, Italy, B.C. Binning borrowed the diminutive three-part format of private devotional paintings to create a modern secular icon composed of shape and of colour that sparkles like jewels against the mat-black background. With the precise delineation of forms suggesting the buoys, pennants and beacons that caution sailors in night navigation, the bright hues and delicate white lines beam like signals of reassurance in the unfathomable darkness.

Looking back on his career, Binning reminisced, "I once said that the business of serious joy should be one of the main preoccupations of the artist. I do like joy…I do like order. I think my work plays between the two sides of me…a certain joy and fun—perhaps even wit—but this seems to vacillate between another extreme of plain coolness, which I call a classic sense."

Binning, a resident of Vancouver since childhood and a sailor himself, adopted boats, harbours and seascapes as the dominant subject of his art. Following studies in England in the late 1930s with the purist painter Amédée Ozenfant, Binning embraced a language of simplified form and flatly applied colour. In 1955, he founded the Department of Fine Arts at the University of British Columbia, where he taught for 25 years, championing the integration of art in modern architecture.

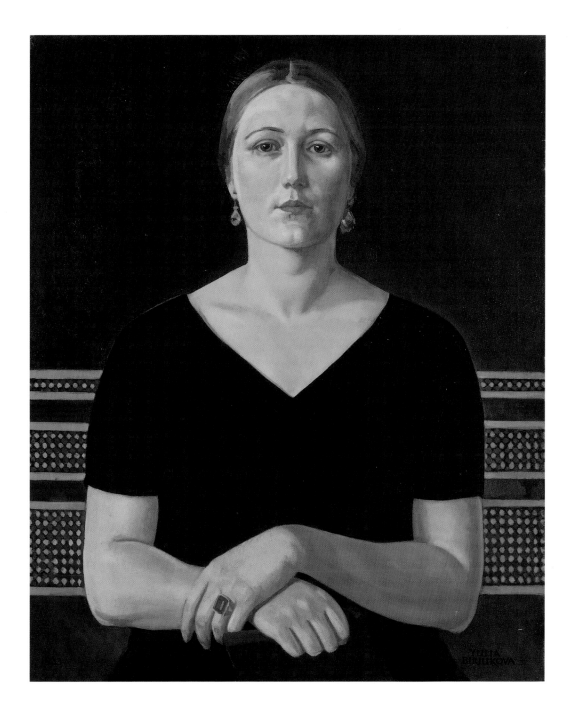

Portrait of Mrs. Carl Schaefer (née Lillian Evers)

Yulia BIRIUKOVA

1933; oil on canvas; 91.7 cm x 73.9 cm; Art Gallery of Ontario; Gift of a Friend of the Gallery, 1992

(1895-1972)

Radiant against the night-blue background, Lillian Schaefer, the wife of artist Carl Schaefer, stares with a composure and serenity that are enhanced by the precise symmetry of her pose. Wearing an elegant black evening dress, whose dramatic V neck is the point of alignment for her head and folded hands, she appears calm and eternal. While the smooth oval shape of her head and tightly pulled-back hair evoke the monumental simplicity of a 15th-century Madonna, the static centrality of the figure recalls the formality of the religious icons that were a legacy of the artist's Russian heritage.

Yulia Biriukova was born in Vladivostok and attended the Imperial Academy of Art in what is today St. Petersburg. Following the Bolshevik Revolution, she and her family moved first to Hong Kong and later to Rome, where Biriukova studied for four years at the Royal Academy of Art. She arrived in Canada on October 29, 1929, the day the stock market crashed, and settled in Toronto, where she rented a room in the Studio Building. There, she met the Group of Seven, as well as younger artists—Carl Schaefer among them—many of whom became the subjects for her distinct style of portraiture. From 1942 to 1963, Biriukova taught at Toronto's Upper Canada College, where, in 1968, a gallery displaying her works was named in her honour.

43

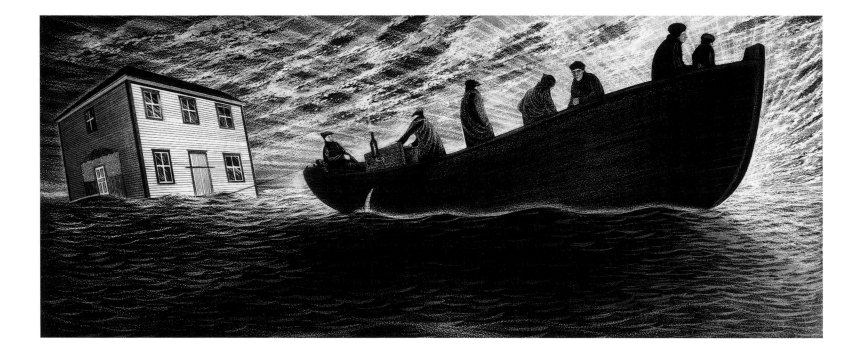

David BLACKWOOD

Uncle Eli Glover Moving

(1941-)

1982; etching; 35.6 cm x 86.4 cm; Collection of the artist

Like a phantom in a dream, a large boat hauls the house of Uncle Eli Glover 25 kilometres across the dark waters from Bragg's Island, the home of David Blackwood's maternal grandparents, to mainland Newfoundland. The light glowing from behind creates silhouettes of the sombre figures on board and illuminates the lonely façade of the house, its front door fixed with a plank. The austerity of the composition, with the stark contrasts of blue-black and white

afforded by the etching process, embodies the severity of life and the wrenching anguish for many uprooted Newfoundlanders in the government's resettlement project of the early 1950s.

When Blackwood speaks of Wesleyville, his birthplace on Newfoundland's east coast, his destiny as a printmaker seems to have been predetermined: "The region is very flat and barren, the dominating features are the sea and the sky...all shades of grey, black and

white. That's the big influence." Blackwood was born into a family of fishermen, who supported him in his artistic endeavours, and in 1961, he enrolled at the Ontario College of Art, where Jock Macdonald encouraged him to look to his provincial heritage as the source of his art. By 1963, Blackwood had created his first series of prints and had launched a career that would chronicle, with a singular drama and emotion, the past lives of the Newfoundland coastal communities.

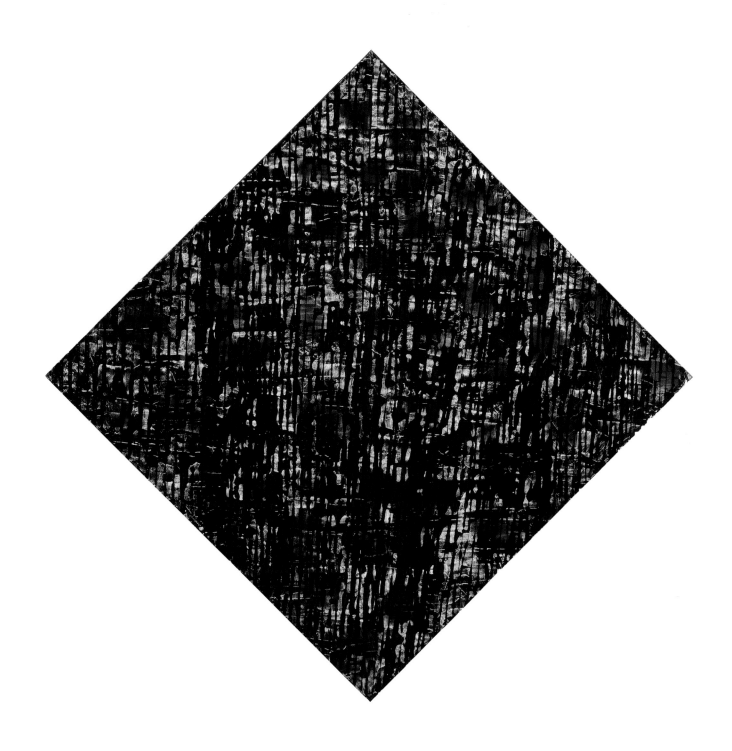

Painting Ronald BLOORE

1959; stovepipe enamel and oil on hardboard; 221.8 cm x 220.0 cm, measured square; National Gallery of Canada (1925-)

"Art," said Ronald Bloore, "is a serious not a casual activity. It cannot be approached simply by the recognition of the spectator's past experience. Any truly creative work should be a revelation to the beholder, an extension of his experience in life, not a confirmation of what he already knows." In *Painting*, Bloore challenges our notions of art and experience by producing a work that first, by its tipped orientation, upends the traditional expectation that a painting is

a window onto the familiar world. Here, the painting is an object in its own right. The shiny surface of the black stovepipe enamel scraped over a bed of brown and blue oil paint forms an irregular grid, a newly invented image.

Bloore studied art and archaeology at the University of Toronto and in the United States and England, returning to Canada in 1957 to teach in Toronto. At that time, he turned to nonfigurative abstraction. In

1958, he was appointed director of the Norman Mackenzie Art Gallery in Regina, Saskatchewan, where he presided over the invitation of American artist Barnett Newman to lead an artists' workshop at Emma Lake, Saskatchewan. In 1961, an exhibition entitled "Five Painters from Regina" illustrated the very individual excursions into abstraction explored by Bloore, Ted Godwin, Kenneth Lochhead, Arthur McKay and Douglas Morton.

Eleanor BOND

Rock Climbers Meet with Naturalists on the Residential Parkade

(1948-)

1989; oil on canvas; 243.8 cm x 365.0 cm; MacKenzie Art Gallery, Regina;
Purchased with the assistance of friends in the memory of Ian Phillips; Photo by Don Hall

High above an industrial city distinguished by a busy harbour, factories and skyscrapers, "the residential parkade"—a parking garage for mobile homes—spirals upward like a small mountain, its exterior offering lush grass and rock faces for recreation. Engulfed by the monumental scale and perspective of the painting, the viewer experiences a feeling of vertigo and a sense of hovering over a vast but unpeopled site that towers above a dark, sinister-looking city.

As one of a series of eight equally large paintings that propose fictional views of urban environments, the work raises questions about our social future and the relationships among humanity, culture, architecture and nature. Eleanor Bond explained: "My intention is that the viewer enter this projection, this debate—that these sites function as forums, not as landscapes in the traditional sense. The debates are those that surround us…health care, housing, the

position of women and the elderly in our society…the culture of nature …The intentional blurring, the hazy effects, the multiple vantage points suggest an absence of authority." Bond leaves us in limbo, uncertain of whether the vision is utopian or dystopian.

A Winnipeg native, Bond began her studies in interior design at the University of Manitoba, graduating in 1976 from the university's School of Art. She has exhibited widely, both nationally and internationally.

46

Leeward of the Island (1.47)

Paul-Émile BORDUAS

1947; oil on canvas; 114.7 cm x 147.7 cm; National Gallery of Canada

(1905-1960)

Inspired by Surrealist theories of automatism, which advanced ideas of the artist working freely and spontaneously from the subconscious and creating forms without preconceived ideas, *Leeward of the Island (1.47)* was the first in a series of works that Paul-Émile Borduas began in 1947. Bright orange and olive-green dabs of paint, complemented by more delicate applications of black and white, float over a grey-brown area encircled by blue, suggesting the view of an imagi-

nary island as seen from the air. The title came after the painting was complete. Borduas' purpose was to explore fresh concepts of space in art, establishing freedoms that reflected his desire for a new order in society. Following the exhibition of this work, a Montreal critic dubbed Borduas and his colleagues "the Automatistes."

Borduas was born in the village of St-Hilaire, Quebec, where he worked as a church decorator with Ozias Leduc, his first teacher, from 1922 to 1923.

He studied under Maurice Denis at the Ateliers d'art sacré in Paris from 1928 to 1930. There, he was exposed to concepts of modern art that stressed the importance of the relationships of colour and form to express the artist's feelings.

After returning to the Church-dominated society of Quebec, Borduas took up teaching and became associated with a group of younger artists who were interested in Surrealist theories *(continued on page 48)*

47

Paul-Émile BORDUAS

(1905-1960)

1956; oil on canvas; 199.8 cm x 250.0 cm; National Gallery of Canada

(*continued from page 47*) and the writings of Freud and who similarly sought new modes of artistic expression.

In 1948, Borduas and the Automatistes issued a manifesto called *Refus global* (*Total Refusal*), condemning injustice and exalting freedom of expression: "Our duty is clear, we must break with the conventions of society...and reject its utilitarian spirit...We refuse to keep silent! Make way for magic! Make way for love!" The manifesto's provocative and rebellious language caused a furor and cost Borduas his teaching position at the École du meuble.

In self-imposed exile, Borduas moved to New York City in 1953, where contact with the work of American abstract expressionists such as Franz Kline inspired a starker palette and a more open space. In 1955, Borduas moved to Paris, and his paintings became increasingly austere. In *3+4+1*, irregular black shapes float on a thickly painted white ground, applied with the sweeping motions of a palette knife. Without the intermediary of colour, the surface appears two-dimensional, eliminating the perception of depth and establishing a space so shallow that black and white alternate as foreground and background. One of Borduas' daughters recalled the shock of seeing these paintings when they were returned to Canada after his death in Paris. For her, they were an attempt "to reconcile the irreconcilable and to make it sing."

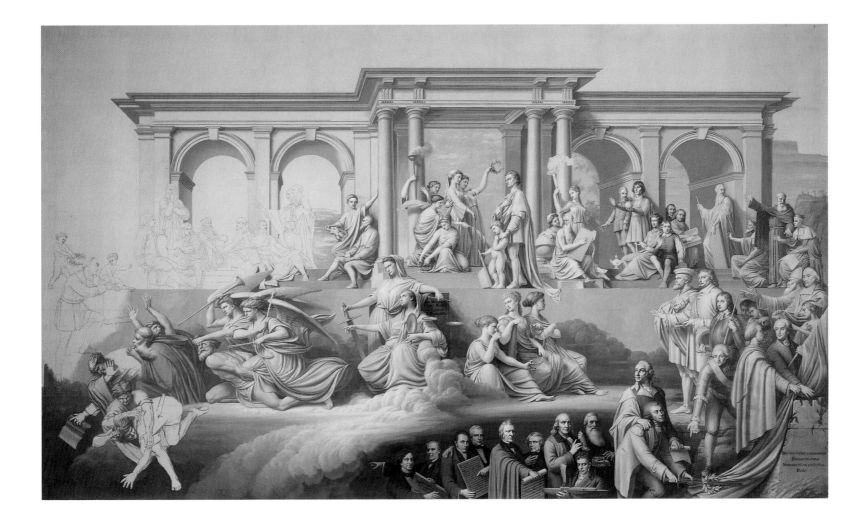

The Apotheosis of Christopher Columbus

Napoléon BOURASSA

1904-1912; oil on canvas; 481 cm x 734 cm; Musée du Québec; Gift of Madame Augustine Bourassa, 1928; Photo by Patrick Altman/MQ

(1827-1916)

The aspirations, erudition and considerable talent of Quebec artist Napoléon Bourassa are reflected in the scale and scope of this monumental mural. Although Bourassa was almost in his eighties when he began working on this canvas, the glorification of Christopher Columbus was a subject he had begun to explore 40 years earlier. Central to his inspiration for this painting was his admiration for Raphael's murals at the Vatican and for the work of French neo-classical painter Jean-Auguste-Dominique Ingres, whose *Apotheosis of Homer* he had admired in Paris in 1855. In both, Bourassa saw a reflection of his own ambition to create murals depicting noble themes that exalted a nation's history.

At the centre of a classical façade, Columbus awaits his crown of laurel wreath, as allegorical figures and historic personages famous in the culture of Western civilization gather to pay homage. Below and to the right, the successors of Columbus, such as Jacques Cartier and Samuel de Champlain, head a procession of other luminaries, including one from Bourassa's own political times, Sir John A. Macdonald. Painted in *grisaille*, or shades of grey, to resemble a sculptural relief, it has an architectural aspect that Bourassa had hoped would suit its eventual placement in a government building. Bourassa's death in 1916, however, prevented the completion of the work.

49

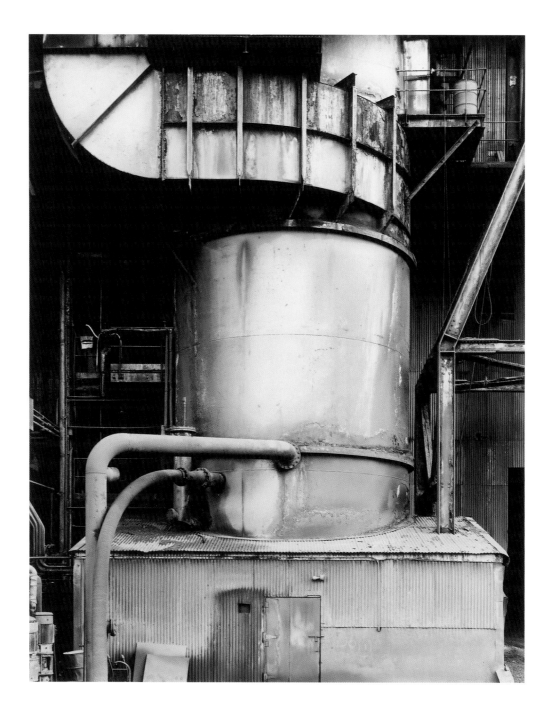

Robert BOURDEAU

Steel Plant, West Virginia, U.S.A.

(1931-)

1996; gold-toned gelatin silver print; 27.9 cm x 35.6 cm; Photo courtesy Jane Corkin Gallery

In the heart of an abandoned steel plant, the light reflecting from a giant tank, twisting ventilation ducts and tight vertical patterns of corrugated steel creates an image of timeless monumentality that eclipses the obsolescence of industry. "These industrial sites," said Robert Bourdeau, "are places that possess a power to which I feel vulnerable, with a sense of ominous stillness ...that transcends the specificity of time. These [sites] are in a state of transition...where order and chaos are in perpetual altercation. I must emphasize that this is not a documentary but a photographic and inner quest."

Throughout Bourdeau's photographic journey and examination of subjects as varied as verdant landscapes and derelict industrial sites, his use of light has been, in the words of art historian James Borcoman, "the transforming power...transforming the commonplace into the poetic, revealing the fabric of things through darkly glowing structures and luminous white spaces to capture the sense of place."

A native of Kingston, Ontario, Bourdeau studied architecture and became interested in photography in the late 1950s after seeing the work of Americans Paul Strand and Minor White, whose examples of formal structure and dramatic light combined with a sense of poetic truth nurtured Bourdeau's own photographic aesthetic. Bourdeau began exhibiting in 1967 and has since shown widely both nationally and internationally.

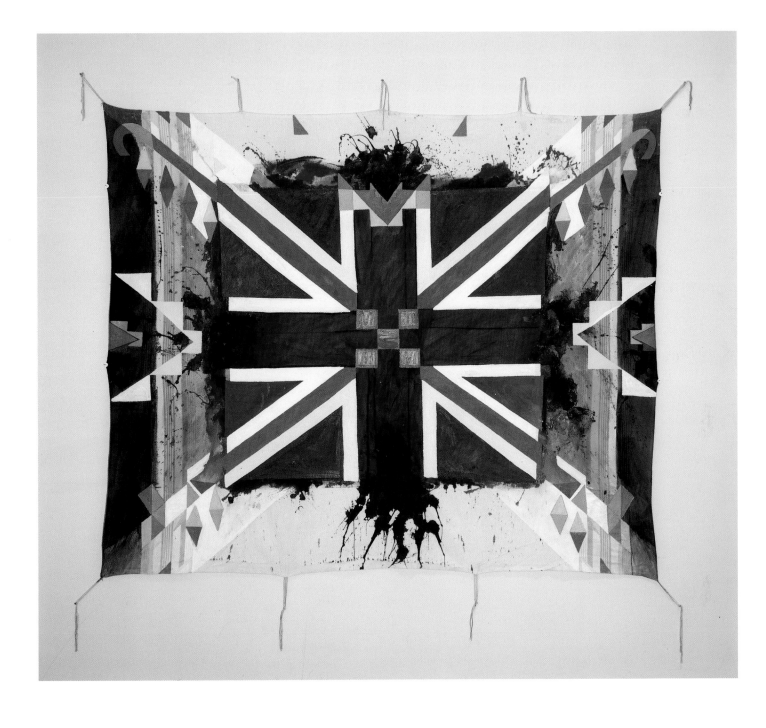

A Minor Sport in Canada

Bob BOYER

1985; acrylic and oil on cotton blanket; 188 cm x 221 cm; National Gallery of Canada

(1948-)

Here, the image of the Union Jack is painted over with the geometric designs of the Plains Indian and is juxtaposed with splatterings of dark red paint that suggest spilled blood, creating a clash of imagery which alludes to the violent persecution of aboriginal peoples by the Europeans. The artist's use of a cotton blanket as the painting's support is equally eloquent and addresses the spread of disease in the 19th century through the trade in blankets contaminated with smallpox.

Bob Boyer was inspired to paint on blankets following a 1983 trip to China and Japan, where he saw prayer cloths and banners conveying political messages. "I came back with a real hatred of oppression," he said. This anger was directed not only at social injustices but also at the art establishment's exclusion of aboriginal artistic expression. Boyer's first blanket painting was a deliberate break with the materials of Western art—oil paint on canvas. Using a cotton

blanket nailed to the wall, Boyer was negating the convention of "framing" and affirming the continuity of art and life central to traditional native art. The title is characteristically ironic, suggesting an attitude of paltry amusement inappropriate to the massive destruction of the native population.

Boyer, who studied at the University of Saskatchewan, explores an individual aesthetic that reflects his mixed identity of European and native ancestries.

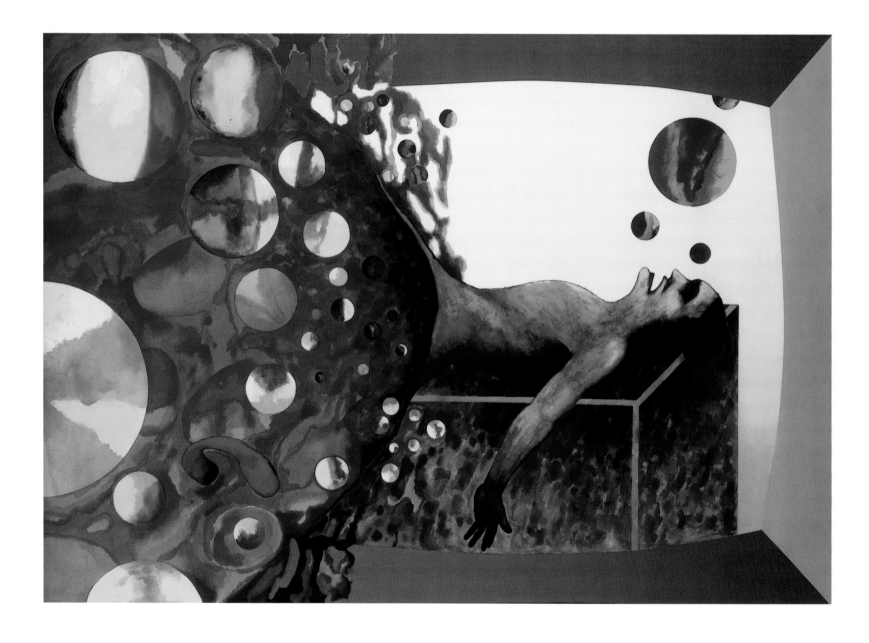

Claude BREEZE

Transmission Difficulties: The Operation

(1938-)

1968; acrylic on canvas; 172.7 cm x 238.8 cm; National Gallery of Canada

Here, we are confronted by a painting of a giant television screen, where the bright pink body of a man on a blue table is juxtaposed against a strident yellow background. With mouth agape, eyes sunken pools of darkness and arms flailing helplessly, the man's torso erupts into a volcanic explosion of colour that is as curiously joyful as it is macabre. The prismatic spectrum of colour gushes out of the television screen into our space, while multihued bubbles float from the man's mouth with a disturbing comic sensibility.

Claude Breeze was born in British Columbia and studied with Ernest Lindner in Saskatoon and later with Art McKay and Roy Kiyooka in Regina. In 1962, Breeze combined figurative painting with abstract aesthetics as a means to address his concerns for the human condition. In 1966, he embarked on the Home View TV series, which denounced the disengagement of television viewers from the circumstances of violence.

The notion of "transmission difficulties" suggests aberrations in communication, technological or otherwise, while the depiction of an abandoned "operation" smacks of indifference to society's vulnerable. These issues were also reflected in works about the American civil-rights movement and the atrocities perpetrated during the war in Vietnam. Breeze's continuing fascination with the "media screen" has, in recent work, been manifest by the inclusion of a computer monitor.

52

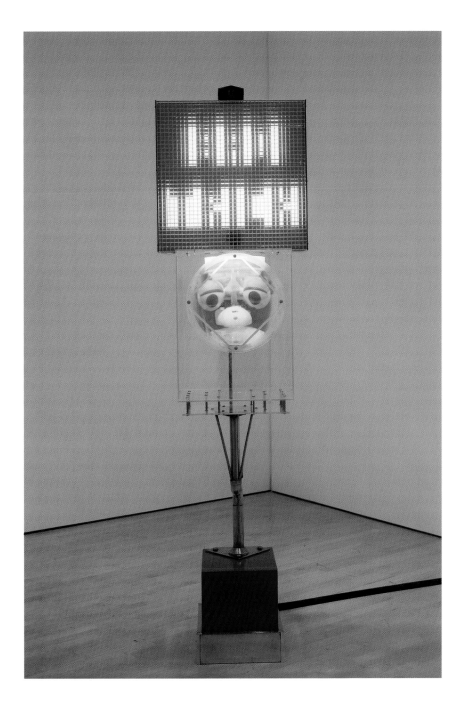

Bad Trick Roland BRENER

1989; plastic, copper, bronze, ceramic, motion detector, electronic components, wiring, audiocassette, lightbulb, fluorescent lights; (1942-)
H: 236 cm, W: 106 cm, D: 81 cm; National Gallery of Canada; Gift of the artist, Victoria, 1992

An illuminated sign with the words "Bad Trick" draws the viewer to a tall electronic sculpture. Moving close to the work activates the voice and the talking movements of a pared-down robotic head that is enlarged by a magnifying lens, all of which is contained within the body of a Plexiglas box. The voice on the audiotape reads business letters addressed to the artist, but its tone is haughty and uninviting. The recording is unclear, is difficult to understand and ends arbitrarily.

The upper technological part of the sculpture is overwhelming and implies a communications overload, which is reinforced by the babble of the recording. So imposing at first glance, the "talking head" is seen, upon closer inspection, to be miniature behind the glass. In the face of this unorthodox assemblage of communications equipment that was originally designed to improve discourse, our efforts to comprehend are subverted. "While one might be understandably intimi-

dated by the imposition of new technological systems," explained Roland Brener, "one does not have to be reverent or passive about them. They are not sacred."

Born in South Africa, Brener graduated in 1965 from the St. Martin's School of Art, in London, England, where he studied with sculptor Anthony Caro. He moved to Canada in 1974 and settled in Victoria, British Columbia, where his use of prefabricated materials and modern technology has been the hallmark of his work.

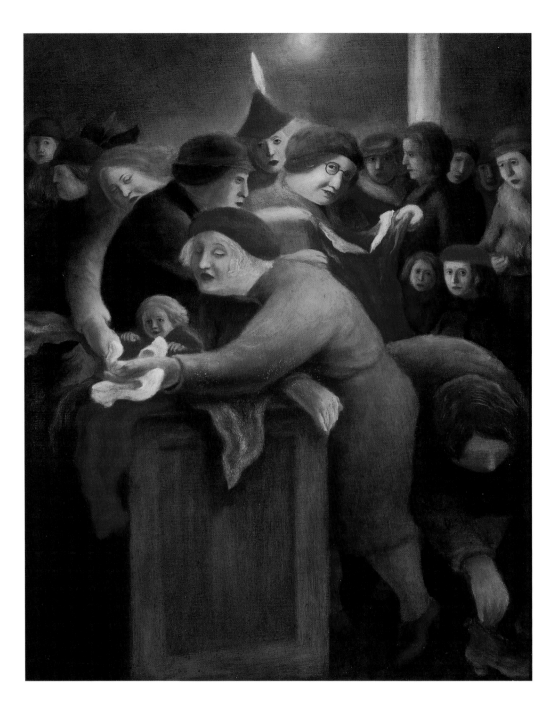

Miller BRITTAIN

The Rummage Sale

(1912-1968)

1940; oil on Masonite; 63.5 cm x 50.9 cm; National Gallery of Canada

In the foreground, a knot of women lean, stretch and bend, eagerly diving for bargains. Their rounded bodies overlap and push against each other, creating a feeling of crowdedness and confusion. In the centre, two women dispute the ownership of a red dress, and behind them, thinner women with fur collars and more elaborate hats look with reserved disdain at the theatre before them. While the little faces of the waiting children betray their boredom, the bright colours of the women's clothes lend an air of gaiety to the necessity of thrift. As Miller Brittain observed, "A picture ought to emerge from the midst of life."

Brittain studied at the Art Students League in New York in 1931-32. There, he came into contact with artists associated with the American Ash Can School, so called for their frank portrayals of dreary urban neighbourhoods and the impoverished inhabitants. He admired in particular the different faces of disillusionment seen in Raphael Soyer's office girls and Reginald Marsh's derelicts.

In the decade following his return to his native Saint John, New Brunswick, Brittain painted the people of his city going about their daily business in the shops, bars and harbour and on the public transportation systems. His ability to survey a crowd and capture characteristic behaviour with both sympathy and satire earned him the nickname "the Canadian Brueghel."

Sounds Assembling Bertram BROOKER

1928; oil on canvas; 112.3 cm x 91.7 cm; Collection of the Winnipeg Art Gallery; Photo by Ernest Mayer/WAG (1888-1955)

"I plunged into painting in 1927 without any knowledge," wrote Bertram Brooker, "…attempt[ing] to paint the experiences I derive from music…some sort of replica of the colour, the volume and the rhythm I experienced while listening to music." Here, orange, yellow, green and blue rods zoom into the picture plane, thrusting toward blue rings that project pale-coloured poles with flat ends, creating an imaginary space which expresses the invisible inner energy and excitement inspired by the joyful accumulation of music evoked in the painting's title.

Born in England, Brooker settled in Manitoba in 1905, where he was employed as a labourer, a clerk and a journalist before moving to Toronto in 1921 to work as an advertising executive. In 1923, he joined the Arts and Letters Club, where he met Lawren Harris and other members of the Group of Seven, whose work he admired for "liberating young artists from the stuffy tradition of strict realism." He was influenced by discussions with Harris about the spirituality of art and was inspired by the writings of Russian artist Wassily Kandinsky, whose book *Concerning the Spiritual in Art* proposed music as a model for the artist seeking to express his inner soul. In 1927, Brooker was the first artist in Canada to exhibit abstract art and, in 1936, the first to win the Governor General's Award for fiction for his novel *Think of the Earth*.

William Blair BRUCE

The Phantom of the Snow

(1859-1906) 1888; oil on canvas; 151.1 cm x 192.1 cm; Art Gallery of Hamilton, Bruce Memorial, 1914

In a desolate snowy landscape lit by the eerie light of the moon, a man with snowshoes lashed to his back falls in the snow and reaches toward a phantom striding by, apparently indifferent to his plight. Does the phantom represent a hoped-for saviour or the shadow of death? In a letter to his mother, William Blair Bruce identified his inspiration as C.D. Shanly's poem *Walker in the Snow*, thus clarifying the phantom's sinister mission: "For I saw by the sickly moonlight, / That

the walking of the stranger / Left no footprints in the snow / ...I had seen the shadow hunter / And had withered in his blight."

Bruce painted this work (also known as *The Phantom Hunter*) at a time when the Canadian press was calling for the establishment of a national art imbued with Canadian themes. In correspondence with his mother, he reported his pride in the acceptance of this subject at the Paris Salon of 1888. It was Bruce's

second start as an artist in Paris. In 1881, he had studied at the Académie Julian and at Barbizon, a village south of Paris, but his work from this period was lost in a shipwreck in the St. Lawrence in 1885. Returning to France in 1887, he spent time in Giverny, where, in the company of other Canadian, American and Scandinavian artists, he painted *en plein air*, directly from nature, using Impressionist techniques to render the landscape.

A Wreath of Flowers

William BRYMNER

1884; oil on canvas; 122.5 cm x 142.7 cm; National Gallery of Canada;
Royal Canadian Academy of Arts diploma work, deposited by the artist, Ottawa, 1886

(1855-1925)

"The difficulties of painting children the size of mine are awful. Keeping the pose for two minutes and then doing something altogether different for ten nearly drives me wild sometimes," protested William Brymner in a letter written in 1883 from the picturesque fishing village of Runswick Bay, Yorkshire, England. There, on the slopes of an orchard perched over the sea, he painted this, his largest canvas.

Our path along the hill is halted by the gathering of three small girls. Two are absorbed in making daisy chains, while the third turns sulkily from her knitting and looks toward them. In the distance, another child approaches with freshly picked flowers. In contrast to the detailed description of the children in the foreground, the surrounding landscape has been painted more spontaneously, exhibiting Brymner's exploration of Impressionist techniques to render the fleeting effects of nature. While the children's clothing tells

of a bygone era, their expressions timelessly evoke the bored leisure of childhood.

In 1876, Brymner left his native Montreal to study art in Paris, where he mastered an academic style of painting characterized by a faithful depiction of the human figure and a highly finished naturalism. In 1886, he returned to Canada and, for the next 35 years, was one of the most influential teachers at the Art Association of Montreal.

Jack BUSH

Dazzle Red

(1909-1977)

1965; oil on canvas; 205.7 cm x 264.2 cm; © Estate of Jack Bush; Art Gallery of Ontario; Purchase, Corporations' Subscription Endowment, 1966; Photo by Carlo Catenazzi/AGO

When Jack Bush painted *Dazzle Red* in 1965, he had already spent over 10 years probing abstraction, achieving an eloquence of expression that would earn him an international reputation before he received a national one. Here, horizontal bands of colour stacked one upon the other are soaked into the fabric of the canvas, the hot red kept in check by the orange and mauve above and the green and blue below. The deep yellow on either side defines the edges of the central monolith and maintains the flatness of the picture plane. Drawing on the *experience* of life rather than its appearance, Bush is said to have been inspired by a mannequin wearing a brightly coloured blouse and skirt, belted at the waist with a colourful sash. "The risk of going without gimmicks and painterly techniques has freed the colour to act freely on the open field of the canvas," he wrote in 1965, "[creating] pictures that are easy for the eye to contemplate, challenging in their simplicity and difficult to pin down."

Bush studied in Montreal from 1926 to 1928, then moved to Toronto, where he worked as a commercial artist, taking evening classes at the Ontario College of Art from 1929 to 1939 and exhibiting with established art societies such as the Royal Canadian Academy of Arts and the Ontario Society of Artists. After the Second World War, Bush and other young Toronto artists began to learn of modern art

Polyphonic Fugue

1975; acrylic on canvas; 173.4 cm x 417.8 cm; © Estate of Jack Bush; The Edmonton Art Gallery Collection;
Purchased with funds donated by Northwest Utilities and the Women's Society of The Edmonton Art Gallery; Photo by Eleanor Lazare

through magazines such as *Time* and *Life* and through the *Skira* art books, which introduced them to the work of artists such as Picasso and Matisse. By the early 1950s, the Toronto artists were travelling regularly to New York City. As Bush recalled, "We were very influenced by the abstract expressionists, where paint was thrown on and scooped around and was a very wild sort of free painting." Excited by the expressive possibilities and boldness of this approach to

abstraction, Bush and 10 others organized the first Painters Eleven exhibition in 1954. But Toronto was not ready for this kind of art, according to Bush. "It upset everybody," he said, "critics and older artists, so we got the hell pasted out of us in the press."

A visit to France in 1962 consolidated Bush's love of the monumental and colourful paper cut-out collages by Matisse, inspiring lyrical and polychromatic canvases that also reflected his passion for jazz. In

Polyphonic Fugue, he worked his paints thinly, like watercolour, as had been suggested by American art critic Clement Greenberg. Short multicoloured bars dance across a wide canvas like high and low notes falling from left to right and juxtaposed against a grey-brown background whose transparent gestural brush strokes provide a counterbalance—echoing the theme of the title. "I paint from my belly," explained Bush. "It's instinct, a gut feeling."

59

Geneviéve CADIEUX

Memory Gap, an Unexpected Beauty

(1955-)

1988; dye coupler print and mirror on wood; 208 cm x 472 cm x 14 cm; National Gallery of Canada

In a hybrid format combining photography and sculpture, we are confronted by a monumental image of a scar that is partially reflected in the adjacent mirror like a shadowy phantom. The scar is obvious as such but is also mysterious, in that we are excluded from knowing to whom it belongs or the reasons for its creation. And while its billboard scale endows it with a public presence—an allusion to the seduction and appeal of mass-media advertising—its intensely intimate nature is unsettling. It is also ironic that the scar normally associated with the identification of a particular individual has been made completely anonymous by the photograph's close cropping. Contrary to the title, which asserts a lapse in memory, the scar endures as a reminder of personal history and collective vulnerability.

Since 1980, Geneviéve Cadieux has explored the medium of large-format photography, focusing on the body and on fragments of the body, skin and scars as the subjects for her art. As art critic Peggy Gale has observed, "Skin is a sensitive surface, fragile and susceptible to age and disfigurement, recalling the light-sensitive paper and chemical baths of photography. All are memory traces, recording the passage of time and events."

Cadieux was born in Montreal and graduated from the University of Ottawa in 1977. In 1990, she represented Canada at the Venice Biennale.

Animated Item

Oscar CAHÉN

c. 1955; oil on canvas; 71.5 cm x 87.0 cm; National Gallery of Canada

(1916-1956)

An unusual assemblage of shapes, animated by hot oranges and pinks, bright blues, greens and turquoise delineated with bold black lines, fills this canvas, leaving us in a curious limbo between abstract and representational worlds. "I paint what my emotions dictate," said Oscar Cahén, "and I find it impossible to make a clear-cut analytical statement…although I know that it is somehow a search for faith and an escape from loneliness through communication."

A Dane by birth, Cahén arrived in Canada in 1940 as an enemy alien, because he held German citizenship, and was interned in a camp at Sherbrooke, Quebec. His outstanding artistic skills as an illustrator, developed from his European training in Dresden, Paris, Stockholm and Prague, were discovered in 1942 by a Montreal newspaper, which offered him a job and secured his release. In 1944, Cahén moved to Toronto, building his reputation as an illustrator for

magazines such as *Maclean's* and *Chatelaine*. In the late 1940s, he met Harold Town and other Toronto painters committed to abstraction and, in 1953, joined them to form Painters Eleven. Just as Cahén's approach to abstraction was anchored by an evocation of material reality, so his use of exotic colour was inspired by the vivid sunsets and tropical landscapes he enjoyed on his visits to Florida from 1952 until his untimely death in a car accident in 1956.

AUTOPORTRAIT À LA TABLE LUMINEUSE, ATELIER, 1984.

Michel CAMPEAU

Self-Portrait at the Light Table, Studio

(1948-)

1984; gelatin silver print; 40.2 cm x 50.5 cm; Courtesy Canadian Museum of Contemporary Photography

In the silent shadows of his studio, Michel Campeau dons his white gloves and, like a magician of light, contemplates images that reflect his history and identity, the fragments of a life's narrative. Caught in the dichotomies of darkness and light, the artist is centred in an erratic field of black-and-white grids articulated by the pattern of his jacket, the array of slides on the light table and the display of photographs in the background. Pausing to rub his eye, seeing and not seeing, the artist momentarily hovers between dream and reality. "Obviously, it is myself I am examining in this photographic narrative...To trace the stumbling record of what I could call my emotional chaos, I call on the experiences that have forged the periods of tempest and calm in my emotional life and that have shaped the perceptions of my universe."

Campeau was born in Montreal and began his photographic career in the early 1970s, examining the human and social landscape of Quebec. Discouraged by the critical reception of this work, Campeau turned the camera on himself, delving, as he said, "into the mysterious waters of intimacy and secrets." *Self-Portrait at the Light Table, Studio* is from the series Heart Murmurs, in which the artist combines photographs from family albums with images from the history of photography and film, selected for their role in the artist's autobiographical fiction.

Four Directions —
War Shirts, My Mother's Vision

Joane CARDINAL-SCHUBERT

1986; oil, oil pastel, chalk, graphite on paper; 121.0 cm x 80.7 cm each sheet;
Canadian Museum of Civilization, image numbers 13659-61, 13489

(1942-)

In four large, richly coloured drawings, Joane Cardinal-Schubert repeats the image of the war shirt worn by her Blood ancestors as sacred protection in battle to combat today's environmental destruction. Using iconography inspired by pictographs from sites such as Milk River and Writing-on-Stone in Alberta, she paints hands protectively touching the shirts. In the domelike spheres below, which resemble the shape of the native sweat lodge—a place of ritualistic purification—the hands search, wave and reach, ambiguously seeking connection in a chaotic world that has lost its respect for nature. Together, the drawings portray the four cardinal directions symbolized by the stencil-like silhouettes of the animal spirits that confirm the unity of humanity and nature. "I use Indian history as subject matter," said Cardinal-Schubert, "but, more important, as a personal expression of a contemporary artist—no different from any contemporary artist who seeks the essence [of that] which transcends any culture or historic period."

Cardinal-Schubert was born in Red Deer, Alberta, and studied at the Alberta College of Art and the University of Calgary. In addition to painting and drawing, she also creates installation work inspired by memory, native history and social injustice: "As artists, our only weapon in this battle for survival…is our knowledge, responsibility and…commitment to share our world view with others."

63

Florence CARLYLE

<div align="right">The Tiff</div>

(1864-1923)

1902; oil on canvas; 183.8 cm x 134.6 cm; Art Gallery of Ontario;
Gift of the Government of the Province of Ontario, 1972; Photo by Carlo Catenazzi/AGO

With its expressive brushwork and sensitive treatment of light and colour, this large work, painted at the turn of the 20th century, exemplifies Florence Carlyle's glance back at the narrative painting of the previous century and her look forward to modernism. Warm afternoon light permeates the stillness of the room, giving substance to the figure of the young woman, whose rosy cheeks and sulky expression are almost overwhelmed by the voluminous abundance of her flowered dress. Traces of light outline the hand relaxed upon the table, directing our gaze to the glassware and to the neat white collar and cuffs of her companion, who faces the diffused patterns of green and yellow light from the window in the background.

Carlyle was born in Galt, Ontario, and like many young artists of her time, she was drawn to Paris to study, travelling there in 1890 with Paul Peel and his sister. In 1893, she exhibited work at the Paris Salon—a reflection of her successful training in Paris ateliers—and also received a silver medal for a painting shown at the World's Fair in Chicago. She returned to Canada in 1896, where she taught at Havergal College in Toronto and was elected an Associate of the Royal Canadian Academy of Arts. In 1899, Carlyle left for New York City, where she opened a studio. She enjoyed a steady market for her work, which continued following her move to England in 1913.

Bay of Islands Franklin CARMICHAEL

1930; watercolour on paper; 51.3 cm x 64.4 cm; Art Gallery of Ontario; (1890-1945)
Gift from Friends of Canadian Art Fund, 1930; Photo by Larry Ostrom/AGO

Across a bay of smooth grey islands that jut out of the water like ancient beasts, Franklin Carmichael offers us a panoramic view of the north shore of Lake Superior, animated by windswept trees in the foreground and a lively sky of billowing clouds. Carmichael, the youngest member of the Group of Seven artists, frequently accompanied the Group on sketching trips to northern Ontario, but he sought his own innovations in his response to the land. Through the sensitive and versatile medium of watercolour, he captured the breadth and brightness of the wide-open spaces flickering with light and shadow. For Carmichael, watercolour was a medium "capable of responding to the slightest variation of effect or mood…clean-cut, sharp, delicate and forceful or subtle, brilliant or sombre."

Carmichael's introduction to art occurred when he worked as a carriage decorator in his father's shop in Orillia, Ontario. In 1911, he moved to Toronto and was employed as a designer at Grip Ltd., where he met Tom Thomson and other artists who would later form the Group of Seven. Encouraged by Arthur Lismer and F.H. Varley, Carmichael travelled to Antwerp, Belgium, in 1913 to study at the Royal Academy of Art. With the outbreak of the First World War, he returned to Canada, resuming his career as a commercial artist, teacher and highly acclaimed designer and illustrator.

Emily CARR

<div style="text-align:right">Red Cedar</div>

(1871-1945) 1931-1933; oil on canvas; 111.0 cm x 68.6 cm; Vancouver Art Gallery, Emily Carr Trust VAG 54.7; Photo by Trevor Mills

In her autobiography, *Growing Pains*, published post-humously, Emily Carr describes the importance of "the deep sacred beauty of Canada's still woods…the deep lovely places that were the very foundation on which my work as a painter was to be built." And although Carr depicted First Nations villages and totem poles throughout her career, it was always nature—primarily the forest and the towering sky—in which she found her most personal expression. In *Red Cedar*,

the luminous orange-red trunk stands majestically in the centre of the canvas, tossing its silken green foliage in an undulating pattern that is echoed in the sea of undergrowth on the forest floor. Delicate tendril-like branches float downward, repeating the vertical rhythm of the trees and reflecting Carr's wish to distil the forms of nature to their very essence, simplifying and capturing pure movement.

In 1933, when she was in her early sixties, Carr

purchased an old caravan that she towed to various sites outside her hometown of Victoria, British Columbia, during the summer months. These venues inspired new subjects for her art. "Wouldn't be good to rest the woods?" she wrote. "Am I one-idea'd, small, narrow? God is in them all." After painting views of the cliffs, beaches and sea, she discovered the sky as a subject in itself.

In *Sky*, a cloud-filled heaven radiates with life and

Sky

c. 1935; oil on wove paper; 58.7 cm x 90.7 cm; National Gallery of Canada

energy as rippling brush strokes create an image of shimmering light. This expression of movement and energy was, for Carr, a reflection of her spiritual beliefs, as she noted in her journals: "A main movement must run through the picture…The transitions must be easy [and] shall express some attribute of God—power, peace, strength, serenity, joy." Carr's technical innovations also contributed to her success in expressing this happiness and exuberance. Com-

bining oil paint and turpentine, to make the paint thin and fluid, and working on paper, which was light in weight and therefore easy to transport, Carr captured living, breathing nature with a newfound spontaneity and freedom.

From her beginnings in staid 19th-century Victoria through ill health and financial limitations, Carr went to extraordinary ends—travelling to California, England and France—to educate herself as an artist. Re-

turning home in 1911, she produced a large body of work inspired by visits to First Nations villages. After a fallow period from 1914 to 1927, during which she ran a boardinghouse and painted little, an invitation to exhibit her work in eastern Canada and a meeting with the Group of Seven artists helped Carr to rekindle her creative spirit and to discover her own voice as an artist. She received the Governor General's Award in 1941 for her publication *Klee Wyck.*

Ian CARR-HARRIS

(1941-)

1994; wood, Arborite, steel, ellipsoidal spotlight, lens, motor and pulley assembly; installation dimensions variable; National Gallery of Canada; Courtesy Susan Hobbs Gallery; Photo by Isaac Applebaum

In an empty windowless room, we watch a slowly changing grid of light travel across the walls, like sunlight shining through a window. Its constant change in brightness and position over its 20-minute journey suggests the passage of light from morning to night. The title *137 Tecumseth* is the address of Ian Carr-Harris's gallery in Toronto, and the patterns of light we observe through the powers of a projector mimic the light that would have shone through the gallery's now-blocked windows. The artist explained: "My work situates itself in that space we reserve for our recognition that the histories and structures which we use to give definition to identity are themselves contingent and fluid, no less elusive than the identities we seek to secure...the work seeks to disturb our field of knowledge while leaving it also apparently intact."

Carr-Harris was born in Victoria, British Columbia, and graduated from the Ontario College of Art in 1971. Previous studies in modern history and library science have permeated the themes of his art with a preoccupation with systems for the transmission of knowledge and memory. In the context of his installation work, often composed of several seemingly unrelated objects, light is frequently a unifying component. In *137 Tecumseth*, we could perhaps think of the light as a symbol of the transitory and fragmented nature of experience itself.

Portrait of a Woman — after D.G.R.
[Dante Gabriel Rossetti; 1828-1882]

Sidney CARTER

c. 1906; platinum print; 21.2 cm x 15.7 cm; National Archives of Canada/PA-112216

(1880-1956)

At the turn of the 20th century, camera clubs were centres of debate about the merits of pictorialism, an approach to photography in which the primary function was the expression of emotion. It favoured the use of soft-focus lenses, a suppression of factual information and the manipulation of the image in the darkroom to give it the look of a loosely brushed painting. Sidney Carter, a bank clerk and member of the Toronto Camera Club, was one of the foremost proponents of pictorial photography in Canada. An associate member of Alfred Stieglitz's New York-based Photo-Secession, which promulgated the notion of photography as fine art, Carter not only practised pictorialism but actively promoted it through the organization of exhibitions and publications in Canada.

Here, a woman with stars in her abundant tresses materializes like a dream from the soft light and the ethereal grey shadows of the platinum print. Inspired by the tonal symphonies painted by American artist James McNeill Whistler, Carter also looked specifically to the work of Pre-Raphaelite artist Dante Gabriel Rossetti, whose idealized portraits of women were echoed in his poetry. The words "after D.G.R" in the title refer to Rossetti's poem *The Blessed Damozel*, whose lines "She had three lilies in her hand, / And the stars in her hair were seven" find visual embodiment in Carter's photograph.

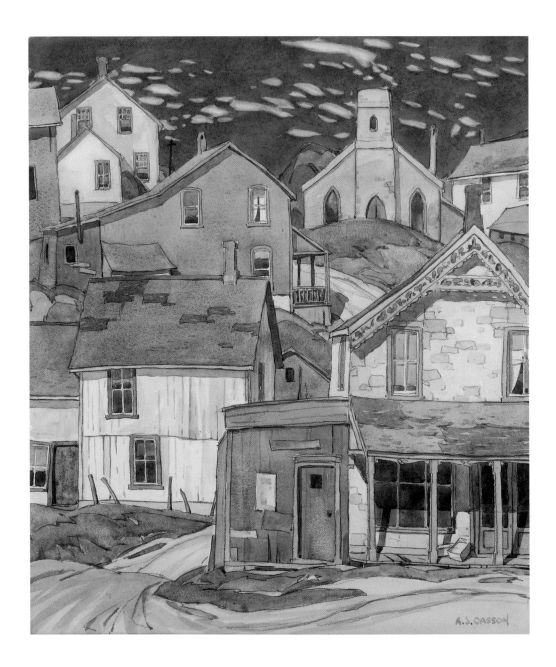

Alfred Joseph CASSON

Hillside Village

(1898-1992)

1927; watercolour on paper; 52.1 cm x 43.8 cm; Art Gallery of Ontario;
Gift from the Reuben and Kate Leonard Canadian Fund, 1928; Photo by Larry Ostrom/AGO

With an assured hand and an astute eye, A.J. Casson applied thin washes of watercolour, bringing to life the sunny tranquillity of an Ontario hillside town. The rhythm of delicately drawn architecture creates rectangular patterns enlivened by the red, white and yellow walls of the buildings that are embellished with blue and green trim. A church perched on the rocky horizon completes our journey up the sun-bleached road, where the blue sky is dappled with paper-white clouds. Invited to join the Group of Seven in 1926, Casson embraced the Ontario hillside town not only as a means of exploring characteristically Canadian subject matter but also as a way to distinguish his art from that of the rest of the Group. "I began to dig out places of my own," he said later. "I also loved to paint villages…and I'm glad, because they're pretty much gone now. They've all changed, fallen down or been destroyed."

Born in Toronto, Casson was raised in Guelph and Hamilton. In 1919, he returned to Toronto to work at the commercial art firm of Rous and Mann, where he was apprenticed to Franklin Carmichael. Casson shared Carmichael's love of watercolour and accompanied him on sketching trips. In 1925, along with commercial artist Frank Brigden, they formed the Canadian Society of Painters in Water Colour, which still exists today.

70

401 Towards London No. 1

Jack CHAMBERS

1968-1969; oil on mahogany; 182.9 cm x 243.8 cm; Art Gallery of Ontario;
Gift of Norcen Energy Resources Ltd., 1986; Photo by Carlo Catenazzi/AGO

(1931-1978)

In this large painting dominated by a vast autumn sky, ethereal white clouds cast sharply defined shadows on the strip of land where the ribbon of highway cuts through the countryside. To capture this "eternal present," Jack Chambers used photography, securing the details of a scene usually perceived in a blur from a car. The photograph was, for Chambers, an "object to see with…rather than a thing just to see." The roar of the highway has been stilled to a vista of contemplation and the seeming banality of the subject transformed by the overwhelming presence of light and by the delicacy of the brushwork, celebrating the ordinary as an aesthetic experience. In his notebooks, he wrote: "Perception's gleam is of wonder, not memory, and its beauty is the beauty of encounter, not comparison."

Chambers began his art studies in his native London, Ontario, and in 1953, he left for Europe and studied at the Academia de Bellas Artes in Madrid. In 1961, he returned home and produced dreamlike images of domestic interiors, landscapes and fantasy subjects inspired by personal history. In 1969, the year in which he finished this painting and was diagnosed with leukemia, he published "Perceptual Realism," an essay influenced by his Roman Catholicism as well as his readings of French phenomenologist Maurice Merleau-Ponty.

Melvin CHARNEY

Canadian Centre for Architecture Garden,
showing partial views of the Esplanade and Allegorical Columns

(1935-)

1987-1990; sculpture: concrete, stainless steel and copper-covered wood;
Esplanade and nursery: 0.9 hectares; Photos by Carlos Letona and Robert Burley

At the hectic confluence of Autoroute Ville Marie and Boulevard René-Lévesque in downtown Montreal, Melvin Charney's sculpture garden for the Canadian Centre for Architecture is an oasis of calm and contemplation, an appreciation of the importance of nature in urban development and an evocation of the city's architectural history, past and present. On the block-wide esplanade that overlooks the remains of the late-19th-century industrial part of the city,

10 freestanding sculptures in the form of allegorical columns illustrate the evolution of modern architecture, from the Doric temple to the grain silo and the static monumentality of chimneys and houses to the "Dancing de Stijl," the legacy of abstraction and modernism. Sloping down toward the street, the garden includes a stone façade constructed to mirror the 1874 Shaughnessy House, now the Canadian Centre for Architecture, across the street. The façade is flanked

by a meadow, alignments of stone walls and rose-bushes and an apple orchard that alludes to the pastoral and agricultural origins of this now urban space.

Charney studied at The Montreal Museum of Fine Arts and graduated in architecture from McGill and Yale universities. Nationally and internationally acclaimed, Charney has exhibited his work throughout the world, and in 1996, he received Quebec's Prix Paul-Émile-Borduas in the visual arts.

Hochelaga, je me souviens Domingo CISNEROS

1992; mixed media; 92 cm x 63 cm x 107 cm; Collection of the artist (1942-)

In 1992, many aboriginal artists created works that denounced the 500th anniversary of the arrival of Christopher Columbus in the Americas, an event they regard as the genesis of the devastation of their cultures. Artists in Montreal also protested the 450th anniversary of the routing of the native population by Jacques Cartier on the island of Hochelaga, formerly an Iroquois settlement. In *Hochelaga, je me souviens*, Domingo Cisneros used a cowhide suspended by wooden poles to function as a funeral bier for the contorted fox skeleton that symbolizes aboriginal suffering. Above, the horizontal inertia of a chain-bound second hide suggests death and imprisonment. Below, two more skins lie on the pelt, like dead bodies. "Those who came to colonize this beautiful country rarely tried to communicate with the spirits of the wilderness," said Cisneros. "They came to clear, to domesticate, to control. They believed they were bringing order to the place, unaware that an order already existed."

Cisneros employs natural materials that evoke the cycles of life, death and regeneration, creating a metaphor for the survival and endurance of native peoples and asserting the links between native identity, spirituality and nature. A Mexican Métis, Cisneros studied fine art, architecture and cinematography at the University of Nuevo León, Mexico, and immigrated to Canada in 1968, settling in La Macaza, Quebec.

Paraskeva CLARK

<div align="right">*Petroushka*</div>

(1898-1986) 1937; oil on canvas; 122.4 cm x 81.9 cm; National Gallery of Canada; © Clive Clark and Benedict Clark

When Paraskeva Clark arrived in Toronto in 1931, she brought with her the Socialist ideals of the Bolshevik Revolution adopted during her artistic training in her native St. Petersburg. A friend of Norman Bethune and active in the Committee to Aid Spanish Democracy in the late 1930s, Clark passionately stated her views on the responsibility of the artist: "Those who give their lives, their knowledge and their time to social struggle have the right to expect great

help from the artist. And I cannot imagine a more inspiring role than that which the artist is asked to play for the defence and advancement of civilization."

This work was inspired by newspaper reports of the killing of five striking steelworkers by the Chicago police in the summer of 1937. To express her feelings of social injustice, Clark has adapted the story of *Petroushka*, or the Peter puppet—a traditional Russian symbol of suffering humanity—to a North American

context. The puppet show reaches its climax when the proletariat robber is arrested by the police and the rich capitalist waves his money in triumph. The audience seems restless and disapproving: The older people in the lower right raise their fists in protest; others seem apprehensive, while the narrator with the drum points a cautionary finger. In the background, the buildings tip and sway uneasily, alluding to the tensions in society.

General Hospital, Quebec

James Pattison COCKBURN

1830; watercolour and gum arabic over graphite on wove paper; 38.0 cm x 52.3 cm; National Gallery of Canada

(1779-1847)

James Pattison Cockburn, like his compatriot George Heriot, studied painting with Paul Sandby during his training at the Royal Military Academy in Woolwich, England. An inveterate recorder of the people and places he encountered in his far-ranging travels, Cockburn had already published six books about his European excursions before his second posting to Canada around 1826. As Major General and Commander of the Royal Artillery in British North America, Cockburn used his sketchbook extensively on his annual tours of inspection in Upper and Lower Canada. But he reserved his greatest body of work for his home garrison of Quebec City. There, he conducted a methodical examination of the city's streets and architecture, delineating particular buildings from many points of view.

In this carefully painted watercolour dominated by sky and trees, the object of Cockburn's interest is the Quebec General Hospital, as seen from a road on the outskirts of the city. While the street scene filled with passersby adds an element of scale to the image, it also allows Cockburn to include one of the city's local heroes: a solitary but well-known priest distinguished by his black cassock and skullcap. Brother Bonami, the last of the Récollet order of early French missionaries to Quebec, lived near the hospital and frequently visited the patients.

SPA

Lynne COHEN

<div align="right">Spa</div>

(1944-) 1994; gelatin silver print, graphite, formica; 110.3 cm x 128.4 cm; Courtesy P.P.O.W., New York

Lynne Cohen probes illusions and incongruities, selecting and revealing private and public spaces as she finds them, unoccupied territories that tell of the travails and pastimes of absent inhabitants. Using a large-format camera to produce highly detailed prints, Cohen depicts spaces such as classrooms, laboratories, offices and spas with a light-filled clarity latent with a complex eeriness and tension that render the familiar unfamiliar and the ordinary mysterious.

In *Spa*, all notions of pampering and relaxation are thrown into question by the austere rationality of the space and the enigmatic function of the objects regimented along the walls like abstract sculpture or a parade of alien soldiers. "My aim is to make photographs that are deceptively neutral…while hinting at something deeper," said Cohen. "Although each picture has an aura of scientific precision, the story it tells is difficult to decipher. I see the cool veneer functioning as a false lead and exploit it to counterbalance the strangeness of the narrative."

Cohen studied at the Universities of Wisconsin, Michigan and Eastern Michigan and at the Slade School of Art in England. She turned to photography in the early 1970s as an extension of her work in sculpture and printmaking, in which she employed found objects and ready-made environments. She has taught, exhibited and published her work extensively.

Yonge Street, Willowdale Robin COLLYER

1995; digitally retouched chromogenic print; 48.7 cm x 58.9 cm; Courtesy Canadian Museum of Contemporary Photography (1949-)

Since the mid-1970s, Robin Collyer has been established primarily as a sculptor, creating work that actively critiques urban and industrial environments and contemporary communications systems. Just as his sculpture integrated found materials and industrial fragments to create new fictional objects and structures, so does much of Collyer's photo work embrace modern environs, challenging the commodification of late-20th-century society. Commenting on postmodern suburbia, Collyer said, "Things tend to be out of scale with the human. They are much more temporary or built to last only a few years, long enough to maximize profits. Signage is everywhere fighting for our attention...We passively accept this visual invasion, and the line between the public and private is blurred."

In *Yonge Street, Willowdale*, from the series Retouched Photographs, Collyer uses digital-image technology to eliminate text and manipulate colour relationships and, in so doing, undermines the notion of the "truth" of photography. Stripping his hometown of Willowdale of its particular identity, he stresses the geometric simplicity and anonymity of the contemporary-built landscape. Linked to the nearby signage by the colour orange, the lone passersby become unwitting players in a dehumanized environment alienated from nature.

Collyer studied at the Ontario College of Art from 1967 to 1968 and has exhibited widely since then.

Alex COLVILLE

<div align="right">Horse and Train</div>

(1920-) 1954; glazed tempera on board; 41.2 cm x 54.2 cm; Art Gallery of Hamilton; Gift of Dominion Foundries and Steel, Ltd., 1957

A lone riderless horse gallops confidently toward an approaching train. Its graceful black body is silhouetted against the dying light and contrasts with the linear precision of the silver-coloured railroad tracks, cold and bright against the dimly lit landscape and ominous sky. The exacting brushwork and the precise definition of the objects heighten the suspense and the anticipation of collision. Does the horse symbolize nature threatened by the powers of technology?

Is the painting a metaphor for uncertainty, of latent fears of survival, of death?

Unlike most of Alex Colville's work, which springs from his personal life and the people and places he holds dear, *Horse and Train* was inspired by a poem written by South African poet Roy Campbell. *Dedication to Mary Campbell* included the lines: "Against a regiment I oppose a brain / And a dark horse against an armoured train." On one level, the painting literally

reflects the antagonisms of animal and machine, but in light of Campbell's intentions and Colville's inclinations, the horse is a symbol of the independent individual, and the train, bound to its track, is a symbol for unthinking mass behaviour. As art historian David Burnett has proposed, "Its meaning is suspended in the precision of its presentation and the associations it opens in the spectator's mind."

Colville was born in Toronto and moved with his

Woman in Bathtub

1973; acrylic polymer emulsion on particleboard; 87.8 cm x 87.6 cm; Art Gallery of Ontario; Purchased with assistance from Wintario, 1978; Photo by Larry Ostrom/AGO

family to Nova Scotia in 1929. He graduated in 1942 from Mount Allison University in Sackville, New Brunswick, where he had studied with painter Stanley Royle, an English Post-Impressionist. That same year, Colville joined the army, and from 1944 to 1946, he worked as a war artist in Europe, an experience which most profoundly influenced his artistic vision. "Art," he once explained, "is one of the principal means by which a human tries to compensate for, or comple-

ment, the relentlessness of death and temporality."

In *Woman in Bathtub*, the foreground is dominated by the rounded form and warm flesh tones of a woman sitting in a tub of shallow water whose curving shape echoes her own and quietly envelops her. Her nudity is made dramatic by the presence of a darkly robed man, his figure cropped below the face, adding to the mysterious, unknown nature of their relationship. The white geometric tiling is similarly

ambiguous, suggesting both a modern home and the austerity of an institution. Because of the suspension of fragmented action, the narrative remains open and uncertain. We can see the nude as vulnerable and threatened, or we can imagine her in the context of the classical women bathers popular with artists since antiquity and perpetuated in the colourful, intimate interiors of French painter Pierre Bonnard, who was much admired by Colville.

Charles COMFORT

The Dreamer

(1900-1994)

1929; oil on canvas; 101.7 cm x 122.1 cm; Art Gallery of Hamilton; Gift of *The Spectator*, 1957

In the centre of three vertical bands, a man in a boldly striped dressing gown looks upward with a worried, glazed expression, his haggard demeanour suggesting the desperate hope for sleep. His long, thin fingers splay across his narrow lap and contrast with the bulk of his upper body, creating a feeling of tension and awkwardness that permeates the painting.

The sitter was a young architect friend with whom Charles Comfort enjoyed discussions of avant-garde literature by such authors as André Gide and Aldous Huxley, alluded to in the text in the painting. While the title may suggest a benign exploration of the subconscious, this disturbing image in fact refers to the pair's shared misgivings about the future.

The Scottish-born Comfort was a versatile artist who began his prolific career as a commercial artist in Winnipeg. Following studies at the Art Students League in New York City, he moved to Toronto in 1925, where he continued to work as a graphic designer. He produced dreamlike landscapes and expressive portraits, worked as a muralist and was appointed senior official war artist in 1943. A professor at the University of Toronto (1938-60) and author of *Artist at War* (1956), Comfort was president of the Royal Canadian Academy of Arts (1957-60) and was the first artist to direct the National Gallery of Canada (1960-65).

Column

Ulysse COMTOIS

1967-1968; aluminum plates on steel base; 195.6 cm x 162.5 cm x 22.0 cm; National Gallery of Canada

(1931-1999)

An independent spirit and a skepticism for forms of authority that Ulysse Comtois claimed to have inherited from his father also filtered into his art, imbuing his exploration of sculpture with singular innovation. In this work, 67 aluminum rectangles, each weighing almost 45 kilograms, are positioned symmetrically around a central axis, offering viewers a rare opportunity to participate in determining its outward shape. In contrast to the usual notion of a column as fixed, monolithic and inflexible, Comtois' column is anarchistic and kinetic, inviting the creation of an infinite variety of forms.

A native of Granby, Quebec, Comtois began his artistic career as a painter in the post-Automatiste era of Montreal in the early 1950s. He studied at the École des beaux-arts for a year, then began producing abstract paintings whose repetitive modular aspects were later echoed in his sculptures. After exploring welded metal sculpture in the early 1960s, Comtois worked with laminated wood, layering thin slices to create curving shapes. This led to experimentation with identical slices of wood stacked on a rod so that the individual elements could be pivoted. Comtois continued these investigations in aluminum, attractive not only for its light-reflective character but for its durability. Although the precise machine-made quality of the uniformly shaped planks suggests factory mass production, Comtois made every plank himself in his studio.

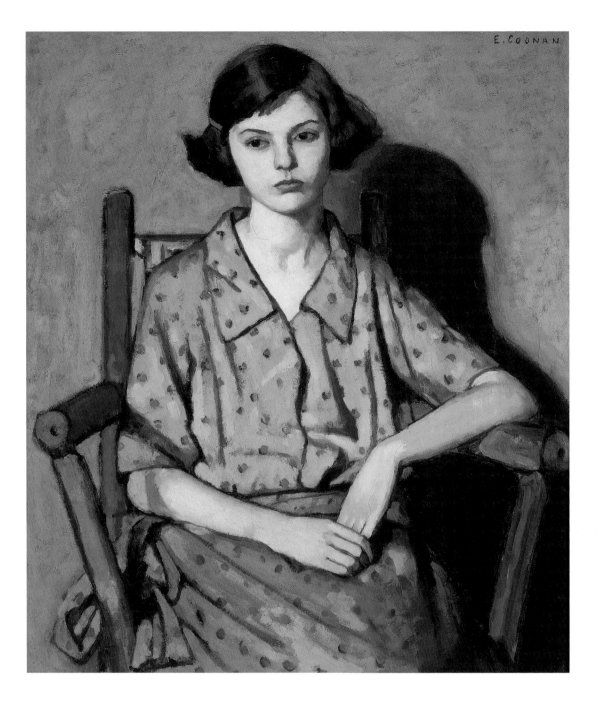

Emily COONAN

<div align="right">Girl in Dotted Dress</div>

(1885-1971)

<div align="right">c. 1923; oil on canvas; 76.0 cm x 66.4 cm; Art Gallery of Hamilton; Gift of The Spectator, 1968</div>

The solemn, almost brooding expression of the young girl seated in a chair sets the mood for this delicately painted study of colour and form. Light from the left allows for a refined sculptural modelling of the subject, whose slight proportions seem to be over-whelmed by the generous folds of her dotted mauve dress. Centred on a cool grey background, her solitary figure casts a dark shadow to the right, creating a quiet, melancholy atmosphere.

Emily Coonan was born in Montreal and, in her youth, was recognized for her artistic ability. As a student of William Brymner at the Art Association of Montreal in 1912-13, Coonan benefited from his lessons in the academic study of the figure and, like him, admired the paintings of James Wilson Morrice, whose modernist distillation of colour and form advanced the exploration of Post-Impressionism in Canada. Associated with the Beaver Hall Hill Group,

she was acclaimed for her individuality in the 1920s, and she and Lilias Torrance Newton were the first women to be invited to exhibit with the Group of Seven in 1923. Following Brymner's advice to be inde-pendent, Coonan pursued a path of her own, drawing the praise of a critic in 1925, who wrote that "her art is unlike anyone else's, and these days, that is enough to give her distinction." Coonan's direct style marked her as part of the 1920s avant-garde in Canada.

Hood

CREE ARTIST (James Bay)

c. 1890; broadcloth, cotton, beads, thread; 50.8 cm x 25.4 cm; Canadian Museum of Civilization, image #S97-3724

During the 18th and the first half of the 19th centuries, Cree women living in the region east of James Bay wore colourful beaded hoods on special occasions and in rituals pertaining to the caribou hunt. The intricacy of the floral decoration varied considerably, but the beadwork was typically arranged in three spatial areas, a number the Cree believed symbolized the division of the cosmos into sky, earth and underworld. In the earthly realm, the representation of

flowers in bud and full bloom acknowledges the cycle of life, and their colour and composition testify to Cree women's aesthetic sensibility and mastery of design. The depiction of flowers also empowered the wearer. As art historian and ethnologist Ruth B. Phillips explained, "The belief in the animate nature of plants …is a pre-contact feature of native religion…it is reasonable to assume that when a native woman represented a plant or flower…she understood it not

only as a decorative motif but also as a power image."

The red lining and the embellishment on the interior of the hood further demonstrate the care and pride involved in its manufacture. Not only did Cree women seek particular colours of beads in exchange for the hare and marten that they trapped themselves, but the time spent sewing the very small beads onto the woollen fabric was an indication of the value assigned to personal adornment.

83

Maurice CULLEN

Wolfe's Cove

(1866-1934) 1904; oil on canvas; 144.6 cm x 176.2 cm; Musée du Québec; Photo by Jean-Guy Kérouac/MQ

Newfoundland-born Maurice Cullen began his study of art in Montreal in the sculpture studio of Louis-Philippe Hébert. In 1889, Cullen travelled to Paris to study at the École des beaux-arts, where he decided to shift his attention to painting. He soon turned his back on the academic tradition and embraced the colourful, light-filled and loosely painted style of the Impressionists. Returning to Montreal in 1895, Cullen continued to paint in an Impressionist style,

making small oil sketches out-of-doors, even during snowstorms. Later, the sketches would be used as departure points for the larger works that he painted on canvas in the studio.

The luminous and dramatic landscape around Quebec City was a favourite sketching spot for artists, and Cullen often painted there in winter. This view of Wolfe's Cove, however, depicts an autumn scene, when the golden light of the season casts the last rays of

warmth over the steep slopes of Cap Diamant, jutting boldly into the St. Lawrence. Below, the houses along the shoreline hug the curving road, which carries our eye across the smooth waters to Lévis, on the opposite shore, and up into the breathtaking vastness of the sky. Cullen's talent in capturing the clarity of the light in a brilliant palette of complementary colours drew the praise of the art critic in Montreal's *Gazette* when this work was exhibited, along with five others, in the

Craig Street, Montreal

1912; oil on canvas; 76.4 cm x 102.0 cm; Musée du Québec; Photo by Jean-Guy Kérouac/MQ

1904 Royal Canadian Academy of Arts exhibition: "All show startling originality in composition, treatment and colour scheme. He is in no small degree a mood-painter."

Although the general public was slow to appreciate his sensitive and imaginative interpretations of the Canadian landscape, Cullen was greatly admired by contemporary artists. James Wilson Morrice, with whom Cullen had painted abroad and at home, insisted, "He is one artist who gets to the guts of things." And for younger Montreal artists at the turn of the 20th century, he was, in the words of A.Y. Jackson, "a hero" for introducing them to "the fresh and invigorating movements going on in the art circles of France."

From about 1908, Cullen painted numerous works of Montreal in winter. In *Craig Street, Montreal*, we peer through a swirling blizzard, where a horse-drawn carriage emerges, ghostlike, from a haze of rainbow-coloured snow. Light shines from the isolated moons of gaslight and from the windows and doors of the Viger Hotel, whose solidity has been dissolved by the snow. As the solitary driver fuses in the dusk with the bulky dark energy of the horses, the shapes of the animals' striding legs silhouetted against the grey-white road reassure us of their progress. "At some hour of the day," observed Cullen, "the commonest subject is beautiful."

Greg CURNOE

Zeus 10-Speed

(1936-1992) 1972; acrylic on plywood; 104.7 cm x 177.0 cm; Art Gallery of Ontario; Gift of the Volunteer Committee, 1997; Photo by Sean Weaver/AGO

In 1972, Greg Curnoe, also an amateur cyclist, began making portraits of his bicycles, which were unique assemblages of parts from an assortment of manufacturers. While many of these works were paintings on paper, with text that listed the bicycle's pedigree or featured nationalistic slogans, *Zeus 10-Speed* is painted on plywood cut out in the shape and size of the actual bicycle. In a gallery, it leans against the wall with the informality and directness that distinguish Curnoe's art.

He once claimed that he had learned nothing at the Ontario College of Art, where his teachers promoted abstract expressionism and believed, he said, "in a culture that had no connection with popular culture." However, in Toronto, Curnoe met artists such as Michael Snow and Michael Sanouillet, a professor who introduced him to Dada, a First World War anti-art nihilistic movement that suited his anarchistic view of the art establishment.

Curnoe's art was rooted in his birthplace of London, Ontario, and reflected views from his studio window of the city hospital, his family, local and historical heroes, jazz bands and bicycles. Executed in a range of media, from painting to collage and assemblage, his work was characteristically animated by bright flatly painted colour and undisguised methods of construction. In November 1992, Curnoe was killed in an accident while cycling with the London Centennial Wheelers.

Audrey Jean-Philippe DALLAIRE

1957; oil on canvas; 86.2 cm x 66.4 cm; National Gallery of Canada; © Jean-Philippe Dallaire/SODRAC (Montreal) 2000 (1916-1965)

With simplicity and directness, Jean-Philippe Dallaire presents his portrait *Audrey*, in which he has captured the innocence and spontaneity of childhood itself. Audrey's large head, topped with a black-and-white bow, balances precariously on her tiny neck and suggests a certain fragility, while her wide-eyed stare and dreamlike gaze lend an air of fantasy that is enhanced by the artist's use of thickly applied nonnaturalistic colours. This manner of painting, which evokes a

child's way of composing and filling space, asserts the flatness of the canvas and alludes to Dallaire's interest at the time in the work of French artist Jean Dubuffet, whose fascination with *l'art brut*, the art of untrained artists, and with the art of children brought a freshness to postwar painting.

Born in Hull, Quebec, Dallaire began his artistic career in 1936 painting religious images for the Dominican convent in Ottawa. He went to Paris in 1938

and studied with Maurice Denis, whose famous dictum that a painting was "essentially a plane surface covered with colours assembled in a certain order" encouraged Dallaire to pursue a modernist approach. The influence of Surrealist dreamlike imagery fuelled the artist's imagination. "I work according to my intuition and whim," said Dallaire. "As it is in Surrealism, it is the subconscious that I express, and that is made explicit through form and colour in the painting."

Charles DAUDELIN

Crouching Woman

(1920-)

1947; limestone; 58 cm x 67 cm x 37 cm; National Gallery of Canada; © Charles Daudelin/SODRAC (Montreal) 2000

Charles Daudelin's Cubist still lifes give us a clue to this imaginative figure, classical in its theme of the crouching woman but modern in its fanciful assemblage of gourdlike shapes and cones to define the human body. Amid the cluster of rounded organic forms, the serene moonlike face transports us to the world of dreams, attesting to Daudelin's attraction to the fantasy imagery of Surrealism and to his admiration for the work of Alfred Pellan, who similarly main-

tained references to nature in his whimsical abstractions. Although the example of French sculptor Henri Laurens, with whom Daudelin studied in Paris between 1946 and 1948, was also important for this work, Daudelin proposed his own sensuous and organic vision of the figure in an effort to achieve, in his words, a kind of "ripening of the forms."

Daudelin studied with Paul-Émile Borduas at the École du meuble from 1941 to 1943. During

that time, Borduas produced his first Surrealist-inspired gouaches, which served as a liberating example for many younger Montreal artists. In 1942, Daudelin began to experiment with clay sculpture, whose soft pliability lent itself to organic-shaped fantasy forms. He was recognized for his innovations, and one art critic commented in 1946 that "Daudelin has created a style all of his own, [which] will likely bring about a small revolution in the domain of sculpture."

The Happy Blowhole

Robert DAVIDSON

1992; yellow cedar; Diam.: 37.5 cm, D: 17.8 cm; Vancouver Art Gallery Acquisition Fund VAG 92.50; Photo by Trevor Mills (1946-)

In the golden yellow cedar of his native West Coast, Robert Davidson, a great-grandson of the legendary Charlie Edenshaw, pays homage to the canons of traditional Haida art, endowing it with innovation and a modern sensibility. In *The Happy Blowhole*, Davidson deftly balances the flowing, voluptuous form of the killer whale with precise, elegant lines, adapting Haida iconography and imbuing it with an optimistic spirit of joy and energy. The wood grain, left unpainted, suggests the undulations of the sea, asserting the unity between art and nature. "Art is a gift from the spirit world," said Davidson. "When we crystallize these ideas…we are giving birth to new images, new ideas, new directions…We are now giving new meanings to the songs, dances, crests and philosophies…which is no different from what our forefathers did."

Davidson's involvement in Haida ceremony nourished his creation of new art forms. "We now sing an old song called 'Eagle Spirit,' " he said. "The song is old, but we have created a new dance that expresses who we are today." As a member of the Eagle clan (all Haida belong to either the Eagle or the Raven clan), Davidson demonstrates his expertise with two-dimensional design in executing works that similarly rejuvenate ancestral imagery. In *Eagles*, the painting that serves as a model for the silkscreen print *Eagle Transforming*, Davidson employs bold (continued on page 90)

Robert DAVIDSON

Eagles

(1946-)

1991; gouache and watercolour on paper; 101.6 cm x 101.6 cm;
Vancouver Art Gallery Acquisition Fund VAG 94.3; Photo by Teresa Healey

(*continued from page 89*) ultramarine blue for the formline and adds red and turquoise to produce a joyful pattern where eagles, young and old, in profile and frontal view, spread their wings in a cohesive union of Haida iconography animated by a refined line and shape.

Davidson was born in Hydaburg, Alaska, and moved to Old Masset on Haida Gwaii (the Queen Charlotte Islands), where he carved small wooden and argillite totem poles with the encouragement of his father and grandfather. In 1965, he moved to Vancouver and immersed himself in the study of Haida art in the local museums. He met Bill Reid in 1966 and embarked on an 18-month apprenticeship, during which he augmented his knowledge of Haida design and learned the techniques of gold and silver engraving. His studies at the Vancouver School of Art (1967-68) helped him hone his drawing skills, a talent he would exercise in his paintings and designs for silkscreen prints, the first of which he made in 1968. In 1969, when he carved a 12.2-metre crest pole—the first to be raised in Masset in over 50 years—the experience proved seminal: It opened the door to his participation in Haida rituals and increased his confidence in the realm of Haida art. As a painter, printmaker and jewellery maker and in his numerous national and international commissions, Davidson continues to celebrate Haida culture and identity.

View of the Great Falls on the Ottawa River, Lower Canada

Thomas DAVIES

1791; watercolour over graphite on wove paper; 34.6 cm x 51.4 cm; National Gallery of Canada

(c. 1737-1812)

In 1755, young Lieutenant Thomas Davies attended the Royal Military Academy in Woolwich, England, where he also received training in watercolour before embarking the following year on the first of his four postings to Canada. In his leisure time, whether in war-torn Louisbourg, Nova Scotia, during his first sojourn or in the more peaceful environs of Quebec City during his last, Davies depicted the forts, harbours and landscapes of his surroundings, infusing them with his British sense of the picturesque and an orderly taming of the rugged environment.

With a true military penchant for accuracy, Davies added a precise inscription identifying the view of Great Falls on the Ottawa River. In the foreground, a bank of flat rocks and a line of small trees sweep up to the right, framing our view of the fast-moving Chaudière Falls. In the middle ground, several indigenous people in red and blue clothing provide colour-ful relief to the expanse of rock, while on the opposite shore, tiny figures portage canoes. Davies' view was a highly personal one, detailed and enhanced by the brilliance of the colour, the refinement of the painting and the delicacy of the drawing. While Davies' output was extremely varied, reflecting the diversity of his travels in Canada, his vision was always ordered and peaceful, perhaps as he wished to remember his military excursions.

Tom DEAN The Floating Staircase, 1979-1981 / Burning of the Floating Staircase, 1981

(1947-) wood and steel; 24' x 24' x 24'; Photos courtesy of the artist

In 1979, Tom Dean built a towering wooden staircase over three metres high and set it afloat in Toronto Harbour. On a formal level, Dean—who by this time had a history as a sculptor, draughtsman and performance artist—saw the staircase as a monumental metaphor for two aspects of human nature: the active vertical side and the passive horizontal side. With its stepped ascension supported by the large, flat platform, the staircase reconciled both prospects in a

cohesive form. The staircase was also the embodiment of contradiction: Its optimistic ascent, the symbol of spiritual aspirations, was negated by the absence of a destination. A beautiful and absurd staircase to nowhere, it was a testimony to Dean's creative spirit. "We set the will of dreams against the inertia of the waking world," he said. The work also endured as a mark of Dean's tenacity. Over the next three years, enormous energy and resources were required

to protect it from vandals and the harbour police.

Finally, in a semipublic ceremony in 1982, Dean set the staircase on fire. He then salvaged its charred remains and later assembled them to create a new work, a horizontal sculpture that retained the profile of the original staircase. Dean was born in Markdale, Ontario, and graduated from Montreal's Sir George Williams University in 1970. He represented Canada at the Venice Biennale in 1999.

92

Dorset Mask DORSET ARTIST

700 A.D.-1000 A.D.; carved driftwood, red ochre; 18.7 cm x 13.3 cm x 3.0 cm; Canadian Museum of Civilization, image #S89-1828

This life-sized mask was found in the early 1970s on the south coast of Bylot Island, in the central Arctic. To date, this is the only place where wooden artefacts belonging to the Dorset Culture have been found. So named for the site near Cape Dorset, on Baffin Island, where specimens related to their culture were first identified, the Dorsets were descendants of Paleoeskimos, who traversed the Bering Strait to Alaska about 2000 B.C., then dispersed across Arctic Canada and Greenland. The Dorsets existed from about 800 B.C. to 1000 A.D.

At the peak of the Dorset Culture's expansion across the High Arctic, there was a major increase in the production of small carvings of animals, human figures, maskettes and masks created largely from antler, bone and ivory, as well as some wood. These objects, believed to have been associated with the Dorsets' religious beliefs and shamanistic rituals, may have been made by the shamans as well. This mask was carved from driftwood, painted with red ochre and embellished with a fur moustache and eyebrows attached by pegs to the surface, signs of the shaman's desired alliance with the animal kingdom. While the precise function of this mask remains uncertain, it may have been worn in the performance of ceremonies to symbolize the distinction between the shaman and the community. It may also have served as a shaman's death mask.

Stan DOUGLAS

Nu•tka•

(1960-) 1996; single-channel video projection with sound; duration: 6:50 minutes each rotation; installation view at the Vancouver Art Gallery, 1999; Photo by Trevor Mills, courtesy David Zwirner, New York

In a darkened gallery, a large video screen displays an out-of-focus image of the forested coastline and sea along Nootka Sound, as seen from San Miguel Island, the site of a Spanish defensive in the late 18th century. The moving image, with its non-naturalistic colours, renders the landscape monumental and obscure. In fact, it is composed of two videotapes that run simultaneously on separate tracks. Complementing this visual disorientation, two voices—one in the role of an English ship

captain, James Colnett, and the other in that of a Spanish commander, José Esteban Martinez—concurrently deliver conflicting narratives of their struggles to conquer this territory. Absent are the voices of members of the Mowachaht Nation, who already inhabited the land.

Stan Douglas explained: "The interlaced images are mostly in continual motion—panning and tilting, presenting various features of Nootka Sound—but they come briefly to rest, and into exact registration, on six

occasions." As the narrators persist and the images separate again, the camera continues its circular surveillance of the island, simulating the colonizers' telescopic gaze that prefaced their settlement and contributed to the devastation of the environment.

Vancouver-born Douglas graduated from the Emily Carr College of Art and Design in 1982. He has attained an international reputation for his critical views of social, political, cultural and historical messages.

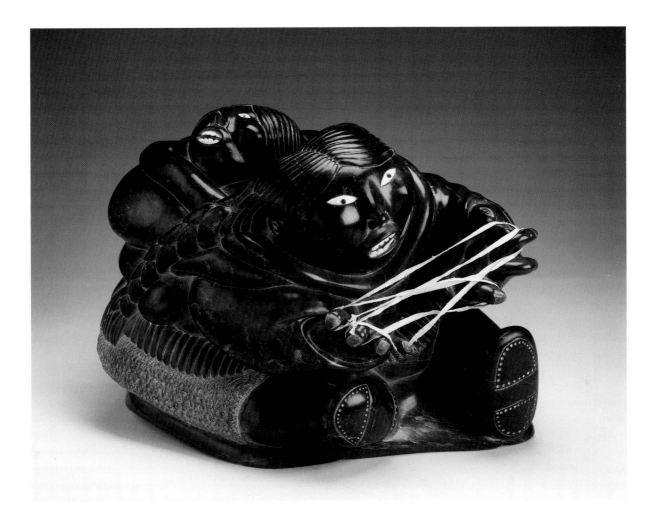

Woman Playing String Game

Noah ECHALUK

1987; dark green veined stone, ivory, hide; 26.1 cm x 38.7 cm x 24.1 cm; National Gallery of Canada

(1946-)

Noah Echaluk here employs the dark green serpentine of the Inukjuak area, insetting ivory for teeth and eyes and using hide to provide this robust woman with the material for her string game, a traditional form of amusement popular among Inuit during the long winter months. By rounding and polishing the stone, Echaluk has created a figure whose generous proportions are set against the rhythmic linear detailing of her braided hair, the fringe on her parka and the

stitches on the soles of her boots. In areas such as the skirt, the stone is worked and left unpolished, affording contrasting colour. The exaggerated energy of the woman's gestures and startled expression lends an element of humour that is echoed in the wide-eyed, open-mouthed grimace of the child.

Echaluk was born at a camp located some 70 kilometres north of Inukjuak, in Nunavik, on the east coast of Hudson Bay. He began carving in the mid-

1960s, inspired by his uncle, Lucassie Echaluk, and by the example of older artists such as Johnny Inukpuk who used the local serpentine and contrasting inlay to depict scenes of everyday life and thereby established an Inukjuak style. While the sturdy massiveness of the stone and the ivory embellishments in this sculpture recall the work of Inukpuk, the complex play of organic form and bold expressiveness gives Echaluk's work a power of its own.

Charlie EDENSHAW (Tahaygen)

Haida Argillite Model Totem Pole

(c. 1839-1920) 1880-1900; argillite; 49.5 cm x 9.9 cm x 8.0 cm; Courtesy of the Royal British Columbia Museum, Victoria, B.C./Cat. No. 16473

Charlie Edenshaw was born at Skidegate in Haida Gwaii (the Queen Charlotte Islands) and later moved to Masset, where he succeeded his maternal grandfather as a master carver of Haida ceremonial objects and crest poles. Edenshaw is most famous for his carvings from argillite, an indigenous form of brittle black slate used by the Haida early in the 19th century for carving objects to sell to travellers. The first carvings were of pipes with complex designs; these were followed by objects such as plates and bowls and later by miniature crest poles. By the early 1860s, just as the carving of these poles was on the rise, the Haida suffered a small-pox epidemic that reduced their population from 9,000 to 1,200 between 1862 and 1863. This tragedy was followed in 1884 by a government ban on the traditional gift-giving ceremony, the potlatch. Haida artistic expression was effectively suppressed.

Argillite carving, however, continued. In this work of the late 19th century, Edenshaw combines animals traditionally found on the large poles with a delicate figure of a man holding the moon. The man's expression of vulnerability is perhaps a reflection of the hardships Edenshaw himself encountered throughout his life. Recognized as the first professional Haida artist, Edenshaw balanced tradition with innovation. His work became the foundation for the revival of 20th-century Haida art. "Edenshaw," said Bill Reid, "was my Rosetta stone."

Mount Orford, Morning

Allan EDSON

1870; oil on canvas; 91.6 cm x 152.8 cm; National Gallery of Canada

(1846-1888)

Time stands still in the cool, misty morning of Lake Memphremagog in Quebec's Eastern Townships. Light shining on the far shore illuminates the mirrorlike lake that reflects the stumps and logs around its edge. Only the gentle landing of small birds in the lower right disturbs the calm. The presence of humanity, symbolized by a wooden rowboat in the foreground, is made even more humble by the lushly forested hills ascending to the crest of Mount Orford. When Allan

Edson first exhibited this painting, in 1871, a reviewer wrote: "Just so may the old mountain have looked ages before the foot of man had disturbed the silence of the 'forest primeval,' in the dim dawn when ancient night and chaos lay a-dying."

Born at Stanbridge in the Eastern Townships, Edson worked in Montreal with American artist Robert Duncanson and then studied for two years in England. In 1867, he returned to Montreal, where

he became known for landscape paintings that combined romantic idealization with a Victorian penchant for "truth to nature" nurtured by the era's fascination with photography. While the impact of a photographic aesthetic is evident in the precise rendering of such details as the blades of grass, the birds and the reflections in the water, the rich colours and panoramic proportions of the work return it to the realm of painting.

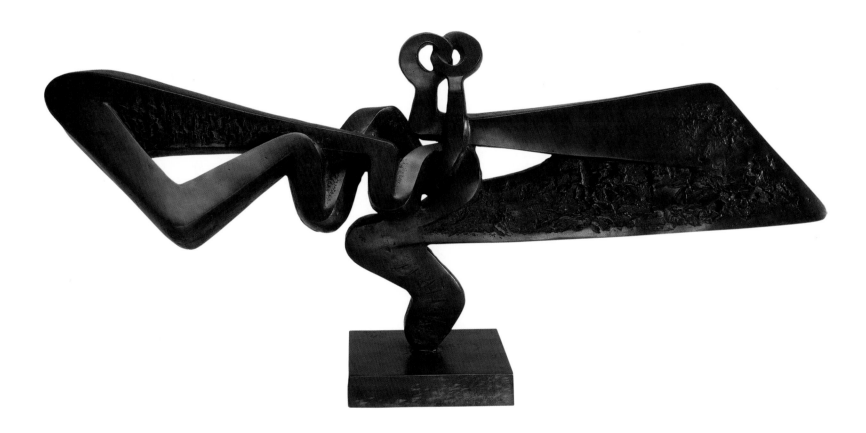

Sorel ETROG

<div style="text-align: right">Flight No. I</div>

(1933-) 1963-1964; bronze; 40.0 cm x 84.8 cm x 22.2 cm; Art Gallery of Ontario; Gift of Sam and Ayala Zacks, 1970; Photo by Carlo Catenazzi/AGO

Like two mechanical figures embracing, knotted forms pivot and loop in and out and back toward the centre before pushing sideways in a horizontal thrust, embodying the essence of flight. Recognizing in Sorel Etrog's work the relationship between humanity and the machine, the late Marshall McLuhan, media guru, wrote that it "presents the tension between the old organic visual world and the new electronic discarnate man…[who] now rebels and flips into his integral, spontaneous, primitive state once more—the state of space-time awareness."

Etrog was born in Romania and studied at the Tel Aviv Art Institute from 1953 to 1955. In 1958, he won a scholarship to the Brooklyn Museum School in New York City, where the appeal of Near Eastern, African and pre-Columbian art had a profound influence on his approach to form. Etrog settled in Canada in 1963 and began to attract a series of important commissions, producing works such as *Flight No. 1*, a maquette for the larger bronze selected for the Canadian Pavilion at Montreal's Expo 67, *Powersoul* for the 1988 Olympics in South Korea and *Sunbird II*, a Second World War memorial in France. Etrog has illustrated books by Eugène Ionesco and Samuel Beckett, and he produced the film *Spiral*, which was aired on CBC-TV in 1975. In 1994, Etrog was made a Member of the Order of Canada.

The Chowder Maker

EVERGON

1986; Polaroid triptych; 77.6 cm x 169.0 cm overall; Courtesy Canadian Museum of Contemporary Photography

(1946-)

Marrying new technology with the iconography of the old masters, Evergon reconstructs the theatre of 17th-century Dutch genre painting and propels it instantaneously into the present using large-format colour Polaroid photography. With sexually suggestive overtones characteristic of the homoerotic subjects for which Evergon is well known, *The Chowder Maker* looks at us invitingly as she opens a fresh oyster. On the left panel, her arm thrusts into the centre of the composition, where

artfully arranged foodstuff echoes the round shapes and curving sensuality of the centre image. On the right, the erect cabbage flanked by the circular forms of the cut lime and red onion furnish an unsubtle reference to male genitalia. Evoking the drama and chiaroscuro of Baroque painting, Evergon sets the props and the central character against an impenetrable black background, thus throwing into relief an image united across the surface by the warm yellow light and cool purple shadows.

Born in Niagara Falls, Ontario, Evergon studied art at Mount Allison University in New Brunswick. After graduating from the Rochester Institute of Technology in Rochester, New York, in 1974, he made innovative explorations into colour Xerox, collage and Polaroid photography using friends and lovers to fabricate his personal mythology and create imaginary narratives. Evergon has been inspired as much by his admiration of classical art as by his probing of contemporary experience.

Paterson EWEN

Cloud Over Water

(1925-)

1979; acrylic and metal on gouged plywood; 224 cm x 335 cm; Art Gallery of Ontario; © 2000 Paterson Ewen

With the primal vigour of the elements themselves, Paterson Ewen gouges giant sheets of plywood with an electric router to create images that overwhelm the viewer with the authoritative power of nature. Here, a single white-metal cloud is suspended like an undetected missile over a black body of water animated by orange and turquoise streaks reflecting the waning sunny brilliance above. The sheer weight and evident texture of the wood evoke the brute forces of nature,

while the irregularities of knots and gouging suggest its unpredictable temperament. Ewen explained, "I call my work 'Phenomascapes,' because they are images of what is happening around us as individuals—rain, lightning, hail, wind…They are sometimes inner phenomena. I observe, contemplate and then attack."

Born in Montreal, Ewen studied at McGill University and, from 1948 to 1950, at The Montreal Museum of Fine Arts with W. Goodridge Roberts. In

the early 1950s, he exhibited abstract art with the Automatistes. Ewen moved to London, Ontario, in 1968, and in 1970, while hand-gouging a piece of plywood in preparation for a woodcut, he discovered that by applying paint to the surface with rollers, his work was complete and he had no need to make a print. Armed with this new technique, Ewen embraced his long-standing interest in meteorological events, the Earth, the moon and outer space.

Wildcat Hills

Ivan EYRE

1976; acrylic on canvas; 142.3 cm x 304.8 cm; The Montreal Museum of Fine Arts;
Purchase, Horsley and Annie Townsend Bequest; Photo by Marilyn Aitken/MMFA

(1935-)

Evoking the timeless beauty of a medieval tapestry, a luminous panorama stretches before us, meticulously detailed and evenly textured. Trees from different seasons border rambling fields that extend far into the distance and, it would seem, beyond the frame. Although this and other landscapes might recall the prairie vistas of Ivan Eyre's youth, they are, in fact, invented places—"geographies of the spirit," sometimes tinged with unhappiness—created from the artist's memories of real places. Here, the absence of living creatures and of a single focal point lends an eerie feeling to this display of nature's bounty. "As Joseph Conrad knew," wrote Eyre, "there is darkness in every human heart…in my recent work…the darkness has moved underground, but there are some who still see it lurking behind the membrane of subject matter."

Eyre was born in Tullymet, Saskatchewan, and studied drawing with Ernest Lindner and, later, Eli Bornstein in Saskatoon. He graduated from the University of Manitoba School of Art in 1957 and taught there from 1959 until his retirement in 1992. In 1965, a Canada Council grant enabled him to travel throughout Europe, where his discovery of Japanese and European old masters confirmed his belief that "the degree to which the human spirit is locked into a work of art measures the work's 'nowness' and the artist's greatness."

Joe FAFARD

Dear Vincent

(1942-)

1983; clay and acrylic paint; 63.5 cm x 28.0 cm x 44.0 cm; Courtesy of the artist; Photo by Don Hall

In this small plaster portrait, Joe Fafard brings to life an intensely contemplative Vincent Van Gogh, sitting with his boots on in the yellow chair made famous in Van Gogh's painting of his own bedroom. Although the work is three-dimensional, Fafard has rendered the figure and clothing with the lush colours and expressive brushwork of Van Gogh's paintings, cleverly uniting the man with his medium. "The candle," said Fafard, "is like a light unto the world…he was lighting up things

that we [have] only [begun] to see a hundred years later." Fafard has portrayed other artists he admires, but it is Van Gogh whom he holds in greatest esteem for his singular dedication to art and to "ordinary souls."

Fafard was born in Saskatchewan and graduated from Pennsylvania State University in 1968. Although he admired the irreverent glorification of consumer culture reflected in the work of such American pop artists as Claes Oldenburg, Fafard sought an artistic

expression rooted in his community. In 1968, when he began teaching at the University of Saskatchewan, he started to produce plaster portraits of his colleagues, an activity spurred by the arrival of American artist David Gilhooly. Fafard also portrayed people in his hometown of Pense, Saskatchewan, and later expanded his repertoire to include domestic animals, especially cows, as well as politicians and individuals from his artistic community.

Picnic with Birthday Cake and Blue Sky

Gathie FALK

1976; ceramic, acrylic, varnish and wood; 63.6 cm x 63.4 cm x 59.7 cm; National Gallery of Canada

(1928-)

Here, we look through a window into a box that contains a ceramic sculpture of a birthday cake sitting on a picnic blanket on a lawn. The background is a painted blue sky and clouds. Because the billowing flames of the candles also resemble the shapes of windswept trees, the cake starts to assume the monumental proportions of a towering inferno, transcending the innocence of sugary confections and imbuing the work with ambiguity. The meaning of the fire is complex, linked to memories of grass burning, the hot flame of the kiln and difficult personal times. "Fire," Gathie Falk observed, "is associated with warmth, danger, excitement and purification. It is a certainty that I went through fire in those years."

Born in Manitoba and raised by Mennonite parents, Falk studied at the University of British Columbia. In her work as a painter, sculptor and performance artist, she has always drawn on her immediate environment, embracing the ordinary and transforming it with both humorous and disturbing effects. The idea for the "picnic" sculptures evolved from performance pieces in which Falk held picnics in uncommon places, while procuring bizarre objects from the picnic basket. She has referred to these ceramic sculptures as "nice headstones." Her representation of objects such as a clock with black eggs evokes thoughts of death and recalls traditional still-life painting with its moralistic overtones.

103

Murray FAVRO

Sabre Jet, 55% Size

(1940-) 1979-1983; aluminum, steel, fibreglass, Plexiglas and aircraft hardware; 256 cm x 603 cm x 650 cm; National Gallery of Canada

The theme of flight and a love of mechanical ingenuity long dominated the art of Murray Favro, manifesting itself for many years in depictions and constructions of airplanes, kites and propellers. At its heart, said Favro, was his fascination with "creativity itself, in the process of invention and, then, in how it forms in a material expression."

Captivated since childhood by the Sabre jet airplane and its sleek metallic finish and design, Favro had, by 1965, grown dissatisfied with his painterly depictions of the jet. Now he worked intuitively and used wood, metal and fibreglass to construct a half-sized Sabre jet, producing a work with a crude finish that only approximated the original. By 1979, however, Favro proceeded in a more scientific manner, using photographs, precise calculations and a computer to design a work whose scale would be precisely 55 percent of the original jet and employing real aircraft materials. The final work is large enough for him to sit in yet small enough to fit through the door of his dealer's gallery. Although the unfinished side and the absence of an engine deem the work clearly unfit for flight, the exposure of the structure of the body permits an appreciation of the rational beauty of the construction. Here, Favro's admiration for aviation design is rendered with an aesthetic sensitivity that transcends its original function.

Fish and Door

Gerald FERGUSON

1992; enamel on canvas and painted wood; 213.3 cm x 223.5 cm; Art Gallery of Nova Scotia; Purchased with funds provided by Trimark Investment Management, Inc., Toronto, 1994

(1937-)

This large work, over two metres high, offers the unusual juxtaposition of a canvas blanketed with images of unevenly stencilled fish and an old wooden door, its paint cracked and faded, from the house of a fisherman. On one level, the pairing alludes to the fishing industry and to the weather-beaten architecture of the Maritimes, where Gerald Ferguson lives. For the artist, however, the cruciform shape of the door's frame recalls Christian icons, endowing the fish with a new level of symbolism. Ferguson's choice of enamel paint and stencils associated with folk art and 19th-century furniture decoration intentionally challenges the traditional preciousness of painting on canvas and subverts the imprint of an individual artist. The artist's use of a roller diminishes the sense of an individual hand, and the found door ensures that the image remains relatively anonymous.

While the associations that viewers bring to this pairing will depend on their personal perspectives, Ferguson's exploration of this kind of imagery comes partly from a long history of questioning the authority and meaning of painting together with a more recent interest in still life, folk art and the formal structures of the Christian art of the past. Ferguson graduated from Ohio University in 1966 and, in 1968, began teaching at the Nova Scotia College of Art and Design.

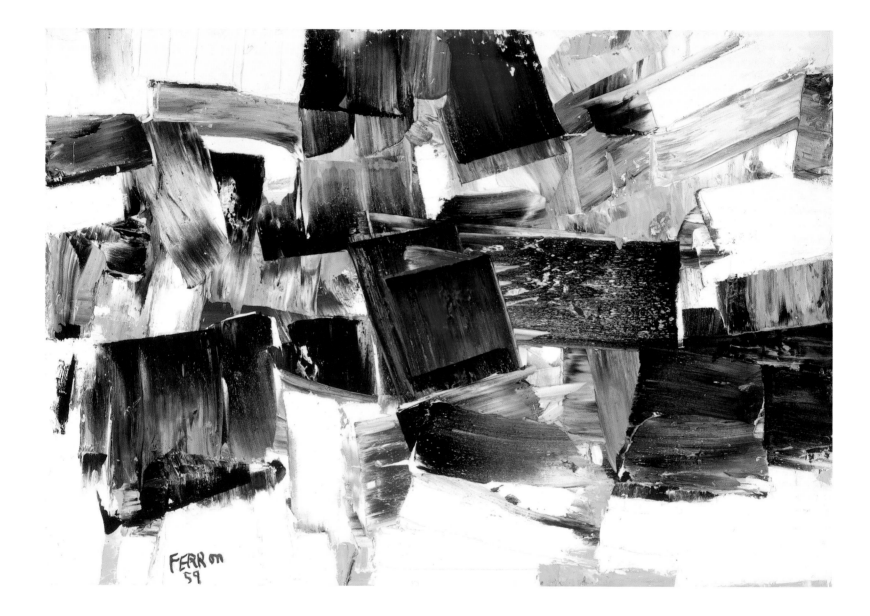

FERRon
59

Marcelle FERRON

The Dorset Signal

(1924-)

1959; oil on canvas; 114.2 cm x 162.0 cm; The Montreal Museum of Fine Arts;
Purchase Grant from Canada Council and Horsley and Annie Townsend Bequest; Photo by Brian Merrett/MMFA

Marcelle Ferron studied under Jean-Paul Lemieux at the École des beaux-arts in Quebec City in 1942, then moved to Montreal, where she became associated with Paul-Émile Borduas and the Automatistes. As a signatory to the 1948 manifesto *Refus global*, Ferron embraced a style of abstraction inspired by Surrealist theories of automatism, where the artist worked spontaneously from dreams and the subconscious. This nonrepresentational and gestural expression was a call for a new order in art as well as in society.

For *The Dorset Signal*, Ferron ground her own pigments and blended them with poppy-seed oil to achieve colours of unusual brilliance. She applied the paint with a broad trowel-like instrument, mixing it directly on the canvas. Here, swatches of red-black sweep down from the top, while a symphony of blues and blue-greens collides with orange to create an image of energy and excitement. This allover pattern-ing of colour, in which no single element of the composition dominates, may reflect Ferron's beliefs in so-cial egalitarianism, but it may also be an expression of the joy and liberty she experienced following her move to France in 1953. The repressive Church-dominated society of Quebec had been unsympathetic to her artistic vision. In France, however, where artistic ex-pression was embraced, Ferron's feelings of emancipa-tion were manifest in bigger and brighter paintings.

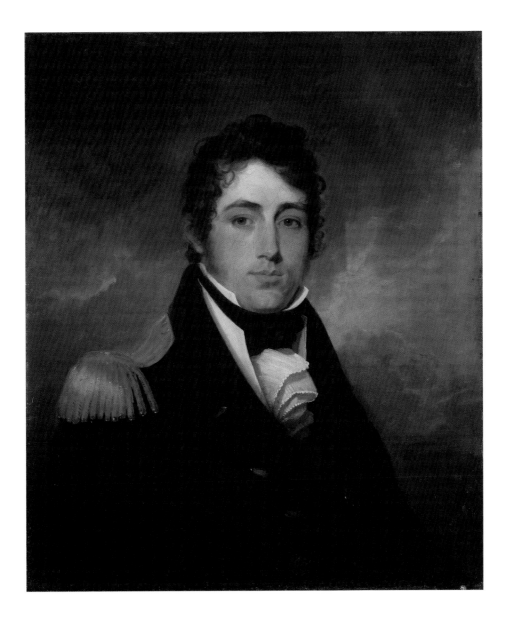

Lieutenant Provo William Parry Wallis, R.N.

Robert FIELD

1813; oil on canvas; 76.2 cm x 63.5 cm; National Gallery of Canada

(1769-1819)

The capture of an American frigate on the Atlantic Coast by the H.M.S. *Shannon*, commanded by the young Second Lieutenant Provo William Parry Wallis in the War of 1812, provided the occasion for this portrait. Shortly after the event, Wallis sat for Robert Field, Halifax's most eminent portrait painter.

With the dignified bearing of a classical bust, the 22-year-old Wallis looks at us with serene confidence, fresh from victory. He is presented as a romantic hero,

set against a background of stormy clouds, his boyish expression and steady gaze complemented by a head of brown curls tousled in an imaginary wind. He is elegantly attired in the undress uniform of a British lieutenant, and the gold of his epaulette and crisp white frill of his shirt add to his flair.

British-born and trained at the Royal Academy in London, Field learned a manner of portrait painting that combined an admiration for classical art with a

hint of romanticism. Like many artists of his time, Field travelled widely in search of commissions. After 14 years in cities along the east coast of the United States, he arrived in Halifax in 1808. To promote his skills as a portraitist, he placed a notice in the *Royal Gazette* and attracted enough business painting portraits of Halifax's wealthy elite and ruling government officials to sustain his stay in the city until 1816. Three years later, Field died of yellow fever in Jamaica.

107

Lionel LeMoine FITZGERALD

Doc Snyder's House

(1890-1956) 1931; oil on canvas; 74.9 cm x 85.1 cm; National Gallery of Canada; Gift of P.D. Ross, Ottawa, 1932

The sinuous shapes of leafless trees interspersed across the cool blue snow-covered lawns contrast with the flat brown fence and the rectangular simplicity of the houses. In the frozen quiet of a Winnipeg winter afternoon, when no one ventures outside unnecessarily, nature and architecture have been distilled to their essences. The passive blue sky contributes to a feeling of eternal stillness that is enhanced by Lionel LeMoine FitzGerald's meticulous brushwork. "I work very slowly and [for] a long period over each work," he wrote. "[This painting] represents two winters, including two full weeks each Christmas vacation as well as all weekends." While technique was important to FitzGerald, he cautioned, "What you have to say is of first importance; how you say it is always secondary."

FitzGerald's development as an artist, from his training in evening classes in Winnipeg at the age of 19 through his study at the Art Students League in New York City at 31, entailed the gradual purging of all extraneous detail from his art. While this pondered, painstaking approach was very much a product of the Manitoba-born artist's contemplative personality, it was also influenced by his admiration for American artists such as Charles Sheeler, who pruned his own view of urban architecture to a near-abstract pattern, a path that FitzGerald himself would take in the last decade of his life.

From an Upstairs Window, Winter

c. 1950-1951; oil on canvas; 61.0 cm x 45.7 cm; National Gallery of Canada

Doc Snyder's House was part of the 1932 Group of Seven exhibition, an association that the rather reclusive FitzGerald enjoyed. He had a particular affinity with the meditative Lawren Harris, who wrote an appreciation of FitzGerald's work in a 1945 issue of *Canadian Art*: "There is a grace and ease of technical accomplishment in these paintings which, in its mastery, could only have been achieved by an utter simplicity of mood and dignity of spirit."

In *From an Upstairs Window, Winter*, we look with the artist through a window frame at a view of neighbouring backyards asleep under the winter's snow. In contrast to the geometric simplicity of the architecture, nature—in the forms of the trees—moves with organic unpredictability, creating complex linear patterns. Inside, order is restored with the carefully selected objects on the windowsill. Here, the flat sketch pad and the thin pencil are balanced by the verticality

and roundness of the small white jug. "We can only develop an understanding of the great forces behind the organization of nature by endless searching [of] the outer manifestations," FitzGerald offered, "and we can only know ourselves better and still better by this search…I pray that I shall never [lose] the inspiration that comes from the constant communication with living forms…I want to walk in the light that is never ending with an open heart and open mind."

Martha FLEMING and Lyne LAPOINTE

La violence des vagues (The Violence of the Waves)

(1958-)
(1957-)

1984-1987; gouache, graphite, linseed oil and enamel paint on paper; 281.9 cm x 508.0 cm;
The Musée d'art contemporain de Montréal Collection; Acquired through the generosity of the Foundation of the Friends of MACM

Between 1982 and 1997, art critic Martha Fleming and artist Lyne Lapointe collaborated on artworks that used abandoned buildings as sites for visual art and performance and as a metaphor for exploring ideas of marginalization and abandonment in society. As Fleming wrote, "Each of our projects is a complex process of grafting and counterpoint, where architectural and artistic conventions are both used and undercut."

The Violence of the Waves was among the backdrops cre-

ated for Fleming and Lapointe's 1987 project *La Donna Delinquenta*, a complex installation of sound, light, music and visuals inspired by a 19th-century Italian treatise that linked female criminality with physical traits. Over a three-month period, the deserted Corona Theatre in Montreal became the site for multidisciplinary dramatizations of the stories of legendary female criminals and explorations of the theme of lesbianism, whose proponents had been marginalized like the

deserted buildings. Here, a fragmented composition explores an allegory about power and authority. In the top section, the killing of the snake—an ambiguous symbol of knowledge and evil—is contrasted with the images of women as prisoners of men, below. On the left, a woman is physically restrained in a chair, and on the right, the nude odalisque is a captive of the male gaze. Circular sentences link these images and spell out the condemnation of women.

L'Orme à Pont-Viau (The Elm at Pont-Viau)

Marc-Aurèle FORTIN

c. 1935; oil on canvas; 136.9 cm x 166.4 cm; Musée du Québec; © SODART

(1888-1970)

A massive elm tree dominates the foreground and commands our attention as a symphony of green defines its abundant foliage. Dwarfed by its size, casting fishermen create elegant black lines that are almost lost against the verdant land and the strip of sleepy blue river. Behind billowing white clouds, the sky darkens to a violet-blue, and a storm, announced by a fork of lightning between the church steeples, threatens the idyllic quiet.

The image's tranquillity belies the spontaneous method with which it was painted. Subsequent to his 1935 trip to Europe, Marc-Aurèle Fortin began to experiment with his *manière noire*, or black manner, whereby he covered the entire surface of his canvas or board with black enamel. Once it was dry, he deposited colour directly from the tube and then later extended these applications with a brush, achieving an intense luminosity and brilliance of colour.

Fortin was born in Ste-Rose, Quebec, once a suburban village north of Montreal, and for his entire life, he was devoted to landscape painting that celebrated the beauty of nature. Even when depicting the port or suburbs of Montreal, such as Pont-Viau, he focused on the bucolic aspects of regions not yet encroached by modern urbanism and remained faithful to the role of the artist as a celebrator of nature's beauty. "Painting," he said, "is silent poetry."

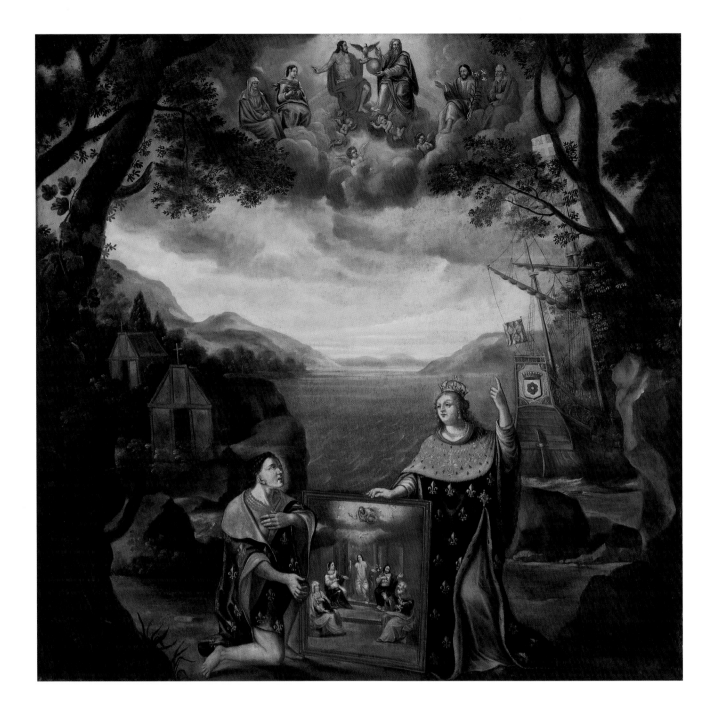

Claude FRANÇOIS (Frère Luc)

(1614-1685)

La France apportant la foi aux Hurons
de la Nouvelle France

c. 1670-1671; oil on canvas; 227 cm x 227 cm; Monastère des Ursulines; Collection Ursulines de Québec

In August 1670, Parisian artist Claude François, a Récollet priest also known as Frère Luc, arrived in Quebec City. He travelled with the intendant Jean Talon, who had been charged by Louis XIV to reestablish the Récollets in New France. Whether François painted this work has been a matter of some debate, but the fact that he was a member of a religious order known to be loyal to the Crown fits with the didactic and allegorical nature of the painting.

On the shores of the St. Lawrence River, a woman who personifies the reigning French monarchy points toward the heavens, where the Roman Catholic Trinity is assembled with saints. On the ground, she presents a painting, which depicts an enthroned Jesus Christ, to a kneeling man, whose native garb has been replaced by a cloak embellished with the insignia of the French monarchy.

The painting, on one level, is a reflection of the common practice in 17th-century New France of importing works of art to remind settlers of their religious beliefs and to further the conversion of the native peoples. Also, in the context of the struggle between the state and the monarchy for control of the Church in New France, the painting implies that religious authority is in the hands of the monarchy, since it is "la France" that is literally, as the title suggests, "bringing the faith to the Indians."

The Sun's Last Kiss on the Crest of Mt. Stephen, B.C. John Arthur FRASER

1886; watercolour on pressed paperboard; 44.5 cm x 65.7 cm; The Beaverbrook Canadian Foundation,
The Beaverbrook Art Gallery, Fredericton, New Brunswick

(1838-1898)

Born in London, England, John Arthur Fraser may have studied art at the Royal Academy Schools. He moved to Montreal around 1860, where he worked tinting photographs in William Notman's studio. In 1886, Sir William Van Horne, vice president of the Canadian Pacific Railway, offered landscape painters free passage on the newly built line that extended to British Columbia. He wanted to provide the artists with the opportunity to record and thereby pro-

mote the splendour of the Rocky Mountains. Fraser accepted the invitation.

Here, a magnificent sunset illuminates Mt. Stephen, saturating the sky with intense rose-orange tones. The snow near the peak resists the fiery warmth of the sun and retreats into the crevices of the mighty rock. In the foreground, a dense green forest forms an impassable thicket, where the tallest pines reach upward silhouetted against the mountain. While some aspects of the work,

such as the abrupt fencelike foreground, recall the photographs of Alexander Henderson, which Fraser had seen at Notman's, the work remains painterly in Fraser's selection of details and romantic use of colour. Exhibited in Toronto in the fall of 1886, Fraser's mountain watercolours garnered praise in *The Globe*: "He has risen to their sublime plane and depicted their dizzy heights, cavernous depths, dazzling lights and massive shadows, with...daring but truthful colour."

Vera FRENKEL

...from the Transit Bar

(1938-)

1992, reconstructed 1994; a six-channel videodisc installation and functional piano bar; dimensions vary according to site; National Gallery of Canada; Gift of the artist, 1997

This installation combines a functional piano bar with table and chairs, where visitors may order a drink, talk with the bartender, chat with each other, listen to music and view tapes on any of the six monitors in which individuals recount experiences of loss and exile in a variety of languages. It is unclear whether these stories are true or fabricated. This experience, while not unpleasant, is rather disorienting within the confines of an art museum, leaving the visitor hovering in the simulacra between reality and fiction. Where are we really? Who are we here? Vera Frenkel explained: "It is in this sense of providing a theatre for reinvention and presentation of the self that the Transit Bar, like any other, offers an echo of the larger shifts of meaning in the world outside."

Since 1974, the Czech-born Frenkel has been in the vanguard, creating video installations that explore relationships between reality and illusion and investi- gate the themes of memory, migration and displace- ment, experiences which strongly characterized the late 20th century. Invited in 1992 to make a site-specific work for Documenta IX, an international exhibition of contemporary art held in Kassel, Germany, Frenkel decided "to make a work about being foreign and how it feels, about the costs of forced or voluntary exile and, by implication, about some of the traumas of the century which have prompted these uprootings."

Steps (December)

Charles GAGNON

1968-1969; oil on canvas; 203.2 cm x 274.2 cm; The Montreal Museum of Fine Arts;
Purchase, The Saidye and Samuel Bronfman Collection of Canadian Art; Photo by Brian Merrett/MMFA

(1934-)

Greyish white brush strokes crisscross the large surface of the canvas like a blinding blizzard obscuring our view. In contrast to the gestural freedom of the white space, the severity of the black border is still, functioning as a window frame to a limitless space. Most pronounced is the ambiguity created by the illusion of a bright space that appears both shallow on the surface and illusionistically deep, receding behind the black border. These dynamic contrasts of black and white, combined with the free brushwork and the large scale of the painting, are a testimony to Charles Gagnon's study of art in New York City from 1954 to 1960. A resident during the heyday of abstract expressionism, Gagnon admired the dramatic effects of a reduced palette, gestural application of paint and simplified structure in the work of artists such as Franz Kline and Robert Motherwell.

Returning to Montreal in 1960, Gagnon—who is also a photographer and a filmmaker—worked with a variety of media. "Media are to be used," he has said. "I don't see any difference between film and photography and sculpture and painting and thinking and farming...It's life that interests me." Because he is not limited by narrow definitions of media, Gagnon seeks to express his personal vision and appreciates that painting, photography and film all allow him to explore the illusion of space on a flat surface.

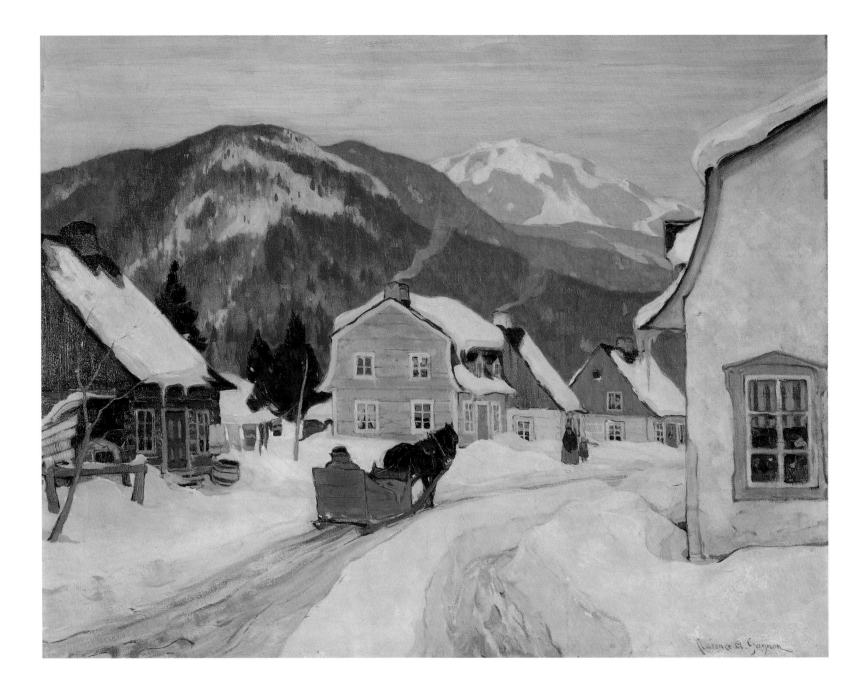

Clarence GAGNON

Laurentian Village

(1881-1942) before 1928; oil on canvas; 73 cm x 92 cm; Musée du Québec; Photo by Jean-Guy Kérouac/MQ

At the edge of a small Quebec village, we follow the path of a horse-drawn sled amid 19th-century rural architecture. In the distance, the Laurentian Mountains loom large and eternal, enclosing the village in a protective embrace. The white snow, warmed by the vibrant colours of the houses, covers the village in a blanket of silence.

Like his contemporaries in the Group of Seven, Clarence Gagnon longed to dissociate himself from

an academic tradition in painting and was interested in creating a national art, although not one based on the untamed wilderness. Gagnon's idea of "national" was rooted in his love of the people and the land of Quebec, as reflected in his depictions of cultivated landscapes, in which nature has been transformed by agriculture and human settlements.

Gagnon was born in Montreal and began studying art in 1897 with William Brymner at the Art Associa-

tion of Montreal. He went to Paris in 1904 to study at the Académie Julian, where Jean-Paul Laurens encouraged his students to compose with clarity and simplicity. For the following few years, Gagnon travelled throughout Europe, employing the vivid palette and loose brushwork of the Impressionists that he would later apply to his painting of Canadian subjects. He also distinguished himself abroad as a printmaker, winning awards in the United States and

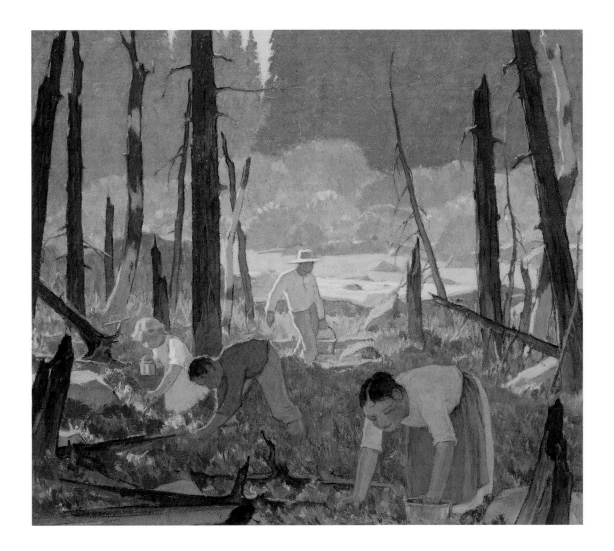

Picking Blueberries (from *Maria Chapdelaine*)

1928-1933; mixed media on paper; 17.7 cm x 19.7 cm; McMichael Canadian Art Collection; Gift of Col. R.S. McLaughlin

France for his picturesque engravings of villages and towns. In 1909, he began to divide his time between Montreal and Charlevoix County, east of Quebec City, on the north shore of the St. Lawrence—"Christmas card country," as his friend A.Y. Jackson called it. Already attracted to the work of artists such as Horatio Walker, who celebrated the hardships of farm life, Gagnon became renowned nationally and internationally for the winter villages of his native land.

Although he would live most of his life in France, his years in Baie-St-Paul, from 1919 to 1924, furnished him with memories of the toils and virtues of rural life.

In 1928, Gagnon embarked on his most famous oeuvre: the 54 paintings that would illustrate the 1933 deluxe edition of Louis Hémon's novel *Maria Chapdelaine*. Drawing on his experience of the customs and hardships of the communities of rural Quebec, Gagnon pictured the changing seasons and rituals

of these people who lived close to the land. "My purpose in illustrating *Maria Chapdelaine*," he wrote, "was to catch the spirit of Canada and of the French-Canadian life, which the book immortalizes. That book represents the struggle of a brave little minority and reveals the true pioneering instinct of those early settlers. It is Canadian yet universal in its picture of a struggle where people are determined to maintain their own religion, language and customs."

Yves GAUCHER

Triptych

(1934-)

1966; acrylic on canvas; each panel 203.2 cm x 152.7 cm; Art Gallery of Ontario;
The Canada Council Special Purchase Assistance Program and Wintario, 1977; Photo by James Chambers/AGO

Born in Montreal, Yves Gaucher studied at the École des beaux-arts from 1954 to 1960, specializing in printmaking. In the early 1960s, he attended contemporary music festivals in Paris, where he felt challenged and disturbed by the music of composers such as Pierre Boulez and Anton von Webern.

"The music seemed to send little cells of sound into space," explained Gaucher, "where they expanded and took on a whole new quality and dimension of their own." These musical cells would later become "signals" in paintings such as *Triptych*, composed of three monochromatic panels punctuated with short horizontal lines arranged rhythmically over their surfaces. The relationship between the boldly coloured primaries of the panels and the more softly coloured signals evokes distinct moods that suggest an unexpected poetry within the cool geometric format. This lyricism is echoed in the artist's titles for each of the panels: *Signals, Another Summer* (red); *Signals, Very Softly* (yellow); and *Silences, Silence* (blue).

The work of American abstractionist Mark Rothko also influenced Gaucher, who was struck by the capacity of Rothko's large, minimally detailed coloured surfaces to captivate his attention to the extent that he lost a sense of time passing. This led Gaucher to create paintings that invited a similar mood of contemplation.

Intimate Chlorophyll

Pierre GAUVREAU

1949; oil on canvas; 45 cm x 45 cm; National Gallery of Canada; © Pierre Gauvreau/SODRAC (Montreal) 2000

(1922-)

In the poetically titled *Intimate Chlorophyll*, curious organic forms dabbed with green paint occupy a shallow stage-like area. A squared-off arch in the background opens to a clear blue space that gives no clue as to the scale or the location of the unfamiliar objects. Like many of the artists who were associated with Paul-Émile Borduas and who likewise signed the *Refus global* in 1948, Pierre Gauvreau came to maturity in an era of cultural suppression. These artists created dreamlike visions in their work that reflected their desire for artistic and social reform.

Unless they were able to travel outside Canada, their awareness of modern-art movements came through books and periodicals. But literature was highly censored by both Church and State, and Gauvreau has recalled being barred from finishing high school because he owned copies of Charles Baudelaire's *Les Fleurs du mal* and Arthur Rimbaud's poetry. This interest in avant-garde literature influenced his visual thinking, and although he did not entirely embrace the current Surrealist theories, the legacy of the gestural freedoms associated with automatism appealed to him. Interviewed in 1979, Gauvreau declared, "I paint without preconceived ideas, and I am ready for anything which manifests itself on my canvas. I don't manipulate movement or form or colour to conform with questions of taste…spontaneous perceptions cannot be filtered through rational censorship."

119

GENERAL IDEA

One Year of AZT/One Day of AZT

(active 1968-1994)

1991; background: 1,825 units of vacuum-formed styrene with vinyl, each unit 12.7 cm x 31.7 cm x 6.3 cm; foreground: five units of enamelled fibreglass; National Gallery of Canada

In 1968, three Toronto-based artists known by the pseudonyms AA Bronson, Felix Partz and Jorge Zontal banded together under the title of General Idea, a name whose ambiguous evocations of the military and of commercial corporations forecast the cryptic and elusive nature of its multidisciplinary expression. Believing that "three heads were better than one," they debunked the notion of the artist as an individual genius and appropriated and manipulated the formats of mass media

and popular culture, staging performances and producing installations, sculptures, paintings, graphics and even their own magazine, *File*, an artistic spoof on *Life*.

Although the tone of the artists' work darkened in the late 1980s with the focus on AIDS-related subjects, their fascination with exaggeration and the impersonality of mass production continued unabated. This work fills a large room, lining its walls with shiny white capsules that symbolize a year's dose of AZT,

the drug alleged to impede the spread of HIV. On the floor, five giant capsules (a day's dose) evoke futuristic coffins that vacillate between clinical innocence and the macabre. Despite the subject's gravity, the artists characteristically deployed the upbeat language of advertising: "Our image would have to be generic...a capsule! ...a common everyday image of wellness dispensed just around the corner!" In 1994, Partz and Zontal died of AIDS-related illnesses, ending the trio's collaboration.

She Sat Upon a Hill Above the City Henry George GLYDE

1949; mixed technique on cardboard; 60.6 cm x 76.2 cm; Glenbow Collection, Calgary, Canada (1906-1998)

With unselfconscious abandon, a nude woman reclines serenely across the foreground of the painting, her curving forms echoed in the undulating landscape. The palpable realism of her body is countered by the setting, miraculously cut away to reveal a squalid underworld in which the shadowy faces of men express sadness and remorse as well as unrepentant lust. Above, the phantomlike figures of a couple, perhaps on their way to the church in the distance, shield their eyes from the woman, whose identity as either a symbol of untouched nature or a temptress of the flesh remains ambiguous. "Art," said Henry George Glyde, "is a silent affair."

Glyde was born in England and studied at London's Royal College of Art (1926-30). Although he admired the surreal figurative work of his contemporary Sir Stanley Spencer, Glyde was captivated by artists of the past, such as the early Italian Renaissance painters Giovanni Cimabue and Piero della Francesca and British artists Henry Fuseli and William Blake, renowned for their haunting fantasies. In 1935, Glyde arrived in Calgary to teach at the Provincial Institute of Technology and Art. Intending to stay for only a year, he remained at the school until 1966. One of the most influential art educators of his time, Glyde championed an art rooted in the local community and in the beauty of his adopted Alberta landscape.

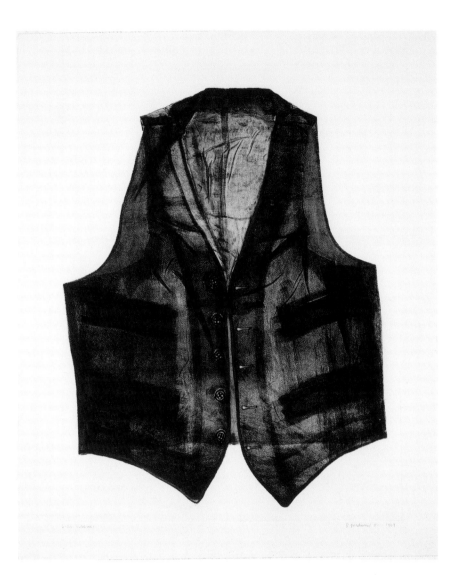

Betty GOODWIN

Vest No. 1

(1923-)

1969; soft-ground etching on wove paper; 70.0 cm x 56.3 cm; Art Gallery of Ontario; Gift of Martin and Betty Goodwin in memory of Clare Roodish and Paul Goodwin, with the support of the Volunteer Committee, 1996; Photo by Carlo Catenazzi/AGO

In the early 1960s, long before Betty Goodwin made her breakthrough in the art world with a series of etchings based on men's vests, she knew that the objects in a work of art "must possess an intense reality revealing more than the visible."

Since 1947, the self-taught Montreal-born Goodwin had been exhibiting her domestic still lifes and figurative work, which showed her compassion for postwar suffering in an expressive style of social realism. Critical reception had been lukewarm, however, and Goodwin knew that she had yet to tap the visual language to express her inner self.

In 1968, she attended an etching class given by Yves Gaucher at Sir George Williams University (later Concordia) in Montreal and began to experiment with printing, using objects of clothing pressed into the etching plate. "The Vest series was related to experiences that had been submerged," she explained. "It was something I totally identified with…and for that reason, it was a point of incredible satisfaction and the starting point of everything else."

In *Vest No. 1*, the imprint of a man's vest is made ghostlike by the transparency of the front, allowing us to view the crinkled lining of the back—a haunting memory of material reality in its conjuring of the absent body. The image of the vest was symbolically charged for Goodwin: Her father, who died when

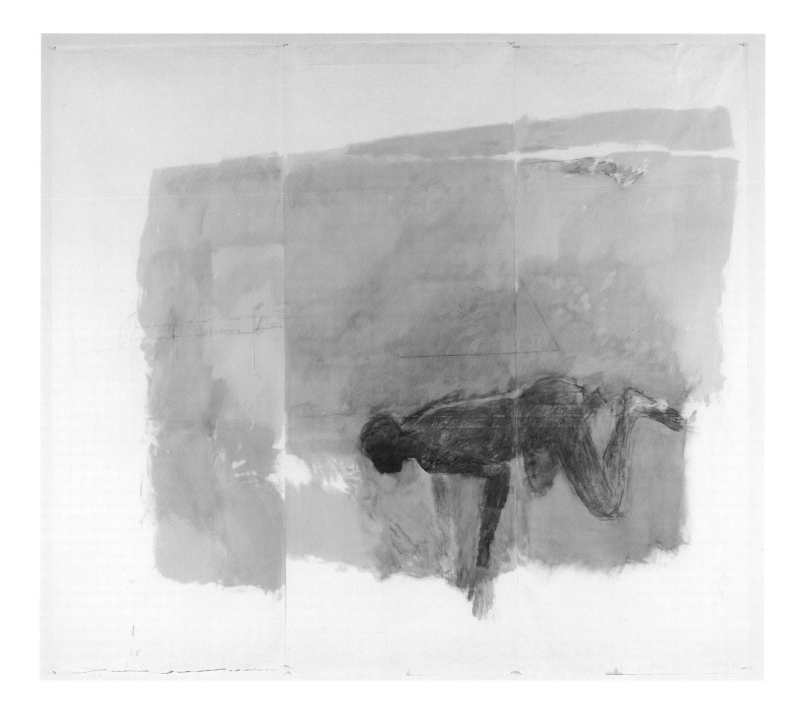

Moving Towards Fire

1983; oil, coloured chalks and graphite on three sheets of thin wove paper; 291 cm x 324 cm; Art Gallery of Ontario

she was 9, had owned a company that made men's clothing; and German artist Joseph Beuys, whom Goodwin greatly admired for extending the materials of artistic expression, was frequently photographed wearing a vest.

Goodwin has explored a variety of materials and techniques over the course of her career, producing sculpture, paintings, prints and installations. However, it is her drawing and the revival of an emotionally fraught figurative art that are considered by many to be her most important contribution to Canadian art.

The impact of *Moving Towards Fire* is made increasingly powerful by the drawing's huge scale—almost three metres high—coupled with the near life-sized red figure descending stiffly into the transparent green waters, leaving a red wash in his wake as if he were bleeding or dissolving. Although this fiery plunge dominates the composition, the delicate drawing of a bridge to the left and the arrival of another swimmer in the top-right corner signal that the red figure is not alone. Embracing the ambiguity of this narrative, Goodwin addresses the uncertainties and fragility of life. Speaking of the Swimmer series, she said: "It has to do with the idea that water certainly is a giver of life, but it's also a taker of life…there's a struggle between moving out or being pulled down…water is all-giving but treacherous. I like that dichotomy."

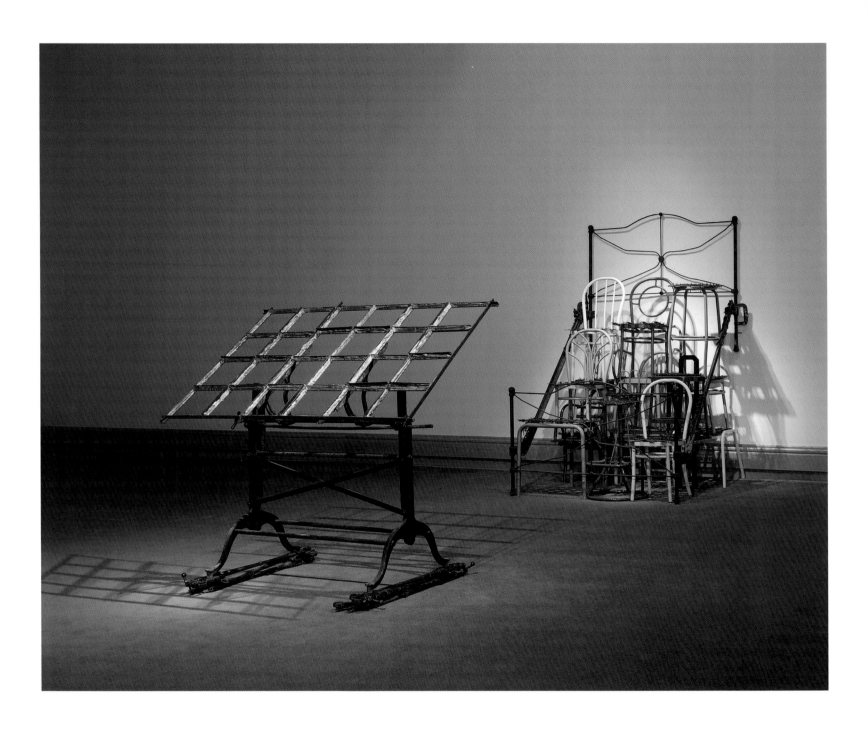

Michel GOULET

(1944-) 1987; frames of chairs, stools, table legs, rifle barrels and bed; 239.0 cm x 145.6 cm x 481.0 cm; Musée du Québec; Photo by Patrick Altman/MQ

In Michel Goulet's *Motives/Mobiles*, the frame of a draughting table precariously balanced on rifle barrels faces a bed frame propped up against the wall, replete with a stack of coloured chair frames and stools. The seats of the chairs have been topped with braided wire that forbids use and echoes the ways in which the other objects have also been stripped of their functions. By reducing these items to hollowed-out linear shapes that negate the volume of traditional sculpture, Goulet cre-

ates a new order, deconstructing one reality to construct another and inviting the visitor to devise meaning.

The "motives" are the things in the work that we recognize, objects whose very identity and purpose have been undermined. Their original intent has become "mobile," threatening the order and stability of material reality and creating a feeling of uncertainty and ambiguity. Goulet has stated, "I am a belated sentimentalist and humanist: 'To instil doubt in what one be-

lieves one knows is to permit exchange and continuity.'"

Born in Asbestos, Quebec, Goulet studied in Montreal at the École des beaux-arts and the Université du Québec (1969-71). Following his exploration of conceptual and performance art in the 1970s, Goulet embraced the world of found objects in the 1980s, probing their possibilities for transformation. In 1990, he received the Paul-Émile Borduas Prize, Quebec's highest visual-arts award.

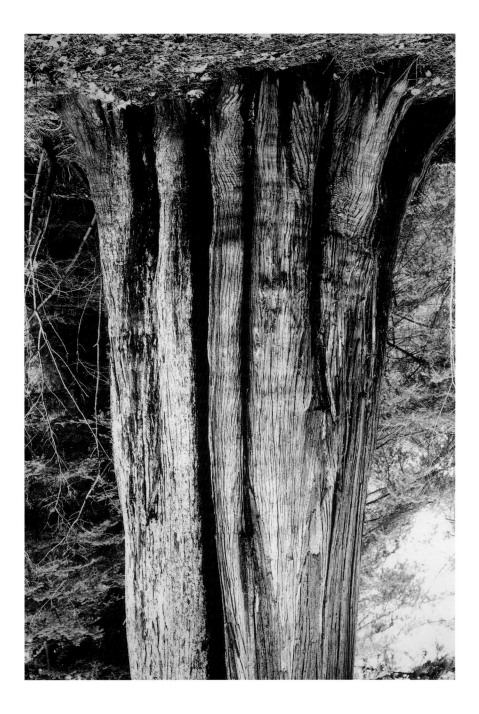

Stanley Park Cedar, No. 7

Rodney GRAHAM

1991; dye coupler print, printed from black-and-white negative on paper; 264.5 cm x 180.5 cm; National Gallery of Canada

(1949-)

Rodney Graham's inquiries into photographic processes began in Abbotsford, British Columbia, in 1979, when he constructed a large camera obscura to secure the inverted image of a single tree on a 2.4-metre-high interior wall. This led to a proposal, in 1986, for an urban plaza that would boast a camera obscura theatre built in a steel tower, painted the same yellow as industrial logging equipment and designed to capture the life of the tree from sapling to full maturity. While the lofty size of *Stanley Park Cedar, No. 7* conjures the scale of the actual tree, the inverted presentation of the photograph clearly makes it a cultural artefact. Graham has featured a variety of species in his tree portraits, but his choice of the red cedar situates this work in the debate over clear-cut logging in British Columbia, allowing the tree to be seen as nature literally turned "upside down," vulnerable and threatened by industry.

Graham is internationally recognized for his conceptual and multidisciplinary art, which includes text work, music, installations and film. His interest in photography and the creative analysis of cultural systems is rooted in the dialogue he shares with other Vancouver artists, such as Ken Lum, Jeff Wall and Ian Wallace. These artists also produce photo-based work that, despite its seemingly humorous and lyrical aspects, is fraught with critical intention.

Angela GRAUERHOLZ

(1952-)

1992; azo dye print (Ilfachrome) on polyethylene-coated paper; 120.5 cm x 181.3 cm; National Gallery of Canada

Like figures poised in front of a vast, horizonless sea, two men stand dwarfed by the magnitude and infinity of knowledge accumulated before them. The soft-focus image and sepia tones inspire in the viewer a sense of time past, of vague memories, and a feeling of being removed from reality, while the contemporary aspect of the men's clothing roots them in the present, creating tension and an ambiguous narrative. Notions of the library as a place of illumination and of photography

as a medium of clarification are undermined by the dim light and the atmosphere of shadowy gloom that transform it into a site of mystery and elusiveness, one which alludes to the ephemerality of knowledge and the uncertainty of truth. About her desire to evoke a sense of loss and doubt in her work, Angela Grauerholz stated, "I want these photographs to be as open as I can possibly make them so that the viewer can reinvest what he or she feels into a particular scene."

In her images of figures and landscapes, public and private interiors and urban vistas, Grauerholz embraces and recasts the material world in shadowy-toned, large-format photographs to suggest metaphors for an inquiry into the meaning of human experience. German-born, Grauerholz studied German Romantic literature at the University of Hamburg and, following her move to Montreal in 1976, attended Concordia University.

Black Seeds

John GREER

1996; Spanish marble; five pieces approx. 89 cm x 56 cm x 30 cm each; Collection of the artist; Photo by Vanessa Paschakarnis

(1944-)

Walking between the carved marble stones of John Greer's *Black Seeds*, feeling not unlike Gulliver in the land of the giants, one observes a whimsical dissonance between that which is minute and capable of transformation in nature and that which has become monumental and eternal in art. At the same time, the black marble, veined and flecked with minerals, is nature transformed by the artist, nature altered by culture. Greer, however, wants the viewer to see beyond

the sensuous mystery of these objects. "Sculpture," he has said, "is thought in form." Here, the individual character of each of the seeds—some rough on the outside, others smooth and hollowed—conjures notions of presence and absence, of a life once lived and of the potential of the future. The placement of the seeds on the ground makes us aware of our scale and of our separateness from and dependence on the earth.

Greer studied in his native province at the Nova Scotia College of Art and Design and later at the Vancouver School of Art. In 1978, after exploring conceptual art and working in a variety of media, Greer became interested in traditional approaches to sculpture, shaping stone, bronze and steel into representational forms. In 1985, he spent six months in Pietrasanta, Italy, where access to the centuries-old quarries consolidated his love of sculpting marble.

GWICH'IN ARTIST

<div align="right">Shin Gwi'ik</div>

late 19th century; caribou hide, sinew, porcupine quills, silver willow seeds;
L: 115 cm overall; Canadian Museum of Civilization, image #S95-24013

In the northernmost corner of Canada's Northwest Territories, the Gwich'in, who are members of the Dene Nation, trusted in the bounty of the land for every aspect of their livelihood. The caribou conferred the materials for food, shelter, clothing and tools; the waterways supplied fish; and the forests provided wood for building and berries for food and dyes. Clothing was both a protection against the harsh climate and a vehicle for artistic expression for these seminomadic people. While men hunted the animals, the preparation of the hide, the sewing and the quillwork embellishment were the responsibility of the women and represented an opportunity to demonstrate their artistry.

This man's summer suit was made from caribou sewn with animal sinew to make a light, warm garment. The hood, mitts and one-piece trousers with moccasins offered efficient cover on cool days and protection from ferocious insects; the long, pointed shape of the tunic shielded the hunter from the wind. As ethnologist Judy Thompson noted: "Clothing reflected spiritual as well as social relationships: directly, through wearing parts of animals…and indirectly, in the sense that clothing materials were attainable only if a good rapport with animal spirits had been achieved."

The suit's style predates European contact, but its fine condition suggests that it was made for trade with visitors to Fort McPherson in the late 19th century.

Head of Vilhjalmur Stefansson

Emanuel HAHN

1929; bronze; 42.4 cm x 29.4 cm x 38.8 cm; National Gallery of Canada; Estate of Elizabeth Wyn Wood and Emanuel Hahn

(1881-1957)

This portrait of Canadian-born Arctic explorer Vilhjalmur Stefansson, much admired for his 1921 publication *The Friendly Arctic*, is boldly sculpted. With hair that suggests rough seas and a collar that seems to be carved out of rock, the subject has a determined gaze and rugged features which evoke the robust character of the northern terrain itself. The sculpture was celebrated for capturing "the ideal of the hardy explorer of vision and resourcefulness, undaunted by hardships and perils." Considered by many as Emanuel Hahn's masterpiece, it earned him first prize in the Willingdon Arts Competition of 1930. That same year, he was awarded the commission for his most ambitious project, the Sir Adam Beck monument, unveiled in 1934 on University Avenue in Toronto.

The German-born Hahn had a long and varied career, and although his first ambition was to be a sculptor of public monuments, family responsibilities forced him to take a variety of jobs: sculpting First World War monuments, for instance, and teaching at the Ontario College of Art from 1912 to 1951. He collaborated with Frances Loring, Florence Wyle and his wife Elizabeth Wyn Wood on several sculptures involving architecture and garden projects. As a designer of stamps, medals and coins, Hahn may best be remembered for his 1937 design for the Canadian dime and the quarter, both still in use today.

129

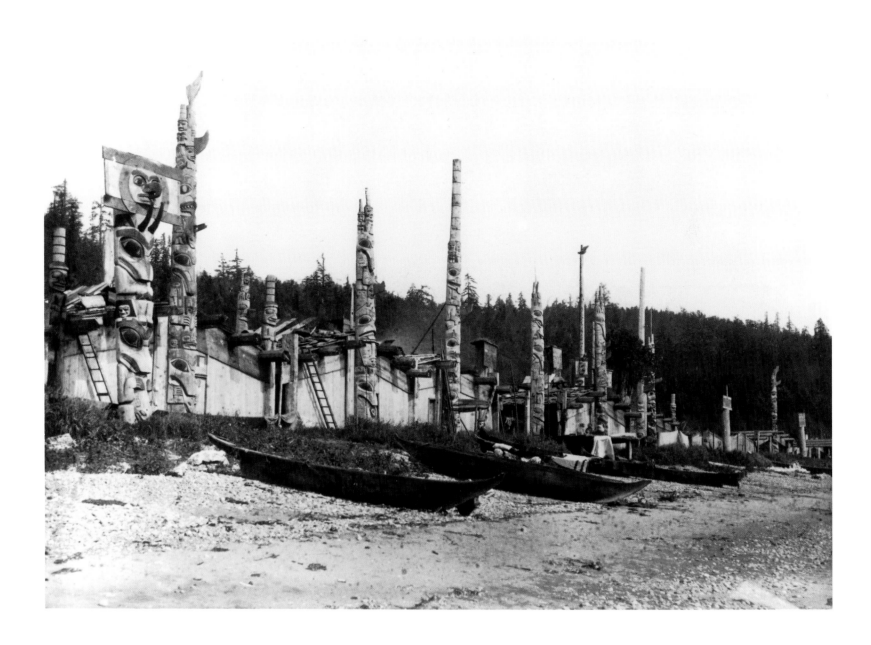

HAIDA ARTISTS

<div style="text-align:right">

Skidegate Indian Village, July 26, 1878

</div>

1878; Photo by George M. Dawson; Courtesy Canadian Museum of Civilization, image #255

This photograph of the Haida village of Skidegate was taken in 1878 by the celebrated geologist George M. Dawson when he was surveying the Queen Charlotte Islands. Dawson reported that although the indigenous population had dropped by half, 53 poles remained standing as an eloquent testimony to Haida traditions.

From about 2000 B.C., the Haida lived on Canada's northwest coast, along the bays and inlets of Haida Gwaii (the Queen Charlotte Islands) and southern Alaska. The wet, mild climate produced lush vegetation and teeming forests that provided food, clothing and materials for shelter and canoes. This natural affluence led to the emergence of refined social systems, rituals and art that reflected ancestral and religious relationships. All Haida belonged to the Eagle or the Raven clan and made visual their ancestry through a display of inherited family crests composed of animals and imaginary creatures that were woven into clothing, painted on house fronts and war canoes and carved into masks, boxes, household objects and crest (totem) poles. Trade with the Europeans in the 19th century increased Haida wealth and provided access to better tools with which to carve bigger and more elaborate poles, but by mid-century, the influx of diseases carried by Europeans had ravaged the Haida population. In 1876, two years before Dawson took this photograph, the federal government's Indian Act began to oppress traditional native culture.

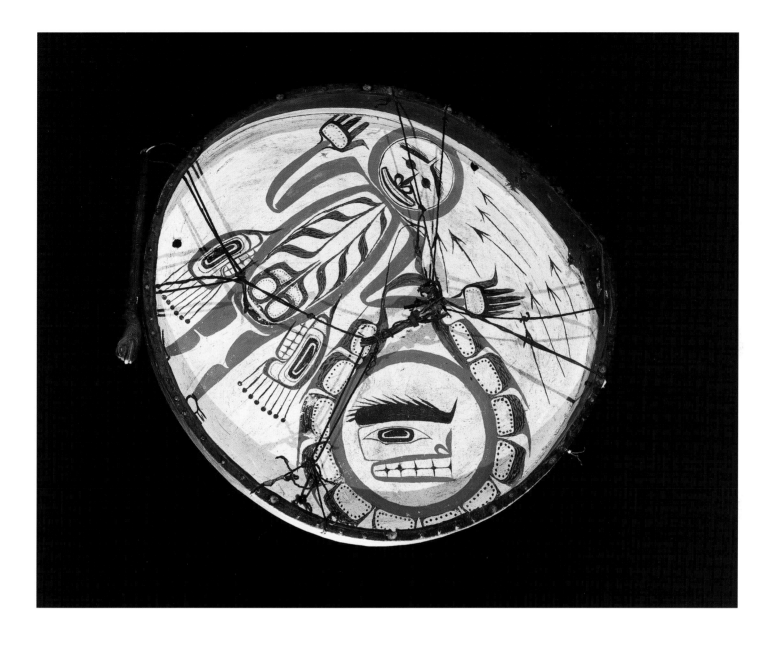

Drum HAIDA ARTIST

before 1900; stretched hide; D: 62.4 cm; H: 9.0 cm; Courtesy of the Royal British Columbia Museum, Victoria, B.C./Cat. No. 10630

A 19th-century Haida artist designed this drum following the dictates of tribal traditions prescribing the use of a strong outline, or formline, embellished on the interior by a series of oval and elongated ovoid shapes that were inspired by the contour of a fish's head. Here, the artist's hand sweeps gracefully across the surface of the deerskin drum, painting lines that curve and swell continuously like the waves of the sea. Using a porcupine brush and vermilion-red paint obtained from Chinese traders, the artist repeated the drum's steamed and bent wooden form in depicting a round-headed shaman whose skeletal body and open palms are vulnerable to the forces of good and evil. Also inscribed in a circle is a frog, the shaman's helping spirit, which protects him from the barrage of arrows flying toward his head.

A painting that tells a story is rare in Haida art, since the usual purpose of painting objects with images of animals was to acknowledge the owner's ancestral crests or affiliations. The shaman's robes, mats, drums and other paraphernalia, however, could be painted with additional images to empower him when he performed ceremonies. The brilliant colour and line drawn on the deerskin surface of the drum have been preserved because it was beaten from the other side. The image faced the shaman, and its powers flowed toward him.

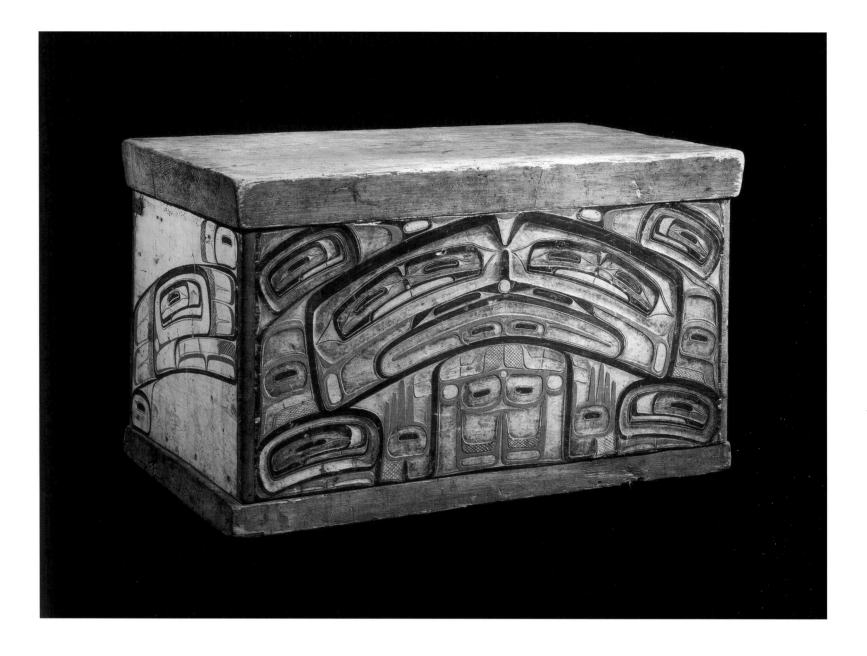

HAIDA ARTIST

Chest

before 1900; wood; 48.2 cm x 81.8 cm x 47.3 cm; Courtesy of the Royal British Columbia Museum, Victoria, B.C./Cat. No. 1295

The abundant growth of straight-grained red and yellow cedar, spruce and yew provided the people of the Northwest Coast with wood that could be cut into wide planks suitable for the construction of bent-corner chests. Using a remarkable technology of steaming and bending a single plank of wood, craftsmen would cut grooves, or kerfs, strategically spaced so that corners could be fashioned. The ultimate joining corner was secured with pegs or spruce-root lacing woven through

drilled holes. The addition of a base and a tightly fitting lid furnished a highly valued container that was water-tight and vermin-resistant. It was used to store preserved food, ceremonial objects or a shaman's paraphernalia.

While the designs varied from tribe to tribe, the Haida artists showed a strict adherence to the age-old dictates of "formline" design, where the lines were continuous, swelling and shrinking in thickness but never revealing an endpoint. Here, the black formline articu-

lates the principal creatures, while secondary ovoids, or elongated ovals, are outlined in red. Blue was often used as a third colour, and traces of it can be seen in the central area. The designs on the front were typically symmetrical and usually depicted the owner's crest or other designs that indicated power and status within the community. The chests were, as anthropologist Martine Reid wrote, "imbued with social, cosmic and mythic resonances…[they] made tangible the invisible."

coiled, red, in the river bed
cradled – in the grave

The Coil: A History in Four Parts

<div align="right">

Pam HALL

</div>

1988-1993; coil: fishnet, cord, framed elements of various media including colour photocopy, 24 dye coupler prints (Ektacolor), coloured pencil and graphite (1951-)
on wove paper; 24 colour photographs: 27.5 cm x 35.0 cm each (framed); 28 montages: 101 cm x 76 cm each (framed); National Gallery of Canada

In 1988, Newfoundland artist Pam Hall created a 32-metre-long cord by wrapping a used cod fishnet with red twine. Then, over the next five years, she proceeded to transport its 136-kilogram mass to four locations—the shores of Newfoundland; the badlands of Alberta; the beaches of Vancouver Island; and Japan—all the while reconfiguring its shape in response to the land and thereby creating new narratives (*A History in Four Parts*) at each site.

In a gallery setting, the coil spreads its sinuous body on the floor, its red twine plaintively evocative of life and death. On the surrounding walls, mixed-media collages, or "Biographical Notes," combine photography, maps, drawings and poetic texts that chronicle the coil's journey and ritualistic interaction with the land and the sea. The texts respond to the site-specific formations that the coil assumes and address its inherently paradoxical origins as a trap and

a killer of fish and as a life-giving provider of food. Here, in a collage from the Alberta Badlands series, the coil is shaped in a spiral like a snake, alluding to both the life of the present desert and the death of the inland sea that existed there millions of years ago.

Hall was born in Kingston, Ontario, and graduated from Sir George Williams University in Montreal in 1973 and from the University of Alberta in 1978. She has made her home in Newfoundland since 1973.

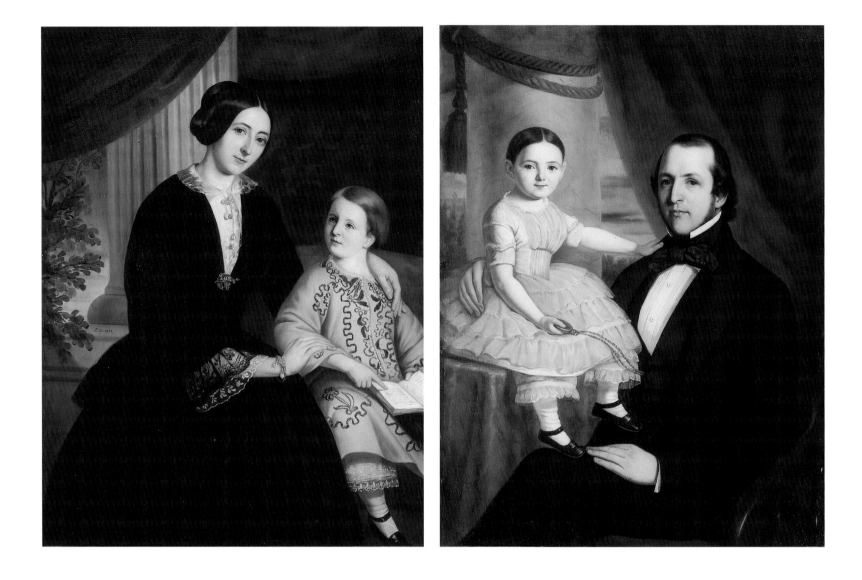

Théophile HAMEL

(1817-1870)

Madame Cyrice Têtu, née Caroline Dionne, and Her Son Amable/ Cyrice Têtu and His Daughter Caroline

1852; oil on canvas; 122.4 cm x 90.7 cm / 121.2 cm x 91.0 cm; Musée du Québec; Restoration made possible with help from the Friends of the Musée du Québec; Photo by Jean-Guy Kérouac/MQ

Pairing the mother and son in one canvas and the father and daughter in the other was considered unusual for a family portrait in mid-19th-century Quebec. Together, they create a symmetrical composition, the parents placed protectively on the outer edges against architectural backgrounds that suggest good taste and prosperity. Madame Têtu looks at us with maternal confidence, her arms around 4-year-old Amable, who is pointing to a page in his book.

Cyrice Têtu, a flourishing Quebec businessman, sits with 3-year-old Caroline, who is holding his gold pocket watch. The artist's skill in depicting the sensuous textures of fabric is particularly evident in Madame Têtu's dress, where the luxurious blackness of the velvet contrasts with the diaphanous lace trim and provides a perfect foil for her brooch.

The son of an affluent farmer, Théophile Hamel was apprenticed at the age of 16 to the prominent

Quebec painter Antoine Plamondon. After travelling throughout Italy and Flanders, Hamel returned to Quebec, where his skills as a portrait painter were renowned. Since Hamel and Têtu were good friends, it is not known whether these paintings were a gift or a commission. The year after they were completed, Hamel received a large government commission that secured his reputation as the official portraitist of the governments of Upper and Lower Canada.

B.J.

Noel HARDING

1990; cardboard, metal strapping, metal cornerbead, office chair wheels; 3 m x 3 m x 2 m; Macdonald Stewart Art Centre

(1945-)

Two massive cardboard jackets, elegantly configured and supported by steel frames, gesture toward each other. From this perspective, it appears to be a formal interaction, as the jacket on the left assumes an up-right pose in deference to the polite bow of the bent one. Viewed from behind, the bent jacket appears to be on the attack, while the erect one recoils with sur-prise and indignation. The intention is not to suggest that there are two sides to a story but, rather, that

gestures and communication are frequently unclear, indecisive and ambiguous. Art critic Richard Rhodes has observed, "This wayward structural character of the work is…a metaphor for the intransigent faults and desires of human agency."

When questioned about the meaning of his title, *B.J.*, Noel Harding replied, "All over the world, they have secret societies; when you are asked, you don't answer."

The allusions to a theatre of the absurd have

filtered through Harding's career over the years, from his exploration of video and installations (sometimes using vegetable produce and live animals) in the early 1970s to freestanding figurative work in the early 1980s and, later, to monumental sculpture inspired by his work for a theatre in Amsterdam. Born in Eng-land, Harding studied philosophy and political science in the late 1960s at the University of Guelph. He has exhibited widely both nationally and internationally.

135

Lawren S. HARRIS

(1885-1970)

The Corner Store

1912; oil on canvas; 88.5 cm x 66.2 cm; Art Gallery of Ontario;
Gift from The Estate of Mary G. Nesbitt, Toronto, 1992; Photo by Carlo Catenazzi/AGO

When Lawren Harris painted *The Corner Store* in 1912, he had already begun to dream about a distinctly Canadian art that would express, in his words, "the character, the power and clarity and rugged elemental beauty of our own land." Harris, who came from a wealthy Brantford family that co-owned the farm-machinery company Massey-Harris, studied in Berlin and spent a year and a half travelling and working as a magazine illustrator before settling in Toronto in 1908.

Since 1910, Harris had been painting pictures of the houses in a community in Toronto known as "the Ward," a neighbourhood that was home to many immigrants at the turn of the century. The buildings in these works present a flat friezelike pattern across the middle ground of the painting and are animated by the organic irregularity of the trees, which cast their shadows on the façades. For Harris, images such as *The Corner Store*, illuminated by the crisp winter

light, portrayed a distinctly Canadian scene, warm and cheerful despite the snow and the ice-blue sky.

In 1911, Harris met J.E.H. MacDonald, whose exhibition of landscape paintings at the Arts and Letters Club impressed him profoundly. The two became friends, and in 1913, they saw an exhibition of modern Scandinavian paintings in Buffalo, New York, that convinced them of their mission. According to Harris, "Here was an art, bold, vigorous and uncompromising,

Lake and Mountains

1928; oil on canvas; 130.8 cm x 160.7 cm; Art Gallery of Ontario;
Gift from the Fund of the T. Eaton Co. Ltd. for Canadian Works of Art, 1948; Photo by Carlo Catenazzi/AGO

embodying direct experience of the great North." By 1914, however, the impetus of these like-minded artists, whose numbers had grown and now included Tom Thomson, was cut short by the First World War.

Following the war, Harris led sketching trips to the Algoma region of northern Ontario, and in 1920, he was central in the organization of the first Group of Seven exhibition at the Art Gallery of Toronto. Thereafter, although the artists continued to exhibit as a group until 1932, they tended to go their separate ways. The spiritually minded Harris, influenced by his reading of Wassily Kandinsky's *Concerning the Spiritual in Art* and by his interest in theosophy, sought a landscape that would better express his religious beliefs. After a number of excursions to, and a great many famous paintings inspired by, the austere grandeur of the north shore of Lake Superior, Harris explored the Rockies in 1924. There, he found "a power and a majesty and a wealth of experience at nature's summit."

In *Lake and Mountains*, the blue triangular shapes of mountains soar upward to clouds whose clawlike forms accentuate the frozen stillness. For Harris, this simplification and distillation of nature's forms evoked an ascent to spiritual awareness that would later find its most complete expression in the purified realm of abstraction.

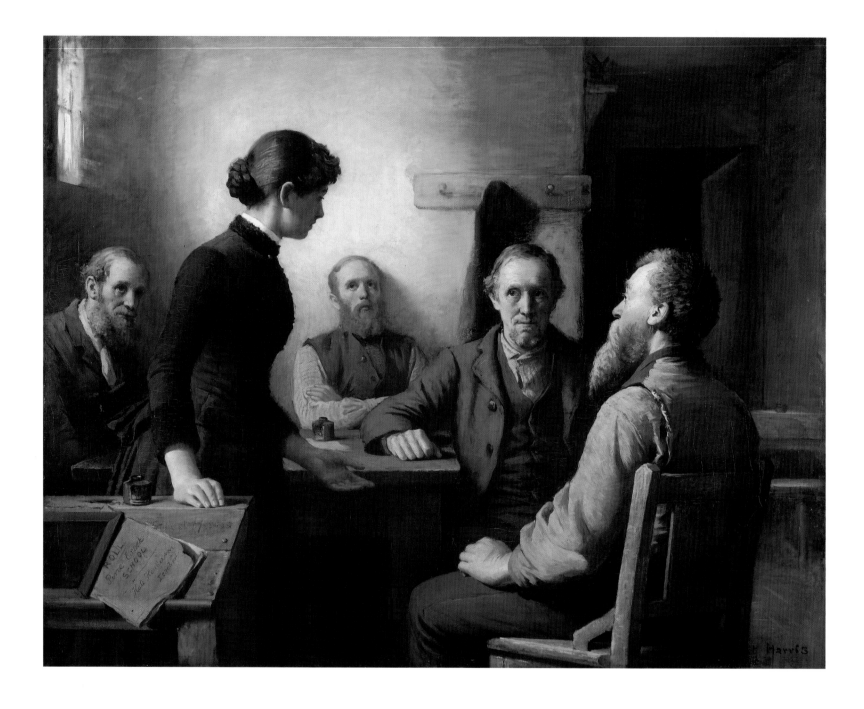

Robert HARRIS

A Meeting of the School Trustees

(1849-1919)

1885; oil on canvas; 102.2 cm x 126.5 cm; National Gallery of Canada

This well-known masterpiece by Prince Edward Island native Robert Harris was painted following Harris's honeymoon in Europe, during which he and his wife Bessie visited numerous art galleries. In his auto-biography, Harris expressed his debt to artists such as Rembrandt and Vermeer: "These men show us, for once and for all, that there is an art which deals… directly with the spirit of man; an art ever aspiring to the noble, the beautiful and the sublime."

Adapting a compositional format from Nether-landish painting, where light from the upper left illu-minates a group of people gathered at a table, Harris depicts an event described to him by his friend Kate Henderson, who reported that she had been "laying down the law" to the school trustees and generally "talking them over." Silhouetted by the golden light, the prim, youthful figure of the teacher (modelled by Bessie) contrasts with the untidy farmers gathered

to advise her on matters concerning the school. Like actors in a silent play, the trustees declare their re-sponse to her beckoning hand through their facial ex-pressions and body language. From mild hesitation to closed-fisted resistance, the trustees exhibit a symbolic reluctance to change in the face of necessary progress and reform. To show his own support for the strug-gles of rural teachers, Harris carved his name in the desk by Kate's hand.

Los Desaparecidos

Jamelie HASSAN

1981; ceramic; 74 pieces, various sizes; National Gallery of Canada

(1948-)

Born in London, Ontario, of Lebanese parents, Jamelie Hassan has travelled to Lebanon and Central and South America, journeys that have served to galvanize both her sense of rootlessness and her empathy with people suffering from political, economic and social oppression—and to inspire her art.

Hassan created this work after she learned of the accounts of three Argentinean grandmothers who had participated in the silent vigils in Buenos Aires wearing kerchiefs that bore the names of "the disappeared ones" to protest the state's abduction of their loved ones. "The issues themselves determine the form," said Hassan. "The process of making the work involved reading about each person and then making a corresponding ceramic kerchief…the viewer has to move close to it, bend down and try to read the writing…one chooses one's own level of involvement."

Placed on the floor in the form of a giant kerchief, the individual parts appear as discarded shards of pottery, a broken whole alluding to the fragmentation of families and the shattering of lives that are the consequence of violence and oppression in Argentina and throughout the world. Each piece bears the name and the date of disappearance of an individual, information that is also recorded in the book nearby. Easily broken, the ceramic becomes a metaphor for the fragility of life itself.

Faye HEAVYSHIELD

Untitled

(1953-) 1992; wood, cement, acrylic; 12 elements, each 244.5 cm x 13.5 cm (diam.); assembled diam.: 190.5 cm; National Gallery of Canada

Tall, delicately whittled wooden poles, almost three metres high, are anchored by small bulbous shapes and arranged in a circle. Their pale yellow colour suggests bones, a skeletal structure that is strong and erect but also fragile and vulnerable by its openness and sparseness. For Faye HeavyShield, who grew up in the 1950s on the Blood Indian Reserve in southern Alberta, the image of a European fort on land once hunted by her ancestors haunted her memories.

At first investigating the notion of imprisonment represented in the idea of a fort, she transforms it, imbuing the architecture of defence with a native identity that evokes the circular form of the tipi or the sacred circle of the Sun Dance. The work also embodies memories of her father returning from the hunt, skinning deer and exposing the bones of the dead animal. "When I began my formal art training," she explained, "these influences surfaced in the form

of biomorphic images, skeletal armatures with vestiges of 'flesh'—monochromatic, after the solitude and simplicity of the prairie."

In 1979, HeavyShield enrolled at the Alberta College of Art in Calgary and was drawn to abstract art as a means of exploring her native identity. Seeking to lift layers of memory and compress visual expression to its essentials, she said, "I am not going to try to dress a memory, because that would just weigh it down."

The Port of Montreal Adrien HÉBERT

1924; oil on canvas; 153.0 cm x 122.5 cm; Musée du Québec; Photo by Jean-Guy Kérouac/MQ (1890-1967)

From a lofty perspective, ships' masts and poles frame our view of the daily operations in the port of Montreal. They create stark linear patterns against the clusters of lifeboats, chimneys and foghorns that occupy the middle ground, where warm sunlight illuminates the white walls of the cabins and the orange-red mass of the smokestacks. The same red draws our attention to the workers carrying their loads across the drawbridge. In the background, grain elevator number 2,

built entirely of concrete, circa 1912, towers majestically like an acropolis on the port, its austere geometry and broad, even surfaces providing visual relief from the bustle below.

For artist Adrien Hébert, son of sculptor Louis-Philippe Hébert, the busy port's complex array of lines, shapes and colours was a thing of beauty, a worthy subject for art and a welcome symbol of industrial progress. "Listen to its music," he wrote, "the great

symphony created by the loading and unloading of grain, the banging of the steel cables, the noise of the winches and the chatter between tugboats and ocean liners." A contributor to the avant-garde arts publication *Le Nigog* since 1918, Hébert was part of a Montreal artistic elite that battled for the tolerance of current artistic movements. "Having accepted modern life," he said, "it is only logical to embrace modern subjects in art."

141

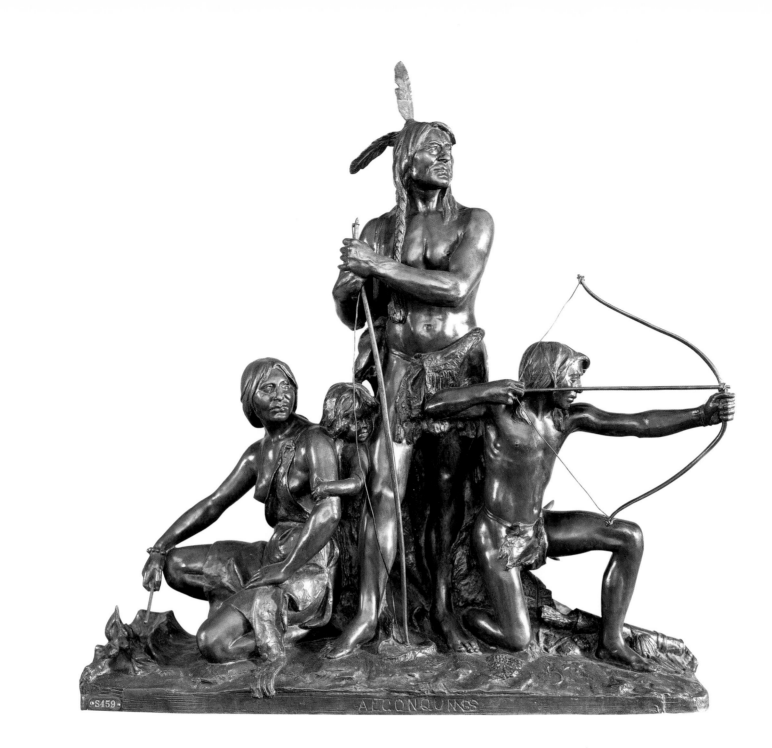

Louis-Philippe HÉBERT

Algonquins

(1850-1917)

1916; bronze with brown patina; 67.0 cm x 65.4 cm x 22.4 cm; Musée du Québec; Photo by Patrick Altman/MQ

In the spirit of Canadian nationalism that permeated the arts following Confederation, painters and sculptors devoted their energies to depicting scenes from Canadian history—both real and imagined. Here, a native family gathers around the muscular figure of the father, who gazes confidently into the distance and forms the central axis of the composition. The other family members crouch, creating a symmetrical classical form. On the left, the mother stokes a fire, while

the young child takes shelter between her parents. On the right, the son aims his arrow at an unknown target. Considered one of Louis-Philippe Hébert's greatest works, the sculpture received an honourable mention at the Paris Universal Exhibition at the turn of the century, where it was admired for its romantic representation of indigenous peoples through an academic approach to the figure.

Hébert began his training with eight years of

study in the studio of Napoléon Bourassa. He was the first sculptor in Quebec to work in bronze and would later become the most prominent sculptor of his generation. *Algonquins* is one of 10 large sculptures Hébert was commissioned to produce in 1886 for the façade of the Legislative Buildings in Quebec City and can be seen there today. This reduced version of the original, commissioned by an art collector in 1916, was later acquired by the Musée du Québec.

Spring Inundation, 1865 — Bank of St. Lawrence River Alexander HENDERSON

1865; albumen silver print; 11.1 cm x 19.0 cm; National Gallery of Canada (1831-1913)

Against the pearly illumination of the open sky, the leafless trees of spring are silhouetted and reflected in the calm floodwaters, where the passengers in the rowboat are dwarfed by the tranquil grandeur of nature. Combining his admiration for the aesthetics of painting with his interest in the landscape, Alexander Henderson published photographs such as this one in his 1865 album *Canadian Views and Studies, Photographed from Nature*. The publication garnered awards in London,

Dublin, Paris and New York and was acclaimed for capturing a sense of the country's vast space with a romantic intimacy and poetry esteemed by Victorian audiences.

Scottish-born and independently wealthy, Henderson immigrated to Montreal in 1855 and established himself as a professional photographer. Travelling widely throughout eastern Canada, he included as subjects ports and ships, peaceful lakes and villages, waterfalls and ice and snow scenes, all rendered with an aura of

serenity and a sensitivity to light. From the late 1860s, the Grand Trunk Railway of Canada and, later, the Intercolonial Railway engaged him to record the construction of rail lines, bridges and viaducts. Sponsored in 1885 by the Canadian Pacific Railway, Henderson joined forces with other artists, contributing to the CPR's image as a "builder of the nation." In 1889, he founded the Montreal Camera Club, an important forum for society's burgeoning enthusiasm for photography.

George HERIOT

Lake St. Charles Near Quebec

(1759-1839)

c. 1801; watercolour over graphite on laid paper; 27.3 cm x 44.5 cm; National Gallery of Canada

As Deputy Postmaster General of British North America from 1799 to 1816, George Heriot travelled widely throughout the Canadas, inspecting postal stations and noting, with sketchbook in hand, the amusements and favourite nature spots of the garrison societies. Benefiting from his education at the Royal Military Academy, Woolwich (where he had been trained by renowned British watercolourist Paul Sandby), Heriot learned to combine accurate descrip-tion with atmosphere, fusing precise drawing with delicate transparent washes of watercolour.

Heriot described his impressions of Lake St. Charles in his 1807 publication, *Travels through the Canadas*: "On arriving at the vicinity of the lake, the spectator is delighted by the beauty and picturesque wildness of its banks...The lofty hills...in shapes singular and diversified, are overlooked by mountains which exalt beyond them." Our view of the lake in this painting is dominated by the large trees, rendered in soft tones of green and brown, that dwarf the tiny figures in boats silhouetted against the pearly lake. Across the water, the thinly painted mountains rise with the ethereal quality of a mirage, transforming the wilderness into a poetic vision of a magical park-land. Without the title to reassure us of its location, we might think we were travelling with some other Romantic painter in Europe.

Sisters of Rural Quebec

Prudence HEWARD

1930; oil on canvas; 157.4 cm x 106.6 cm; Art Gallery of Windsor; Gift of the Women's Committee, 1962

(1896-1947)

In Prudence Heward's painting, the figures of two sisters from rural Quebec intersect to create opposing diagonal thrusts that are echoed in their contrasting expressions. The younger Pierrette sits with her hands folded, but her despondent expression is at odds with her bright turquoise apron and violet-pink chair. The older Rollande is slightly defiant, her back pressed firmly into her chair and her dark clothes underscoring the severity of her expression. The starkness of the space defined by repeated window frames and sparse foliage evokes the austerity of life effected by the economic deprivations of the 1930s.

The work is typical of Heward's portrayals of women whose emotional vulnerability and intimation of sadness contrast with a physical impression of strength. In the words of art critic Paul Duval, "[her] painted world is one of sad reflections. Her subjects look out of their frames wondering and a little afraid. They strike one strongly as people living in a world which they cannot quite comprehend."

Heward studied art in Montreal and Paris and, with other Montreal artists such as Edwin Holgate and Lilias Torrance Newton, formed the short-lived Beaver Hall Hill Group (1920-21). Invited to exhibit with the Group of Seven in 1928 and again in 1931, Heward continued to be recognized for her bold and innovative approach to the figure.

Humphrey Lloyd HIME

An Ojibwa Woman with Baby

(1833-1903)

1858; albumen silver print; 16.9 cm x 14.1 cm; National Gallery of Canada

In 1858, the Irish-born Humphrey Lloyd Hime was hired as a surveyor and photographer by Henry Youle Hind, the geologist and naturalist who led the Assiniboine and Saskatchewan exploring expedition—an endeavour linked to the Canadian government's crusade to keep American expansion at bay. Hime produced the first photographs of the Canadian frontier, securing images of the vast land, peoples and government buildings encountered on his westward journey.

In September 1858, the expedition arrived at the Red River settlement in southern Manitoba, where Hime made portraits of the "Native Races," as he termed them, for a portfolio of his photographs that was published in 1860. Most aboriginals feared the camera, seeing it, as Hime reported to *The Illustrated London News*, as a means by which the white men "would make evil medicine over them…and take their land."

Recalling the intimate settings of British Pre-Raphaelite paintings, Hime posed an Ojibwa mother and child in front of a buffalo skin supported by the wheel of a Red River cart. While the skin and the papoose-bound child reflect the traditional life on the land, the mother's freshly unfolded shawl and cloth dress are a testimony to the Ojibwa's gradual assimilation by white society. The tranquillity of the mother's pose contrasts with her baby's restless movement, betraying the slowness of the wet-collodion process.

Bar in Mining Camp, B.C.

William G.R. HIND

1865; watercolour, graphite on paper mounted on board; 25.5 cm x 35.5 cm; McCord Museum of Canadian History, Montreal

(1833-1889)

In the shadowy light of a crowded Cariboo bar, heavily bearded miners rest their weary bones, relaxing on their bulging packs while, in the words of William Hind, "the more successful drink boisterously." In his characteristic fashion, Hind meticulously describes the individuality of the haggard faces, the roughness of the torn and tattered clothing and the solidity of the wooden bar, with its diagonal boards nailed together to support the rowdy miners.

British-born Hind immigrated to Toronto in 1851 to join his brother Henry Youle Hind, a prominent geologist, naturalist and author. There, he worked until 1857 as a drawing teacher at the Toronto Normal School. In 1861, he accompanied his brother up the Moisie River into Labrador as the expedition artist, producing sketches that later appeared in H.Y. Hind's *Explorations in the Interior of the Labrador Peninsula*. William, an inveterate traveller, then joined

the Overlanders of 1862, a large group of Ontario settlers who made the long and arduous journey across the country, seeking their fortune in the Cariboo Gold Rush. From Fort Garry to Victoria, Hind produced more than 160 sketches and paintings that depicted a range of wilderness experience, from the vagaries and hardships of travel with broken carts, stranded horses and flooded rivers to buffalo hunts and stunning landscapes.

Edwin H. HOLGATE

Nude

(1892-1977) 1930; oil on canvas; 64.8 cm x 73.2 cm; Art Gallery of Ontario; Gift from Friends of Canadian Art Fund, 1930; Photo by Larry Ostrom/AGO

Warmed by the afternoon sun, a dark-haired nude woman relaxes on the shores of a crystal-blue lake. The curves of her firmly modelled body are echoed in the smooth, rounded shapes of rocks casting their reflections in the calm waters below. When Edwin Holgate exhibited his nudes in the 1930 Group of Seven exhibition, the art critic for *The Toronto Daily Star* acclaimed: "Holgate sets a new fashion in nudes—away from French decadence to the Laurentians for a back-

ground; splendidly painted nudes without cosmetics." Indeed, Holgate showed innovation in presenting a nude in a wilderness setting, free of the subtleties of drapery and the pretences of mythology often associated with traditional depictions of the subject.

Holgate studied at the Art Association of Montreal with William Brymner and Maurice Cullen before travelling to Paris in 1912, where further training with Russian artist Adolf Milman impressed upon

him the importance of fine draughtsmanship and strong colouring. Holgate also admired French artist Paul Cézanne, whose emphasis on solid structure inspired his compositions. In the early 1920s, Holgate was a member of the Beaver Hall Hill Group, and along with such artists as Prudence Heward and Lilias Torrance Newton, he explored a modernist approach to portraits and landscapes, employing the same directness that he had applied to the unclothed figure.

Untitled, from the series Jolicure Pond

Thaddeus HOLOWNIA

1997; chromogenic print; 16.9 cm x 42.5 cm; Courtesy Canadian Museum of Contemporary Photography

(1949-)

Since the mid-1970s, Thaddeus Holownia has used a reconstructed "banquet camera" (originally designed to take portraits of the throngs at a banquet) to explore the transient relationships between humanity and nature. In his extensive treks across North America, Holownia has produced a diverse body of work, examining the specific and the local to reveal the timeless and the universal. His large detailed contact prints apprehend the impermanence of these environments with a precision and poetry that exceed the fleeting glance of the human eye.

Holownia's travels also heightened his sensitivity to the beauty of his own backyard in rural New Brunswick. The view of Jolicure Pond and the distant fields inspired a series of works recording the perpetual transformations of the land and sky through the passing light and seasons of a year, like an extended portrait that offers a prolonged engagement with a subject over time. In this image of spring, the violet-blue pond rests like a northern oasis on the flat red-brown soil, while a blue sky animated by sweeping clouds acts as a lively foil to the tranquil spread of earth below.

Holownia graduated from the University of Windsor in 1972 and, since the mid-1970s, has taught at Mount Allison University in Sackville, New Brunswick, while continuing an active exhibition schedule.

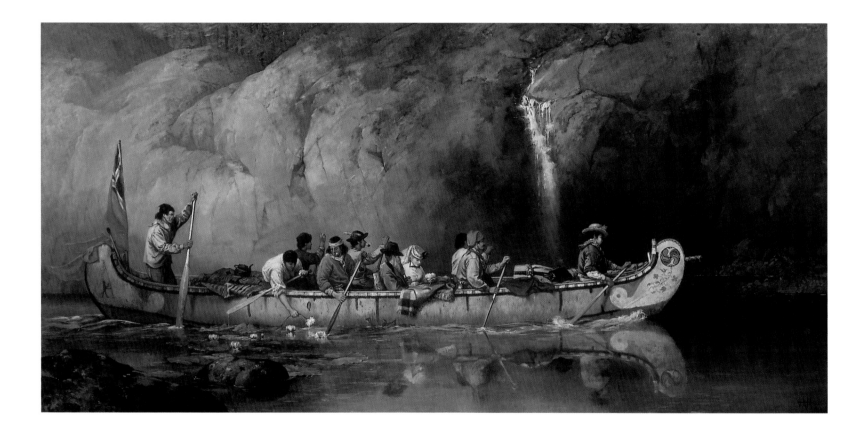

Frances Anne HOPKINS

Canoes Manned by Voyageurs Passing a Waterfall

(1838-1919)

1869; oil on canvas; 73.7 cm x 152.4 cm; National Archives of Canada/C-002771

As the granddaughter of eminent British portraitist Sir William Beechey and the daughter of Arctic explorer Rear Admiral Frederick William Beechey, Frances Anne Hopkins was primed for a career as an artist beyond the conventions of Victorian society. Hopkins arrived in Canada in 1858 with her husband Edward, a Hudson's Bay Company official whose responsibilities included inspecting the company's fur-trading posts, thus affording her unusual subject mat-ter for a woman of her time. In a letter of 1910, she reported, "I have not found Canadians at all anxious hitherto for pictures of their own country."

Hopkins accompanied Edward on at least two trips to Fort William, at the head of Lake Superior, making countless sketches and noting the details of scenery, which would be combined later in studio paintings. With a high degree of realism befitting the tradition of a Victorian narrative, Hopkins records the painted canoe built for transporting officials of the Hudson's Bay Company, the blankets, the luggage, the British flag and the individual faces of the voyageurs; in the centre, she and her bearded husband admire a lily plucked by one of the men. In contrast to this meticulous detailing of objects and people, nature has been depicted in summary fashion, as seen in the loosely painted expanse of rock face and in the fluid reflections in the river.

Kanata

Robert HOULE

1992; acrylic and Conté on canvas; 228.7 cm x 732.7 cm; National Gallery of Canada

(1947-)

In the 1990s, Robert Houle explored the representation of native peoples in European art, quoting these images in his own work as a critique of colonial attitudes toward the indigenous population. In appropriating Benjamin West's 1770 painting *Death of General Wolfe*, Houle recalled his grandfather's words: "Remember when this country was named, native people were present and native people signed treaties." Indeed, the word "Canada" is derived from the Huron-Iroquois word *kanata*, meaning village or settlement.

Seizing the monumental scale of American abstract expressionism, Houle presents a monochromatic version of West's painting and flanks it with red and blue monochromatic canvases symbolic of the British and French forces. Only the allegorical figure of the Indian seated in the foreground is enhanced by these colours, signifying the involuntary "assimilation" of the native peoples whose lives would be irrevocably changed by

the "two founding nations." The Indian, as Houle said, is "in parenthesis…is surrounded."

Houle, who is from the Saulteaux Nation, grew up on the Sandy Bay Indian Reserve northwest of Winnipeg and studied at the University of Manitoba and McGill University. He sees abstraction as a means for native artists to explore the side of their identity central to the "reconstruction of cultural and spiritual values eroded by faceless bureaucracy and atheistic technology."

E.J. HUGHES

Logs, Ladysmith Harbour

(1913-) 1949; oil on canvas; 76.2 cm x 101.6 cm; Art Gallery of Ontario; Gift, Robson Memorial Subscription Fund, 1950

With the intricacy of a richly embroidered tapestry, E.J. Hughes presents a singular view of the West Coast landscape, elaborately embellished with the textures, vitality and wondrous patterning of nature. The repeated cylinders of the coarse brown logs cram the harbour and contrast with the perpetual rippling of the rapidly flowing river, attesting to Hughes' rigorous attention to the complexity of nature. In a vista dominated by the lush stands of forest and ominous grey

sky, humanity—symbolized by the brightly coloured tugboats, rafts and tiny figures of men—is humbled. Unpretentious and direct about his objectives as an artist, Hughes has said that his intentions were "to make art out of picturesque and popular subjects…in a matter-of-fact way to organize nature as well as possible in the rectangle provided."

Although Hughes was acquainted with the modernist directions of his teachers F.H. Varley and Jock

Macdonald in Vancouver, he was more attracted to the art of the past. In particular, he admired French painter Henri Rousseau, sharing with him a disregard for perspective and scale in order to make a picture more interesting. Following a career as a commercial artist and muralist, Hughes worked as a war artist from 1940 to 1946, then returned home to create, in the words of art historian Doris Shadbolt, "a permanent poetry of Canada's Pacific Coast."

The Pensive Child (Winnie) Jack HUMPHREY

1941; oil on Masonite; 81.5 cm x 61.0 cm; Art Gallery of Hamilton; Gift of Wintario, 1980 (1901-1967)

Winnie rests her chin on her hands and stares with timid expectation. Creating an almost sculptural presence, Jack Humphrey fills the frame with her figure, carefully modelling the features of her face and hair and defining the curving shapes of her rounded shoulders, bent arms and lap. In contrast to the large dominant area of colour established by the green sweater and the dark brown skirt, Winnie's delicate hands and wistful expression evoke the vulnerability and inno-

cence of childhood. "My particular problem," wrote Humphrey, "is to achieve quality which is as universal as it is contemporary while surrounded by a purely regional nourishment."

The "purely regional nourishment" to which Humphrey referred was that of his native Saint John, New Brunswick, a city which had offered him nothing in the form of art education but was the only home to which he could return when the Depression began

in the early 1930s. Prior to that, Humphrey had enjoyed a peripatetic education in the United States, France, Italy and Germany, honing his drawing and painting skills. But back on his native soil, trapped by financial misfortune, Humphrey fused the lessons of the academy and modernism and discovered his most enduring subjects in the city's desolate streets and architecture and in the faces marked by hardship, endurance and hope.

Jacques HURTUBISE

Isabelle

(1939-)

1965; acrylic on canvas; 121.8 cm x 152.3 cm; Musée du Québec; Photo by Jean-Guy Kérouac/MQ

Against the cool equilibrium of electric-blue and night-black rectangles, hot-red paint surges across the canvas with an audacious splash, breaking the static geometry of the background with an excited, energetic pulse. Balancing "reason" and "passion" and inspired by his admiration of Constructivist artists such as Kasimir Malevich, Jacques Hurtubise delivers a rationally structured surface with the *look* of gestural, spontaneous action, which was prompted by his

contact with New York abstract artists in the 1960s.

In this piece and in others in the series titled with women's names, Hurtubise employed masking tape to control and limit the shape of the red area, where the paint was applied with a roller. Working in this manner, Hurtubise holds fast to his Montreal roots and to the work of his contemporaries Guido Molinari and Claude Tousignant, who were similarly painting in a geometric fashion and were maintaining the hard-edge

limitation of shapes with the use of masking tape. As Hurtubise said, "It's a splashy hard edge…they are flat colours. The splashes are flat…So it was the fight between a flat plane and a flat splash."

Hurtubise studied at Montreal's École des beaux-arts from 1956 to 1960 and then spent a year in New York City. In 1965, *Isabelle* won first prize in a province-wide competition, which launched Hurtubise on a prolific exploration of abstraction and expressionism.

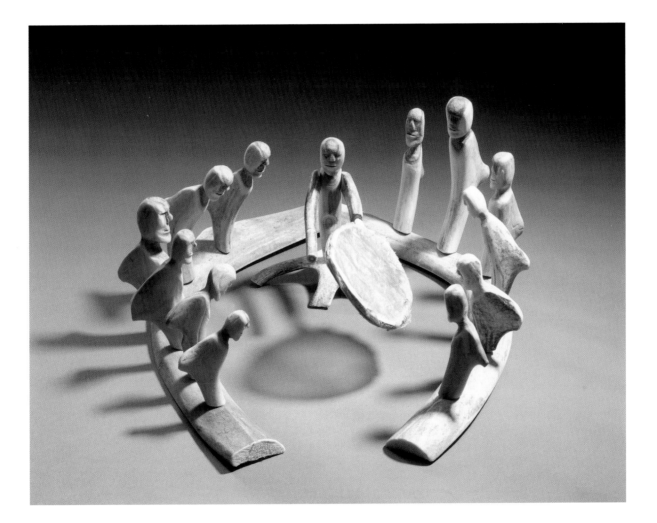

Drum Dance

Luke IKSIKTAARYUK

c. 1974; antler, wood, sinew, metal, gut; 16.4 cm x 32.6 cm x 40.7 cm; Art Gallery of Ontario;
Gift of the Klamer Family, 1978; Photo by Carlo Catenazzi/AGO

(1909-1977)

The resourcefulness that Inuit apply to survival on the land is reflected in the imaginative work of Luke Iksiktaaryuk, who reconfigured and carved caribou antlers to create art. Here, two curving pieces of antler tied together with sinew form a path on which small figures bow and bend to the rhythm of the drum. The antlers' natural protrusions suggest the fuller parkas of the women. In the centre, the tiny drummer, whose drumstick is a natural extension of his arm, beats a miniature drum. This economy of means is characteristic of Iksiktaaryuk's work and is also a reflection of Inuit ingenuity and efficiency.

Born in the Kazan River area in the central Keewatin region of Nunavut, Iksiktaaryuk moved to Baker Lake in the mid-1950s, when the depletion of the caribou made living on the land untenable. He began carving in the mid-1960s, and unlike many other Inuit artists who used antler for added details, Iksiktaaryuk employed it as his dominant medium with extraordinary innovation, creating composite carvings of family groups, drum dances, shamans and figures from Inuit legend. While the caribou no longer allowed him to survive on the land, they did continue to provide the materials for his art, affirming Inuit identity and its relationship to nature. Iksiktaaryuk was also acclaimed for his drawings, many of which were published as prints by the Sanavik Co-operative.

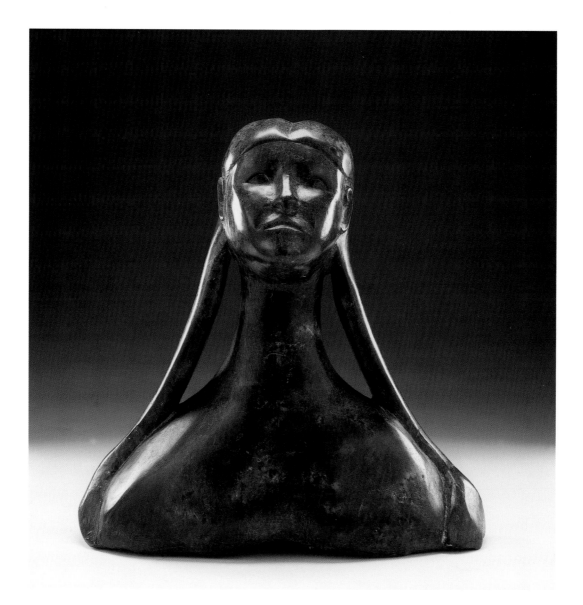

Osuitok IPEELEE

Bust of a Woman with Braids

(1922-)

c. 1977; dark green stone; 41.0 cm x 39.6 cm x 16.5 cm; National Gallery of Canada;
Gift of the Department of Indian Affairs and Northern Development, 1989

Osuitok Ipeelee carved this work "in memory of the nice long hair the women used to have." In the manner of his elegant and often precariously balanced carvings of birds and animals, *Bust of a Woman with Braids* demonstrates Osuitok's highly refined artistry. Here, the fragile thinness of the braids and the smooth elongated neck contrast with the sculptural mass of the head and shoulders, producing a sculpture whose polished surface and monumental sense of grace are echoed in the woman's calm and distant expression.

Born near Cape Dorset, Osuitok lived in camps along the southwest coast of Baffin Island. He learned to carve by watching his father create ivory objects for the crews of the annual supply ships from the South, and as a young child, he fashioned toys for himself from scraps of wood. In the early 1940s, Osuitok sold small ivory carvings to the missionaries in Cape Dorset to supplement the living he made as a hunter.

One of Osuitok's early ivory pieces of a miniature fox trap that opened and closed shows the precision of his carving skills and his characteristic ability to challenge the limitations of the materials. By the early 1950s, when James and Alma Houston arrived in Cape Dorset, Osuitok was admired by his contemporaries as a highly proficient carver, a reputation that he would uphold, over the years to come, in his extensive exploration of a variety of materials and subjects.

Green Highlands No. 5

Gershon ISKOWITZ

1977; oil on canvas; 195.6 cm x 228.7 cm; The Montreal Museum of Fine Arts;
Gift of the Gershon Iskowitz Foundation; Photo by Brian Merrett/MMFA

(1921-1988)

Engulfed by the scale of this large painting, we find ourselves in a spatial limbo. Are we high in the air, looking down on masses of colour floating in a sea of white space, or are we below, watching free-falling colours and shapes coalesce? The bright greens, oranges and blues dance their own secret language and bring joy to the dreamlike ambiguity of this work.

Although Gershon Iskowitz's ambitions to enrol at the Warsaw Academy were extinguished by the German invasion of Poland in 1939, his urge to create persisted through the atrocities of the Nazi concentration camps of Auschwitz and Buchenwald. There, Iskowitz depicted the horrors and endurance of the people in the camps with a graphic expressionism.

After the war, he studied briefly with Austrian painter Oskar Kokoschka, and in 1949, he immigrated to Canada. Settling in Toronto, he embraced nature as his subject and responded to the brightness of the light and the vividness of the colour in work that abstracted the vitality and essence of the landscape. Of particular importance to the development of his vision was a helicopter trip over Canada's North in 1967. The memories of the land seen through the falling and ascending movements of the helicopter hovering and defying gravity inspired imaginative, intuitive perspectives.

157

Alexander Young JACKSON

The Red Maple

(1882-1974)

1914; oil on canvas; 82.0 cm x 99.5 cm; National Gallery of Canada

When A.Y. Jackson's *The Edge of the Maple Wood* was exhibited in Toronto in 1911, it so impressed Lawren Harris that he purchased the painting. He then invited Jackson to come to Toronto to collaborate with an informal group of artists who were also interested in distinctly Canadian subjects. Jackson had been working in his hometown, Montreal, as a commercial artist and had studied in Paris, where his exposure to Impressionism fostered techniques for capturing the fleeting effects of light that he would later apply to the Canadian landscape. His meeting in 1913 with Tom Thomson and future Group of Seven artists led to sketching trips that excited Jackson about the rugged beauty of the Canadian wilderness.

In the autumn of 1914, just before the artists were dispersed by the war, Jackson visited Algonquin Park with Thomson, F.H. Varley and Arthur Lismer and made a sketch for *The Red Maple*. With wide, sweeping brush strokes and vivid colours, Jackson creates an intimate view of a rapidly flowing stream seen through a screen of crimson leaves. "Seldom is there found a subject all composed and waiting to be painted," wrote Jackson. "Out of the confusion of motifs, the vital one had to be determined…One must know the north country intimately to appreciate the great variety of its forms."

Jackson enlisted in the army in 1915 and, in 1917,

Winter, Charlevoix County

c. 1932-1933; oil on canvas; 63.5 cm x 81.3 cm; Art Gallery of Ontario

received a commission as a war artist from the Canadian War Memorials Fund. He returned to Toronto in 1919 and joined Harris, J.E.H. MacDonald and Frank Johnston on a painting trip to Algoma, reestablishing the prewar artistic camaraderie. In early 1920, despite inhospitable weather, Jackson painted at Georgian Bay. When he arrived back in Toronto in the spring, he learned of the formation of the Group of Seven and of his membership in it. Although

members of the Group shared a common purpose (as Jackson noted in his autobiography, *A Painter's Country*, "to express, in paint, the spirit of our country"), their interests and responsibilities diversified as the decade progressed and as each artist sought out particular areas of the country to paint.

Although he would later sketch in the Rockies and the Arctic, Jackson maintained an attachment to his native province, and in the spring of 1921, when the

deep snows still blanketed the fields, he made the first of many trips to the Quebec countryside. In *Winter, Charlevoix County*, we follow a twisting road through the undulating snow-covered farmland on the north shore of the St. Lawrence River. As a horse-drawn sleigh journeys homeward in the pink glow of the sun at the end of the day, telephone poles cast long blue shadows that seem to dance and sway in time to the rhythm of the land.

Geoffrey JAMES

Vimy Ridge

(1942-)

1993; gelatin silver print; 71.1 cm x 88.9 cm; National Gallery of Canada

Like twigs on the horizon, the thin lines of telephone poles and the slender frame of the conveyor shaft lend a sense of scale to these enormous slag heaps, the imposing mounds of industrial waste whose stark monumentality touches the sky over the now abandoned asbestos mines in southeastern Quebec. Photographed from an elevated point of view in the raking afternoon sun, their incised surfaces suggest centuries-old patterns of erosion that imbue them with a timelessness

at odds with their contemporary origins. Man-made, they sit like giant tumours on the body of Mother Earth, an involuntary part of our planet's history.

Geoffrey James' photography examines humanity's marks on the landscape and the impact of such interventions over time. In contrast to earlier work that embraced historical landscapes and utopian spaces, such as the Italian *campagna* or the gardens of Versailles, here, in an image from the Asbestos series,

James directed his camera, as he said, to "a landscape that can be viewed as dystopian—created out of brute expediency with an almost total disregard for the present, let alone the future." *Vimy Ridge* is rendered increasingly poignant with a name that recalls the French industrial wasteland where thousands of Canadians lost their lives during the First World War.

Born in Wales, James studied modern history at Oxford University before moving to Canada in 1966.

The Doggone Weakbacks

Alex JANVIER

1975; acrylic on canvas; 56.0 cm x 71.3 cm; McMichael Canadian Art Collection

(1935-)

A sinuous blue line snakes across the surface of the canvas, and from its underbelly, organic abstract shapes and colour suggest animal life. Other lines descend, flowing into serpentine forms; their narrow heads, at first unnoticed, start to twist and writhe. Although Alex Janvier's title has a political bent and alludes to his criticism of "bureaucratic weakbacks" whose theories never touch the people they are supposed to serve, the work is, at the same time, rooted in his native

Dene heritage. In their meandering expansion, the lines evoke the rhythms of the rolling Alberta landscape, and the shapes refer to patterns from traditional hide paintings and quill- and beadwork. As National Gallery of Canada curator Diana Nemiroff has noted, "Janvier's vision is a highly subjective one, recording his personal quest for a spiritual identity."

Janvier studied at the Alberta College of Art in the early 1960s with Illingworth Kerr and Marion Nicoll,

whose instruction in automatic painting opened his imagination to an expression of inner worlds in abstract form. He was also attracted to the work of Russian artist Wassily Kandinsky, whose abstract compositions of line and shape sought to encompass spiritual realities. In 1973, Janvier joined with artists such as Daphne Odjig and Norval Morrisseau to form the Professional Native Indian Artists Inc., a group of seven artists who focused on marketing and exhibiting their work.

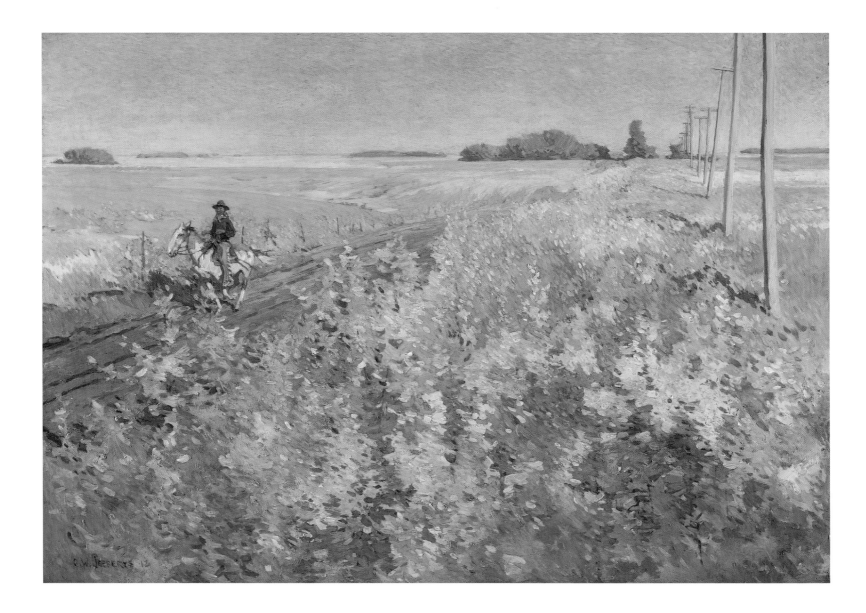

Charles William JEFFERYS

A Prairie Trail ("Scherzo")

(1869-1951)

1912; oil on canvas; 90.8 cm x 128.9 cm; Art Gallery of Ontario; Reproduced with the permission of the C.W. Jefferys Estate, Toronto; Gift of the Canadian National Exhibition Association; 1965; Photo by Larry Ostrom/AGO

Beyond a patch of richly hued bushes, a road cuts a diagonal path through flat prairie fields that are illuminated by the golden midday sun. An atmosphere of tranquillity pervades the canvas as the lone horse and rider silently gallop by. In recounting his first reaction to the Prairies, C.W. Jefferys professed his wonder to a journalist in 1913: "Words fail to describe my impressions of that amazing land. Limitless horizons extend over endless sweeps of virgin soil…the pageantlike magnificence of it all—pigment fails the ordinary colourist."

Born in England, Jefferys settled in Toronto in 1891 and worked at the Toronto Lithographic Company as a designer-draughtsman and then at *The Globe*, where his talents as a historical illustrator were given their debut. Studies with George Reid introduced him to the "French" method of working directly from nature. Later, during his sojourn in the United States

as an artist-reporter, Jefferys had the opportunity to see the work of the French Impressionists, which confirmed, for him, the suitability of their technique for capturing the peculiar luminosity of the Canadian landscape. Jefferys was considered a precursor of the Group of Seven and was much admired by those artists. A.Y. Jackson once remarked, "Charles Jefferys painted canvases of the West that make one regret that he had to work most of his life as an illustrator."

Serenity, Lake of the Woods

Frank H. JOHNSTON

1922; oil on canvas; 102.3 cm x 128.4 cm; Collection of the Winnipeg Art Gallery; Photo by Ernest Mayer/WAG

(1888-1949)

In 1921, the year after his first and only participation in a Group of Seven exhibition, Francis Hans (later Franz) Johnston moved to Manitoba for two years to become principal of the Winnipeg School of Art. In the summers, he enjoyed painting at nearby Lake of the Woods, where snowy sunlit clouds dominate the flat prairie terrain, casting their reflections on the peaceful surface of the lake. In the distance is a barely visible puff of smoke, while on the left shore, cottages bask in the late-afternoon sun. Johnston simplifies the forms of nature with a characteristically muted palette, creating a poetic and lyrical effect that distinguishes his work from the images of rugged wilderness usually associated with the Group of Seven.

Johnston's relationship with these artists dated back to 1908, when he met Tom Thomson and J.E.H. MacDonald at the commercial art firm of Grip Limited, in Toronto. In 1915, he was commissioned by the Canadian War Memorials Fund and produced 73 paintings recording the activities of the Royal Air Force in Canada. Although Johnston accompanied the future Group artists on sketching trips to the Algoma region after the war and shared their passion for painting the Canadian landscape—especially the effects of light on ice and snow in the Arctic and the Northwest Territories—he preferred to pursue a path of his own, separate from group affiliations.

Anne KAHANE

Acrobat

(1924-)

1986; aluminum; 91.4 cm x 45.7 cm x 25.4 cm; Collection of the artist

The acrobat contorts his lithe body, exploiting human flexibility with astute control. Using a thin sheet of aluminum, cut and softly bent, Anne Kahane defines the essential forms of the figure, balancing its precarious position with the strength of the material. Kahane has embraced the figure as a metaphor for the human condition and, throughout her career, has explored the dichotomies and contradictions of existence in sculpture. Here, the performer of constant change also embodies

equilibrium, just as the aluminum, pliable and rigid, suggests both human vulnerability and endurance.

Born in Austria, Kahane grew up in Montreal where, in 1940, she attended the École des beaux-arts. She studied at the Cooper Union Art School in New York City from 1945 to 1947, and there, her exposure to the simplified expressionistic sculpture of artists such as Jacques Lipchitz and Ossip Zadkine proved to be a seminal influence. Returning to Montreal, Kahane

transformed flat materials into volumetric expression, exploring copper and wood in the 1950s and 1960s and metals such as brass and aluminum in the 1970s.

Kahane's preoccupation with the dualities of the human condition has permeated her art. From the austerity of her 1953 award-winning maquette for a monument to the *Unknown Political Prisoner* to the tragicomic figure of *Man on His Head* for Expo 67, Kahane balances her depiction of human frailty with wit and imagination.

Life in Igloo

Helen KALVAK

1967; stonecut on paper; 46.0 cm x 59.9 cm; Collection of the Winnipeg Art Gallery;
Bequest from The Estate of Arnold O. Brigden; Photo by Ernest Mayer/WAG

(1901-1984)

As if endowed with magical x-ray vision, we see both the inside and the outside of an igloo in Helen Kalvak's portrayal of traditional Inuit domestic life. On the outside, a man makes repairs to the wall of the snow house, while on the inside, two women look after the necessities of the home. The mother sits on skin blankets and nurses a child; the other woman attends to the stone lamp, where the delicate jagged edge inside the large white oval represents the flame.

Near the wall, a drying rack supports the family's socks and mittens. In this refined graphic distillation of the women's world, the egg-shaped cross section of the igloo suggests the shape of the female uterus.

Kalvak lived on the land on Victoria Island, in the central Arctic. In her early sixties, she moved to Holman, on the island's west coast, where she was encouraged to draw by the resident Roman Catholic priest, who assisted in the founding of the local

printmaking co-operative. A prolific artist, Kalvak depicted her memories of camp life, shamanism and legends in over 3,000 drawings, almost 200 of which were made into prints.

Life in Igloo is characteristic of the early approach to printmaking in the community of Holman, where line drawings were traced directly onto stone, then cut and printed in dark colours to produce dynamic silhouetted images.

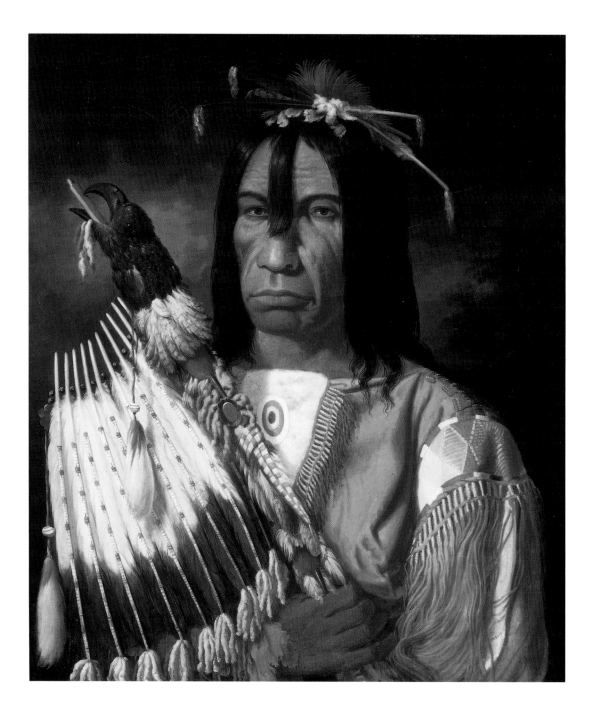

Paul KANE

<div style="text-align: right">Kee-a-kee-ka-sa-coo-way</div>

(1810-1871)

c. 1850; oil on canvas; 45.7 cm x 73.6 cm; Photo courtesy of the Royal Ontario Museum, © ROM

Paul Kane's ambition "to devote whatever talents and proficiency I possess to painting a series of pictures illustrative of the North American Indians and scenery" was fuelled by his admiration for the work of American painter George Catlin, whose mission had likewise been to record Native American people visually. Kane, who had been born in Ireland and had immigrated to Canada in the early 1820s, set out in 1845 on a trek that would take him across the Canadian prairies, over

the Rockies to the Pacific and back again. Despite the hardships of travel, Kane produced more than 500 sketches of the native peoples and their habitats, rituals and landscapes.

In his travel memoirs, *Wanderings of an Artist Among the Indians of North America*, published in 1859, Kane wrote of his arrival at Fort Pitt on the North Saskatchewan River in January 1848 and of his meeting with Kee-a-kee-ka-sa-coo-way, the Cree chief. When

he did this oil painting in the studio two years later, Kane elaborated upon his original sketch, which shows the chief with one naked shoulder and a white wolf pelt over the other. While the unwavering gaze and clenched expression resemble the chief's features in the sketch, the additions of the fringed buffalo-skin shirt, feathered hairpin and intricate medicine-pipe stem were a "dressing up" by Kane to comply with Victorian society's image of the "noble savage."

Grey Owl (Archibald Belaney, 1888-1938)

Yousuf KARSH

1936; gelatin silver print; 50.1 cm x 40.2 cm; National Gallery of Canada; Gift of the artist, Ottawa, 1989

(1908-)

The chiselled features and solemn expression of Grey Owl emerge from the shadow of his wide-brimmed hat, creating an image of gravity and enigma that characterized his very persona. Recalling his attraction to Grey Owl, whom he later named "the counterfeit Indian of Canada," Yousuf Karsh wrote, "His false identity cannot, however, diminish his achievements as one of Canada's early conservationists. His writings, speeches and travels demonstrated a love of nature,

the wilderness and its animals…In that sense, he was not an impostor but, I like to think, a prophet."

A survivor of the Armenian massacre, Karsh immigrated to Canada in 1924 at the age of 16, settling in Sherbrooke, Quebec, with George Nakash, an uncle from whom he learned the rudiments of portrait photography. To advance Karsh's already apparent photographic talents, his uncle sent him to Boston (1928-31) to study with the celebrity portraitist John H.

Garo. In Boston, Karsh also encountered the photography of Edward Steichen, whose use of studio lights was of seminal inspiration. Karsh returned to Canada, opened a studio in Ottawa in 1932 and embarked on a lifelong pursuit of the portrayal of greatness which he saw reflected in the faces of people in the arts, politics and science, seeking to remove, as he said, "the mask that all humans wear to conceal their innermost selves from the world."

Augustus KENDERDINE

Windswept

(1870-1947)

early 1920s; oil on canvas; 67.3 cm x 87.0 cm; Glenbow Collection, Calgary, Canada

With a discerning palette of browns and greens, Augustus Kenderdine employs energetic brush strokes to convey the force of the wind against the tall, dark pines. Broader, heavier brushwork depicts the less distinct fields and mountains in the distance, evoking the desolate drama of the prairie landscape.

Kenderdine was born in England and studied briefly in Blackpool and then in Paris at the Académie Julian. Returning to England, he discovered the work of British artists John Constable and J.M.W. Turner, whose striking use of light and loose brushwork fuelled his romantic response to nature. Although he enjoyed artistic recognition in England, Kenderdine was attracted to Canada by the offer of free land, and in 1908, he immigrated to Lashburn, Saskatchewan. Not until 1918, however, when the farm was sufficiently established, did Kenderdine begin painting his new environs, embracing with vigour the vitality of the wide-open spaces. Exhibitions of his work brought good reviews, and in 1921, he was offered a studio at the University of Saskatchewan. By 1928, Kenderdine had become the first paid studio artist in a Canadian university. His passion for art education is best remembered through his founding of the university's summer art school at Emma Lake. It opened in 1936 and would become renowned for workshops with national and international artists.

Ravenscrag, Ross's Ranch

Illingworth KERR

1930; oil on canvas; 76.8 cm x 92.1 cm; MacKenzie Art Gallery, Regina; Gift of Mr. Norman MacKenzie; Photo by Don Hall

(1905-1989)

On the aptly named Ravenscrag Ranch, a large brown barn with a red roof dominates the land, adding an element of cheer to the open fields and low hills surrounding it. While the landscape remains stark, the palette used by the artist to describe the garden is marked by a symphony of greens, ranging from a blue-green to a yellow-green, that is balanced by the grey of the rocky hills and the passive blue sky.

Having grown up in Lumsden, Saskatchewan,

Illingworth Kerr began his arts education by taking correspondence courses in lettering. He moved to Toronto in 1924 to attend the Ontario College of Art, where the instruction—dominated by Group of Seven artists—left him ill-prepared to render the vast prairie spaces. In his unpublished autobiography, *Paint and Circumstance*, however, he acknowledged retaining some good advice. From Arthur Lismer, he remembered to "look for the design elements in nature," and

from F.H. Varley, he learned to have "a sense of awe and reverence for one's subjects." Returning home in 1927, Kerr painted in the rolling Qu'Appelle Valley of southern Saskatchewan, basing his canvases on field studies afforded by his travels as a sign painter, harvester and trapper. From 1947 to 1967, he was the influential head of the art department at Calgary's Provincial Institute of Technology and Art (now the Alberta College of Art and Design).

James KERR-LAWSON

Portrait of Alice and Louise Cummings
("Music, when soft voices die, vibrates in the memory")

(1862-1939)

c. 1885; oil on canvas; 56.3 cm x 69.0 cm; Art Gallery of Windsor; Gift of Mr. and Mrs. William N. Tepperman, 1978

In a room shuttered from the afternoon sun, Alice Cummings plays the piano while her sister Louise, who would later become a distinguished mathematician, sings. Taking its title from a poem by Percy Bysshe Shelley, this intimate painting is itself a visual poem of hushed tones evoked by the soft grey colouring and by the women's quiet concentration. A subtle rhythm of line and shape crosses the canvas, moving from the clutter of books and papers on the left to the erratic arrangement of bows and creases of Alice's skirt and finally coming to rest in the harmony of horizontal lines lent by the shutters and by the stripes on Louise's dress.

James Kerr-Lawson was born in Scotland and immigrated to Canada with his parents around 1865. Settling in Hamilton, where the father of the Cummings sisters was once mayor, Kerr-Lawson studied first in Toronto and then in Paris. He was influenced by French realist Jules-Bastien Lepage and by American artist James McNeill Whistler, whose distilled compositions and restrained use of colour he greatly admired. Although his reputation was achieved abroad, Kerr-Lawson returned to Canada between 1884 and 1887 and thereafter maintained his Canadian contacts through friendships with artists, exhibitions and a commission from the Canadian War Memorials Fund for murals, two of which are in the Senate Chambers in Ottawa.

Music and Dancing

1961; graphite on wove paper; 45.8 cm x 58.2 cm; National Gallery of Canada; Gift of M.F. Feheley, Toronto, 1985

(1888-1966)

Born in Arctic Quebec, Kiakshuk later migrated with his family to southwest Baffin Island. His art had a powerful influence on other Inuit and, in particular, on his younger cousin, graphic artist Pitseolak Ashoona, who recalled, "Because Kiakshuk was a very old man, he did real Eskimo drawings. He did it because he grew up that way, and I really liked the way he put the old Eskimo life on paper."

Here, an accordion player and a fiddler create music for a gathering of young people in southern dress who are dancing outside the nearby tents. Observing his culture in transition, Kiakshuk lavishes individual attention on the three Inuit in traditional parkas sitting on the stools. The attention to detail on the South Baffin parkas contrasts notably with the uniform description of the young people's dress, differentiated only by the varying direction of the pencil line that suggests plaid material from the South.

Kiakshuk was in his seventies when, at the invitation of James Houston, he began to draw for the budding Cape Dorset printmaking co-operative. His depictions of camp life and hunting are distinguished by their refined and precise delineations and perhaps reflect his skills as a hunter. On the land, Kiakshuk's expertise with sharp knives, harpoons and spears embodied the same dexterity and acute eye that he brought to his exacting draughtsmanship.

Janet KIGUSIUQ

(1926-)

Caribou Meat Covered with Flies

1990; graphite and coloured pencil on wove paper; 57.1 cm x 76.1 cm; National Gallery of Canada

The image of a freshly skinned caribou lying on the tundra continues to be a welcome sight to Janet Kigusiuq, who in her youth led a traditional life on the land in the Back River area of Keewatin, where caribou was the primary sustenance. In contrast to earlier drawings that depicted, with fine graphic detail, scenes of everyday camp life and Inuit legends, Kigusiuq's work in the 1990s became more colourful and less illustrative of life in a narrative sense. Here,

in a large drawing that resembles a collage, the head, hooves and torso of a caribou carcass are juxtaposed like flat abstract shapes. Exercising her distinctive affinity for fine linear detail, Kigusiuq meticulously blankets the caribou's head and torso with hundreds of delicately drawn flies, imbuing the natural process of decay with a decorative, almost whimsical beauty. In her desire to fill the drawing, she applies richly layered areas of green and brown to contrast with the red-

ness of the flesh and the brightness of the white paper.

Kigusiuq moved to Baker Lake in the early 1960s, and like her famous mother Jessie Oonark and several of her siblings, she embraced the arts as a means of supplementing the family income. Kigusiuq sold many drawings that were later translated into prints at the Sanavik Co-operative. With the closing of the print shop in 1990, she began to draw more freely, liberated from the exigencies of the print media.

172

Red Complex (Hoarfrost)

Roy KIYOOKA

1959-1960; oil and Duco automobile lacquer on hardboard; 182.5 cm x 122.5 cm;
The Estate of Roy Kiyooka; Photo courtesy Catriona Jeffries Gallery

(1926-1994)

A lacelike pattern of white and off-white lines weaves an intricate screen on the surface of the painting, obscuring our view of the red, blue and green colours beneath, creating an image whose entangled beauty seems to extend beyond the frame. The reference to nature in the title directs us to Roy Kiyooka's inspiration: In the fall of 1959, while walking to the School of Art in Regina, Kiyooka was struck by the contrast in brightness between the hoarfrost on the green trees and the clear blue sky. Distilling this experience into visual form, Kiyooka demonstrated his intuitive response to life and asserted his freedom from any particular style. In a 1991 interview, he said of painting: "It's always a movement towards clarity. Ideally, one wants the utmost complexity along with that clarity."

Born in Saskatchewan of Japanese parents, Kiyooka studied art with Jock Macdonald in Calgary (1946-49), and in 1956, he spent eight months at the art school in San Miguel de Allende, Mexico. There, he experimented with Duco, a quick-drying automobile lacquer, which he used for the bright colours in this painting. In 1959, he attended the Barnett Newman workshop at Emma Lake, Saskatchewan, along with Ronald Bloore and other artists who sought new approaches to abstraction. In the late 1960s, Kiyooka explored poetry, photography and collage.

173

Dorothy KNOWLES

The River

(1927-) 1967; oil and charcoal on canvas; 144 cm x 144 cm; Collection of the Mendel Art Gallery, Saskatoon; Gift of Mr. and Mrs. Harvey S. Smith, 1973

Dorothy Knowles drives her van, a portable studio, across the rolling prairie in search of subjects for her art. Working directly from nature on a large canvas, she has captured the vast expanse of prairie space where the Saskatchewan River meanders through low bush and golden fields. The enormous sky overhead is a vaporous umbrella of clouds stretching to the flat horizon.

Knowles came to art unexpectedly. From 1944 to 1948, she studied biology at the University of

Saskatchewan. Then, on a friend's suggestion, she enrolled in the university's summer art course at Emma Lake, where she discovered her artistic talent. Although Knowles continued her training at the university, at Banff and in England, the Emma Lake workshops were her most important inspiration. Particularly encouraging was the 1962 session led by American art critic Clement Greenberg, who wrote: "The problem was how to master the prairie's lack of feature…Knowles

was the only landscape painter I came across…whose work tended towards the monumental in an authentic way." Subsequent workshops led by American abstractionists such as Kenneth Noland and Jules Olitski, who soaked their canvases with pigment, prompted Knowles to thin her oil paint, thus making it more translucent, like watercolour. This technique helped Knowles to realize her ambition of integrating charcoal sketches with her painting so that the drawing would show through.

Part 4 from the Reactor Suite

Wanda KOOP

1985; acrylic on plywood; 243.8 cm x 487.6 cm; National Gallery of Canada

(1951-)

Wanda Koop described the *Reactor Suite*, composed of four large panels, as consisting of "the reactor cooling towers, the shadow man and the great blue heron, the nuclear submarine and the two human silhouettes partially submerged in water." The images were created as the result of an extensive sketching trip that Koop made from May to September 1984, when she travelled from northern Manitoba to British Columbia. Later, reviewing the 260 drawings she produced

during that four-month period, she discovered that particular groupings evolved. Those in the *Reactor Suite* expressed her views about the vulnerability of humanity and nature in the face of nuclear disaster. With its stark compositional simplicity and monumental scale, which overwhelms the viewer and augments the tone of disaster, Part 4 of the series embodies the evening light and eerie tone of the other panels. Here, two figures rendered faceless in the dying light stand apart

in the boundless blue water, reinforcing the mood of ominous loneliness that pervades the suite.

Born in Winnipeg, Koop graduated in fine arts from the University of Manitoba in 1973. Her characteristic practice of working on a large scale is inextricably linked with her environment. "When you live on the prairies," she once said, "you have no limitations. You walk out into a horizon that goes on forever, and you have this tremendous rush of freedom."

Cornelius KRIEGHOFF

Merrymaking

(1815-1872)

1860; oil on canvas; 87.6 cm x 121.9 cm; The Beaverbrook Canadian Foundation, The Beaverbrook Art Gallery, Fredericton, New Brunswick

After peripatetic beginnings that featured his birth in Amsterdam, his upbringing in Germany and a spell in the United States Army fighting in the Seminole War in Florida, Cornelius Krieghoff started his artistic career as a painter of portraits in Boucherville, Quebec. In 1844, he left for Paris, where he registered as a copyist at the Louvre, consolidating his attraction to landscapes and genre scenes, which he would later adapt to a Canadian context. He returned to Canada in 1846 and, in 1854, moved to Quebec City, where the English-speaking merchants and the British garrison families provided a steady market for his idealized scenes of Quebec rural life, local First Nations and popular outing destinations such as Montmorency Falls.

Krieghoff entertains us here with a spectacle of chaotic activity, where the arrivals and departures of winter travellers create mishap and confusion on the veranda and grounds of the Jolifou Inn. In assembling this cast of characters, the artist quoted earlier pictures that featured isolated events such as the overturned sleigh, drunken revellers or people on snowshoes. Ever enterprising, Krieghoff took full advantage of *Merrymaking*'s instant celebrity: As was his practice with other successes, such as *Bilking the Toll* (of which he painted close to 30 versions), he proceeded to produce variations on the theme of jovial carousing. None, however, is as elaborate as this one.

176

Qaggiq (Gathering Place)

Zacharias KUNUK

1989; videotape, 58:21 minutes on ¾" cassette; National Gallery of Canada; Photo by Isuma Productions

(1957-)

As other Inuit artists explore sculpture and print-making to celebrate the traditions of Inuit life, so Zacharias Kunuk embraces video to keep the past alive through the re-creation of the rituals of Inuit camp life in the 1930s. In the opening scenes of *Qaggiq*, a dog team pulling a family appears out of the blowing snow and vast Arctic space. On the soundtrack, a man's voice singing an Inuit song gives way to the music of the howling wind. Authentic details, such as the handmade caribou clothing, the rituals of tea making and drum dancing and the use of traditional tools, frame the tale of a young man's request for marriage and the opposing responses of the girl's father and mother. All is apparently harmonized in the building of the *qaggiq*—the large communal igloo that the families construct to salute the coming of spring.

In this photograph from the production, the girl's mother, illuminated by the stone lamp in the diffused light of the igloo, sits patiently, listening to the men's discussion. The starkness of the photograph captures both the austerity and the economy of means that characterize Inuit life on the land.

Born at Kapuivik, near Igloolik, Kunuk used the proceeds from the sale of his carvings to purchase a video camera—a tool he employs to produce award-winning videos about Inuit history, establishing an accord between Inuit identity and technology.

177

William KURELEK

Green Sunday

(1927-1977)

1962; oil and graphite on gesso on Masonite; 69.2 cm x 74.4 cm x 2.3 cm; National Gallery of Canada

William Kurelek was born of Ukrainian parents near Whitford, Alberta, and as a child, he moved to Manitoba, where memories of the harsh and happy experiences of growing up on a farm would later provide subject matter for his art. In 1949, the year he graduated from the University of Manitoba, the family moved to Ontario, and in defiance of his father's wishes, Kurelek enrolled at the Ontario College of Art in Toronto. Although he was attracted to the

work of teachers such as Carl Schaefer, whose rural themes impressed him, Kurelek stayed for only a year, then travelled to Mexico to see the murals of such artists as Diego Rivera, whose social conscience and devotion to the culture and dignity of ordinary people touched him profoundly. Kurelek, however, was uncertain of his direction and became deeply troubled. In 1952, he sought psychiatric help in England, and by 1957, with the aid of these treatments and his conver-

sion to Catholicism, he set a new course for his life.

Kurelek returned to Toronto in 1959 and worked as a framer at The Isaacs Gallery. He held his first exhibition in 1960. *Green Sunday* is one of a series of works shown in 1962 under the theme "Memories of Farm and Bush Life." As Kurelek explained, "This is the farm kitchen on a May Sunday morning and combines three occurrences…an annual spring custom of bringing branches of poplar trees into the house

Ukrainian Pioneer, No. 6

1971-1976; mixed media on Masonite; 153.0 cm x 121.5 cm; National Gallery of Canada; Reproductions courtesy The Estate of William Kurelek and The Isaacs Gallery, Toronto

to be placed in the corners of the living room…the maid is posing in the traditional Ukrainian costume of the province of Bukovina, where my people come from…the youth with the accordion represents our neighbours' son…I used to be entranced by his playing." Art historian Charles Hill has noted that for Kurelek, these paintings were "a means of reclaiming an identity and [of] bonding with a community from which he had been alienated."

Ukrainian Pioneer, No. 6 is the last of a six-panel series that chronicles the departure from the old country and the arrival in the new, through the hardships of travel and clearing the land to the final bounty of the autumn harvest. Here, a golden field of wheat is punctuated by the figure of a lone farmer admiring the grain from which his richness has come. "Materially, he 'has it made,' " wrote Kurelek. While the addition of the black car in the upper right aug-

ments this celebration of prosperity, the mushroom cloud on the distant horizon is a reminder of impending doom. "It is the nemesis of mere materialism," said Kurelek. Despite his popularity as a writer and an illustrator of children's books, which drew on his youthful experiences on the farm, Kurelek continued to be preoccupied with humanity's spiritual frailty in the face of atomic catastrophe, a theme that haunted his later painting.

LABRADOR ARTIST

Two Women Carrying Tub

c. 1874-1892; ivory, black, red and yellow colouring, string; 5.4 cm x 7.7 cm x 1.5 cm;
Winnipeg Art Gallery; The Cotter Collection; Acquired with funds from an anonymous donor; Photo by Ernest Mayer/WAG

The advent of the Little Ice Age, which produced shifts in animal populations in Arctic Canada between 1600 and 1850, coupled with the increasing presence of the white man precipitated what is known as the "historic period" of Inuit art. Although Inuit continued to carve objects for their personal and ritualistic use, the influx of European explorers, traders and missionaries inspired them to fashion ivory objects, animals, figures and game boards to trade.

The arrival of Moravian missionaries in northern Labrador in 1771 fostered the advancement of ivory carving in this area. These miniature figures were collected between 1874 and 1892 by James Alma Wilson, a proctor for the Hudson's Bay Company at Rigolet, Labrador. They belong to a group of objects that illustrates traditional Inuit activities, tools and modes of transportation. Here, two women in eastern Arctic-style parkas, embellished with colouring to sug-

gest embroidered and braided decoration, share the weight of what appears to be a tub of fresh blubber. The woman on the left carries a baby in her pouch as well as a small pail secured by a thread handle through a hole in her hand. While the diminutive scale, delicate carving and refined application of colour identify the tiny figures as ornaments and objects of exchange, they also assert the artist's sense of innovation and creativity in a time of transition.

The Slave to Machinery

Alfred LALIBERTÉ

c. 1929-1934; painted plaster; 27 cm x 21 cm x 12 cm; The Montreal Museum of Fine Arts;
Purchase, Gilman Cheney Bequest; Photo by Christine Guest/MMFA

(1878-1953)

Alfred Laliberté employs the mythological figure of Ixion (whose punishment by Zeus was to be forever bound to a fiery wheel) as a fitting metaphor for his view of society's relationship to industrialization. The weary figure of the nearly naked man slumps against the winged wheel, his independence sacrificed to its mechanical revolutions. Painted with a bronze-coloured paint touched with green to suggest a metal patina, the tiny plaster assumes an epic monumentality

associated with Laliberté's best-known public work.

After studying at the Conseil des arts et manufactures in Montreal, Laliberté travelled to Paris in 1902 to attend the École des beaux-arts and successfully showed sculptures based on Canadian themes at several spring Salons. He returned to Canada in 1906 and embarked on several decades' worth of commissions for sculptures that commemorate Canada's history and heroes, of which the 1926 *Monument to the Patriots*

of 1837 in Montreal is among his most celebrated. In 1928, he turned to his rural Quebec roots and executed over 200 small bronze sculptures devoted to the occupations, customs and legends of French Canada. His attachment to the old ways made it difficult for him to accept the pace of modern life. In *Mes souvenirs*, Laliberté expressed his fear that "machinery is also the reason for the near collapse of art." A prolific artist, he produced more than 900 sculptures over his career.

181

Jacques LEBLOND DE LATOUR (attributed)

Tabernacle

(1671-1715)

1695-1705; gilded wood; 286 cm x 274 cm x 72 cm; Musée du Québec; Photo by Patrick Altman/MQ

As the son of a painter of the French Royal Academy of Painting and Sculpture, Jacques Leblond de Latour brought exceptional training with him when he arrived in Quebec City from his native Bordeaux in 1690. During the French regime in Quebec, the Roman Catholic Church was a major patron of artists, contracting them to design the interior decoration of churches and to produce paintings and sculpture. Of central importance to the overall scheme was the main altar at the front of the church, which was usually composed of a *tombeau*, or tomb-shaped table, and crowned with a tabernacle, such as we see here.

This tabernacle was commissioned by the Church of the Guardian Angel in Montmorency, west of Quebec City. Modelled on the façade of 17th-century Baroque buildings, complete with miniature columns, niches for sculptures and doors behind which sacred vessels were stored, the entire richly carved surface was gilded, in recognition of its symbolic place within the rituals of the Church. While the Baroque building was a common model for tabernacles at the time, this one is distinguished by the outstanding quality of the carving. In 1696, Leblond de Latour entered the Quebec Seminary to study for the priesthood. He contributed to the decoration of the chapel there and collaborated on other important church interiors in the Quebec City area.

Solar Strata

Fernand LEDUC

1958; oil enamel on canvas; 160.0 cm x 113.9 cm; The Montreal Museum of Fine Arts;
Purchase, Horsley and Townsend Bequest; Photo by Brian Merrett/MMFA

(1916-)

A brilliant choreography of geometric shapes fills the space, juxtaposing primary colours of deep red and bold blue with secondaries of hot orange and medium green. Together, these create a balanced composition that asserts the flatness of the picture plane. The small black square in the centre is countered by the openness of the white areas, while the entire composition is made dynamic by the diagonal orientation of the forms, radiating with their own inner light.

During the time that Fernand Leduc studied at the École des beaux-arts in Montreal (1938-42), modern art was highly derided: "We were told Matisse couldn't paint…Picasso couldn't draw…and then there was a Borduas exhibition…and for all of us, it was a complete revelation." Paul-Émile Borduas' exploration of Surrealist theories and abstraction opened the door to a freedom of expression embraced by Leduc and other young artists who would sign the *Refus global* in 1948. Explaining his passage from 1940s automatism to the geometric abstraction of the 1950s, Leduc said, "I am attracted by order rather than the fluid appearance of form. It's more important to discover order." In 1956, he became the founding president of the Non-Figurative Artists' Association of Montreal and participated in an exhibition at l'Actuelle, the first gallery in Canada dedicated to nonrepresentational art.

Ozias LEDUC

Boy with Bread

(1864-1955) 1892-1899; oil on canvas; 50.7 cm x 55.7 cm; National Gallery of Canada; © Estate of Ozias Leduc/SODRAC (Montreal) 2000

A young boy with a torn shirt and bare feet pauses at his meal to play the harmonica. His relaxed pose, in combination with the modesty of the setting, contributes to a feeling of peacefulness that is enhanced by the subdued palette and enlivened by the rose tones of his shirt and the gold-coloured bowl on the table. "By respectfully exalting the real," wrote Ozias Leduc, "(think for a moment that Nature must be handled gently to extract poetry), this art will necessarily add

beauty to the world (think here of the supreme goal of art)." Although grounded in the specificity of the artist's life—Leduc's young brother Ulric was the model—the painting captures a universal moment resonant with the beauty of simple existence and the pleasures of everyday pastimes.

The reverent tranquillity that permeates this painting similarly imbued Leduc's long and prolific career as church decorator for 31 churches in Quebec, Nova Sco-

tia and the eastern United States. For his own pleasure, he painted still lifes, landscapes and portraits, always in search of a beauty that would lead to a greater truth. Leduc was a primary influence on his student Paul-Émile Borduas, who would later lead artists committed to abstraction. "It is the struggle between rebel matter and thought," wrote Leduc. "It is through this struggle that human beings perfect their intelligence and penetrate even further into the order of Nature."

Fire in the Saint-Jean Quarter, Quebec, Seen Looking Westward Joseph LÉGARÉ

1845-1848; oil on canvas; 81.3 cm x 110.5 cm; Musée du Québec; Photo by Jean-Guy Kérouac/MQ (1795-1855)

An apocalyptic vision of orange flames and fiery sparks heats up the black sky in an earthly inferno as fire destroyed more than 1,300 homes in the Saint-Jean Quarter of Quebec City on the night of June 28, 1845. Presenting a panoramic view of the disaster, Joseph Légaré imposes order on chaos, structuring the composition in quadrants created by the intersection of streets in the middle ground. On the ramparts, the fresh green rectangles of grass define a safety zone

from which people watch the destruction while heaping their few remaining possessions against the stone walls. In the foreground, at the entrance to Saint-Jean's Gate, hundreds of tiny figures huddle in fear as they attempt to retreat from danger.

While the artistic potential of a scene of natural destruction was certainly not lost on Légaré and his romantic vision as an artist, his social and political conscience was also roused. He was passionate about

recording Quebec's history in his art and was active on many committees, including one to seek financial assistance for fire victims. Unlike his famous student Antoine Plamondon, Légaré never studied in Europe but taught himself to paint by copying and restoring paintings brought from France. Among his varied output of religious copies, portraits and genre scenes, his innovative landscape paintings represent his most singular contribution.

Jean-Paul LEMIEUX

Summer

(1904-1990)

1959; oil on canvas; 58.4 cm x 126.4 cm; London Regional Art and Historical Museums;
Gift of Maclean Hunter Publishing Co., Ltd., Toronto, 1960

In a vast, deserted field, the lone figure of a young girl dressed in red and illuminated from behind breaks the horizon line. Against the soft grey sky and olive-green fields, the colour of her dress seems to heighten her solitude, accentuating her separateness from her environment. The flat, even application of paint evokes a feeling of distant otherworldliness that is echoed in the girl's melancholy expression. "What fascinates me most is the dimension of time," said Jean-Paul Lemieux.

"I paint because I like to paint. I have no theories. In landscapes and figures, I try to express the solitude in which we live…I try to recall my inner memories."

Lemieux studied at the École des beaux-arts in Montreal from 1926 to 1934; during that period, he also spent some time studying art in Paris. From 1937 to 1965, he taught at the École des beaux-arts in Quebec City. In the early 1940s, his painting went through a series of changes, as he explored portraits,

still lifes and allegorical subjects. By the mid-1950s, he began focusing on solitary figures and small groups set against austere landscapes. Indifferent to his contemporaries' preoccupation with abstraction, Lemieux looked to 14th-century Italian painting and early Quebec folk art for his inspiration. "I try to convey a remembrance, the feeling of generations," he said. "I sometimes see myself as the central figure, but as a child in the continuity of generations."

186

Combat nordique Rita LETENDRE

1961; oil on canvas; 126.5 cm x 137.0 cm; Musée d'art contemporain de Montréal; Photo by MACM (1928-)

With a frenzied energy that plays itself out in the thick applications of paint and in gestural expressiveness, the canvas becomes a battlefield where hot reds challenge cool blues and bright whites struggle against the overwhelming darkness. The feeling of conflict is further accentuated by the forms the colours take—with a jagged sharpness, they assert their identity against the blackness.

Disenchanted with the teaching at the conservative École des beaux-arts in Montreal, Rita Letendre quit after a year's study and became an associate of Paul-Émile Borduas and the Automatistes, embracing their style of abstraction informed by dreams and the subconscious. In 1950, she appeared with them in the Les Rebelles exhibition and continued to explore gestural abstraction throughout the decade, exhibiting widely and drawing critical acclaim for her expressive use of colour and thick impasto. While witnessing the evolution of the work of such abstract artists as Jean-Paul Mousseau and Fernand Leduc in Montreal, Letendre also looked to New York City, admiring in particular the dramatic black-and-white paintings of Franz Kline. By the early 1960s, critics recognized the rich chaotic tension and agitation we see in *Combat nordique*, prompting one art critic to suggest that the work "seems to have emerged from a witch's cauldron, redolent with powerful images and turbulent paint."

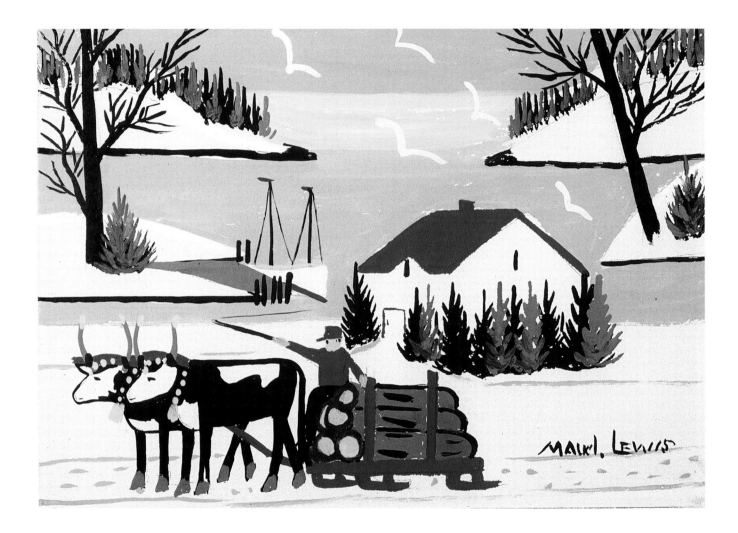

Maud LEWIS

Oxen and Logging Wagon

(1903-1970)

undated; oil on pulpboard; 26.0 cm x 35.8 cm; Collection of the Art Gallery of Nova Scotia; Gift of Louis Donahoe, Halifax, 1996

A pair of oxen wearing an elaborate harness pulls a sleigh loaded with logs along a winter road whose frozen surface makes travel easier. In the background, a house overlooks the water where a ship is moored. Painting simply and directly with a palette of bright colours, Maud Lewis has dug into her childhood memories to re-create a setting near the port of Yarmouth, Nova Scotia, where her father's business as a blacksmith and harness maker attracted steady customers from the nearby forestry and fishing industries.

Lewis's childhood had been happy, but fragile health (the result of birth defects) and the loss of family support as she grew older left her without an income. Despite the deprivations of daily life and the pain endured from her increasing infirmity—and even after her marriage to Everett Lewis, a miserly fish pedlar—she summoned her creative spirit and looked back on her youthful past for the subjects of her art. When Lewis was painting, she was happy, and she was delighted to make the meagre sums she charged for her art.

In the words of Bernard Riordon, director of the Art Gallery of Nova Scotia, "Maud Lewis…embodies the free spirit of folk artists working outside the mainstream, liberated from preconceived notions about art. By creating work that brings joy and reflects simplicity, she succeeded in illuminating the best of the human spirit."

Uprooted

1969; acrylic on canvas; 101.6 cm x 76.2 cm; National Gallery of Canada; CARfac © Collective

Ernest LINDNER

(1897-1989)

An uprooted tree spreads before us like a starfish, its purple-brown core animated by the yellow-orange colours of the torn stump. Around it, leaves, blades of grass and fragmented bits of wood create a natural mosaic that brims with vitality in the hot midday sun. Here in the forests of northern Saskatchewan, which teem with creation and decay, Ernest Lindner found a subject that conveyed his preoccupation with the cycle of life. Fascinated by minute detail and by the texture of surfaces, both of which are especially evident in his intricate nude drawings, Lindner sometimes turned to photography, using slides to magnify the specificity of nature lost in fleeting impressions. When we view *Uprooted* at close proximity, however, the photographic precision is lost as the clusters of colour and light dissolve into abstract form.

Born in Vienna, Lindner served in the Imperial Austrian Army during the First World War, and after stints as a bank clerk, a designer and a manager, he immigrated to Saskatchewan, where he worked as a farm labourer in the summer and studied art in the winter. In the early 1930s, he began teaching, influencing three generations of Saskatchewan artists. Finally, at the age of 60, he embarked with full force on a painting career, exploring his urge "[to be at] one with my environment, of belonging to the fermenting life of the forest."

Arthur LISMER

Old Pine, McGregor Bay

(1885-1969) c. 1929; oil on canvas; 82.5 cm x 102.2 cm; Art Gallery of Ontario; Bequest of Charles S. Band, 1970; Photo by Larry Ostrom/AGO

The twin trunks of the old pine rise out of the bedrock like two ancient columns, as younger branches flourish their green needles, twisting and writhing over the choppy blue water. In the sky, heavy clouds echo the dynamism of the foreground, where the energetic brush strokes and thickly painted surface evoke the rugged splendour of northern Ontario. "Nature is not beneficent," wrote Arthur Lismer in 1925. "It is ruthless, with a strange, savage beauty,

tearing down as well as building up, but destroying that it might create anew."

Born in Sheffield, England, Lismer studied there and at the Académie royale in Antwerp, Belgium, before immigrating to Toronto in 1911. Finding employment as a graphic artist at Grip Limited, he met Tom Thomson, J.E.H. MacDonald and, eventually, the other artists who would form the Group of Seven. Describing himself as "a newcomer, raw English, full

of enthusiasm," Lismer joined the artists on sketching trips to Algonquin Park, later claiming that these experiences in the Canadian bush were "turning points" in his life. As a passionate advocate of art education, he inspired countless students as the vice principal of the Ontario College of Art (1919-27), as the director of education at the Art Gallery of Toronto (1927-38) and at The Montreal Museum of Fine Arts (1941-67).

Goal Keeper

Frances LORING

1935; plaster with patina; H: 242 cm; Art Gallery of Ontario;
Gift of the Estates of Frances Loring and Florence Wyle, 1983; Photo by Carlo Catenazzi/AGO

(1887-1968)

With the classical composure of a Greek hero and a sombre soldierlike face, a seven-foot-tall goalkeeper stands ready for battle, his crossed stick breaking the symmetry of his pose. A repeated pattern of rectangles defines the front of his tunic, and his heavy gloves and bulky leg pads provide him with the armour of the sport. During the lean years of the Depression in the early 1930s, when commissions were scarce, Frances Loring created this work on speculation. Al-

though she cast it in plaster and painted it a greenish grey colour, she hoped that it would eventually be cast in bronze and erected in front of the Hockey Hall of Fame—a fate that continues to elude it.

American-born Loring studied in the United States and Europe and enjoyed a varied career. Her commissioned work ranged from war memorials and architectural sculptures to portrait busts. She and Florence Wyle, Loring's partner of more than

50 years, were among the most prominent sculptors in Canada between the two World Wars. They cofounded the Sculptors' Society of Canada in 1928, and their studio-home, an old church in Toronto's Rosedale district, became an important gathering place for artists similarly interested in the portrayal of Canadian themes in art. As Loring observed, "The best art is an expression of the life around you—you must do what you know."

Attila Richard LUKACS

Where the Finest Young Men...

(1962-)

1987; oil, tar and enamel on canvas; 427.0 cm x 484.0 cm x 3.2 cm;
National Gallery of Canada; Gift of Ira and Lori Young, West Vancouver, 1990

Working on a heroic scale and using oil paint, tar and enamel, Attila Richard Lukacs evokes the theatrical architecture and dramatic lighting of Italian Baroque painting and combines it with the depiction of a contemporary degenerate society, creating a feeling of dissonance between the style and the content of the image. Far from the military academies, "where the finest young men" enlist for an education to serve their country, the skinheads of North America, Eng-

land and Germany gather in their own ritualistic communities, secure in their fascist beliefs. Here on the scaffolding, nude booted men assume a variety of positions. Some stare with indifference at the viewer; another directs our attention to the activity below, where men in red aprons and black gloves perform a mysterious ceremony. The group on the right, dominated by the man with the ass's head, lends a satanic tone, suggesting a dark underworld existence.

Lukacs' interest in skinheads as a source for his art is as a voyeur in a marginalized site of male beauty. "What I am trying to do," he said, "is deal with the male nude in the way classical nudes have always been dealt with."

Born in Edmonton, Alberta, Lukacs went to Vancouver in 1983 to study at the Emily Carr College of Art and Design. In 1986, he moved to West Berlin, where he attracted international acclaim for his innovative approach to the male nude.

192

Symphony

Alexandra LUKE

1957; oil on canvas; 246.7 cm x 208.3 cm; The Robert McLaughlin Gallery, Oshawa;
Gift of Mr. and Mrs. E.R.S. McLaughlin, 1972; Photo by VIDA/Saltmarche, 1979

(1901-1967)

In her statement for the Canadian Abstract Painters Exhibition that she organized in 1952, Alexandra Luke wrote, "For me, colour is a very important instrument to be played like a flute or like a trumpet or like a symphony, controlled intuitively but uninhibited." In this work, a pageant of pinks, reds and yellows is balanced by an array of blues and cool greens. Like a symphony, all the colours play in harmony, eliciting an emotional response that is as large and overwhelming as is the scale of the painting itself.

In 1945, after years as a homemaker and nurse, Luke enrolled at the Banff School of Fine Arts, studying with Jock Macdonald and A.Y. Jackson. Macdonald was particularly influential in her pursuit of abstraction. He introduced Luke to Surrealism, with its dream-inspired imagery, and to new discoveries in science, encouraging her "to create from within, with no relation to natural forms." From 1947 to 1952, Luke studied in the summers with Hans Hofmann in Massachusetts, exploring colour and its relationship to music. As a result of the 1952 exhibition that toured the country, Luke met younger Toronto painters such as Harold Town and William Ronald and joined with them to form Painters Eleven in 1953. "Art is a powerful instrument," she wrote. "It should not stop with already discovered beauty but should continue searching forever."

Laura Muntz LYALL

Interesting Story

(1860-1930)

1898; oil on canvas; 81.3 cm x 100.3 cm; Art Gallery of Ontario;
Gift of the Government of the Province of Ontario, 1972; Photo by Carlo Catenazzi/AGO

In 1898, when the successful Laura Muntz Lyall painted *Interesting Story*, she had come a long way from her beginnings in rural Ontario on a farm on Lake Muskoka. Despite her family's disapproval of her artistic inclinations, regarded as "traits requiring discipline and correction," Lyall moved to Hamilton in 1881, where she studied to be a teacher while learning to paint under the tutelage of portraitist J.W.L. Forster. She had accumulated sufficient funds to travel to London, England,

by 1887, where she briefly attended the South Kensington School of Art, and then to Paris, where she enrolled at the Académie Colarossi. There, her academic study of the figure was complemented by the influence of the Impressionists, whose loose brushwork and luminous colour made an impact on her work.

Although "respectable" single women could visit cafés and walk the busy Parisian boulevards, women artists were expected to respect the "spheres of femi-

ninity," the domestic world of women and children exemplified in the paintings of Mary Cassatt and Berthe Morisot, whose work Lyall would have seen in Paris. Here, two children in their nightclothes read with quiet attentiveness as light, secured with sweeping brush strokes, pours down from the window. Lyall exhibited frequently to critical acclaim at the Paris Salon. She returned to Canada in 1898, where she continued to make a living from portrait commissions.

Portrait of Marcelle

<div align="right">

John LYMAN

</div>

c. 1935; oil on canvas; 60.7 cm x 50.5 cm; Art Gallery of Ontario;
Purchased with assistance from Wintario, 1978; Photo by Larry Ostrom/AGO

(1886-1967)

After 24 years abroad, John Lyman returned to his native Montreal in 1931 and declared that "the essential qualities of a work of art lie in the relationships of form to form and of colour to colour. From these, the eye...derives its pleasure and all artistic emotion." Lyman's philosophy was rooted in his Paris training and, principally, in the six months spent in the Académie Matisse in 1909, where he learned that painting was an art of sensation and that the combination of colour, line and shape was the carrier of "aesthetic feeling."

In *Portrait of Marcelle*, a woman looks up from her reading with a pursed expression. We are struck by the bold contrasts set up by the dark green of her hat and scarf that is punctuated with a yellow-green colour, repeated in her shirt. In emphasizing the rose-red tones of his subject's skin, Lyman establishes an eccentric play of complementary colours that challenges the equilibrium of the composition.

A vociferous critic of the Group of Seven's domination of the Canadian art scene, the financially independent Lyman opened the Atelier in 1931 and, in 1939, founded the Contemporary Arts Society, an association of young artists committed to free artistic expression and to the cause of international modernism. These advances would later pave the way for the artistic revolution led by Paul-Émile Borduas and the Automatistes.

James Edward Hervey MACDONALD

The Tangled Garden

(1873-1932)

1916; oil on beaverboard; 121.4 cm x 152.4 cm; National Gallery of Canada;
Gift of W.M. Southam, F.N. Southam and H.S. Southam, 1937, in memory of their brother Richard Southam

In this large canvas, J.E.H. MacDonald depicts the late-summer garden of his home in Thornhill, Ontario, then a small farming community north of Toronto. Amid the tangle of rich green foliage and brightly coloured flowers, the sunflowers hang their heavy heads, illuminated by a streak of sunshine that penetrates the fragrant abundance. In the background, the wooden siding of the house provides a restful horizontal pattern that balances the intensity of the foreground. When exhibited in 1916, this painting sparked a famous controversy. The art critic from *Saturday Night* magazine accused MacDonald of throwing "his paint pots in the face of the public," while *The Toronto Daily News* reported that the painting looked "like a huge tomato salad." With characteristic aplomb, MacDonald replied: "It would seem to be a fact that in a new country like ours, which is practically unexplored artistically, courageous experiment is not only legitimate but vital to the development of a living Canadian art."

He was not alone in his attempt to develop a distinctly Canadian art. Following MacDonald's exhibition of rural landscapes at the Arts and Letters Club in 1911, Lawren Harris declared that the paintings captured "an indefinable spirit which seemed to express the country more clearly than any painting [he had yet seen]." This admiration for MacDonald's work

196

Falls, Montreal River

1920; oil on canvas; 121.9 cm x 153.0 cm; Art Gallery of Ontario; Photo by Larry Ostrom/AGO

led to a friendship and a subsequent meeting between Harris and MacDonald's colleagues at the commercial design company of Grip Limited, some of whom would later form the Group of Seven.

Falls, Montreal River was exhibited in the first Group show at the Art Gallery of Toronto in 1920 and is based on sketches that MacDonald made in 1918 and 1919 during the so-called boxcar excursions to Ontario's Algoma region east of Lake Superior. Equipped with bunks, a stove and a water tank, the boxcar was hauled to chosen destinations by a freight train and then shunted onto a side line from which the artists scouted their painting places.

A.Y. Jackson described MacDonald as "a quiet, unadventurous man who could not swim or paddle, swing an axe or find his way in the bush, [but he was] awed and thrilled by the landscape of Algoma...he loved the big panorama." Here, an energetic torrent of line and colour cascades before our eyes as the white water of the falls tumbles turquoise in a sinuous path to the swirling blue river below. The dense forest on each side of the river creates a mosaic of colour that all but blocks our view of the sky in the far distance. For MacDonald, the wild magnificence of Algoma, where he sought "to paint the soul of things, the inner feeling rather than the outward form," filled him with "something of the feeling of the early explorers."

J.W.G. "Jock" MACDONALD

Iridescent Monarch

(1897-1960)　　　1957; oil, acrylic resin, Lucite 44 and sand on hardboard; 105.7 cm x 121.8 cm; Art Gallery of Hamilton; Gift of the Canada Council, 1960

Singular organic shapes juxtaposed by concentrations of thick black lines float across the picture plane, displaying a harmonious arrangement of orange-reds, greens and yellows. Here, Jock Macdonald experiments with new quick-drying paints, which add a shimmering translucency to the colour, enhancing his vision of an inner world informed by scientific discoveries that raised questions about the essence of reality. In his 1940 lecture "Art in Relation to Nature," he said: "Art now reaches the plane where it becomes the expression of ideals and spiritual aspirations. The artist no longer strives to imitate the exact appearance of nature but, rather, to express the spirit therein."

In 1922, the Scottish-born Macdonald graduated in textile design and wood carving from the Edinburgh College of Art. He immigrated to Canada in 1926 to teach at the Vancouver School of Decorative and Applied Arts. There, he met F.H. Varley, under whose guidance he began to paint in oils. Although his early work embodied the study of visible nature, Macdonald was influenced by the writings of Russian artist Wassily Kandinsky and by the teachings of theosophy, and he sought a spiritual expression in his art. After a brief sojourn in Calgary (1946-47), Macdonald moved to Toronto, where, in 1954, he joined Painters Eleven. There, Macdonald's imaginative powers coalesced, and he produced his most significant body of work.

Lost River Series, No. 12

Landon MACKENZIE

1981; acrylic on canvas; 198.7 cm x 228.5 cm; Art Gallery of Ontario; Photo by Carlo Catenazzi/AGO

(1954-)

In the centre of a dark landscape that seems to extend to infinity, a lone creature pauses to drink from a pool whose waters create a pink effervescent ripple. The imaginary animal finds its own reflection in the deep shadows of the water and hovers close to the fish and colourful red plant life that thrive beneath the surface. The isolation and vulnerability of the animal are enhanced by a mound of white that evokes snow, while a ribbon of blue encloses it protectively from the boundless secrets of the empty landscape.

Landon Mackenzie's Lost River series was inspired by several Yukon river trips she took over three summers in the late 1970s and early 1980s. Her realization of the fragility of the natural environment moved her to create an allegory of powerlessness and lost innocence in the face of ecological destruction, a theme symbolically extended to the alienation of humanity from nature. As Mackenzie observed, "You learn that you're just a very frail human being trying to exist in a much larger ecosystem where you're not the ruler, the grizzly bear is…Living there forced me to address fears."

The Lost River series won first prize in the Third Quebec Biennale of Painting in 1981, launching a career in which Mackenzie continues to map abstract-dream territories, to probe the mystery of the land and to chart the isolation of the individual.

Pegi Nicol MACLEOD

Self-Portrait with Flowers

(1904-1949)

c. 1935; oil on canvas; 91.4 cm x 68.7 cm; The Robert McLaughlin Gallery, Oshawa

In an unconventional self-portrait, Pegi Nicol MacLeod gives us a fragmented view of her nude torso nearly overwhelmed by the tangled profusion of plants and flowers in her lap. The spirit and energy of this painting, with its eccentric perspective that incorporates her hand large on the left and a foreground writhing with colour and line, are typical of the imaginative exuberance and passion for life that the artist brought to her work. Years later, art critic Graham

McInnes commented that owning a painting by Nicol MacLeod was "like smelling daffodils in winter."

Nicol MacLeod studied with Franklin Brownell in Ottawa, followed by a year at Montreal's École des beaux-arts. Her landscape paintings of the late 1920s revealed her admiration for the Group of Seven artists, and she later defined her own voice in spontaneous, loosely brushed and vibrantly coloured images of everyday life. In 1937, she moved to New York

City but returned to Canada each summer. Hired in 1944 to portray the activities of the Canadian Women Services, she created a vivid record of the on-and-off-duty reality of the women's war effort. On the occasion of Nicol MacLeod's memorial exhibition in 1949, Vincent Massey, then chair of the board of trustees at the National Gallery of Canada, praised the original style that sprang from "her impulsive nature and…her unreserved love of humanity."

Siamese Twins

Medrie MACPHEE

1987; oil on canvas; 178 cm x 147 cm; Collection of the artist

(1953-)

Here, the anticipated ugliness of a deserted industrial site has been transformed by the beauty of a monumental painted surface and the anthropomorphizing of mysterious machinery. In the foreground, small and large funnels are stacked upon each other like a head and body whose pipe arms salute its shadow with a certain whimsy. The shadow's identical shape and attachment (at the hat) confer the meaning of the title. The combination of luminous colours, deep shadows and vigorous, decisive drawing invites us to see these derelicts of industry in a humane way, arousing our respect for the contemporary ruins and allowing us to see them as living remnants of our own civilization to be revered as those from antiquity. Inspired by the views of deteriorating factories now deemed useless, Medrie MacPhee considers these sites "secret places… They embody the feeling of heroic fiction. Now there's a kind of pathos about it, something very compelling."

Born in Edmonton, Alberta, MacPhee studied at the Nova Scotia College of Art and Design and in Regina. In 1976, she moved to New York City, where her attraction to the towering architecture of the city solidified her admiration for the art of Edward Hopper and themes of urban solitude. Interviewed in 1999, she commented, "To a certain extent, I think my whole body of work has been a long meditation on survival, personal and public."

Lani MAESTRO

Cradle

(1957-)

1996; mosquito netting, woven palm mats and sisal; dimensions vary; Collection of the artist

Lani Maestro's work fills a room with woven palm mats and mosquito-net sleeping tents, whose lines of suspension weave and crisscross through the space with the impenetrable delicacy of a spiderweb or the beguiling configurations of the string game "cat's cradle." For Maestro, who was born and raised in the Philippines, the materials and diaphanous gentleness of *Cradle* are potent with memories of her homeland, of the tents as a place of dreams and of the presence of her *nanay*, or "heart mother," who nurtured her through childhood. The ethereal walls of the tents evoke the fragility of life, while their emptiness alludes to death and the absence of the body. To leave the tent and the protectiveness of dreams is to be exiled from the womb, the mother and the country, empowered to remember and to wander in the maze of intersecting existences elsewhere.

Speaking of the feminism in her art, Maestro said, "I am aware that I am unravelling certain power relations between myself and the work, between the work and the viewer, between the viewer and culture… There is a kind of decentring that happens here, where positions are exchanged and where there is no fixed or static place. I like this circularity…I try to do this both formally and conceptually." Maestro studied in the Philippines (1977) and at the Nova Scotia College of Art and Design (1988).

Dorothy, a Resemblance

Liz MAGOR

1981; lead and steel; 90.0 cm x 121.5 cm x 86.0 cm; National Gallery of Canada

(1948-)

Four steel tabletops mounted on springs to enable them to function as scales support an assortment of cast-lead objects, such as fish, candles, slices of bread and lightbulbs, evoking a sculptural still life. On closer inspection, we see that one object on each table is stamped with the words "I have always weighed 98 lbs.," while texts on other objects account for variations in this weight over the years. The relationship between the printed messages and these disparate sym-bols of life and survival lies in Liz Magor's encounter with Dorothy, a real person who told her life story in terms of her weight. These fluctuations, embodied in the varying poundage of the objects on the tables, were the way she remembered incidents in her life. As Magor explains, "Of course, she was still herself when she weighed less or more, but not so completely herself."

Central to this work is Magor's preoccupation with the question of identity and the inadequacies of verifiable information, such as weight or other external descriptions, to portray the reality of one's inner life and the complexities of human experience. The artist's use of lead, which is stable and permanent, to repre-sent objects that are, in reality, ephemeral lends a note of irony. Magor was born in Winnipeg, Manitoba, and studied at the University of British Columbia, the Parsons School of Design, in New York City, and the Vancouver School of Art.

David MARSHALL

Evolution

(1928-)

1978; marble; H: 50.0 cm, W: 35.5 cm, D: 21.0 cm; Vancouver Art Gallery,
Director's Discretionary Fund VAG 95.6; Photo by Teresa Healey

Intrigued with the idea that life evolves from inert matter, David Marshall worked slowly and precisely on *Evolution*, releasing traces of a human form from the geometric solidity of the marble. The two round eyes express wonderment as the vertical thrust of the figure splits the horizontal rectangle with organic necessity. The smooth finish of the stone with its petrified veins of minerals suggests the deliberate progression of nature, caught up in its secret and irrepressible process

of transformation. Responding to the timeless simplicity of Marshall's work, a critic writing in *The Vancouver Sun* in 1978 felt that the works evoked "archetypal figures… ancient faces…[and] artefacts from a forgotten culture."

In developing this marriage of ancient and modern form, Marshall admired the sculpture of avant-garde artists such as Constantin Brancusi and Henry Moore, who themselves were inspired by the so-called primitive art of Africa, Asia and Mexico. Attracted to its expres-

sive simplicity, the artists forged a new sculptural language that bridged modernist abstraction with figuration.

Marshall was born in Vancouver and began his studies in the late 1940s at the Ontario College of Art and the Vancouver School of Art. From 1953 to 1954, he studied at the Heatherly School of Fine Art in London, England, during which time he met Moore, whose passion for a truth to materials fostered Marshall's own desire to reveal the character of stone, wood and bronze.

Bright Red No. 8 Ron MARTIN

1972; acrylic on canvas; 213.3 cm x 182.8 cm; National Gallery of Canada (1943-)

In the early 1970s, Ron Martin embarked on a cycle of monochromatic paintings in red, blue, yellow, green, white and, after 1974, black, which communicated his belief that "painting is a reality in itself instead of just a vehicle to imitate reality." The 1972 series of 24 Bright Red paintings was made under precise predetermined conditions: specific quantities of paint, uniformity of canvas size—the dimensions reflecting the distance the artist could extend his arms across the canvas—and perpetual performance (Martin painted continuously until the two gallons of paint per painting were used up).

Bright Red No. 8 reflects the broad, sweeping movements of the artist's brush as he reaches up and across the canvas or, bending down and stretching, uses his fingers in places to draw rhythmic patterns of line that emphasize the rich viscosity of the paint. The bright red colour invites personal associations, while the vitality of the surface leaves the viewer untethered, self-consciously confronting a mysterious and unfamiliar image, thus fulfilling Martin's ambition to "make a painting that is primarily about the experience of the experiencer."

Martin was born in London, Ontario, and studied at Beal Technical School from 1960 to 1964. In 1977, he and sculptor Henry Saxe represented Canada at the Venice Biennale.

John MAX

Untitled, from the series Open Passport

(1936-) 1972; gelatin silver print; 48.0 cm x 32.5 cm; Courtesy Canadian Museum of Contemporary Photography

An urban sunbather stretches out on the pavement, whose rough surface texture is echoed in the photograph's graininess, which subverts the anticipated sensuality of exposed flesh. Observing the figure from a low perspective, John Max explores the organic rhythms of the body, as the woman's thighs loom like large tubular forms and her torso recedes into the background, a sequence of familiar shapes and mounds.

This work is from the 1972 exhibition Open

Passport, in which Max assembled 160 photographs representing the journey from birth to old age in a subjective documentary style that combined intimacy and universality boldly expressed with deep shadows and dramatic contrasts. "I photograph the inner state," wrote Max. "These images of friends, family…strangers on the street reflect my being, conscious and unconscious." Reviewing the work, a critic from *The Gazette* in Montreal wrote: "He destroys stereotypes. He

shows the beauty and intensity of ugliness. He shows the human reality of the body, of the full-hipped, firm-breasted, narrow-waisted women that are among his best-loved images."

Born in Montreal of Ukrainian parents, Max studied painting with Arthur Lismer. His encounter with the street photography of German-born Lutz Dille in the early 1950s sparked his lifelong use of the camera as a means of aesthetic expression.

Loophole through the Blue

Jean MCEWEN

1961; oil on canvas; 193 cm x 153 cm; The Montreal Museum of Fine Arts; Gift of Mr. and Mrs. Gérard O. Beaulieu; Photo by MMFA (1923-1999)

The first impression of Jean McEwen's *Loophole through the Blue* is of a painting that is both ancient and modern, its lapis lazuli surface burnished and eroded by time, revealing the red, brown and gold underpainting. McEwen layered colour, superimposing transparent and opaque paint, varying margins, edges and internal divisions to create dynamic, luminous compositions. Divided by a central axis, the near symmetry of this work suggests two doors, firmly closed upon their

secrets. The poetic quality of McEwen's work reflects his own lifelong commitment to writing. He assigned lyrical titles to his paintings, not as literal equivalents but for poetic evocation, obliquely summoning an emotional response. In his book, *Cul de lampe*, McEwen wrote, "A painting is created from rhythm, form, space, light, shade and colour—but it is the feeling, the poetry of the painter that produces the harmony."

Self-taught as an artist, McEwen graduated in

pharmacy from the University of Montreal in 1947. In 1951, he went to Paris, where he became enchanted with the light-filled canvases of the Impressionists and encountered Jean-Paul Riopelle and abstract artist Sam Francis, whose harmonious use of colour appealed to his fascination with light in painting. McEwen was acclaimed as an "abstract impressionist," and his painterly approach to colour and the dynamics of space was as innovative as it was unique.

207

John MCEWEN

<div align="right">Boat Sight</div>

(1945-) 1984-1985; flame-cut steel, life-sized animal silhouettes, limestone, locking stone; National Capital Commission;
Courtesy of the artist and Olga Korper Gallery; Photo by Robert Keziere

Approaching John McEwen's *Boat Sight*, situated in Hull, Quebec, just above the Chaudière Falls on the Ottawa River, one is startled by the large metal frame of a boat whose stark linearity contrasts with the silhouetted shapes of two flame-cut steel animals nearby. The striding wolf moves nonchalantly toward the boat; the dog looks alertly over the river, now a panorama of industry. While the hollowed-out vacancy of the boat suggests death and hints at past civilizations, its indus-

trial elegance, like a drawing in space, is clearly modern.

This presentation of animal figures in relationship to nature and a constructed element is characteristic of McEwen's "slow cinema," a gradual unfolding of connections to be discovered as viewers circulate between the parts of the work. "One stands…between two very different objects," said McEwen, "between the container and the animal, between the container of culture and the life of the animal." Here, the animals'

cautious and curious response to the boat, an object of intrusion in nature, suggests a world of lost innocence that is mirrored in their stone platform, designed to resemble a dried-up riverbed, the site of the original waterway, before the advent of industry.

McEwen studied at the Ontario College of Art from 1966 to 1970. In 1972, he bought a blacksmith's shop, where he creates metal sculpture for public places, both national and international.

Cobalt

Yvonne MCKAGUE HOUSSER

1931; oil on canvas; 114.8 cm x 140.0 cm; National Gallery of Canada

(1897-1996)

The northern Ontario mining town of Cobalt was in decline when Yvonne McKague Housser visited in the early 1930s, but she was charmed, nevertheless, by the chaotic rhythm of the quickly assembled houses, the narrow staircases and the twisting streets and alleys that wove between the buildings. She wrote: "People sometimes say to me, 'What on earth do you see in those ugly mining towns?' But there is something romantic about a mining shaft against a northern sky…and about the big mountainlike slag heaps." Expressing her pleasure with her subject, she creates a quirky architectural mosaic of yellow, green and red houses, whose angular stockiness contrasts with the willowy telephone poles cutting the horizon line. In the distance, the colours of the palette become grey and more subdued as we approach the deserted mine shafts and accumulations of industrial waste.

McKague Housser was born in Toronto and stud-ied first at the Ontario College of Art and then for a few years in Europe. By the early 1920s, she was teaching at the Ontario College of Art with Arthur Lismer and F.H. Varley. But in her own work, McKague Housser was attracted to the example of Lawren Harris's urban paintings. Although she sketched in Quebec and the Rocky Mountains, her most dis-tinct contribution remains her depictions of the desolate mining regions.

Art MCKAY

Flux

(1926-) 1964; latex and stovepipe enamel on hardboard; 121.5 cm x 121.5 cm; The Edmonton Art Gallery Collection; Photo by Eleanor Lazare

A rose-hued circular image sits on a square white background, whose flat scraped surface creates an almost photographic illusion of depth. Lines and bands of tonally varied colour meet in the centre and, at their point of convergence, lose their focus in a smudge of colour. Shape and colour combine in an image of balance and peaceful serenity, slowing us down and inviting our contemplation.

Art McKay studied in Calgary (1946-48), in France (1949-50) and at Columbia University in New York City and the Barnes Foundation in Pennsylvania (1956-57), where he was introduced to the writings of philosopher John Dewey. At about the same time, his passion for Zen Buddhism shaped his view of experience in terms of oppositions, such as inner and outer experience. McKay moved to Regina in 1950, and his interest in abstract painting was enhanced by his contact with American artist Barnett Newman and art critic Clement Greenberg at the Emma Lake workshops in Saskatchewan between 1959 and 1962. For the Regina Five exhibition that toured Canada in 1961, McKay wrote: "I do not title paintings by personal and poetic association to various experiences in the past…The sort of world which I find absorbing is not the static objective world of things…It is the continuum of sensed qualities: moving, flowing and constantly in process and flux."

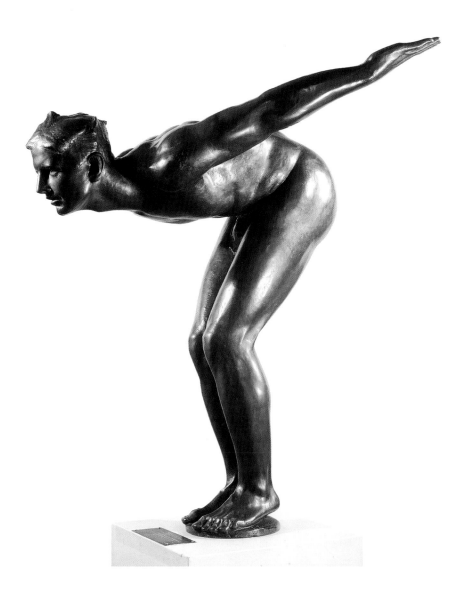

The Plunger

Robert Tait MCKENZIE

1925; bronze; H: 65.1 cm; Art Gallery of Ontario; Gift of Mrs. Thomas Bradshaw, 1950

(1867-1938)

Balanced on the balls of his feet, thigh muscles taut, back curved and arms poised to cut through the water like a knife, the youthful diver waits at the beginning of a race. "Physical perfection," said R. Tait McKenzie, "is as difficult to define as the truth." But it was that representation of physical perfection, as it was adapted to sport, which became the lifetime pursuit of this doctor-artist.

McKenzie was born in Almonte, Ontario, gradu-ated as a medical doctor from Montreal's McGill University in 1892 and, in 1894, was appointed its first medical director of physical training. At about the same time, he began to develop his artistic ability, sketching and learning the rudiments of relief sculp-ture from Louis-Philippe Hébert. In 1904, he became director of physical education at the University of Pennsylvania, where opportunities to observe aspiring competitors provided him with models for his sculpture.

Inspired by classical Greek art, in which a similar admiration for athletic prowess was preserved in sculpture, McKenzie believed that art should reflect its times. He stated in a lecture in 1922 that "no art can depict our time without giving a large place to its athletics." Using his knowledge of human anatomy to inform his artistic endeavours, McKenzie studied the shape of the modern athlete, exploring increasingly challenging poses of physical efficiency.

Isabel MCLAUGHLIN

Tree

(1903-)

1935; oil on canvas; 203.5 cm x 92.0 cm; National Gallery of Canada

Here, a colossal tree looming up from a bed of weeds and Queen Anne's lace towers against the cool grey sky. Its deeply furrowed bark encases it in a protective armour as its twisted clawlike branches embrace the hostile beauty of early winter. In a review a few years earlier, one art critic praised Isabel McLaughlin as "one of the boldest young woman painters we have…Her compositions are intensely modern in feeling…characterized by real power, together with originality of expression and a fine structure."

The daughter of the president of General Motors Canada, McLaughlin began her studies in Paris (1921-24) and later studied at Toronto's Ontario College of Art under Arthur Lismer, whose expressive use of line had an enduring impact. When Lismer left the college, however, McLaughlin became dissatisfied with its conservative teaching. She and several colleagues then founded their own Art Students' League, named after the New York school. Renting a space near the Art Gallery of Toronto, they invited the city's leading artists, such as Lismer, Lawren Harris and A.Y. Jackson, to give weekly critiques of their work. Later, Jackson wrote of McLaughlin's founding role in the Canadian Group of Painters in 1933: "…reserved, shy of acclaim, paints a naturalist's world…She has been a moving spirit in keeping the Group alive, and we are very much indebted to her."

Hunter/Hunted

Gerald MCMASTER

1990; acrylic and oil pastel on mat board; 96 cm x 116 cm; Courtesy McMichael Canadian Art Collection; Private collection

(1953-)

In a field of dreams, the profiles of dark blue buffalo that resemble native pictographs blanket the surface of the mat board and are obliterated in the centre by the figure of a blue cowboy characteristically capped and a red shaman with buffalo horns. The cowboy is shaded and modelled to evoke three-dimensional form, as in the European tradition, while the shaman is painted flat like the buffalo. Gerald McMaster explained: "The two figures viewed the buffalo quite differently.

The buffalo gave the Indian not only its body but its spirit—in the transformation, the man became the buffalo itself…What is stronger here physically? What is stronger here spiritually?"

In the distance, the smooth horizon of the rosy landscape and the large symbolic hailstones speak of the ancestral past, while the splattering of colour in the foreground suggests the spilled blood of buffalo driven to the brink of extinction and the

shattered existence of the assimilated First Nations.

A Plains Cree, McMaster was raised on the Red Pheasant Indian Reserve in northwestern Saskatchewan. He studied at the Institute of American Indian Art, in Santa Fe, New Mexico; the Minneapolis College of Art and Design; Carleton University, in Ottawa; and the University of Amsterdam. He continues to explore issues of identity for native peoples as both an artist and a writer.

Helen MCNICOLL

The Apple Gatherer

(1879-1915)

c. 1911; oil on canvas; 106.8 cm x 92.2 cm; Art Gallery of Hamilton; Gift of G.C. Mutch, Esq.,
in memory of his mother, Annie Elizabeth Mutch, 1957; Photo by Robert McNair

The hot, flickering sunshine virtually radiates from this canvas, where the apple gatherer, silently absorbed in her task, stands juxtaposed against a fluttering pattern of leaves rendered with blunt, energetic strokes loaded with blues and greens. Below, long, spiky strokes describe the green-grey fields that give way in the distance to a shimmering yellow expanse. The apple gatherer herself is a symphony of colour as the deep mauve shadows in her clothing play against the unshaded patches of light filtering through the trees. When this work was exhibited in Montreal in 1911, Helen McNicoll attracted critical acclaim. *The Gazette* praised its "quality of open-air sunshine disarming all thoughts of labour in the studio."

Born into a wealthy Toronto family, McNicoll studied with William Brymner at the Art Association of Montreal from 1899 to 1902, then spent two years at the Slade School of Art in London, England, where figure studies were complemented by an exploration of the gestural, light-filled expression of British Impressionism. In 1905, she left for St. Ives, Cornwall, to study with Algernon Talmage, who advocated painting *en plein air* and, in the summer, held classes in a nearby orchard. Deaf since childhood, McNicoll pictured a hushed, luminous world of women and children quietly engaged in the labours and leisure of everyday life.

On the Road Sax

Eric METCALFE

1972-1974; case: wood, leopard-skin wallpaper; saxophone: red cedar hand-painted with kazoo mouthpiece;
H: 13.5 cm, L: 82.0 cm, W: 34.0 cm; Vancouver Art Gallery Acquisition Fund VAG 91.55 a-b; Photo by Holly Hames

(1940-)

Eric Metcalfe's childhood passion for comic books led to his creation of fantasy cartoons and of the character Dr. Brute—an imaginary persona that he would later adopt as his alter ego in performances and videos in which he critiqued culture and society. Following his studies at the University of Victoria, Metcalfe turned his back on traditional art forms and joined a wave of Vancouver artists who opposed the uniqueness and commercial commodification of art. He embraced,

instead, the ephemeral aesthetics of "mail art," where artists assumed fictional identities and exchanged images by correspondence. In 1970, Metcalfe and his collaborator Kate Craig began to collect thousands of images that featured objects covered with leopard spots. The leopard-spot motif was, for Metcalfe, a "universal image symbolizing both power and banality," an animal camouflage that evoked a sexualized exotic.

Inspired by Roy Kiyooka's painted and laminated

cedar sculptures, Metcalfe carved his first saxophone in 1972 and painted it with leopard spots. *On the Road Sax*, with its chintzy fake-fur carrying case, encapsulated the lowest forms of consumer culture and deliberately challenged conventional definitions of art. Fitted with a kazoo, the wooden saxophone could also be used by Metcalfe as Dr. Brute in performances. A founder in 1973 of the Western Front, Metcalfe continues to work collaboratively, probing the veneers of society.

215

Gilles MIHALCEAN

The Shower (To the Memory of François)

(1946-) 1987; metal, wood, glass, plaster, plastic, granite, wax, oil paint and metallic paint; 284 cm x 975 cm x 53 cm; National Gallery of Canada

Like a poet who employs words to create a poem, so Gilles Mihalcean uses words as departure points for his sculpture, assembling a rhythmic series of images that unfurl like visual poetry. In *The Shower*, we follow a line composed of an assortment of objects and materials that conjure memories of rain. "It assumed the form of a road," explained Mihalcean. "Over the course of a year, I placed, built and displaced the day's various fabrications with found objects, seeking

to constantly associate so as to find a continuity, a breath, a sculpture which would gather in one fell swoop the landscape in my wake."

With a refreshing spontaneity, Mihalcean constructs metaphors associated with rain. The French expression that translates "it's raining nails" finds its equivalent in a row of iron nails standing on their heads. The literal humour of this gesture quickly subsides when we see them in line with a small church, a syringe, a bullet

and an oilcan, where they serve as allusions to religion, medicine, war and other images of power and authority. The artist's use of materials furthers his exploration of the shower—glass suggests its transparency, granite its heaviness. "The materials exploded," wrote Mihalcean. "From cast iron to stone, from wax to wood, they became confounded…chasing each other about to hide…behind the metal casting, the carving, the modelling and beneath the umbrella of my heart."

Box MI'KMAQ ARTIST

c. 1850; birchbark box with dyed and woven porcupine quills; 19.0 cm x 22.5 cm x 15.0 cm; Glenbow Collection, Calgary, Canada

The arrival of European fishermen, explorers and settlers around 1500 gradually disrupted the ancestral ways of the Mi'kmaq, who had inhabited what are today's Maritime Provinces for thousands of years. Not only was there new competition for the area's natural resources, but between 1600 and 1700, diseases from Europe reduced the native population by 90 percent. After 1700, as a testimony to their fortitude, the Mi'kmaq women used birchbark decorated with dyed quillwork to fashion commodities catering to European taste. Objects such as chair seats and backs, lamp shades, fire screens, tea cosies and small containers became a major source of exchange and income for their impoverished makers.

While other native peoples employed birchbark and quills to embellish objects, the Mi'kmaq are recognized as the originators of this technique and are acclaimed for their innovative and intricate geometric designs. In a box collected by an Englishman around 1850, porcupine quills, dyed with homemade or commercial colours, were inserted into holes in the birchbark. The quills were then cut and sewn into complex designs with thread made from the long, thin roots of the black spruce, debarked and split to the required delicacy. Classified as "souvenir craft," because such objects were made solely for trade, the box, with its trompe l'oeil depiction of space in the pattern on its side, is surely the essence of an artistic imagination.

David MILNE

Billboards

(1882-1953)

c. 1912; oil on canvas; 51.2 cm x 56.5 cm; National Gallery of Canada; Gift of Douglas M. Duncan, Toronto, 1962

Born in Paisley, Ontario, David Milne began his study of art by correspondence. In 1903, he moved to New York City to work as a commercial illustrator and studied at the Art Students League, where he received instruction from teachers such as Robert Henri and William Chase, who were renowned for their loosely brushed, highly coloured scenes of everyday urban life. Of central importance to Milne in his decision to become a painter were the exhibitions of modern

European art at Alfred Stieglitz's gallery "291." Reflecting later on the work he saw there, Milne wrote: "In those little rooms under the skylights, we met Cézanne, Van Gogh, Gauguin, Picasso, Brancusi. For the first time, we saw courage and imagination bare, not sweetened by sentiment and smothered in technical skill."

In *Billboards*, the brilliant sunlight appears hot white on the awnings and façades in a New York City

street scene. In the foreground, the horses and wheels of the carriage, together with the tall pair of leafless trees, break the dominant grid of the architecture and colourful billboards. The space is shallow and compressed, and the emphasis on individual brush strokes accentuates the flat surface of the canvas, confirming Milne's commitment to a modernist aesthetic that valued the dynamic arrangement of form and colour over precise detail. Although Milne was beginning to

218

Waterlilies and Sunday Paper

1928; oil on canvas; 51.5 cm x 61.6 cm; Hart House Permanent Collection, University of Toronto; Photo by Thomas Moore

attract critical attention, the expense of living in the city without a regular income from commercial art prompted his move, in 1916, to Boston Corners in Upstate New York, where landscape painting became his primary focus.

In 1917, Milne joined the Canadian Army, and in May 1919, he received a commission from the Canadian War Memorials Fund to record the aftermath of the war in Europe. He returned to the United States

in late 1919, where he continued to live until the spring of 1929, when he moved back to Canada. Camping near Temagami, a mining village northwest of North Bay, Ontario, he often worked in a deserted prospector's cabin, arranging the local flowers and other objects as subjects for his paintings.

In *Waterlilies and Sunday Paper*, Milne uses delicate lines and an almost transparent paint to depict a bowl and a jar of white-petalled water lilies that cre-

ate a starlike pattern against the grid of the Sunday newspaper opened to the comics. On the right, a bottle with flowering branches offers a tighter concentration of line and colour and extends the play of lightness and translucency in the depiction of the water-filled glass containers. "Do you like flowers?" wrote Milne. "So do I, but I never paint them. I didn't even see the hepaticas. I saw, instead, an arrangement of the lines, spaces, hues, values and relations that I habitually use."

MISSISSIPPIAN ARTIST

Buffalo Effigy

1000-1500; green quartzite; 14 cm x 25 cm; Glenbow Collection, Calgary, Canada

As early as 8000 B.C., the Plains Indians, in their pursuit of the buffalo, wandered the prairies from southern Manitoba and the Mississippi River westward to the Rocky Mountains and as far south as Texas. Until the late 19th century, the buffalo moved in enormous herds numbering in the millions and provided meat for food and hide for clothes, tipi covering, moccasins and shields. The hooves, horns and sinew furnished materials for tools, utensils and sewing, and the dung was used for fuel on the treeless prairies. As a ritualistic culture indebted to the spirits and sacred powers of the earth, sky and sun, the Plains people revered nature's bounty and depended on the gifts of power transferred to them by animal spirits.

Plains Indian sculptors fashioned wood and stone effigies of the wildlife they encountered. Buffalo, elk, the bear and, later, the horse were common subjects. These were not idols for worship but, rather, objects used in ceremonies to evoke the power residing in the animal spirit in order to assure a favourable hunt. This buffalo effigy, with its distinct shoulder hump, large mane of hair and bulky body, was found in a farmer's field near Ardmore, Alberta, and was carved from green quartzite with stone chisels. Its worn-down horns and stumpy legs suggest that it was used for generations and, despite its weight, was treasured as a sacred object of these nomadic people.

Rhythmic Mutation No. 9 Guido MOLINARI

1965; acrylic on canvas; 203.2 cm x 152.4 cm; National Gallery of Canada; © Guido Molinari/SODRAC (Montreal) 2000 (1933-)

In *Rhythmic Mutation No. 9*, we are confronted with a large work where a dynamic series of vertical coloured stripes vibrate one against the other, holding tight to the flatness of the canvas, so there is no illusion of volume or depth nor is there a traditional figure-ground relationship. Hot and cold colours of uncommon temperatures keep each other in check and invite the viewer to discover the constantly changing relationships. In a 1977 interview, Guido Molinari said,

"I'm trying to communicate the power, the potential of colour, of colour sequence, of colour energy and specifically the possibility of the viewer to become aware that he is the operator."

Molinari, who was educated at the École des beaux-arts in Montreal and influenced by the advances made by Paul-Émile Borduas in the realm of abstraction, sought an alternative to the "automatist credo." Following on the heels of the first Plasticiens, who fo-

cused on a rational geometric approach to abstraction, Molinari went further, seeking a more radical purification of the elements of art and a hard-edge form of expression. Inspired in this area by the achievements of European artists such as Piet Mondrian, Kasimir Malevich and Wassily Kandinsky and aware of the innovations of American artist Barnett Newman, Molinari sought to purge his art of all figuration, as he said in 1955, "to destroy volume by using the plane."

Ron MOPPETT

All I Know (Ark)

(1945-) 1989; oil on canvas; 165.1 cm x 476.9 cm; National Gallery of Canada; Gift of John R.C. Aitken, Calgary, 1995

The words "A Diamond Exchange" span the width of this canvas in a narrow ribbon that borders a blue space suggesting water, as other seemingly disparate objects float on its surface. We encounter the outline of a chair, a branch, numbers, a large shape that looks like an x-ray of a foot, small profiles of purple pipes and the depiction of a star-filled sky.

Ron Moppett acknowledges the autobiographical character of his work: "I paint the things that I know,

that are around me. They're very romantic and have to do with the artist in the studio, self-portraits, and so on." Indeed, when examined in the context of Moppett's life in 1989, the objects are symbolic of his personal circumstances: The numbers, for example, represent his age; the chair and starry night refer to his fascination with Van Gogh. The pipes could be Moppett's, then a pipe smoker. The word "ark" in the title suggests Noah's floating vessel, which saved those

aboard from the deluge. Perhaps for the artist, this "ark" is a gathering of things of value, which gives them immortality in art.

Moppett was born in England and settled in Calgary with his family in 1957. He studied at the Alberta College of Art (1963-67) and at the Instituto Allende in Mexico (1968). He has been an influential figure on the Calgary art scene since the 1960s, and in 1997, he won the Gershon Iskowitz Prize for visual art.

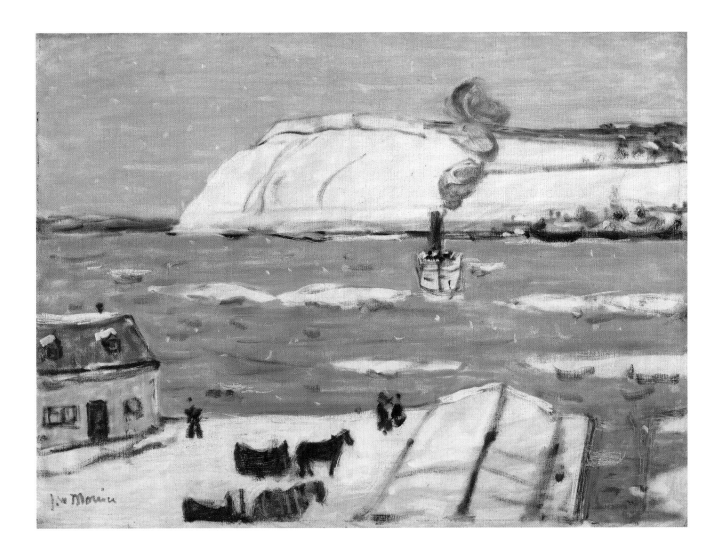

The Ferry, Quebec

James Wilson MORRICE

1907; oil on canvas; 62.0 cm x 81.7 cm; National Gallery of Canada

(1865-1924)

James Wilson Morrice was born into a wealthy Montreal family, and although he trained as a lawyer, he decided, with the support of his family, to become a painter. In 1889, Morrice left for Paris and enrolled at the Académie Julian, where he befriended a large circle of artists keen on exploring the modernist trends that developed after Impressionism. Of particular importance was his admiration for Anglo-American artist James McNeill Whistler, whose art-for-art's-sake aesthetic and penchant for simplified form and subtle colour harmonies appealed to Morrice's poetic sensibility. In the winter of 1896-97, Morrice returned to Canada and embarked on a sketching trip with Maurice Cullen to Quebec City, where he made a sketch on a small wooden panel for *The Ferry, Quebec*. Although the painting was executed on canvas in Europe almost 15 years after the sketch was made, it remained remarkably faithful to Morrice's initial impressions of the ferry approaching from Quebec City across the ice-laden blue-grey St. Lawrence. Details such as the horses and people waiting on the dock in Lévis have been summarily executed so as not to detract from the overall impression of a cool mauve-grey sky presiding over a stark Canadian winter.

Morrice's meeting in 1909 with French artist Henri Matisse served as an introduction to the brilliantly coloured palette and *(continued on page 224)*

James Wilson MORRICE

Café el Pasaje, Havana

(1865-1924)

c. 1915-1919; oil on canvas; 65.8 cm x 67.5 cm; National Gallery of Canada; Gift of G. Blair Laing, Toronto, 1989

(*continued from page 223*) loose brushwork of the Fauves, whose example he synthesized in landscapes and in scenes of people at their amusement or in repose. In his constant and extensive travels throughout Europe, North Africa and, later, the Caribbean, Morrice distilled the essence of the life around him in his art. In the shaded coolness of the nearly deserted *Café el Pasaje, Havana*, a man sitting at a table looks out to the street. Several pedestrians animate the flat patches of

hot yellow sidewalk, and behind them, rows of trees block the brilliant azure sky. Inside, the soft, quiet music of form unfolds as the circular rhythms of the tables and window grillwork play against the rectangular patterns of the windows and architecture. A man alone and at his leisure, whether on a street or a beach or sitting in a café, was frequently the artist himself, who, despite his many friendships and an affable personality, remained an outsider wherever he went. Mor-

rice knew international success during his lifetime, an achievement that was of singular importance to many artists in Canada, such as Cullen and the Group of Seven. Following Morrice's death in 1924, Matisse recalled him in a letter to a friend as an "artist with a sensitive eye, who with a moving tenderness took delight in rendering landscapes in closely related values …On a personal level, he was a real gentleman, a great companion, brimming with liveliness and wit."

Artist's Wife and Daughter

Norval MORRISSEAU

1975; acrylic on Masonite; 101.6 cm x 81.3 cm; McMichael Canadian Art Collection

(1932-)

Norval Morrisseau was born on the Sand Point Indian Reserve near Thunder Bay, Ontario, and learned of the legends and sacred rituals of his Ojibwa heritage from his shaman grandfather. To recover his native identity, which was denied in residential schooling, he embarked on a study of ancient rock paintings in northern Ontario, 17th-century Ojibwa Midewiwin shamans' scrolls and 19th-century Ojibwa beadwork, distinguished by its bright colour and strong linear composition.

In portraying his daughter and former wife, Morrisseau fused the composition frequently used in European painting to depict the Christ child and Mary with a style inspired by his Ojibwa roots. In a manner characteristic of the period between 1966 and 1975, Morrisseau explores the native and Christian dichotomies, which reflects his circumstance of being caught between two cultures and belief systems. Here, he revitalizes native artistic traditions through a dynamic and innova-

tive approach to colour and design, bridging the native past with the present. Following the success of his first solo exhibition in 1962, Morrisseau was acclaimed the leader of the Anishnabe, or Woodland School, and his career was launched. In 1979, he stated: "My art speaks and will continue to speak, transcending barriers of nationality, of language and of other forces that may be divisive, fortifying the greatness of the spirit that has always been the foundation of the Great Ojibwa."

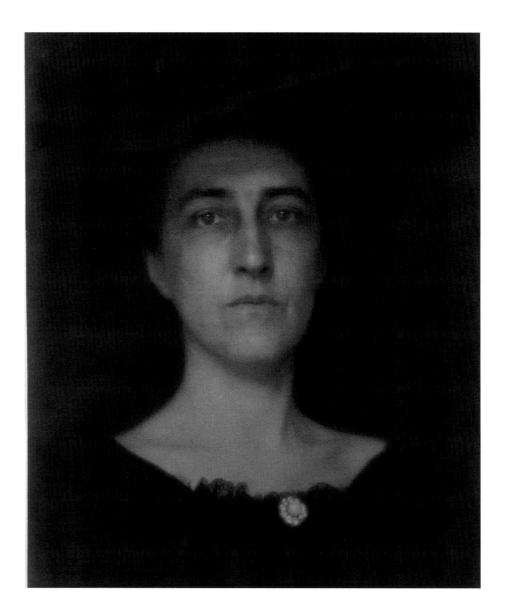

Harold MORTIMER LAMB

Lady Drummond

(1872-1970)

c. 1907; platinum print; 25.4 cm x 19.8 cm; National Gallery of Canada; Gift of Vera Mortimer Lamb

In 1906, the British-born Harold Mortimer Lamb, a professional mining engineer, moved from Victoria, British Columbia, to Montreal and joined with Sidney Carter to open a short-lived professional portrait studio that promoted the soft-focus Impressionistic style of photography characteristic of pictorialism. Here, Lady Drummond—a prominent Montreal philanthropist—sits attired in a sombre black hat and dress relieved by a judicious touch of jewellery. Mortimer Lamb envelops her in a symphony of soft greys and blacks. The subtlety of the tonal transitions and the feeling of quiet melancholy evoke the nocturnes of American painter James McNeill Whistler. This work is also contemporary with the artist's experiments with night photography, in whose poetic and tenebrous moods he saw the fulfilment of pictorialist ideals. Writing in the 1905 issue of *Photogram of the Year*, Mortimer Lamb reiterated its tenets: "A picture is not a picture if it does not possess that identifiable subtle something, called feeling or sentiment, [which is] suggestive of the individuality of the artist."

Following his return to British Columbia in 1919, Mortimer Lamb continued with indefatigable energy as a writer and passionate advocate of both art and mining. In the early 1920s, he promoted the art of Emily Carr in eastern Canada and staunchly defended the work of the Group of Seven.

226

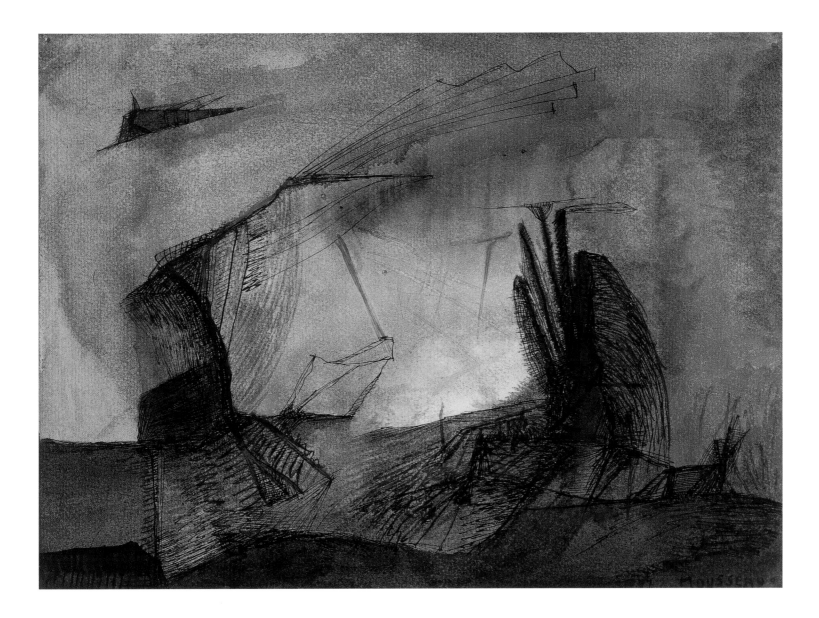

Untitled

Jean-Paul MOUSSEAU

1947; ink and watercolour on paper; 22.2 cm x 30.2 cm; La Collection Lavalin du Musée d'art contemporain de Montréal;
© Jean-Paul Mousseau/SODRAC (Montreal) 2000; Photo by Richard-Max Tremblay

(1927-1991)

In a shallow, dreamlike space, golden light radiates from the centre of the composition, creating a tranquil luminosity that contrasts with the energy of the thin, spiky black lines, which block the brightness with their strange presence. In 1944, 17-year-old Jean-Paul Mousseau befriended the Automatistes associated with Paul-Émile Borduas and became captivated by the Surrealist theories circulating among the Montreal avant-garde of an art inspired by dreams and the subconscious. Mousseau signed the manifesto *Refus global* in 1948, supporting its demand for freedom of expression and for a new social and political order in the Church-dominated society of Quebec.

In a 1967 interview, Mousseau said, "For me, art is the expression of a certain awareness…of conscious or unconscious needs…art should be expressed in all that surrounds us, in all that we touch and in all materials." Mousseau's commitment to an art that was socially engaged led him to produce art outside the frame, when he exercised his talents as a set and costume designer for theatre and dance and as an interior decorator for discotheques. Maintaining his painterly preoccupations with colour and light, he used glass and electric light to create suspended sculptures, and in 1966, he employed ceramic tiles for public spaces such as the murals in the Peel Street station of the Montreal Métro.

227

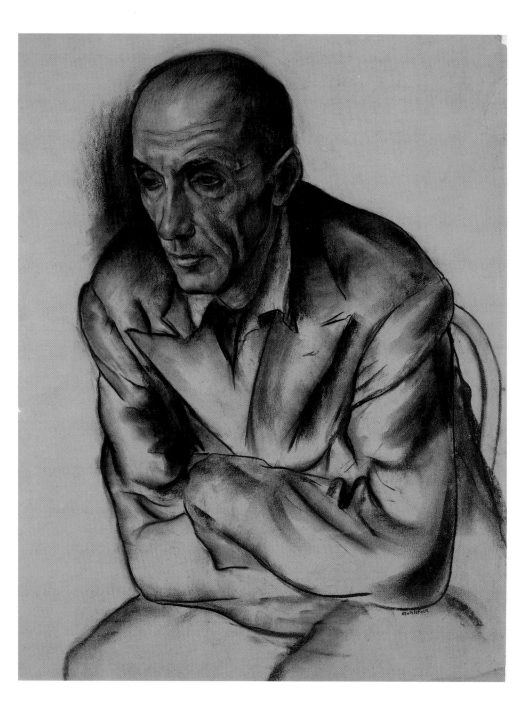

Louis MUHLSTOCK

William O'Brien Unemployed

(1904-)

c. 1935; charcoal and brown chalk on buff wove paper; 68 cm x 51 cm; National Gallery of Canada

Louis Muhlstock explored the city streets of Depression-era Montreal in his time off from the family's fruit-importing business and observed the assemblies of hungry, unemployed men. Among them, William O'Brien caught the eye of the artist—he sat apart, disinterested in the droning chatter. In Muhlstock's work, O'Brien leans forward with his arms crossed, huddled in a large overcoat, his haggard face revealing the endurance and despair of a man who has fallen

on hard times. Muhlstock tenderly describes every crease, line and shadow with rich black charcoal, capturing the composure of a man enveloped in his own despondency. It was essential for Muhlstock that individuals be depicted "with the greatest respect for humankind."

Muhlstock emigrated with his family from Poland to Canada in 1911 and studied at the Art Association of Montreal and at the École des beaux-arts. He trav-

elled to Paris in 1928 and studied the figure with Louis-François Biloul. Returning home in 1931, he focused on the poor and the destitute with a graphic compassion which frequently elicits a comparison of his work to that of German artist Käthe Kollwitz, whose art he greatly admired. Praising Muhlstock for his sympathetic objectivity, art critic Robert Ayre wrote, "He simply makes drawings of the suffering, the despised and the rejected and lets them speak for themselves."

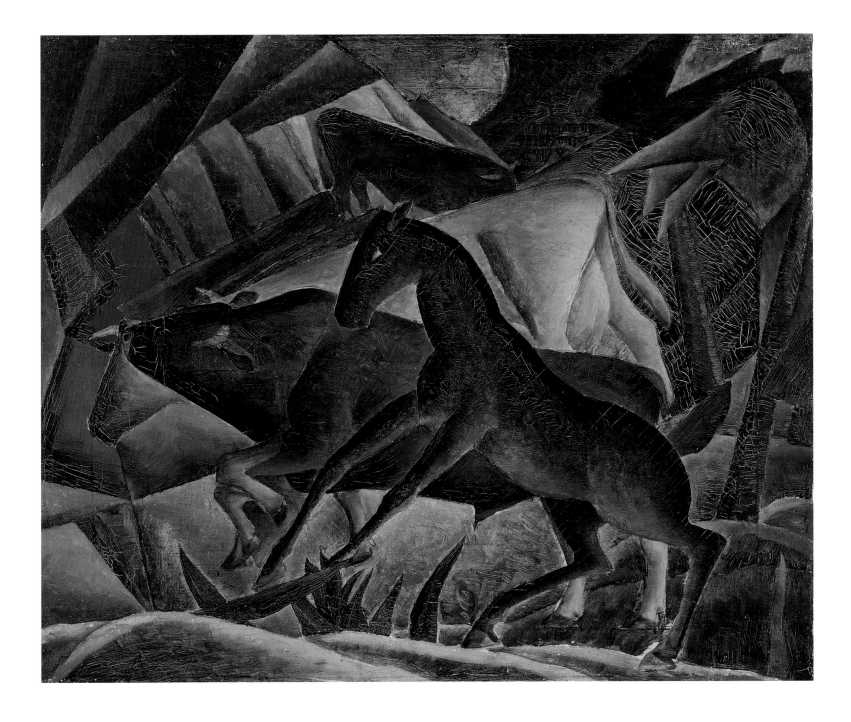

Composition Kathleen MUNN

1928; oil on canvas; 51.0 cm x 60.5 cm; The Edmonton Art Gallery Collection; Purchased in 1983; Photo by Eleanor Lazare (1887-1974)

Recalling the pastoral subjects of her earlier canvases, Kathleen Munn creates a dynamic rhythmic pattern of a horse and cows in a field, simplifying and flattening the forms of nature and unifying figure and ground with the colourful faceting of Cubism, which reflects the cadence of staccato music.

Munn's devotion to international modernism began in 1912, when she left her native Toronto to study at the Art Students League in New York City. By 1920,

her style had evolved from the loose colourful brush-work of Impressionism to the more hard-edge geometric fragmentation of natural form that had developed from her study of the works of French artist Paul Cézanne.

Munn embraced both an intellectual and a spiritual approach to art. Her notebooks reveal that she read extensively about colour theory, Cubism and the relationships between colour and music and that she was attracted to theosophy and various Eastern religions. Like

her colleague and admirer Lawren Harris, Munn sought a formal order in art that would convey spiritual truths. As an "invited contributor," she submitted *Composition* to the 1928 Group of Seven exhibition, after which it was purchased by Bertram Brooker, an artist who praised the work for its "musicality." While most Toronto art critics were uncertain about her pioneering innovations, one recognized that she was "one of the ablest…of women painters and one of the most advanced."

229

Robert MURRAY

Lennon Yellow

(1936-)

1980; painted aluminum; 121.9 cm x 152.4 cm x 58.4 cm; Collection of the Art Gallery of Greater Victoria;
Gift of Gordon Davis; Photo by Bob Matheson

Robert Murray bends, folds and assembles flat metal in unpredictable ways, liberating it from its two-dimensional state and creating a lyrical dialogue of concave and convex forms. With its central mass broken by the vertical cut, *Lennon Yellow* is further animated by the tail-like addition to the base and is balanced at the top by an assertive jutting shape. Using soft tempered aluminum, which is pliable and easy to configure, Murray worked spontaneously, achieving the desired effect of "effortless grace." Originally titled "Lemon Yellow," the work was renamed in the artist's shocked response to the 1980 murder of former Beatle John Lennon.

Born in Vancouver, Murray began his studies as a painter in Saskatoon and Regina, and in 1959, he accepted his first sculpture commission—an abstract work for the Saskatoon City Hall that initiated the first of many controversies which would plague his public sculptures. In 1959, he attended the Emma Lake workshop led by American abstract artist Barnett Newman. Murray moved to New York City in 1960 and, with Newman's encouragement and the example of such American artists as Alexander Calder and David Smith, began to produce sculpture. Murray's work—which he builds directly with metal plate or casts in bronze foundries—evolved from the hard-edged geometric expression of the 1960s to the more fluid manipulation of metal such as we see here.

230

Hunter's Summer Coat

NASKAPI (INNU) ARTIST

c. 1805; caribou skin, sinew, fish-egg paint; L: 108 cm; Photo courtesy of the Royal Ontario Museum, © ROM

Into the early decades of the 20th century, the Innu of the northern and eastern areas of the Quebec-Labrador peninsula relied on caribou as their primary source of food and clothing. They believed that the caribou preferred to be killed by hunters wearing colourful apparel embellished with pleasing designs. The hunt, furthermore, was a spiritual quest that warranted the creation of an elaborate garment to honour the animal and empower the hunter.

From about 1700 to 1930, Naskapi, Montagnais and Cree women fashioned intricately painted caribou coats whose shape resembled that of the 18th-century French frock coats the Innu received as gifts from the Europeans. The caribou skin, sinew and fish-egg paint linked the hunter to the hunted, creating a commonality that would attract the animal spirits and ensure a favourable catch. In devising these multicoloured patterns of parallel lines and double scrolls, the painter

used tools made of caribou antler or bone, some of which had multiple prongs to produce more complex designs. The large triangular gusset inserted into the back of the skirt was shaped like a mountain peak and was recognized as the symbolic centre of the coat's power. Textile historian Dorothy Burnham explained that "it represents the Magical Mountain where the Lord of the Caribou lived" and from whose bastion the caribou were released to the hunter.

Lilias Torrance NEWTON

Self-Portrait

(1896-1980)

c. 1929; oil on canvas; 61.5 cm x 76.6 cm; National Gallery of Canada

Lilias Torrance Newton looks at us with a penetrating gaze and with the intelligence that she would bring to her career as one of Canada's greatest portrait painters. Delving for psychological disclosure and employing a characteristically vibrant palette, Newton creates a strong sculptural presence with a minimum of means. Warm reds, golds and flesh tones focus our attention on her striking demeanour and boldly striped dress. The curves of her head and shoulders, echoed

in the chair, soften the angularity of the composition, whose symphony of contrasts evokes the complexity of her own sensitive and determined personality.

In the early 1920s, Newton associated with like-minded modernists such as Prudence Heward and Edwin Holgate, forming the short-lived Beaver Hall Hill Group. In 1923, she studied in Paris, where she received an honourable mention for a portrait of a woman at the Paris Salon, the large government-juried

exhibition. When Newton returned to Montreal, her career continued to flourish, and commissions from influential individuals such as Eric Brown, then director of the National Gallery of Canada, and Vincent Massey, an avid patron of the arts, led to numerous other commissions from businesspeople and government officials. In 1957, she was distinguished as the first Canadian to paint portraits of the current British sovereigns.

Spring Marion NICOLL

1959; oil on canvas; 91.8 cm x 71.7 cm; Glenbow Collection, Calgary, Canada (1909-1985)

Describing herself in 1959 as a "classical abstractionist," Marion Nicoll noted: "I start with something—the model—the street we live in…and struggle with the thing, drawing it, trying to find the skeleton that is there. I do this 24 hours a day. I dream [it], eat it and agonize over it…You have to fight your way through the underbrush with every painting." In *Spring*, flat, coloured shapes interlock with elegant simplicity and rhythmic harmony, thrusting upward with energy toward the sun, symbolized by the round yellow disc in the upper right. Red, yellow, green and blue suggest the colours of nature, and in the centre, graphic details allude to the trunk of a tree and a root system that feeds the tree/person configuration above.

Nicoll attended the Ontario College of Art from 1926 to 1928, then returned to her hometown to study at the Provincial Institute of Technology and Art, where she later taught. Nature had always been a central theme in her art, but with the arrival of Jock Macdonald at the Institute in 1946, Nicoll began to explore abstraction. Intrigued by Macdonald's instructions in Surrealist-inspired automatic drawing, Nicoll began producing colourful fantasy images. In the spring of 1959, she completed her studies at the Art Students League in New York City with American artist Will Barnet, who sparked her move toward a more structured, simplified approach to abstraction.

William NOTMAN

Skating Carnival, Victoria Rink, Montreal, Q.C., 1870

(1826-1891)

1870; silver salts on glass, wet-collodion process, composite photograph; 10 cm x 13 cm;
Notman Photographic Archives, McCord Museum of Canadian History, Montreal

In 1870, when the elite of Montreal gathered for a costume party on ice to honour Queen Victoria's son Prince Arthur, photography was employed to commemorate the event—but not without an enormous amount of labour. Working in the studios of his prosperous establishment, William Notman (and a battalion of assistants) methodically photographed almost 300 groupings of figures who, posed as lively skaters and conversing spectators, reenacted the excitement of the event.

The photographs were then cut out and pasted onto a painted backdrop according to a composition proposed by Notman. This is a photograph of the original pasteup, which was later rephotographed, enlarged, exposed on a light-sensitive canvas and completed as a painting (*The Skating Party*) by Notman's staff artists.

The Scottish-born Notman studied landscape painting and photography. Shortly after immigrating to Canada in 1856, he opened a photographic studio in Montreal. The business expanded rapidly, and Notman employed a large staff to meet the demand for portraits and photographs of construction projects and landscapes. Following the international success of *The Skating Party*, Notman produced hundreds of composite photographs of the city's select sports clubs, political events and social gatherings. The enterprising Notman and Sons opened 14 branch studios in the Maritimes, Ontario and the United States.

234

Petroglyph Rubbings: Figures

NUU-CHAH-NULTH ARTIST

19th century or earlier; 2.0 m x 3.7 m, Blowhole Beach site near Clo-oose; 1.1 m x 61 cm, Hill site near Clo-oose;
Photos courtesy of the Royal British Columbia Museum, Victoria, B.C.; Cat. Nos. DdSf1/DdSf2

Carvings or paintings on rock are Canada's oldest form of artistic expression. Petroglyph (rock-carving) sites are found across the country, from the Atlantic to the Pacific as well as the Arctic. One of the most fascinating areas is on the southwest coast of Vancouver Island, where the Nuu-chah-nulth (meaning "along the mountains") have lived since about 2000 B.C. They used stone for ritualistic and everyday objects and as a surface upon which to record important events and

ceremonies. Generally speaking, the petroglyphs expressed the Nuu-chah-nulth's relationship to nature, shamanistic beliefs, fears and anxieties and offered the opportunity of giving visual form to the unseen.

While the primordial simplicity of these two rubbings from the Clo-oose sites would suggest great age, the rubbing of the figures on the left is accompanied by carvings of a steamboat and a sailing ship, thus dating the petroglyph to around the 19th century. It is known

that a steamboat passed by the site in 1836, and in 1869, the survivors of a shipwreck were killed by the inhabitants, an expression, perhaps, of their fear of invasion.

On a nearby hill site, the figure on the right of a woman with enlarged genitalia may have been carved as a fertility symbol. She is positioned next to carvings of four killer whales, a giant bird and a copulating couple, suggesting a tie between human reproduction and the bounty of the sea.

John O'BRIEN

<div style="text-align: right">HMS Galatea in a Heavy Sea</div>

(1831-1891)　　　　1888; oil on linen; 43.4 cm x 71.6 cm; Art Gallery of Nova Scotia; Gift of Alice Egan Hagen, Halifax, Nova Scotia, 1955

An 1853 edition of *The Morning Chronicle* announced "to the merchants and shipmasters of Halifax that [John O'Brien] can give most accurate portraits (in oils) of their respective vessels, of all classes and on the most reasonable terms." Launching his career in the "golden age" of Nova Scotia shipbuilding, which saw the province supply thousands of ships for immigration, war and trade, O'Brien found ready patronage with commercial and naval shipowners alike.

Largely self-taught, he learned to draw by copying engravings from contemporary journals, illustrated fiction and accounts of travel at sea and by studying instruction booklets on painting at the local Mechanics' Institute. His early work can be appreciated for its technical accuracy in the details of masts and rigging. But after 1857—and a year's study in England with a follower of the Romantic J.M.W. Turner—O'Brien's documentary powers were complemented and enriched by a more painterly sensitivity to light and atmosphere.

Toward the end of his career, O'Brien did double and triple portraits of ships, chronicling major events in their histories. The *HMS Galatea in a Heavy Sea* is the second work in a triptych that begins with the ship at sunrise in Halifax harbour, its sails filled with a gentle wind as it meanders among smaller craft. In this piece, the *Galatea* endures the trials of dark, turbulent waters, and in the third painting, it survives a raging cyclone.

236

Sunrise on the Saguenay

Lucius O'BRIEN

1880; oil on canvas; 90 cm x 127 cm; National Gallery of Canada;
Royal Canadian Academy of Arts diploma work, deposited by the artist, Toronto, 1880

(1832-1899)

In the stillness of the misty morning light, the imposing silhouette of Cape Trinity asserts its craggy presence and casts a long shadow across the silent waters of Quebec's Saguenay River. Bathed in the silvery pink glow of the rising sun, humanity begins to stir. Smoke rises from a boat in the distance, and closer to shore, small figures greet the day. Despite the development of logging along the river, Lucius O'Brien deliberately offers us a romantic view that focuses on its

leisurely exploration by pleasure boats. Only in the foreground does a discrete pile of logs and scrubby bushes remind us of the intrusion of industry.

O'Brien's emphasis on the effects of light to create a poetic and picturesque view of nature reflects his admiration for American luminist painter Albert Bierstadt. Peaceful and orderly, O'Brien's vision also embodies the gentlemanly comportment of the artist himself, who retired from his job as a surveyor

and businessman at the age of 40 to pursue his love of painting.

O'Brien was the preeminent painter in Ontario in the 1870s and 1880s, and his work was praised for its "marked individuality...feeling and genius far above the average." In 1874, he became vice president of the Ontario Society of Artists and, in 1880, was appointed the first president of the Royal Canadian Academy of Arts.

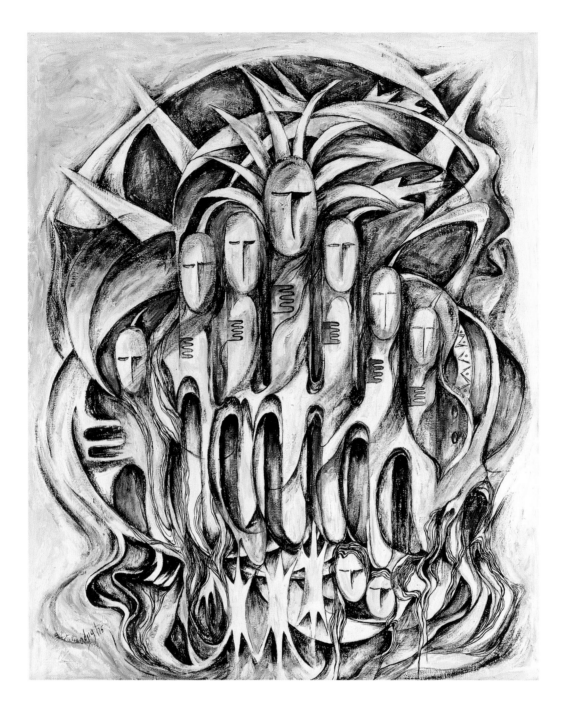

Daphne ODJIG

(1919-)

1975; acrylic on canvas; 101.8 cm x 81.0 cm; McMichael Canadian Art Collection

From a swirling array of lines and shapes, the Great Chiefs of the past emerge like phantoms in a fire, their identities dimmed by time but their spirits undaunted and ever present. The undulating curves that engulf them suggest tree roots and water, while the conelike protrusions arching and curving at the top evoke feather headdresses and tusks, alluding to the integration of native spiritual beliefs with nature.

Daphne Odjig was born on the Wikwemikong In-dian Reserve on Manitoulin Island of an Odawa father and an English mother. Encouraged to draw at home, Odjig later moved to Toronto and began to study Euro-pean art. In the early 1960s, when native people across the country were lobbying for political rights, Odjig began to combine native pictographs and Northwest Coast art with 20th-century European styles, developing an innovative technique that she later employed to depict native legends from her childhood. In 1974, she opened the first Canadian gallery dedicated to native art, in Winnipeg, and in 1973, she joined with Alex Janvier and others to form the short-lived Professional Native Indian Artists Inc., a group of seven native artists who embraced modernism as a means to express national identities. "My aspiration," said Odjig, "is to excel as an artist in my own individual right, rather than to be accepted *because* I am Indian." In 1987, Odjig was appointed a Member of the Order of Canada.

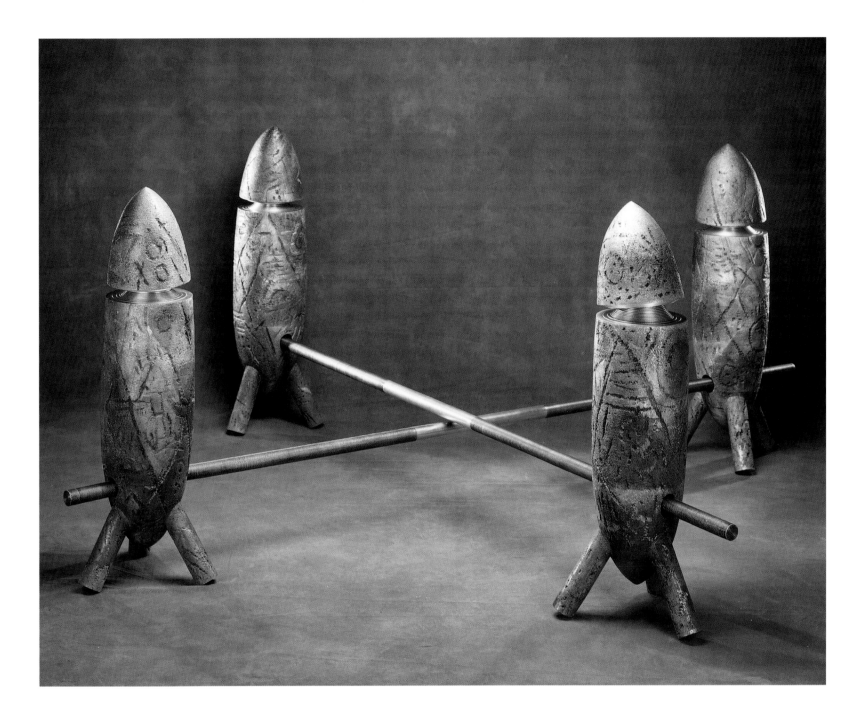

Night Watch Katie OHE

1988-1989; cast aluminum; 127.0 cm x 317.5 cm x 317.5 cm; Collection of the artist; (1937-)
John Dean Photographs Inc. and Alberta College of Art and Design

Four elongated cone shapes that hover in the worlds
between the human figure and rocket ships, between
time past and time present, establish a sturdy metallic
presence. At just over a metre high, they also seem like
dwarfed soldiers, their helmets whimsically tipped and
their weapons uniting them either in battle or in a recon-
ciliation of equals. Despite their uniform size and resem-
blance to one another, their colouring and graphic identi-
ties are individual and affirm Katie Ohe's interest in the

mysterious visual language of ancient pictographs and in
the sculptural essence of the Japanese commemorative
markers she has encountered in her travels. As an artist
who has worked in materials as varied as clay, stone,
bronze and steel, Ohe is attracted to aluminum for its
distinct beauty and its ability to reflect light softly.

 Ohe graduated in 1960 from the Alberta College of
Art, in Calgary. There, she studied with Marion Nicoll,
whose strong spirit and rigorous approach to design

were a central inspiration. Later studies in New York
City consolidated Ohe's admiration for the sculpture
of artists such as Pablo Picasso and David Smith and
launched her exploration of abstract form. In the
1970s, Ohe learned bronze-casting techniques in Italy,
and upon returning to her native Calgary, she explored
chrome finishing and kinetic sculpture, technically
demanding work that reflects Ohe's long-standing ap-
preciation of her collaboration with craftsmen.

OJIBWA ARTIST

<div align="right">

Mishipizhiw

</div>

date unknown; red ochre on stone; Agawa Rock, Lake Superior Provincial Park;
Photo by Ian Wainwright, Canadian Conservation Institute, Ottawa

For the Ojibwa, who inhabited the land northeast of Georgian Bay for tens of thousands of years, the Agawa Rock on the shores of Lake Superior was a sacred site that many thought was the home of the Great Lynx, Mishipizhiw. Readily identified by his large horns, the clumps of fur protruding from his cheeks and the erect dragonlike scales extending along his spine, Mishipizhiw is the chief spirit of the underwater and underground realms, commanding the weather on the lakes by unleashing high winds with a wave of his mighty tail. To his left, the crescent shape is a canoe with passengers respectfully invoking his favour for safe passage. Just below, the long, sinuous lines are water serpents, loyally accompanying the master of their watery domain.

These images are believed to have been painted within the past 500 years by Ojibwa shaman artists, who applied a red-ochre wash to the rock's surface, thereby establishing the spirituality of the site, and then drew the images with their fingers. Composed of an iron oxide extracted from a nearby mine, the red ochre was associated with life and was therefore used in cures and body paint in the desire for longevity. In painting the image, the shaman paid homage to Mishipizhiw, whose help he sought to increase his healing and spiritual powers. Even today, visitors remark upon the spiritual aura of these pictographs.

240

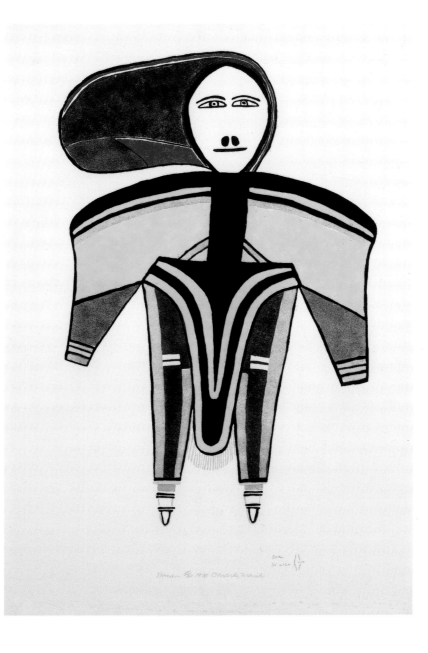

Woman

Jessie OONARK

1970; colour stonecut and stencil on wove paper; 78.5 cm x 54.4 cm; Printed by Thomas Mannik (1948-); National Gallery of Canada; (1906-1985)
Courtesy Public Trustee for the Northwest Territories; The Estate of Jessie Oonark; Gift of Dorothy M. Stillwell, M.D., 1986

Jessie Oonark grew up in camps along the Back River, about 200 kilometres northwest of the community of Baker Lake, in the Northwest Territories. Following the death of her husband in the early 1950s, she suffered increasing hardship. In 1958, Oonark and one of her children were rescued from near starvation and flown to Baker Lake, where she was able to get work scraping and sewing skins for the Hudson's Bay Company. Intrigued by children's art at the local school,

Oonark made her first drawings at the invitation of Dr. Andrew Macpherson, a biologist with the Canadian Wildlife Service who provided paper and coloured pencils and paid for her work as a small relief from her poverty.

By 1961, the federal government had established an arts-and-crafts program at Baker Lake, and with the arrival of artists Jack and Sheila Butler in 1969, the Sanavik Co-operative was established. Oonark's

Woman graced the cover of the first catalogue of prints, published in 1970. With a sureness of hand, an acute perception and a flair for design gleaned from years of cutting caribou skins and sewing clothes for her family, Oonark created an iconic image of womanhood. The figure's broad shoulders and large hooded *amautiq* assert her role as mother, while her serene gaze and the even symmetry of the brightly coloured clothing allude to (continued on page 242)

Jessie OONARK

Untitled

(1906-1985) 1973-1974; duffle, felt, embroidery floss, thread; 186 cm x 181 cm; National Gallery of Canada; Courtesy Public Trustee for the Northwest Territories; The Estate of Jessie Oonark; Gift of the Department of Indian Affairs and Northern Development, 1989

(*continued from page 241*) strength and stability. The attention to the parka's shape and embellishments reflects Oonark's fascination with design and her adept synthesis of Back River and Baker Lake patterns.

The totemlike axis of this untitled wall hanging, which is almost two metres high and wide, is enlivened with real and imaginary creatures combined with the recurring image of the woman's fan-shaped knife, or *ulu*. On either side, horizontal red ground lines define four main registers of space animated by elegant figures in profile, which have been spontaneously cut from single pieces of white and orange felt. Varied and intricate clothing and surface decoration invite us into a mysterious world where the magical meets the everyday. Only the central horizontal strip exhibits real symmetry, where the figures in the blue sled find their mirror image in white on the other side.

Oonark drew and sewed ceaselessly. From 1970 to 1985, she published more than 105 prints and produced scores of highly esteemed wall hangings. The largest, commissioned by the National Arts Centre in Ottawa, was cut and handstitched in her tiny Baker Lake bungalow and viewed in its entirety by Oonark only after it was hung. "What shines through," recalled Jack Butler, "is a tremendous human being with a great command of the artistic language given to her by her culture and developed by herself."

242

Untitled (Seated Figure)

John PANGNARK

1968; dark grey stone; 12.8 cm x 7.0 cm x 13.3 cm; Winnipeg Art Gallery; Twomey Collection, with appreciation to the Province of Manitoba and the Government of Canada; Photo by Ernest Mayer/WAG

(1920-1980)

As a young man, John Pangnark led a seminomadic existence following the caribou herds that migrated across the Keewatin region west of Hudson Bay. With the dwindling of the herds by midcentury, life on the land became increasingly severe, forcing many hunting communities into settlements such as Arviat, where government arts-and-crafts programs offered a means of survival. Conceivably, a life reduced to essentials by hardships created its own aesthetic in the imagination

of artists such as Pangnark, who produced sculpture that was stark and minimally embellished.

Pangnark was renowned for the smooth surfaces, rounded forms and exacting even edges of his sculpture, carved from the hard, dense, dark grey stone of Arviat. His tendency to minimize details and focus more on the volumetric mass of his sculptures imbued his work with a monumental quality despite its minute scale. Here, a seated man is rendered with a minimum

of means, his small head and defined features contrasting with the polished bulk of his body, which is given stability by his straight back and boxlike form.

The elegant austerity and unconscious modernism of Pangnark's work was readily appreciated by collectors in the South and, in particular, by Inuit art historian George Swinton, who wrote, "He was [doubtless] the Brancusi of the North, with a rare feeling for abstraction."

PARR

Bear Hunt

(1893-1969)　　　c. 1966; felt-tip pen on paper; 50.8 cm x 65.6 cm; Art Gallery of Ontario; Gift of the Klamer Family, 1978; Photo by Carlo Catenazzi/AGO

Parr, the old hunter, as he was frequently called, fills the space of the paper with the objects of his quest: the large, bulky bodies of the bears and the angry twisted head and gnashing teeth of the wounded one. The dogs, employed to tire and annoy the dangerous carnivores, are partners in the chase, while the small birds act as pert spectators. Parr's style of drawing is simple and direct, reminiscent of the descriptive pictographs found on ancient rock art as well as the emphatic spontaneity of children's drawing. The small arrow shape to the left of the hunter's leg is Parr's signature, placed without heed to Western conventions.

At the age of 68, after a life of moving between camps, Parr suffered frostbite so severe as to require the partial amputation of one foot. His mobility compromised, he was forced to settle in Cape Dorset, where subsidized housing and medical facilities were available. Like many fellow Inuit who were exploring alternative means of economic self-sufficiency, Parr was introduced to drawing by Terry Ryan, manager of the West Baffin Eskimo Co-operative, a printmaking endeavour that encouraged Inuit to draw as a source for print imagery. Offered paper and pencil and, later, coloured pencils and felt-tip pen, Parr embarked in his forthright manner to express his nostalgia for a passing way of life, producing more than 2,000 drawings in his eight-year career as an artist.

The Little Shepherdess

Paul PEEL

1892; oil on canvas; 160.6 cm x 114.0 cm; Art Gallery of Ontario; Bequest of John Paris Bickell, 1952

(1860-1892)

At the foot of a grassy hill, a little shepherdess abandons her flock, crook and clothing and stops to take timid delight in refreshing herself in the quiet waters of a pond. The shadowy green of the meadow provides a perfect foil for her rosy flesh tones, while a nearby outcrop of irises alludes to her youthfulness and the springtime of her life. Painted in the last year of his short life, this work is a testimony to Paul Peel's acclaim as a painter of sentimental studies of children and young nudes who were often portrayed in an exotic or arcadian setting that tempered the blatant nudity with a narrative context acceptable to Victorian taste.

Born in London, Ontario, Peel studied at the Pennsylvania Academy of Fine Arts under Thomas Eakins, who promoted the study of anatomy as well as painting from the nude model. Peel later spent five years in the Paris ateliers of Jean-Léon Gérôme and Benjamin Constant and came to master the effects of light and shadow and the representation of flesh tones and material textures in a highly finished manner. Although he did not receive high prices for his work in Canada before his death, he was much appreciated in Europe and won a bronze medal at the Paris Salon of 1890 for his painting *After the Bath*, making him one of the first Canadian artists to gain international recognition in his lifetime.

Alfred PELLAN

On the Beach

(1906-1988)

1945; oil on canvas; 207.7 cm x 167.6 cm; National Gallery of Canada

As the first recipient of the government of Quebec's fine-arts scholarship, Alfred Pellan travelled to Paris in 1926 and remained there until the Second World War forced him back to Canada in 1940. A Montreal exhibition of his European work, which revealed his admiration for the 20th-century masters Picasso and Matisse, rocked the Quebec art world. For artists in Quebec on the verge of exploring Cubism and Surrealism, Pellan's work was a liberating example. "Because

of [Pellan]," said one art critic, "we are rushing to recover the half-century by which we have fallen behind."

More than two metres in height, *On the Beach* overwhelms the viewer with the monumental head of a Minotaur dreamily gazing at women sunbathing against brick walls that suggest an urban beach. Reflecting on Picasso's work of the early 1930s, which showed the mythological beast frolicking with nude women, Pellan presents the Minotaur with naturalistic

contours, while the women are twisted and compressed in their shallow Cubist space. Pellan, already acclaimed for his murals, creates a mosaic-like surface, animating the organic shapes with a geometric patterning of textures and lines that transports us to a world of fantasy. In 1948, in opposition to the Automatistes, Pellan and his circle of artists formed the Prisme d'yeux, calling for an art "liberated from all contingencies of time and place, from restrictive ideologies."

246

Kitchen Door with Ursula Christiane PFLUG

1966; oil on canvas; 164.8 cm x 193.2 cm; Winnipeg Art Gallery; Purchased with the assistance
of the Women's Committee and the Winnipeg Foundation; Photo by Ernest Mayer/WAG

(1936-1972)

Through the open kitchen door of Christiane Pflug's Woodlawn Avenue apartment in Toronto, our view is dominated by a winter scene of snow-covered roofs and lawns, with skyscrapers in the distance. This depiction of winter is curiously contradicted by the reflection in the windowpanes of the door of a lightly dressed child, with a background of green trees and shrubs. While this reference to different seasons mirrors the passage of time it took the artist to render the details of this large work, the simultaneous representation of spring and winter may have been an allusion to the cycles of nature, from birth to death and rebirth. As Pflug said, "I would like to reach a certain clarity which does not exist in life. But nature is complicated and changes all the time. One can only reach a small segment, and it takes such a long time."

Pflug was born in Berlin, and in 1953, she moved to Paris to study fashion design. There, she married Michael Pflug, who encouraged her to paint. In 1959, they immigrated to Canada, where she produced paintings of their children, possessions and immediate environs. The gridlike structures that preoccupied Pflug—embodied here by the kitchen cabinetry, door, balcony and architecture and in other works by birdcages—served as both structural refuges and prisons, whose confines Pflug ultimately escaped through suicide in 1972.

YORK BOAT ON LAKE WINNIPEG 104/150

Walter J. PHILLIPS

York Boat on Lake Winnipeg

(1884-1963)

1930; colour woodcut on japan paper; 29.6 cm x 38.7 cm; National Gallery of Canada

As a resident of Winnipeg for over 28 years, the British-born W.J. Phillips made frequent sketching excursions to the nearby lakes. There, he conjured up the journeys made by the York boats used by the Hudson's Bay Company in the 19th century to transport heavy cargo. "It was easy to imagine…the brigades of York boats coming around the bend," he wrote. "They say you could hear the crews singing before the boats came in sight." In his usual fashion

when working directly from nature, Phillips made quick pencil sketches of the windswept lake and distant island and then, in his studio, composed a watercolour as a model for the colour woodcut.

Here, sweeping black lines define the churning waters of Lake Winnipeg, where a strong wind fills the square sail, whose cheerful colour is echoed in the sailors' bright caps and the boat's red rim. In this work, Phillips reveals his debt to the Japanese woodcuts that

had been popular since the 19th century with artists who admired their unusual points of view, the flattened space and the expressive use of line juxtaposed with a delicate colour. Phillips had made his first successful colour woodcut in 1917, but it was only after a trip to England in 1924 and a meeting with the Japanese master Yoshijiro Urushibara that he discovered a technique which would establish his reputation as Canada's foremost colour-woodcut artist between the wars.

248

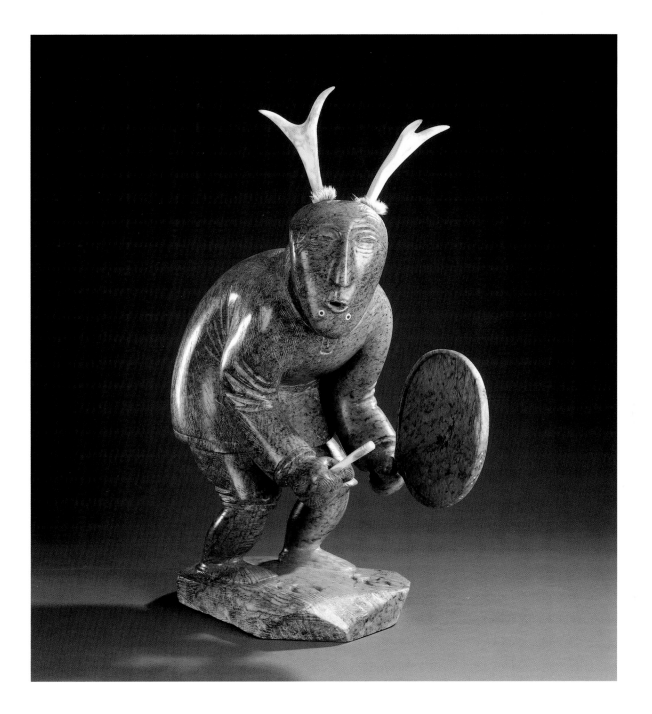

Shaman

David Ruben PIQTOUKUN

1986; brown Brazilian soapstone, antler, caribou fur, wood, ivory, red Arizona pipestone inlay;
55.6 cm x 41.2 cm x 20.4 cm; Art Gallery of Ontario; Gift of Samuel and Esther Sarick, 1989; Photo by Carlo Catenazzi/AGO

(1950-)

In this dynamic sculpture, a shaman whose face is decorated with ivory labrets pierced through his lower cheeks enters a trancelike state with the hypnotic beating of the drum, or *qilaut* ("that which is used to summon the spirits"). His body bent in concentration and his eyes peering into the world beyond, the shaman wears caribou antlers and hide to invoke the caribou spirits and appeal for a successful hunt.

David Ruben Piqtoukun grew up in the Paulatuk area of the western Arctic, living in camps along the coast of the Mackenzie River Delta. In 1967, he was sent to a Catholic residential school, where he received an education in "forgetting" Inuit culture. As an adult, Piqtoukun—now a resident of Toronto—strives to recover his Inuit identity through art. His love of the diverse beauty and colour of stone from around the world is reflected in his exploration of materials such as Brazilian soapstone, Italian alabaster and a variety

of stones from Africa. Although his work has become increasingly abstract since the 1990s, it remains inspired by Inuit legends and rituals. Just as the shaman mediated between the worlds of humans and spirits, so does Piqtoukun's art reconcile Inuit beliefs with contemporary experience. "Even those of us who have made a home in the South," he has said, "must return to the North to regain our bearings and connection to the land."

PLAINS ARTIST Shirt

early 20th century; hide, sinew, quillwork; L: 81 cm, W: 61 cm, sleeve L: 57 cm; Canadian Museum of Civilization, image #S96-5503

With the arrival of horses and guns on the prairies in the 18th century, the buffalo hunt, essential to the Plains First Nations, became more efficient, allowing additional time for the embellishment of tipis, bags and clothing by means of painting, quillwork and beadwork. While men were responsible for hunting and providing the hides, the stretching and curing of skins and the preparation of the quills was the women's domain. Quillwork was regarded as a sacred activity, entrenched in the rituals of highly organized women's guilds.

The most desirable quills were between 3 and 14 centimetres long and were softened with moisture, often by being placed in the woman's mouth where they could also be flattened as they were drawn through her teeth. After being dyed, the quills could be worked in elaborate techniques that involved sewing, wrapping around sinew or vegetable fibre, braiding and weaving.

The dynamic simplicity of the geometric-

patterned quillwork on this man's ceremonial shirt suggests that it may be of Blackfoot origin. The placement of the bands of quills across the shoulders and down the arms is believed to have offered spiritual protection to the wearer in battle, echoing the practice of shamans who tattooed and painted their limbs and joints. As war shirts, such garments could also be augmented with paint, drawings, hair and weasel tails, which contributed to their sacredness and power.

Soeur Saint-Alphonse

<div align="right">

Antoine PLAMONDON

</div>

1841; oil on canvas; 90.6 cm x 72.0 cm; National Gallery of Canada

<div align="right">

(1804-1895)

</div>

The former Marie-Louise-Émilie Pelletier, dressed in the habit of an Augustinian nun, smiles and gazes from the canvas with gentle reserve. Bathed in a light that illuminates her delicate features and casts a halo-like aura behind her, she sits framed by her long black veil and starched white wimple. Their triangular shapes lend an air of stable tranquillity to the portrait. In contrast to the austerity of her dress, the radiant flesh tones and the red of her chair, book and lips add an element of warmth and a contained sensuality.

Inspired by the 18th-century French portrait tradition that depicted nuns set against a neutral background, Antoine Plamondon created a composition whose underlying geometry and highly refined realism reflected his neoclassical training in France more than a decade earlier. His skill in constructing the illusion of material texture, illustrated by the thinness of the muslin veil, the crisp wimple and the sheer linen covering the hands, conveys a realism that is as restrained as it is palpable.

Plamondon, then Quebec's most eminent portraitist, was commissioned by Soeur Saint-Alphonse's father, a prosperous Quebec merchant, to paint this work two years after she had taken her final vows. It would have been hung in the home as a cherished reminder of someone who would never again cross the familial threshold.

Edward POITRAS

Internal Recall

(1953-) 1986-1988; linen, glue, cut aluminum, rope, horsehair, wire; life-sized; The Woodland Cultural Centre, Brantford

Kneeling in forced submission, their heads pressed against the ground and their hands tied behind their backs with ropes that stretch to the ceiling, seven life-sized effigies of aboriginal people have been literally harnessed, stripped of their identity and symbolically tethered to a government reserve. The figures are juxtaposed with the perfunctory words of Treaty No. 4, which established reserves in Saskatchewan and southern Manitoba in 1874. Written and signed in a language not understood by the Indians, the words "Witness/Interpreter/His X Mark" are a reminder of the inequality inherent in the process of colonization. Re-creating the narrative of conflict, the Europeans' recorded terms of agreement are contrasted with the aboriginals' "internal recall," the memory of loss and subjugation. Said Edward Poitras, "The reservation system was a form of apartheid, designed for management and control. All we wanted was a place to live.

We had no idea that we would be confined within its borders, allowed to leave only with a written permit."

Poitras is of mixed heritage, with a Métis father and a Cree-Saulteaux mother. After residential high school, he vowed that his "future educators be of Indian ancestry within Indian institutions." In 1974, he attended the Saskatchewan Indian Cultural College in Saskatoon and, in 1976, studied with Domingo Cisneros at the Manitou College at La Macaza, Quebec.

A Sacred Prayer for a Sacred Island

Jane Ash POITRAS

1991; oil paint, collages of photographs, photocopies and printed papers, blackboard acrylic, wax crayon, eagle feather and five-dollar bill on canvas; side panels each: 187.9 cm x 127.0 cm; centre panel: 198.1 cm x 437.5 cm; National Gallery of Canada

(1951-)

Employing the triptych format of early Christian art, Jane Ash Poitras assembles images that reflect the multifaceted nature of aboriginal experience, history and spirituality. In the centre, a large tipi decorated with ancient native pictographs is flanked by expressive drawings of shamans. Above, a collage of photographs of sweat lodges and sun dancers is linked to images of the hunt and refers to the integration of native spirituality with nature. In the side panels,

Poitras combines photographs of Western thinkers she admires with aboriginal symbols and drawings. While words such as "Manifest Destiny" and maps of the globe allude to the abuse of power in the history of colonization, the preponderance of aboriginal imagery establishes a balance in a world that has lost touch with its spiritual roots. As Poitras stated, "Only through spiritual renewal can we find out who we really are, be empowered to achieve our potential and

acquire the wisdom to eliminate the influences that bring tragedy upon us and destroy us."

Born in Fort Chipewyan, Alberta, and raised as a Catholic by her adopted German mother, Poitras began to recover her Cree heritage and language as an adolescent. In her studies at the University of Alberta and at Columbia University in New York, she cultivated a visual language that combines images and words to express the complexity of personal and collective histories.

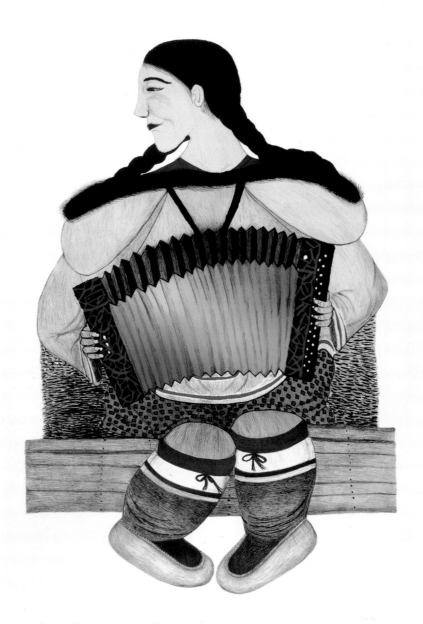

Napachie POOTOOGOOK

My New Accordion

(1938-) 1989; lithograph; 112.4 cm x 79.9 cm; Cape Dorset 1989, no. 23; Printed by Pitseolak Niviaqsi (1947-);
Canadian Museum of Civilization, image #S99-40

As the daughter of Pitseolak Ashoona, Napachie Pootoogook was heir to both her mother's artistic talent and her optimistic spirit, despite the dangers and hardships endured in her life on the land. In the early 1960s, Napachie and her family moved to Cape Dorset, where she and her mother were each introduced to drawing by James Houston, the founder of a printmaking co-operative. Napachie's early drawings depict images of birds and scenes of everyday north-ern life on the land, while her later work reflects Inuit culture in transition, in which the old ways are juxtaposed with the new.

Married to printer Eegyvudluk Pootoogook, Napachie was one of the first artists to experiment with lithography when it was introduced in Cape Dorset in the early 1970s. In this planographic process, the artist draws directly on the printing plate with a lithographic crayon that allows the rendering of fine detail and subtle tonal transitions. In *My New Accordion*, the beauty of the delicate drawing and the attention to the visual description of the clothing and back-ground are complemented by the expression of pleasure on the face of Napachie.

Her pride is also conveyed in the use of colour, notably in the accordion, where the rainbow hues sweep across the expanding instrument like the joyous swell of the music itself.

254

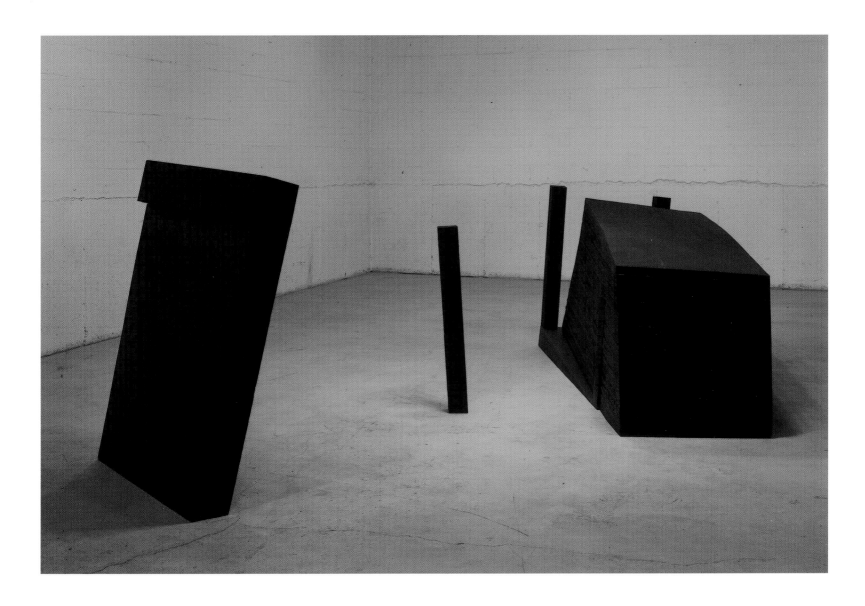

Darkly, into the Vast, Subsiding

Roland POULIN

1989; polychromed wood; 127 cm x 160 cm x 430 cm; The Montreal Museum of Fine Arts; Purchase, Serge Desroches, Mary Eccles, Hermina Thau, Jean Agnes Reid Fleming, David R. Morrice, Margaret A. Reid Estates; Photo by Christine Guest/MMFA

(1940-)

Walking between these heavy, darkly hued wooden sculptures of Roland Poulin, one feels disoriented and unbalanced. In contrast to the reassurance of their physical mass, their slanting and tilting shapes create a sensation of sinking into quicksand or water, leaving the viewer anxious and uncertain. The sombre but poetic elusiveness of the work is echoed in its title and reflects Poulin's meditations on the sacred spaces and monuments of cemeteries. The fragmentation of the sculpture juxtaposes volumes that are tall and thin, narrow, columnar and massive and introduces a tension which is echoed in the enigmatic identity of the large sepulchrelike form that also resembles an upturned table. The allusion to the table, however, is a reminder of life, made ever more precious in the context of death. As the artist confirms, "All my work is concerned with paradox, with that which is ambiguous."

Poulin was born in St. Thomas, Ontario, and moved to Montreal with his family as a child. At the age of 22, a chance encounter with the painting *Black Star* by Paul-Émile Borduas impressed him with its synthesis of materiality and spirituality and inspired his decision to enrol at the École des beaux-arts (1964-69). While the geometric austerity of Poulin's early sculptures seems rooted in the radical abstraction of minimalism, the artist in fact seeks the expressive and symbolic qualities of abstraction.

255

Christopher PRATT

Deer Lake: Junction Brook Memorial

(1935-)

1999; oil on canvas; 114.5 cm x 305.0 cm; National Gallery of Canada; Gift of David and Margaret Marshall, Toronto, 1999

A long, thin rail separates us from the churning waters illuminated by a seemingly infinite series of Palladian windows, whose soft colours and graceful shape suggest a palace or a church rather than an electrical power station. While meticulously rendered institutional architecture has long been a subject of Christopher Pratt's art, the buildings are usually fabricated from his imagination. This work, however, is an exception and was inspired by Pratt's view of a power station near his home in his native Newfoundland. Pratt recalled that he was attracted to the contrast between "the immense power of the water and then…a kind of revulsion at its entrapment, imprisonment behind dams." An element of sadness pervades the painting, with its dark palette and impenetrable sky, and finds its reflection in the word "memorial" of the title. "Junction Brook" is the euphemistic term for the dried-up riverbed, formerly a major confluence of rivers. Pratt wrote: "The forces of nature become the implements of art: the power-house…becomes a secular cathedral…the light comes from the inside out; the windows, their brilliance and variety speak of the achievements of man, not the glory of God…As a painter, all I could celebrate was light."

Pratt studied at the Glasgow School of Art (1957-58) and at Mount Allison University, Sackville, New Brunswick (1959-61), before returning to Newfoundland, where he continues to live.

Eggs in Egg Crate

Mary PRATT

1975; oil on Masonite; 50.5 cm x 60.5 cm; From the Collection
of Memorial University of Newfoundland at the Art Gallery of Newfoundland and Labrador

(1935-)

Light fills the rectangles and hollow cavities of an open carton wherein lie three broken eggs, their delicate shells paper-thin and brittle against the thick pressed cardboard of the container. Haphazardly placed in their gridlike box, the shells harbour the transparent whites and deep yellow remnants of life. Mary Pratt paints meticulously, almost reverently, with seemingly invisible brush strokes, capturing the fragile beauty and chromatic harmonies of everyday life. Although the egg is a powerful metaphor for life, death and regeneration, Pratt insisted: "The reality comes first, and the symbol comes after…I see these things, and suddenly, they become symbolic of life."

Born in Fredericton, New Brunswick, Pratt graduated in 1961 from Mount Allison University in Sackville, where she studied with Alex Colville and Lawren Harris. Moving to Newfoundland with her husband, artist Christopher Pratt, she strove to balance the responsibilities of a family with her desire to paint, inspired by the transforming but fleeting effects of light on food and on the other objects of her domestic environment. Initially, she attempted to paint quickly in order to capture the ephemeral effects of light, but she later embraced photography, sketching with the aid of 35mm slides to preserve the fugitive play of light on transparent jellies, glistening fish reflected in tinfoil and, later, nudes and landscapes.

257

Richard PRINCE

<div align="right">Sailing Past Jupiter</div>

(1949-)

1989; steel, wood, aluminum, electrical motors and light-projection system, glass, paint; 147 cm x 160 cm x 61 cm;
Musée d'art contemporain de Montréal; Photo by Richard Prince

Richard Prince's artistic exploration of the cosmos, planets and natural occurrences dates back to the 1970s, when he saw sculpture as an opportunity to explore the magical and poetic aspects of knowledge and science. He wrote, "The elaborate models and theatrics that I employ are epistemological in nature rather than pictorial or explanatory. Although the work may be based on natural phenomena, the resolution in sculpture is more a statement about the imagination and the structures of language than the reality of the phenomenon itself."

Here, we are transported to the world of dreams and invited to imagine a journey past the largest and fastest-spinning planet in our solar system. Within the confines of the open steel frame, a small projector casts moving shadows of Jupiter's moons across the equator of the wooden sphere. While the construction of a model grounds us in a rational reality that attempts to explain the mechanisms of the universe, it is a symbolic activity, for complete knowledge of the mysteries of the universe continues to elude us.

Prince's use of wooden spheres was inspired by his admiration for the 18th-century models called orreries, which were built to illuminate the workings of the solar system. "I am intrigued by the notion of scientific discovery as a model for the creative act," he said. Prince studied at the University of British Columbia from 1967 to 1973.

Sea Creatures Pudlo PUDLAT

1976; acrylic paint, coloured pencil, black felt pen on wove paper (watermark: "BFK RIVES FRANCE");
49.5 cm x 56.1 cm; National Gallery of Canada; Gift of Dorothy M. Stillwell, M.D., 1987

 (1916-1992)

Beneath the blue waters, a large fish carries Sedna, the Inuit goddess of the sea. Both goddess and fish are embellished by a rhythmic repetition of squares echoed in the line of windows of the airplane flying overhead, signalling a blending of old spiritual and new physical realities that characterizes the art of Pudlo Pudlat. In applying the transparent acrylic wash to describe the water, Pudlo combines spatial perspectives, showing the water both as a transparent medium and as a surface, where the kayaker and dog watch creatures and whales frolic on the horizon of the Arctic sea. Pudlo's creative merging of traditional and modern iconography reflects his optimistic and sometimes humorous view of Inuit culture in transition.

Born at a camp some 350 kilometres east of Cape Dorset, Pudlo lived as a hunter along the southwest coast of Baffin Island, where he endured many hardships in his struggle to support his family. He began to draw around 1960, while living at Kiaktuuq, near Cape Dorset. In his prolific 30-year career, during which he produced almost 4,500 drawings, his art was served by the liveliness of his imagination, a talent for drawing and an eye for colour. "Artists draw what they think…and what they have seen also," he said. "But sometimes, they draw something from their imagination, something that doesn't exist anywhere in the world."

"With Open Mind" Lithograph 31/45 Andrew Karpik Pangnirtung 90'

Andrew QAPPIK

<div style="text-align: right">With Open Mind</div>

(1964-) 1992; lithograph; 40 cm x 49 cm; Printed by the artist; Canadian Museum of Civilization, image #S2000-2375

As part of a younger generation of Inuit artists who grew up in settled communities with access to modern telecommunications, Andrew Qappik admired the drawings in Marvel comic books. Before he finished high school, Qappik began working in the print shop at Pangnirtung, Baffin Island. Qappik's work, like that of other Pangnirtung artists, reflects the legacy of the earlier contact with whalers as well as an enduring fascination with the spirit world.

Qappik gives traditional beliefs modern form in this delicately drawn and sensitively shaded lithograph, setting the transformation of the shaman in a realistic Arctic landscape. With their cheerful, almost human smiles, walrus-faced creatures lounge on an ice floe and portray the shaman's ability to adopt many guises. The walrus in the background waves its whale-like lower body, while the one in the foreground balances on its human arm. Strangest of all, the large,

rounded body casts the shadow of a miniature dog team, reminding us of the shaman's mysterious magic.

"Our heritage includes shamanism," explains Qappik. "A shaman would have a champion animal which he or she would become…like the walrus is feared by the killer whale. Today, the transformation occurs in humans with an open mind. You can know so much more of others' way of life today, and learning this…this knowledge becomes part of you."

Metrical (Romanesque)
Constructions in 5 masses and 2 scales, No. 2

David RABINOWITCH

1975-1976; hot rolled steel; 5.3 cm x 205.0 cm x 175.9 cm; National Gallery of Canada; © David Rabinowitch/SODRAC (Montreal) 2000 (1943-)

Five geometrically shaped slabs of solid steel lie tightly together on the floor like the pieces of a puzzle. The polygonal abstract form they create challenges our expectations of sculpture as a vertical and monolithic entity. As with traditional sculpture, however, our perception changes as we move around the work, appreciating the angle of the light as we peer into the vertical holes bored through the metal. The holes are of different sizes, hence the "2 scales" of the title. Because of the

sculpture's weighty horizontality and our ability to survey it from above, we experience a shifting perspective while keeping the entire work within view. The subdued, irregular colouring suggests weathering, age and the passage of time, while the precision of the thick metal edges and abstract simplicity assert its modernity. "The role of the observer in art," said David Rabinowitch, "is not one of an investigator of motives underlying a consciously made world but, rather, a discoverer of the

structures of his own judgment within a world he experiences as external and as a fully achieved desire."

Born in Toronto, Rabinowitch studied English literature at the University of Western Ontario, in London, from 1963 to 1968. On his first trip to Cologne, Germany, in 1971, he became fascinated with the architecture of Romanesque churches, which inspired a series of abstract sculptures with varying relationships of mass, shape and dimension.

261

Royden RABINOWITCH

<div align="right">Grease Cone</div>

(1943-) 1970-1971; steel and grease; 182 cm x 202 cm; The Montreal Museum of Fine Arts; Gift of Gilles Gheerbrant; Photo by Christine Guest/MMFA

In the pristine environment of the art museum, the tall geometric cone covered with industrial grease offers a singular juxtaposition of the permanence of a hard metal shell and the ephemerality of a sticky viscous lubricant. As we walk around the cone, the oily surface reflects the light, endowing the work with a flickering immateriality that seems to reduce its sculptural solidity. For Royden Rabinowitch, who had already explored the conic shape in sculpture, the application of grease

to the form was both risky and revolutionary. While the decision to do so was modern and unconventional, the result was the creation of an object whose historicity and appearance are ambiguous and timeless. Reviewing an exhibition of a series of Rabinowitch's greased cones in 1971, art critic Gary Michael Dault remarked that the works embodied "a transcendence…of the mechanical alienating world of the measured, the formal, the styled, the tasteful and [the] ambitious."

Following his studies at the Royal Conservatory of Music in Toronto and at the University of Western Ontario, in London, Rabinowitch enrolled at the Ontario College of Art in 1965. As a young sculptor emerging in the mid-1960s, Rabinowitch embraced a form of expression inspired by the abstract world of mathematics and, in particular, the theories of French mathematician Jules-Henri Poincaré, who made a distinction between abstract space and the space of experience.

Les pages-miroirs (Mirror Pages) Rober RACINE

1988; paper, ink, graphite and mirror; 33 cm x 33 cm; Courtesy Galerie René Blouin, Montreal; Collection of the artist (1956-)

Montreal artist Rober Racine is passionate about the French language. It is his muse, his landscape, the territory that he probes and whose space, dimensions and identity he explores. In the early 1970s, Racine recopied all of Gustave Flaubert's novels by hand and later built giant staircases that were three-dimensional manifestations of the length, size and numbers of words in individual chapters of particular books. In public readings, Racine moved from step to step as he progressed through the novel, thus realizing the temporal and spatial dimensions of the text.

For the *Les pages-miroirs* project, the *Dictionnaire Robert* provided a rich and complex source of inspiration. In a series of 2,130 collages, Racine mounted each page from the dictionary on a small mirror. In viewing a page, we see text and definitions, but where the artist cut out words, we see a reflection of ourselves. The identity of the page is now in flux, characterized by the reflection of its immediate environment and, potentially, by the infinite number of spectators. Where words and their definitions were previously finite, they now hover in uncertainty. Instead of clarity, we discover imprecision. Language becomes an object of speculation, playfully throwing us a mirror to ourselves, inviting us to find our reflection in texts and, like any work of art, challenging us to create a relationship with what we see.

William RAPHAEL

Behind Bonsecours Market

(1833-1914)

1866; oil on canvas; 67.5 cm x 109.6 cm; National Gallery of Canada

By the mid-19th century, Montreal was a lively commercial centre whose swelling population made it the largest city in the country as well as its principal seaport. Reflecting this notion of a bustling city, William Raphael captures the animated activity taking place in the shadow of Bonsecours Market, a building that still stands in Old Montreal. As we enter the painting on the street along the river, our path is marked by a man pushing a laden wheelbarrow and by two barefoot boys relaxing with their dog. In contrast to the wide-open sky above the river, the hub of commerce and entertainment to the right seems impenetrable. Here, the brightly coloured dresses of two women stand out against the subdued clothing of passersby who have stopped to listen to a man playing the fiddle. As a witness to this intricate *tableau vivant*, the man near the centre, carrying sketch pads and a five-pronged candlestick, is the artist himself.

Raphael was of Prussian origin and studied art in Berlin before immigrating first to the United States in 1856 as a portraitist. Then, in 1857, he relocated to Montreal, where he continued to seek portrait commissions. Considered one of Raphael's major works from the 1860s, *Behind Bonsecours Market* reflects the legacy of his European training and his roots in the German Romantic tradition, where lively and complex depictions of urban life were commonplace.

Call to Dinner George Agnew REID

1886-1887; oil on canvas; 121.6 cm x 179.8 cm; McMaster University Collection; Gift of Moulton College, Toronto; (1860-1947)
Donated to Moulton College by Mr. and Mrs. John H. L. Patterson, Mr. Robert Lawrence Patterson, Mr. J. F. W. Ross and the artist; Photo by Isaac Applebaum

In the brilliant noonday sun, the artist's sister Susan stands at the edge of the family farm and calls the workers to dinner. The hot light beats down on her hat and upraised arm, casting her face and neck into shadow and bestowing a sculptural monumentality to her figure that spans the height of the large canvas. The blue-green colour of her dress offers a chromatic synthesis of the summer-green fields that extend to the horizon, where the blue sky furnishes a tranquil

heaven. In 1888, a Toronto critic praised George Agnew Reid's work for its "boldness and truth and a thorough acquaintance with anatomy, the laws of perspective and the rules of composition."

Born on a farm in Wingham, Ontario, Reid began his art studies in 1878 at the Central Ontario School of Art and Design in Toronto. There, he met Robert Harris, who promoted the lessons of French academic training. Reid's desire to study the nude model led

him to Philadelphia, where he spent three years with American realist Thomas Eakins, who insisted on a thorough grounding in anatomy and life drawing. Despite the heavy influence of the French academic tradition on artists of his generation, Reid, who would soon become Canada's foremost genre painter, applied this training to Canadian subjects. Many years later, he stressed how essential it was that "the Canadian brush...have for its ultimate (continued on page 266)

George Agnew REID

Forbidden Fruit

1889; oil on canvas; 77.8 cm x 122.9 cm; Art Gallery of Hamilton, Gift of the Women's Committee, 1960

(*continued from page 265*) end the expression of Canadian life, sentiments and characteristics."

Reid travelled to Paris in 1888 to study at the Julian and Colarossi academies, continuing his examination of the nude model and perfecting his attention to the effects of atmosphere and light on the figure. When he returned to Canada in 1889, he embarked on a series of large-genre pictures inspired by his experiences growing up in rural Ontario. The sub-

ject of the censorship of reading, for example, took visual form in *Forbidden Fruit*. In an effort to infuse his paintings with as much realism as possible, Reid constructed a small loft in his studio, pitching hay over a log scaffolding upon which a young model reclined. Although the painting is rooted in Reid's personal recollections of being forbidden to read *Arabian Nights*, the image of a boy privately engrossed in his reading in the bucolic peacefulness of a bed of hay conjures

up our own memories of the pleasures of discovery.

In the late 1890s, Reid was inspired by French artist Puvis de Chavannes, and his passion for Canadian subjects evolved from scenes of everyday life to historical paintings and murals, through which he could express his commitment to public art and education on a grander scale. In 1912, Reid was appointed the first principal of the Central Ontario School of Art and Design, where he presided until his retirement in 1929.

Chrysanthemums, A Japanese Arrangement

Mary Hiester REID

c. 1895; oil on canvas; 45.7 cm x 61.0 cm; Art Gallery of Ontario; Gift of Friends of Mary Hiester Reid; Photo by Carlo Catenazzi/AGO

(1854-1921)

Praised for "diligence and sincerity" in her study of nature, Mary Hiester Reid is best known for her small, intimate paintings of flowers and interiors, which reflect her appreciation of the play of light on colours and textures in nature.

Here, the feathery delicacy of the pink and yellow chrysanthemums contrasts with the cool blues and greys of the smooth, round ceramic vase and the Japanese print in the background. The

inclusion of a Japanese print demonstrates Reid's awareness of the importance of these works to late-19th-century artists, and her use of an asymmetrical composition is an adoption of some of the principles of Japanese design. But her realist approach to the subject reflects her academic training under Thomas Eakins at the Pennsylvania Academy of Fine Arts (1883-85). It was there that the artist, who was born in the United States, met Canadian painter

George Agnew Reid, whom she married in 1886.

Reid's use of words such as "harmony" and "study" in titles of other flower pictures indicates her awareness of the art-for-art's-sake aesthetic of Anglo-American painter James McNeill Whistler. After her death, a Toronto art critic's appreciation characterized Reid in this way: "She was not only a painter of flowers, but their poet...she showed a wonderful felicity of arrangement and facility of execution."

267

Bill REID

Raven and the First Men

(1920-1998)

1980 (assisted by George Norris, George Rammell, Gary Edenshaw and Jim Hart); yellow cedar; 210 cm x 180 cm; Collection of the Museum of Anthropology, University of British Columbia; Photo by Bill McLennan

In Bill Reid's monumental work, derived from a tiny seven-centimetre-high boxwood sculpture, the giant trickster of Haida legend lands resoundingly on the smoothly carved clamshell and claims the human figures struggling to emerge. Their childlike bodies seem awkward as their hands grasp the shell, and their prematurely aged faces stare in anticipation of the uncertainty that lies ahead. In its synthesis of the formality of Haida carving and the emotional expressiveness of

European sculpture, this work marked a turning point in Reid's career. As art historian Doris Shadbolt wrote, "How appropriate that the Raven in the act of releasing mankind into the world by breaking his clamshell container should provide the image through which Reid secures his own release."

Born in Victoria, British Columbia, of a Haida mother and a Scottish-American father, Reid discovered his native ancestry as a teenager: He was a great-grand-

son of Charlie Edenshaw and a grandson of Charles Gladstone, also a silversmith and goldsmith. In 1948, while working as a writer/broadcaster in Toronto, Reid learned jewellery making, and through study of Northwest Coast art in museum collections, he grasped the compositional canons that had been lost to Haida artists since the 19th century. Reid is recognized for liberating the great inheritance of Haida art and reviving contemporary Northwest Coast native art.

Indians Returning from War

Indians Returning from War Peter RINDISBACHER

1825; watercolour, pen and ink; 25.8 cm x 21.3 cm; National Archives of Canada/C-114471 (1806-1834)

When Swiss-born Peter Rindisbacher took his first art lessons with a Bern miniaturist in the summer of 1818, he had no idea that he would become the first European artist to record prairie and Indian life west of the Great Lakes. In 1821, he immigrated to Canada with his parents, arriving at York Factory, a Hudson's Bay Company post on the west coast of Hudson Bay. His first sketches tell of the arduous sea voyage, the hazardous navigation of ships and the aboriginal groups they encountered in their perilous journey to the Red River Colony. In this rare depiction of the interior of a Plains Indian tipi, a warrior dressed in a buffalo hide brandishes an enemy scalp and carries a rifle acquired by trade with the settlers. A young warrior in the foreground, standing with his back to us, wears a Plains Indian buffalo robe characteristically decorated with a sunburst design. The other objects in the tipi, however, are Woodland Indian and confirm the ethnographic mixing prevalent in the Red River area.

An expert draughtsman with a keen eye for detail, Rindisbacher produced hundreds of colourful works, many of which were commissioned by Hudson's Bay officers. As accurate depictions of the daily rituals, hardships and violence experienced by both the native peoples and the settlers, they have proved valuable to historians and ethnologists.

Jean-Paul RIOPELLE

Pavane

(1923-)

1954; oil on canvas; 300.0 cm x 550.2 cm; National Gallery of Canada; © Jean-Paul Riopelle/SODRAC (Montreal) 2000

Although Jean-Paul Riopelle had moved to Paris in 1946, he was an integral part of the artistic revolution that took place in Montreal in the late 1940s. He designed the cover for the 1948 manifesto *Refus global* with a gestural allover linear patterning that characterized his work at the time.

Pavane is considered Riopelle's masterpiece from the 1950s. An immense work spread over three large panels, it envelops the viewer in a swirling, awe-inspiring array of colour. The elongated triangular shape of the artist's palette knife swoops across the canvas with a dizzying energy, creating featherlike patterns of flickering light. From left to right, areas of brilliance and darkness and of warm and cool colours swirl and dip across the canvas with musical rhythms, evoking the flamboyant Spanish dance of the title. "My purpose is not abstraction," said Riopelle, "it's moving towards a free gesture; it's trying to understand what is nature, starting not with the destruction of nature but with the world."

Riopelle studied at Montreal's École des beaux-arts and with Paul-Émile Borduas at the École du meuble, where he came into contact with Surrealist theories of automatism that encouraged a spontaneous expression of the subconscious in art. Recognized abroad by the late 1940s, Riopelle had achieved international success by the 1950s.

270

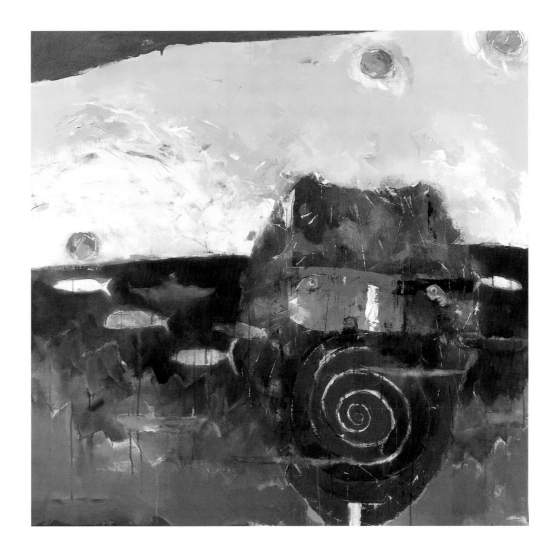

Whaler Mask

Rick RIVET

1999; acrylic on canvas; 139 cm x 140 cm; Indian Art Centre, Department of Indian Affairs and Northern Development, Canada; Photo by Janet Dwyer (1949-)

From the dark waters of the sea, a large greenish mask emerges, its form evoking the ancient masks of the Dorsets, the people who inhabited Arctic coastal regions from about 500 B.C. to 1500 A.D. The mask seems animated, its small eyes peering out and its mouth a curious spiral whose archetypal shape suggests the continuity of time and ancestral secrets. The areas of bright red, yellow and turquoise contrast with the enigmatic shadows of the sea world and lend a material beauty to this dreamlike realm. "In my art," said Rick Rivet, "I seek poetic expression—a visual language which uses the visible universe as a metaphor for the invisible, a communication between the world and the spirit, a mystical relationship."

Working spontaneously and intuitively, Rivet reveals otherworldly imagery that reflects his identity as a native artist. He remains committed to "the idea of 'bearing witness' to the strong spiritual content within the artistic traditions of aboriginal peoples in Canada and worldwide…These ancient artistic traditions, with their basis rooted in shamanic ideology and belief, have survived despite the devastating effects of colonialism."

Rivet, a Métis, was born in Aklavik, Northwest Territories, and later moved to Inuvik. He studied at the Universities of Alberta, Victoria and Saskatchewan. "Art," he said, "is a journey of the human spirit through the space/matter/time continuum."

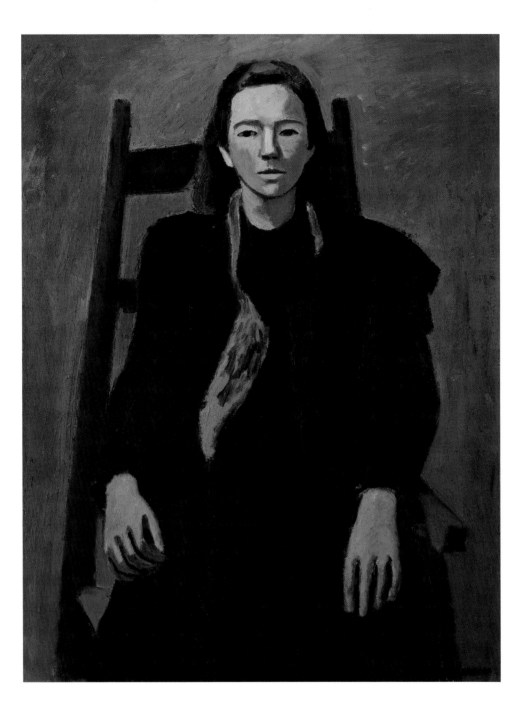

W. Goodridge ROBERTS

<div align="right">Marian</div>

(1904-1974) 1946; oil on canvas; 95.2 cm x 72.4 cm; Art Gallery of Ontario; Photo by Brigdens/AGO

With a solemn monumentality, Marian Roberts sits in a simple ladder-back chair, setting a tone of austerity that is echoed in her masklike expression. Contrasting with her sombre clothing and the boldly painted grey background, the light from the left lends a sculptural quality to her head, creating an area of brightness that continues in her hands and softly falling scarf. Tension and a feeling of sadness pervade the painting, perhaps because this was one of the last portraits Goodridge

Roberts did of his first wife before their separation later that year.

The child of a literary family, Roberts enrolled at the École des beaux-arts in Montreal in 1923. Disliking its staid academic approach, however, he left for New York City to study at the Art Students League (1926-28), where teachers such as Max Weber introduced him to new ways of structuring space and to a daring palette inspired by Cubism and Fauvism. The

city's galleries and museums offered him a glimpse of the work of the Post-Impressionists and the art of Paul Cézanne. "For the first time," wrote Roberts, "I saw painting that moved me." Following his term as the first artist in residence at Queen's University at Kingston (1933-36), Roberts returned to Montreal, where he continued to paint landscapes, still lifes and nudes with his characteristic directness and imaginative use of colour.

272

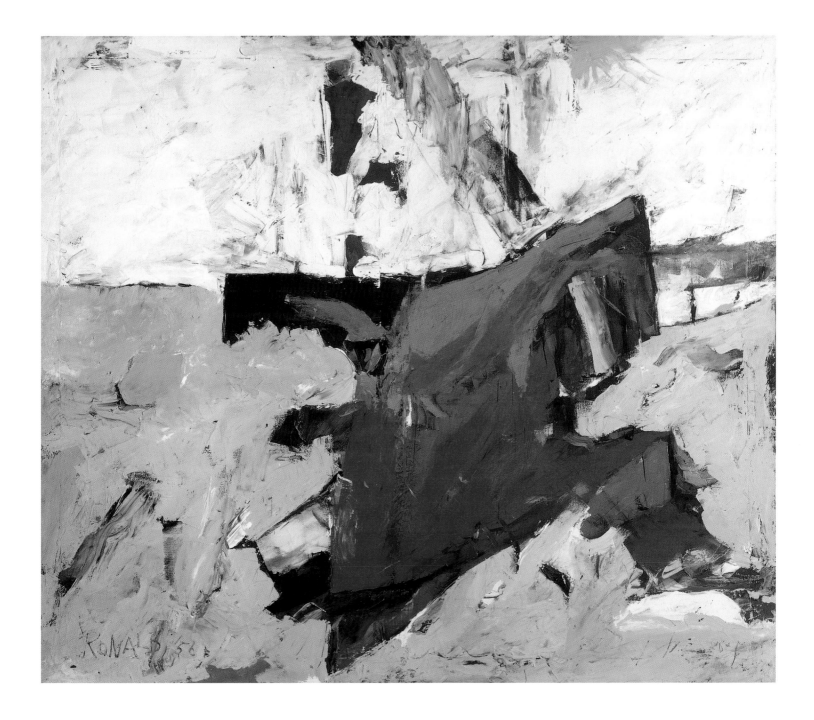

J'accuse

William RONALD

1956; oil on canvas; 152.4 cm x 175.9 cm; The Robert McLaughlin Gallery, Oshawa; Purchase, 1971; Photo by Thomas Moore (1926-)

"Jazz, the crash of bombs, the racing of civilization [all] have a definite effect on painters," said William Ronald in 1952. Here, a bold red shape created by energetically applied oil paint dominates the middle of the canvas, which is divided by an area of thick white paint above and a largely grey area, where rich blacks press against the red. The striking juxtaposition of colours combines with the powerful brushwork to form a strong central image whose newness confronts us with the feelings of uncertainty or aggression echoed in the painting's title.

Ronald studied with Jock Macdonald at the Ontario College of Art in 1952, then briefly in New York City with German abstractionist Hans Hofmann. In 1953, Ronald organized Abstracts at Home, an exhibition at the Robert Simpson department store by artists who would subsequently form Painters Eleven. But as Jack Bush recalled, "Bill Ronald got fed up with Toronto completely. He hated it here. He was a furious and angry young man in those days—and what a painter!" In 1955, Ronald moved to New York City, where his work attracted critical appreciation: "His pictures have an insistent honesty, a refusal to cover up confusion and a compelling painterliness." By 1957, Ronald was being represented by the successful Samuel Kootz Gallery, which promoted abstract art.

273

Robert ROUSSIL

Flying Bird

(1925-) 1949; elm wood; 48 cm x 37 cm x 21 cm; Musée d'art contemporain de Montréal; Photo by MACM

A block of wood has been transformed here into a dynamic flow of abstract shapes whose graceful volumes swell and shrink, creating a sense of rhythmic movement. Although the outline of a bird may be perceived in the disposition of forms that suggest wings and a tiny head, the sculpture is more an exploration of space, freedom and flight than it is a literal representation. Embracing one of his favourite mediums, Robert Roussil challenges its conventions:

"Wood is a personal material; its flexion and tension must be studied."

Roussil had enjoyed drawing as a child, but his dream of becoming an artist was realized only with the federal government's offer of a free education for veterans. He enrolled at the school of The Montreal Museum of Fine Arts and was encouraged by Arthur Lismer to pursue sculpture. A nonconformist who felt that his inability to adapt to "polite society" destined

him to become a sculptor, Roussil was also public-minded. In 1947, he established "Place des arts," a cooperative workshop for tradespeople and artists, where exchanges of expertise benefited all. While Roussil would go on to build his reputation by producing monumental public sculptures, the diminutive *Flying Bird* set the stage for his devotion to themes inspired by nature and for his innovative exploration of materials as varied as ceramic, cast iron and bronze.

Monseigneur Rémi Gaulin

Jean-Baptiste ROY-AUDY

1838; oil on canvas; 84.5 cm x 71.2 cm; Musée du Québec; Photo by Jean-Guy Kérouac/MQ

(1778-c.1848)

From the comfort of his well-stocked library, Monseigneur Gaulin points intently to a document that is likely an account of his pastoral visits in Upper Canada, completed the year this work was painted. The books on the shelf attest to the subject's erudition, no doubt employed in his role as assistant to the Bishop of Kingston. With exacting precision, Jean-Baptiste Roy-Audy describes the silk texture of Gaulin's blue cape, the intricate lace of the cuffs and

the fine weave of the golden cord supporting the pectoral cross. The colour red weaves through the painting, ensuring that we also admire Gaulin's ring, shirt and books as well as the velvet curtain behind his head. The meticulous attention to detail combined with the awkward perspective and the foreshortening of the body in a space too shallow to contain Gaulin's robust frame all point to the naive style of self-taught portraitists such as Roy-Audy.

Born into a family of woodworkers in Quebec City, Roy-Audy studied briefly with François Baillairgé and opened his own workshop in 1802 as a cabinetmaker and painter of carriages and signs. Later, he turned full-time to painting, sometimes travelling as far west as Kingston to secure commissions. Practised in copying religious works, Roy-Audy also created many portraits of the clergy—the one of Gaulin is considered to be his finest.

275

RUNNING RABBIT

Buffalo Robe

(1833-1911)

1909; buffalo skin; 170 cm x 190 cm; Photo courtesy of the Royal Ontario Museum, © ROM

When artist Edmund Morris (1871-1913) travelled across Canada in 1909 to paint portraits of native people, he met Blackfoot chief Running Rabbit on a reserve east of Calgary. During his stay, Morris commissioned eight Blackfoot and Sarcee chiefs to paint their histories on buffalo hides, the traditional robes used by warriors to summarize visually their war exploits, horses or enemies captured and brave deeds.

Here, on the large surface of the buffalo hide, Running Rabbit used the porous part of a buffalo bone as a tool to draw images inspired by "picture writing," or pictographs, found on ancient stone art. Women are easily recognized as skirted, while the triangular bodies of men feature either a single leg in profile or a pair of striding legs. Although Running Rabbit worked within a conventional artistic language where figures were clearly drawn in profile and arranged systematically for tabulation, he still invented personal symbols to represent scalpings or the capture of enemies. He distinguished the players in his chronicles with different colours: Cree were painted in red, Crow in yellow and Blackfoot in blue or black. At Morris's request, Running Rabbit drew red lines around the various groupings to separate the stories that unfolded over a period of time. These events were highly valued within the native community as signs of bravery and were depicted with respect.

The Pow-Wow

<div align="right">

Allen SAPP (Kiskayetum)

</div>

1987; acrylic on canvas; 101.6 cm x 152.4 cm; Collection of the MacKenzie Art Gallery;
Purchased in memory of Mari Stewart; Photo by Don Hall

(1929-)

Beneath a ring of branches, people come together for a summer powwow, a colourful First Nations social gathering. In the foreground, figures painted in primary colours direct our gaze to the procession of dancers dressed in ceremonial beadwork clothing, whose red, yellow, black and white colours symbolize the four cardinal directions and honour the four races of the Earth. The beadwork patterns are similar to those of Allen Sapp, himself a powwow dancer. To

the right, men in white hats stand in a circle and beat on the drum, and in the distance, the tipis stand like tall spectators on the circle's edge. Although Sapp is renowned for his depictions of the cultural activities and daily life of the Northern Plains Cree, Métis artist Bob Boyer insists that "[Sapp's] work is marked by his 'spiritual reverence' for the world and is not merely an illustration of the world around him."

Sapp was born on the Red Pheasant Indian Re-

serve near North Battleford, Saskatchewan, and began to make portraits of friends and family in the 1950s. Adopting the conventions of Western art gleaned in his youth from magazines and calendars and profiting from a short period of study with Saskatoon painter Wynona Mulcaster, Sapp expressed his Cree heritage as "he who knows it," fulfilling the meaning of his native name, Kiskayetum. In 1987, Sapp was made an Officer of the Order of Canada.

Anne SAVAGE

The Plough

(1896-1971) c. 1930; oil on canvas; 76.4 cm x 102.3 cm; The Montreal Museum of Fine Arts; Gift of Arthur B. Gill; Photo by Brian Merrett/MMFA

Here, a close-up view of a plough cuts a strong diagonal across the canvas and provides a window onto an undulating landscape, where a sea of green grass wafts as smooth as silk. The contours of the ploughed fields rise and fall with a steady rhythm until they meet the shining green sky, which is tempered by a wispy sliver of purple cloud.

Through the poetic use of colour and line, Anne Savage evokes her feelings of joy in capturing the splendour of the Quebec countryside along the shores of the Lower St. Lawrence. "The backcountry was always perfectly beautiful," she said. "And it's wonderful the way the land rolls away in great sweeping folds. The forms, they run in long laps right up from the sea. Field after field. It was like a patchwork quilt."

Savage studied with William Brymner and Maurice Cullen at the Art Association of Montreal, and in 1920, she joined the Beaver Hall Hill Group, where she developed a long and close friendship with A.Y. Jackson. Occupied as a teacher for most of her career, she continued to travel the country widely on sketching excursions. Although Savage was influenced by members of the Group of Seven and exhibited with them, her sense of colour and design was a departure from theirs and was marked by a lyrical and passionate response to the land.

Ontario Farmhouse

Carl SCHAEFER

1934; oil on canvas; 106.5 cm x 124.7 cm; National Gallery of Canada; Gift of Floyd S. Chalmers, Toronto, 1969

(1903-1995)

Carl Schaefer left his grandfather's farm and the place of his birth in Hanover, Ontario, in 1921 to study at the Ontario College of Art in Toronto. Through his teachers J.E.H. MacDonald and Arthur Lismer, the young student met A.Y. Jackson and Lawren Harris, whose paintings of Toronto houses he admired. During the Depression in the early 1930s, however, jobs for artists were scarce, and with a family to support, Schaefer was forced to return to his grandfather's farm.

"There is one thing every painter must do," wrote Schaefer, "and this is know his environment…and achieve a proper balance between the technical means and the emotional expression." True to his word, Schaefer embarked on a series of paintings depicting the rural homes and fields of Hanover in a style that evoked the dramatic and uneasy tensions of the 1930s and 1940s. In *Ontario Farmhouse*, a neighbour's home commands a view of the surrounding fields, while a

dramatic sky is animated by a diagonal sweep of clouds that contrasts with the stable geometry of the house. To suggest the cycles of nature and regeneration, Schaefer juxtaposes green plants with harvested and unharvested hay, and to the right, a barren tree foretells the cold sleep of winter that will, in turn, give way to spring. Subject to the perpetual transformations of nature, humanity—which is symbolized by the house and the lone chair—endures.

279

Tony SCHERMAN

Macbeth's Mother

(1950-) 1994; encaustic on canvas; 183 cm x 152 cm; Courtesy of La Serre Art Contemporain/Barbara Farber; Photo by Victor Arnolds

When viewing this work, one hovers in limbo between the awareness of the sensuous surface of the canvas, given luminosity and texture by the oil and encaustic, and the monumental presence of illusion, as the detail of a woman's face assaults us with its huge scale and quivering emotion. In a series of paintings inspired by characters from literature and Greek mythology, Tony Scherman rejuvenates the art of portraiture by combining the "close-up," born from the advances of modern photography and cinema, with the ancient technique of encaustic to present a timeless expression of emotion. While the practice of mixing paint with hot wax can be perilous, the technique appeals to Scherman for its enduring qualities. "I know that my paintings are going to live longer than I will," he explained. "That gives me a sense of satisfaction."

Here, Scherman has fabricated the character of Macbeth's mother, with a soul as tortured and fearful as that of her ambitious and treacherous son. Her wide eyes watch silently as her thin lips speak of woe and resignation. By omitting a setting, the artist portrays the essence of the individual, exposing the surface of memory and experience.

Scherman was born in Toronto and moved to London, England, as a child. He graduated from the Royal College of Art in 1974 and returned to Toronto two years later.

The Croppy Boy (The Confessions of an Irish Patriot) Charlotte SCHREIBER

1879; oil on canvas; 90.2 cm x 76.2 cm; National Gallery of Canada;
Royal Canadian Academy of Arts diploma work, deposited by the artist, Toronto, 1880

(1834-1922)

It is not surprising that Charlotte Schreiber, an artist who had already exhibited paintings at the Royal Academy in London at the age of 21 and had illustrated the poems of Chaucer, Spenser and E.B. Browning, would again turn to literature as an inspiration for her work.

Here, her source is a ballad popular during the Irish rebellion of the 1790s, in which the Croppy Boy, so named for his close-cut hair, kneels to confess his sins before going into battle. With exacting realism, Schreiber faithfully captures the boy's unwitting and tragic encounter with the British soldier disguised as a Catholic priest.

Employing academic skills recognized by the Royal Canadian Academy of Arts, which invited her to become a charter member in 1880, Schreiber portrays a moment that is as taut with emotion as it is striking in its verisimilitude. Its poignancy is further enhanced by the contrast of the worn clothes and tired dusty shoes of the boy beside the brass-buttoned coat and magnificent black riding boots of the soldier. Given the players' mutual hostility, the red of their jackets lends an ironic visual unity to the picture. We might wonder whether Schreiber's sympathies are not reflected in her use of light, with the young patriot situated on the bright side of the canvas and the soldier set against an impenetrable shadow.

281

John SCOTT

Trans-Am Apocalypse No. 2

(1950-)

1993; car with primer, latex paint, incised with text from the Book of Revelation of Saint John the Evangelist, fuzzy dice; 127 cm x 178 cm x 500 cm; National Gallery of Canada

Although antiwar themes addressing the fear of nuclear holocaust and environmental devastation had long inhabited the large-scale paintings of John Scott, it was his admiration for Murray Favro's *Sabre Jet* that inspired him to explore these issues with actual objects. Adapting a 1984 Pontiac Firebird to resemble a Trans-Am—in the artist's eyes, the ultimate "macho muscle car"—Scott used a nail to scratch the entire text of the New Testament's Book of Revelation into the black latex paint. This is the sort of vehicle, Scott imagined, that would be used now by the Four Horsemen of the Apocalypse, the agents of divine wrath arriving to purge humanity in preparation for the second coming of Christ. "Heavy-metal youth cultures are obsessed with death," said Scott. "The car symbolizes destructive masculine egos, environmental destruction, the follies of us all that lead to the end."

For Scott, the familiarity of a car makes it a democratic art form with which people can identify personally, attracted or repelled by its associations with power, identity, seduction and destruction. The sense of threatening menace perpetrated by the blackness of the car is perhaps also a reflection of the fear experienced by Scott growing up in Windsor, Ontario, in the shadow of Detroit, the mecca of the American car industry and a city marked for nuclear eradication during the Cold War.

Stairway

Marian SCOTT

c. 1940; oil on canvas; 72.5 cm x 76.2 cm; The Montreal Museum of Fine Arts; Photo by Christine Guest/MMFA

(1906-)

In the interior of a modern building, our eye is drawn to the bright red dress of a woman descending a spiral staircase. Below, a man in more subdued colours completes his journey and focuses our attention on a couple embracing and another figure turning a corner. The curving forms of these anonymous individuals lend an organic softness to the severity of the architecture, which is composed of a series of angles, lines and rectangular shapes. Painted around 1940, *Stairway* embodies Marian Scott's intention to create works of art that would reflect humanity's ability to establish a rational environment, an optimistic stance in the face of the impending chaos of war.

As a founding member of the Contemporary Arts Society in Montreal in 1939, Scott and her colleagues were frustrated by the nationalism and domination of landscape painting trumpeted by the Group of Seven. They sought new subjects for Canadian art, desiring, as Scott explained, to explore "the cutting edge...to try to add something new to tradition." Her inquiries into more international influences were nurtured by travels throughout Europe, by a short study in London at the Slade School of Art and, later, by the example of American Precisionists such as Charles Sheeler, whose exacting and geometrically simplified depictions of modern architecture furthered her exploration of urban subjects.

Julian R. SEAVEY

Music

(1857-1940)

1890; oil on canvas; 92.2 cm x 56.6 cm; National Gallery of Canada

With poetic precision and an almost tangible realism, a musical still life of balance and counterbalance unfolds before us. In the centre, a violin and bow hang on a nail, creating visual contrasts of volume and line, while the instrument's warm reddish tones play against the cool grey wall and the blue book. On the table, sheet music and a book of duets invite the participation of the woodwind instrument that projects illusionistically into our space. To the left, violin strings form a thin circle whose counterpoint is the cube of translucent resin sitting in a red box on the table. In the tradition of trompe l'oeil paintings, which literally "trick the eye" by giving the impression of real objects, Julian Seavey explores a centuries-old genre that started in antiquity and was revived in the Netherlands in the 17th century, often with moralistic overtones. Whether Seavey intended this musical composition to be a reminder of the ephemeral vanities of life as it might have been perceived in the 17th century or simply an object of sensuous contemplation, we can only imagine.

Seavey was born in Boston, Massachusetts, and studied for three years in Paris, Rome and Germany before settling in Hamilton, Ontario. He taught at the Hamilton Normal School from 1908 to 1931 and became the first president of Hamilton's Art Students' League in 1895.

Baba's Garden, Hafford, Saskatchewan, 1985-86 | Sandra SEMCHUK

1985-1986; 17 cibachrome prints; each approximately 26.7 cm x 34.5 cm;
Courtesy Canadian Museum of Contemporary Photography

(1948-)

Baba's Garden sweeps across the wall, offering a multi-faceted portrait of Sandra Semchuk's smiling grand-mother in her garden. Moving with joy and spontane-ity, Semchuk expands her perspective beyond a static presentation of the individual and points her camera past her subject, to the sky and toward the lush green ground. The view through an artist's eye is inevitably subjective, but here, Semchuk fuses performance and photography, asserting the intimacy and informality that characterize her relationship with her grandmother. The multiple points of view coupled with the segmen-tation of the images evoke the fragmented nature of experience, mirroring the ways we encounter a world that is constantly in flux. "Synchronicity is the orga-nizing principle of every gesture, every shift from out of focus (shifts of consciousness), every breaking of form," she said. "As I photograph, I keep raising alter-native propositions, eluding the traps of my own vision

…the multiple experiences of the mind, when given rein, escape the boundaries of the single personality."

Born in Meadow Lake, Saskatchewan, of Ukrai-nian and Polish parents, Semchuk began her studies at the University of Saskatchewan. Building on her work of the 1970s—portraits of herself, friends and close family members—Semchuk's studies at the University of New Mexico in the early 1980s inspired the com-plex perspectives we see here.

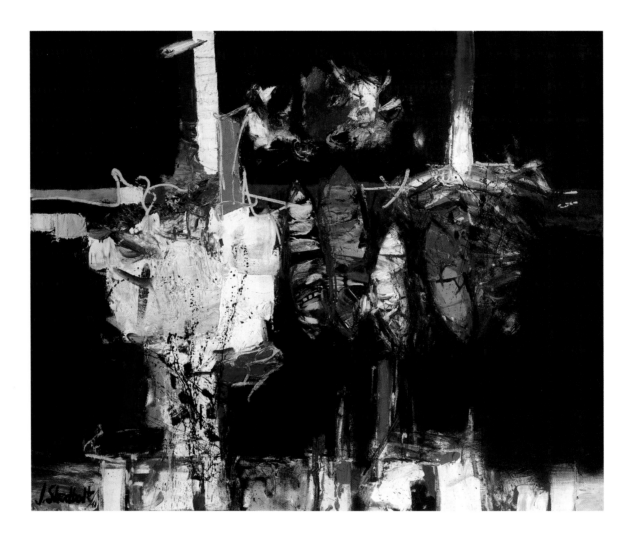

Jack SHADBOLT

(1909-1998) 1961; oil and lucite on canvas; 108.0 cm x 129.2 cm; National Gallery of Canada

Central to Jack Shadbolt's long and prolific career as an artist was his preoccupation with the cycles of nature, as both a metaphor and a symbol of human experience. *Winter Theme No. 7* is one of a series of nocturnal views of Vancouver harbour that Shadbolt painted in the early 1960s. Here, we hover over the harbour, where brightly coloured oval-shaped boats tethered to piers form a linear grid on the pitch-black waters. Looking down from the Burnaby Mountain

area, Shadbolt could see "this deep brown-violet void, with these pulsing, jewel-like, throbbing clusters of lights." While the harbour was the outward inspiration, the work was infused with his perceptions of nature: "The pier…or jetty, with its cluster of almond-shaped dinghies like seedpods around a stem or like beetles eating a leaf, is a motif that has lain so long in my mind that it has become abstracted."

In *Transformations No. 5*, Shadbolt converts the ethe-

real and diminutive butterfly into a monumental study of the cycle of life. "I saw the butterfly," he wrote in 1988, "as a powerful symbol of the natural and spiritual will to survive through change and transformation—a symbol all the more potent in contrast with the fragile and ephemeral beauty of its subject." With characteristic vigour, Shadbolt draws colossal butterfly shapes whose dizzying array of colours and patterns reverberates with vitality, blossoming forth in the

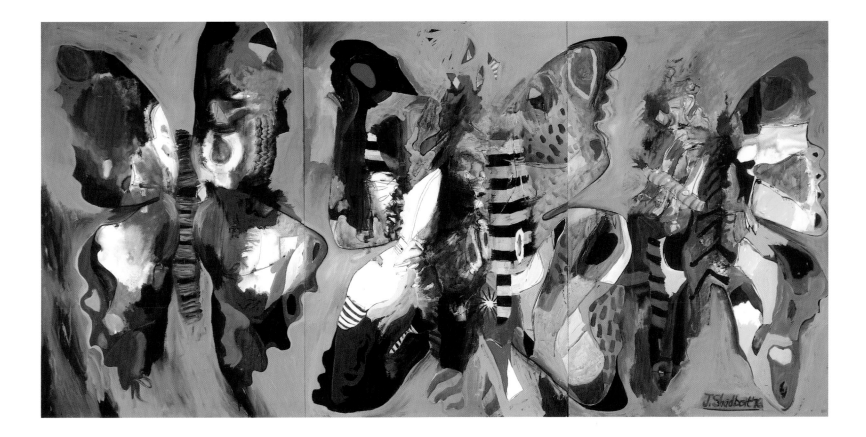

Transformations No. 5

1976; acrylic, latex commercial paint, black ink, pastel and charcoal on illustration board; 152.7 cm x 305.1 cm; National Gallery of Canada

young butterfly on the left, coming to exuberant maturity in the centre and, in the last, withering in the inevitable decline toward death. "I find the butterfly a tremendously erotic image," he said. "The cocoon is almost phallic, this tight-wrapped bar with the life inside it and the capacity for expanding and opening. Then suddenly, the flowering stage, the very unfolding is almost a sexual image in itself." For Shadbolt, the image of the butterfly was redolent with memories of

chasing butterflies as a child, and it reflected his interest in the writings of novelist Vladimir Nabokov: "Reading Nabokov, with [his] superbly literate obsession with butterflies, stepped up my rumination about their enigmatic and symbolic overtones from blind enclosure to rapturous unfolding into release and flight."

Shadbolt was born in England and settled in Victoria, British Columbia, in 1912. In the late 1920s, he met Emily Carr, to whom he would pay homage in a

series of works inspired by her view of West Coast forests. His studies at New York's Art Students League in the early 1930s and late 1940s consolidated his attraction to abstraction as well as to Surrealist-inspired automatism that would sustain his lifelong desire "to reconcile nature with abstraction and deliberation with intuition." He worked as a war artist and taught at the Vancouver School of Art, retiring in 1966 as one of its most influential and admired teachers.

SHANAWDITHIT

Dancing Woman, detail from a sheet of sketches

(c. 1801-1829)

1828; paper and pencil; approx.: 31 cm x 23 cm; Courtesy Newfoundland Museum

This delicate drawing of a woman, her eyes closed in concentration and her arms raised as if dancing, gives us a close-up look at a sheet of sketches by Shanawdithit, one of the last survivors of the now extinct Beothuk Nation that had inhabited the coasts and interior of Newfoundland since prehistoric times. Although the Beothuk were not alone in experiencing violent displacement at the hands of the Europeans, their annihilation had been particularly ferocious.

When Shanawdithit, her sister and mother, all near starvation, were captured and taken to St. John's in 1823, the Beothuk Nation numbered fewer than 20.

Here, Shanawdithit delineates the details of the woman's dress. The decorated border at the top may have been beaver or martin, while the fringe along the bottom was probably made of finely carved caribou-bone ornaments, often worn as religious amulets or sewn onto clothing to provide a rattling fringe.

Shanawdithit drew a series of sketches at the invitation of W.E. Cormack (1796-1868), a merchant, explorer and naturalist who provided her with paper and pencils as a means of recording the Beothuk language and customs. The 10 surviving sheets of sketches reveal a diversity of information about Beothuk housing, food preservation, drinking vessels, maps, captures and murders, all carefully defined with thin striations in pencil. The English annotations were made by Cormack.

288

Self-Portrait

Arthur SHILLING

c. 1975; oil on Masonite; 86.7 cm x 63.6 cm; McMichael Canadian Art Collection

(1941-1986)

Within a dazzling mosaic of colour, Arthur Shilling's gaze is still and unwavering, a centre of calm amidst the swiftly painted brush strokes that define his hair, shoulders and background. In contrast to many of his native contemporaries, who looked to ancestral art forms and legends as the subjects for their art, Shilling painted the people, particularly children and elders, from his birthplace on the Rama Indian Reserve, near Orillia, Ontario. In his 1986 posthumous publication *The Ojibway Dream*, Shilling wrote, "I try to reveal their spiritual soul, the quietness that makes us different, that no other nation or people have."

Shilling was born of Ojibwa parents and was sent to a residential school in Brantford, Ontario, where he developed his drawing skills and later earned a scholarship to study at the Ontario College of Art. He sold his paintings rapidly in Toronto and achieved national acclaim following a solo exhibition in Ottawa in 1967, but health problems spurred his return to the reserve, where he resumed portrait painting in an innovative and expressive style. Although praised by a critic in *The Globe and Mail* as "a thoroughly independent spirit who happens to be Indian," Shilling insisted: "The Indian spirit, the Indian eye, is still free, uncontaminated. And that's what I am trying to maintain. My primary brush is Ojibway…My Indianness is deep within me."

Jori SMITH

(1907-)

1952; oil on cardboard; 60.3 cm x 47.7 cm; The Musée d'art contemporain de Montréal Collection;
Gift of Dr. Max Stern; Photo by RIchard-Max Tremblay

The sister of Vitaline sits solemnly in the shadow of a large, colourful vase of flowers, whose ebullience is contrasted with her look of subdued concentration. Light falls softly on the child's rounded face, illuminating her white dress against the darkness that engulfs her. Painted with a spontaneity that echoes the freshness of the bouquet and the youthfulness of the subject, the loose brushwork and bold drawing animate the surface, revealing a vitality of spirit that reflects the artist's own.

After four years of traditional academic training at the École des beaux-arts in Montreal (1925-29), Jori Smith studied briefly with Randolph Hewton at the Art Association of Montreal and then privately with Edwin Holgate. Like Holgate, A.Y. Jackson and other artists, Smith was attracted to Quebec's Charlevoix region, where she was captivated by the rolling countryside and the character and kindness of the rural inhabitants. As did her friend Jean-Paul Lemieux, who pur-

sued an anti-academic approach to the figure, Smith embraced a style inspired by European modernism as a means of evoking the personalities of these hardworking folk. She was particularly attracted to children as subjects, revealing in their demeanours—especially in the portraits of the 1930s—a gravity beyond their years. In 1939, Smith joined the Contemporary Arts Society, affirming her passion for a dynamic expression that she joyfully pursued into her nineties.

Venus Simultaneous

Michael SNOW

1962; oil on canvas and wood; 200.7 cm x 299.7 cm x 15.2 cm; Art Gallery of Ontario; Photo by Carlo Catenazzi/AGO

(1929-)

Between 1961 and 1967, Michael Snow produced almost 200 works using the silhouetted image of a walking woman, a cut-out figure that became a tool for exploring relationships between figure and ground and for questioning the essence of visual experience. The "walking woman" was transformed in seemingly endless combinations and permutations, in two and three dimensions, cropped, painted, abstracted, sculpted, photographed and installed in public places,

culminating in 11 stainless-steel sculptures for Expo 67.

In *Venus Simultaneous*, the mythical subject becomes contemporary, striding across the canvas with her short dress and bobbed hair, familiar yet anonymous. A cut-out Venus occupies our space in the foreground, having served literally as the model for the seven others painted, outlined and collaged on the surface. The suggestion of progressive motion alludes to the sequence of frames in a film, the primary medium upon which Snow's in-

ternational reputation is based. The multimedia nature of this work also points to the multidisciplinary character of Snow's career as a painter, sculptor, photographer, filmmaker, musician and holographer.

Snow was born in Toronto and studied at the Ontario College of Art (1948-52). Attracted to the New York art scene in the 1950s and 1960s, he particularly admired Willem de Kooning's expressive portrayals of women that combined painting and collage.

Jeffrey SPALDING

Night Fall

(1951-)

1984; oil on canvas; 198 cm x 395 cm; National Gallery of Canada

The immense scale of this painting, which is almost four metres wide, engulfs the viewer and evokes the monumentality and threatening magnificence of one of the world's greatest natural wonders. The impenetrable silver-black mass of water cascades over the Niagara escarpment with tremendous force, issuing a grey mist that rises to obliterate the ebony sky. Along the curved rim of the eroded rock, an effervescent green defines the point of no return. Shrouded in the mystery of darkness, Jeffrey Spalding's *Night Fall* banishes the image of honeymoons and dreams and embraces the grave side of our imagination—disturbing and even nightmarish.

Spalding emigrated with his family from Scotland to Canada as a child. Following studies at Ohio State University and the Nova Scotia College of Art and Design, in Halifax, he pursued a conceptual approach to art, exploring colour theory and painting processes. In the late 1970s, his metaphoric paintings of domestic interiors were imbued with a psychological ambiguity that he extended to his paintings of nature. Here, he questions the relationship between culture and nature. Are the Falls a symbol of prodigious nature, unknowable, mighty, romantic and sublime? Or does the darkness of the image cast nature as endangered and ecologically vulnerable? While a single meaning will probably elude us, the hauntingly beautiful materiality of this painting endures.

Borrowed Scenery

Barbara STEINMAN

1987; installation with video and slide projection; exhibition area: 4 m x 12 m x 8 m; Musée d'art contemporain de Montréal (1950-)

In a darkened room that suggests night and the place of dreams, Barbara Steinman invites us to consider our relationship to nature and to place, in a manner which is as multisensory and experiential as the natural world, travel and migration themselves. In the centre of the installation, a large wooden surface is covered with 500 pounds of salt, raked to evoke the famous rock garden in Kyoto, Japan, which Steinman visited. Video monitors with images of flowing blue waters interrupt the serenity of the salt landscape, while above, a slide projector casts pictures of maps, abstracted representations of actual places. On the wall, three backlit black-and-white photographs are accompanied by texts. The first photo, titled "tourist," shows a large ocean liner; the second, labelled "immigrant," features the same boat transporting Jewish exiles in the 1930s; the third is marked with the word "refugee" and depicts Vietnamese boat people in a small vessel. For all these people, the lands in which they arrive are merely "borrowed scenery," confirming their transient relationship to place. As the maps keep changing over the raked salt table, we are reminded of the power of politics and technology in controlling our view of the world.

Steinman was born in Montreal. Since the 1980s, she has produced videos and installations that explore the individual's relationship to history, nature and technology.

293

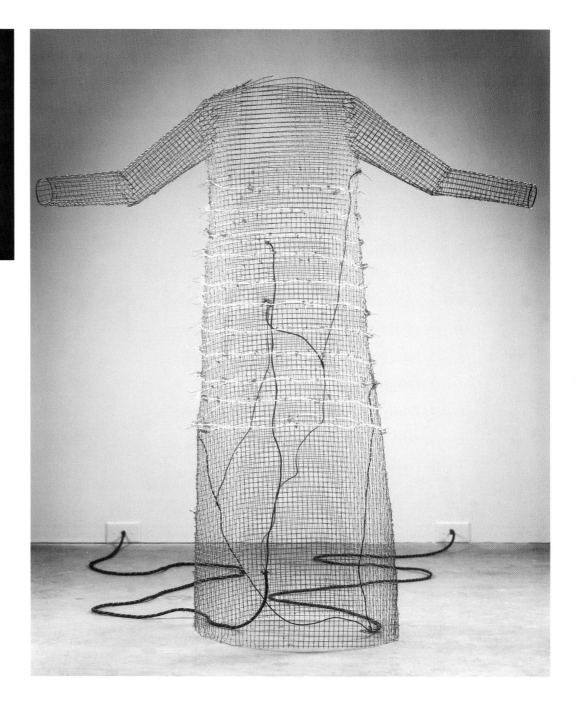

I want you to feel the way I do: There's barbed wire wrapped all around my head and my skin grates on my flesh from the inside. How can you be so comfortable only 5″ to the left of me? I don't want to hear myself think, feel myself move. It's not that I want to be numb, I want to slip under your skin: I will listen for the sound you hear, feed on your thought, wear your clothes.

Now I have your attitude and you're not comfortable anymore. Making them yours you relieved me of my opinions, habits, impulses. I should be grateful but instead ...you're beginning to irritate me: I am not going to live with myself inside your body, and I would rather practice being new on someone else.

Jana STERBAK

I Want You to Feel the Way I Do...(The Dress)

(1955-)

1984-1985; live uninsulated nickel-chrome wire mounted on wire mesh, electrical cord and slide-projected text; 144.8 cm x 121.9 cm x 45.7 cm; National Gallery of Canada

As we approach this life-sized dress made from wire mesh, its arms beckoning, the live stove wire lights up, burning red-hot. We are invited to consider the experience of wearing or touching such a dress and to ponder the intimate proposition in the nearby text: "I Want You to Feel the Way I Do." Exploiting the metaphors offered by her source of inspiration—the story of Medea, who vanquished her rival with a fatal robe—Jana Sterbak bids us to contemplate the analo-

gies suggested by a dress which represents both presence and absence, attraction and repulsion and which functions as clothing that both protects and reveals, empowers and kills.

Sterbak likes the idea of the art object "as irritant" and insists that the meaning of the work is open to interpretation. "I believe the didactic has no place in art," she has said. The text is projected onto the wall near the dress and can be seen, according to the

artist, "as an independent yet thematically related entity which complements the object, and vice versa."

Born in Prague, Czechoslovakia, Sterbak came to Canada in 1968. She studied at the Vancouver School of Art (1973-74) and graduated from Concordia University in 1977. The legacies of her Czech culture and the influence of writers such as Franz Kafka are manifest in her work through the importance she gives to fantasy and freedom of the imagination.

Tondo VIII Françoise SULLIVAN

1980; acrylic on canvas with cord; 287 cm x 298 cm; Musée du Québec; Photo by Patrick Altman/MQ (1925-)

Françoise Sullivan studied painting in Montreal at the École des beaux-arts. In the early 1940s, she became associated with Paul-Émile Borduas and other artists who would sign the 1948 *Refus global*, marking her opposition to academic tradition and a lifelong dedication to art forms inspired by the subconscious and inner emotion. Sullivan trained in dance in New York City with Franziska Boas. Later, her career as a dancer and choreographer permeated her explorations of visual art with a love of dynamic movement and circular form.

In the decades that followed, Sullivan produced metal sculptures, photography, collage and dance performances, and in the early 1980s, she returned to painting, intuitively coming upon the idea of cutting the canvas in a round shape, or tondo. In this first work in the tondo series, Sullivan threw the paint on the canvas, allowing the deep blue and green colours to gather and dry in the creases of the previously folded fabric, thus creating mysterious traces of her actions and expressing, as in dance, the artist's "own inner impulses and dynamisms." While the shape of the canvas and the allover painted surface allude to the world of myth and memory, evoking a cosmic symbolism of ritualistic circles and planets, the linearity of the knotted cord that falls to the floor grounds us in the material reality of the present. In her recent abstract work, Sullivan continues to assert the vital relevance of painting.

Marc-Aurèle de Foy SUZOR-COTÉ

Winter Landscape

(1869-1937)

1909; oil on canvas; 72.2 cm x 94.4 cm; National Gallery of Canada

Born in Arthabaska, in Quebec's Eastern Townships, Marc-Aurèle de Foy Suzor-Coté began his artistic career as a church decorator with the Joseph Rousseau company in St-Hyacinthe. From 1891 to 1894, he made the first of many trips to Paris, where he learned a traditional academic approach to the figure at the École des beaux-arts, and from 1897 to 1901, he studied at the Académies Colarossi and Julian, winning first prize at the latter for his 1898 painting

The Death of Archimedes. The influence of French landscape painter Henri Harpignies was also central to sensitizing his eye to the fleeting effects of light in winter landscapes. Although Suzor-Coté continued to travel extensively between Canada and different parts of Europe until 1912, he had resettled in his native village by 1907 and had begun to paint the rural inhabitants and rolling landscape near the Nicolet and Gosselin rivers in the style of the Impressionists,

whose colourful, loosely brushed landscapes he had admired abroad. "Learn to see the beautiful in what surrounds you," he said, "and that should also be good for your soul."

In *Winter Landscape*, nature's most forbidding season is made inviting by the azure-blue stream that snakes a sinewy path through fields of snow. The pink rocks along the shore are reflected in the water, and their colour enhances the warmth already lent by the bright-

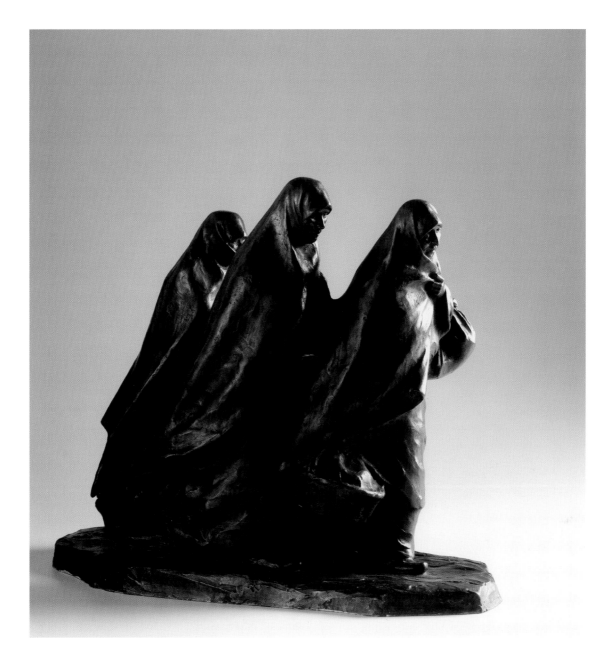

The Women of Caughnawaga

1924; bronze; 43.5 cm; The Montreal Museum of Fine Arts; Gift of F.N. Southam; Photo by Christine Guest/MMFA

ness of the day. Suzor-Coté's use of a palette knife to flatten the thick impasto of the oil paint makes us aware both of the illusion of depth and of the material flatness of the canvas surface. Inspired by the example of Norwegian artist Fritz Thaulow, whose paintings of snow-bordered rivers he had seen in Europe, Suzor-Coté continued to explore this theme in over 20 canvases that celebrate the changing harmonies of light as winter's ice and snow submit to the sun's radiance.

Although Suzor-Coté had exhibited a sculpture at the Grand Palais in Paris in 1907, it was on his return to Canada that he explored in sculpture the themes of rural life depicted in his paintings and in his illustrations in 1916 for Louis Hémon's *Maria Chapdelaine*. *The Women of Caughnawaga*, considered one of his finest sculptures, is admired for its dynamic forms and the simplification of volume that imbues it with an eloquent monumentality. Perpetuating the artist's devotion to the themes of rural life and the effects of the elements, three women of the town stride into the wind, their blanket capes clasped tightly around their heads and their arms laden with baskets and heavy bundles. While their faces express serious concentration and are based on life studies of individuals, their clothing sweeps gracefully around them in billowing shapes, offering a vibrant image of movement from every perspective.

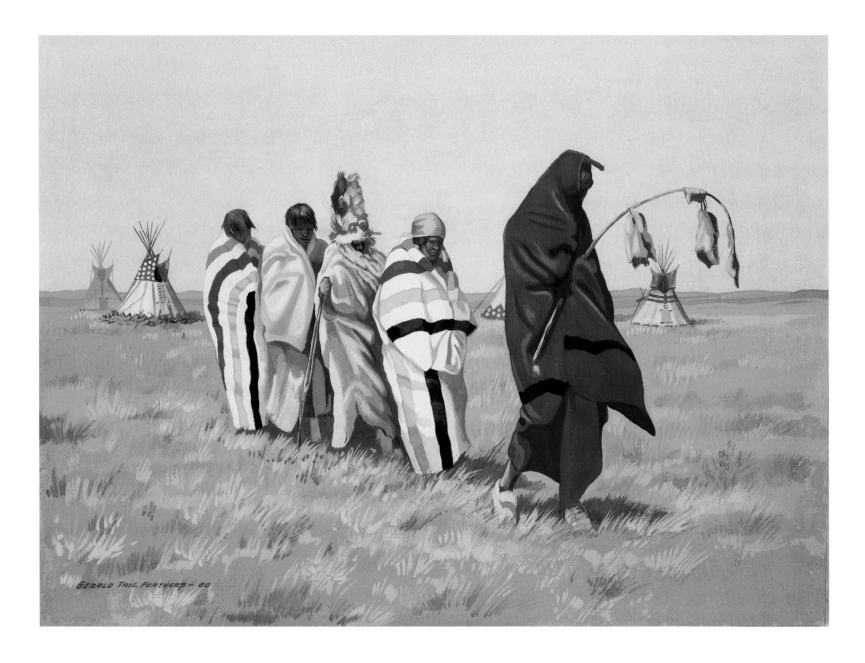

Gerald TAILFEATHERS

Procession of the Holy Woman, Blood Sundance

(1925-1975)

1960; tempera on paper; 36.6 cm x 48.5 cm; Glenbow Collection, Calgary, Canada

On the sunlit plains, the Holy Women solemnly circle the ground on which the sacred dance pole and lodge will be constructed for the midsummer ceremonies of the Blackfoot Nation. The leader, shrouded in a red blanket—perhaps an allusion to the Blood tribe—carries a pole with sacred medicine bundles and is followed by a masked woman and three others gazing sombrely toward the ground. While the open landscape and distant tipis suggest the nomadic life of

the past, the prominent display of the striped Hudson's Bay blankets denotes the impact of trade with the Europeans.

Bridging the artistic traditions of his native ancestors, who had painted on clothing, tipis and shields for personal and ritualistic use within tribal life, Gerald Tailfeathers learned a European style of painting and employed it to depict traditional native life. Born on the Standoff Blood Reserve in southern Alberta,

Tailfeathers grew up listening to the elders' recollections of war, buffalo hunting and sacred ceremonies. His artistic talents were evident in his youth, and at the age of 16, Tailfeathers won a scholarship to the Banff School of Fine Arts, where he studied with Walter J. Phillips, H.G. Glyde and Charles Comfort. He was also influenced by 20th-century southern Plains painters and romantic depictions of the "Wild West" by American artist Charles Russell.

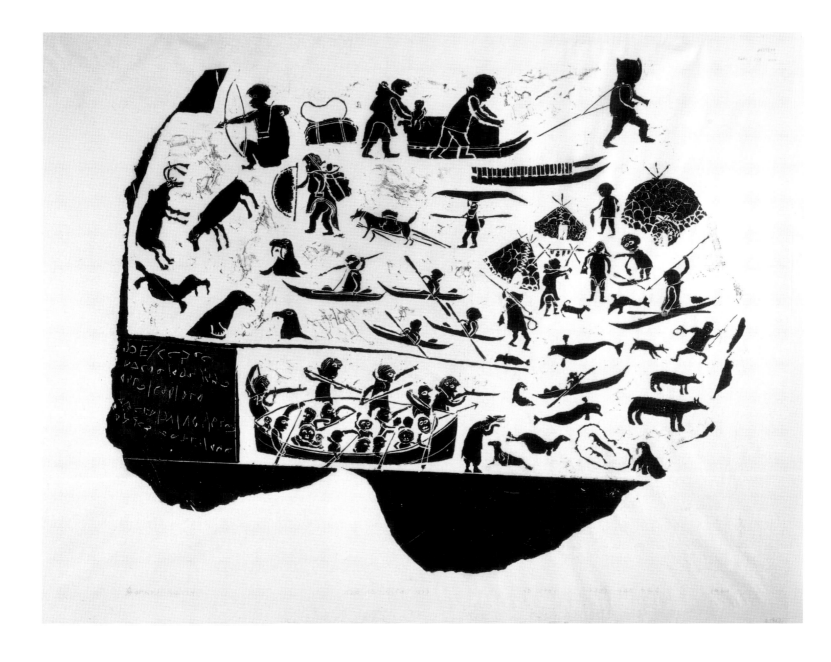

Hunters Who Went Adrift

Joe TALIRUNILI

1965; stonecut; 63.5 cm x 79.0 cm; Canadian Museum of Civilization, image #S99-10071

(1893-1976)

In Joe Talirunili's *Hunters Who Went Adrift*, the jagged edges of the stone on which the image was cut lend their shape to the print in a manner typical of stonecuts printed in Puvirnituq. Here, however, the island shape of the stone has special resonance due to a tragic episode in Talirunili's childhood, in which a group of families from his community was stranded on an ice pan. Talirunili's inscription tells us: "Families who went adrift used skins to make *umiak* [a large skin boat] and kayak [a single-person vessel], using rocks and materials of the land as fish weir, using Inuit methods of survival." The makeshift boats could barely contain their passengers, however, and most drowned in the frigid waters. Talirunili, then a babe in his mother's *amautiq*, never tired of retelling the tale through numerous prints and countless carvings of people in improvised boats. As was common in Puvirnituq, Talirunili often carved the print stone himself, and here, he presents a visual lexicon of the seasonal modes of transportation, shelter and animals pursued during his many years as a hunter.

Talirunili settled in Puvirnituq in the late 1950s and was one of the first Inuit artists to become involved in the printmaking co-operative that released its first edition in 1962. Despite an old bullet wound in his right arm, Talirunili was a prolific sculptor and published more than 70 stonecuts.

Takao TANABE

The Land #6

(1926-) 1974; acrylic wash on canvas; 84.2 cm x 142.6 cm; Vancouver Art Gallery, Permanent Collection Fund VAG 74.40; Photo by Teresa Healey

In *The Land #6*, a ribbon of green earth lies tranquilly beneath the wide expanse of blue sky stretching beyond the frame to infinity, prompting feelings of peacefulness and eternity in the viewer. Far from the depiction of rugged Canadian landscapes popularized by the Group of Seven artists, Takao Tanabe focuses on the space and light of the prairies to create a visual poetry of silence and calm, an echo of the artist's own inner serenity.

Tanabe was born of Japanese parents in Prince Rupert, British Columbia, and began his studies at the Winnipeg School of Art (1946-49) after spending the war years in an internment camp. In 1951, he travelled to New York City, where he worked with Hans Hofmann and was introduced to abstract expressionists Philip Guston and Franz Kline. By the mid-1950s, Tanabe was producing abstract paintings of what he called "interior places." From 1959 to 1961, he studied art in Japan, learning calligraphy and the Japanese ink-wash technique of *sumi-e*. In the series of paintings called The Land, created in the early 1970s, geographical forms are reduced to their essentials and colour, and the brush strokes become increasingly refined. To achieve what art historian Nancy Dillow has called "a larger and metaphysical experience of space," Tanabe applied a thin black wash over the paintings' surfaces, which flattened the space, rendering it more cerebral and less optical.

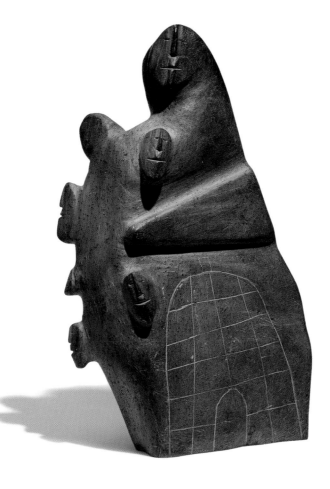

Faces with Igloos

Lucy TASSEOR TUTSWEETOK

prior to 1971; stone; 47.0 cm x 27.8 cm x 15.8 cm; Winnipeg Art Gallery; Twomey Collection,
with appreciation to the Province of Manitoba and the Government of Canada; Photo by Ernest Mayer/WAG

(1934-)

The themes of Lucy Tasseor Tutsweetok's sculpture are universal: mothers and children, family and home. In *Faces with Igloos*, an archetypal symbol of maternity emerges in the form of a large mother figure whose extended arms embrace the heads of her children, while her body provides a surface for the incised drawing of her domain, the snow house. The mother is at once the source of spiritual and physical shelter and, carved from the hard grey stone, exudes emotional warmth. Tasseor explains how she reveals the forms of her sculpture: "When I am working on the faces, I use an axe and files to shape the nose or mouth, but for fixing the body, I use power tools. I prefer to carve by the shape of the stone. If there is a curved area, I'll put a head there. If the heads are standing out from the stone, I have sawn the stone out between them."

Tasseor was born in Nunalla, in northern Manitoba. When game became insufficient to support her and her family, they moved to Rankin Inlet to work in the mine and, from there, to Arviat, where Tasseor began to carve in the early 1960s. Her interest in the representation of multiple faces is rooted in an experience of her youth: "When I first started carving, no one was interested in buying my work. Finally, my grandfather advised me. He showed me what to carve by drawing in the sand. He drew a figure with many heads."

301

Sam TATA

(1911-)

People's Liberation Army Wife and Child,
from the series Shanghai 1949: End of an Era

1949; gelatin silver print; 20.0 cm x 29.7 cm; Courtesy Canadian Museum of Contemporary Photography

The People's Liberation Army took the cosmopolitan city of Shanghai in May 1949, expelling the Nationalist army and changing forever the face of this ancient city. Here, a young mother dressed in the official garb of the new regime rushes along the crowded streets clutching her baby, her air of maternal protectiveness contrasting sharply with the official tone of her clothing. Observing his native city in upheaval and transition, Sam Tata looked uncritically at the revolu-

tion of social order. Many years later, he recalled, "I am not a historian with a camera, merely an observer and, as such, was lucky enough to record fragments of a world-shaking event and great historical change. But perhaps best of all, these records recall to me, with much nostalgia, the streets and alleys of a city I loved, its sights, sounds and smells and its memories."

Having grown up in China with parents who were Parsees from Bombay, Tata was educated in English

schools. He became interested in street photography in the late 1930s but turned to portraiture during the Japanese occupation of China. His meeting with Henri Cartier-Bresson in 1948 rekindled his enthusiasm for street photography and revealed his eye for significant moments filtered through a profound sense of humanity. Tata moved to Hong Kong in 1952 and to Montreal in 1956, where he continued his influential career as a photojournalist and portraitist.

Dance Hall

David THAUBERGER

1980; acrylic and glitter on canvas; 114.9 cm x 172.7 cm; Collection of the Mendel Art Gallery, Saskatoon

(1948-)

The yellow doors and window frames of Memorial Hall are luminous against the blue and red brick façade, where a lone poppy hangs beneath the sign. In contrast to the strict formality of the architecture, the dance hall is a place of dreams and romance, alluded to here in the artist's use of glitter, which lightly covers the surface of the painting like a dusting of magic. While the image is rooted in the local environment of Saskatchewan native David Thauberger, it is, at the same time, anonymous in the context of North American architecture. Like a vernacular icon, the image is static and mysterious.

In 1971, Thauberger graduated from the University of Saskatchewan, where he had studied with David Gilhooly, whose humorous ceramics of food and animals inspired his own study in ceramics at universities in California and Montana. The experience in California was seminal. "This was the first time I had seen so much contemporary art in my life," he said. Of particular influence were American pop artists such as Claes Oldenburg and Jim Dine and Californians William Wiley and Wayne Thiebaud, whose imaginative responses to the subjects of daily life catapulted Thauberger into painting. The candour of Saskatchewan folk art further consolidated his appreciation of local subjects rendered with a pristine geometry animated by lively colour and decorative surfaces.

Tom THOMSON

Lightning, Canoe Lake

(1877-1917)

1915; oil on plywood; 21.5 cm x 26.7 cm; National Gallery of Canada

On a small plywood panel, the threatening magnificence of the sky over Algonquin Park's Canoe Lake is captured with a flurry of brush strokes that portray the wind in the darkening sky and the thunderous clouds overhead. A lone bolt of yellow lightning burns through the greyness, stabbing the quiet of the green-brown shore. As an expert canoeist and woodsman, Tom Thomson was sensitive to the continually changing light and temperaments of the sky; as an

artist, he noted its constant flux. Largely self-taught, Thomson painted nature spontaneously, combining his skills as a graphic artist with a bold sense of colour to produce daringly simple but extremely powerful compositions. As A.Y. Jackson explained, "Not knowing all the conventional definitions of beauty, [Thomson] found it all beautiful…you are struck by the slightness of the motif that induced the painting…He gave us the fleeting moment,

the mood, the haunting memory of things he felt."

Until 1913, Thomson was employed as a graphic artist at Grip Limited, where he befriended J.E.H. MacDonald and, later, other artists who would form the Group of Seven in 1920. Thomson made his first sketching trip to Algonquin Park in the summer of 1912, and then, with his compelling enthusiasm, he convinced artists such as A.Y. Jackson, Arthur Lismer and F.H. Varley to join him.

The Jack Pine

1916-1917; oil on canvas; 127.9 cm x 139.8 cm; National Gallery of Canada

The little sketches made in the woods or on the lakeshore often served as inspiration for large works on canvas, which were painted in the studio in winter. Thomson's famous canvas *The Jack Pine* was painted in his "shack" behind the Studio Building in Toronto from a sketch made during an excursion to Little Cauchon Lake, in northeastern Algonquin Park, in the spring of 1916. Here, outlined in red, the lone tree— a subject that would become popular with the Group

of Seven artists—stands majestically silhouetted against the setting sun. The rhythmic application of green, purple and pink enlivened with areas of yellow in bold horizontal brush strokes asserts the peacefulness of the sky, which is mirrored in the still waters of the lake. In the distance, the blue hills form rounded shapes that are echoed in the organic tracery of the tree's green foliage, thus consolidating the intricate simplicity and power of the composition.

The artistic promise of works such as this one was abruptly severed with Thomson's tragic drowning in Canoe Lake in July 1917. His death, which is still shrouded in mystery, was felt deeply by the Group of Seven artists. In the words of Jackson: "Without Tom, the north country seems a desolation of bush and rock. He was the guide, the interpreter, and we the guests, partaking of his hospitality so generously given."

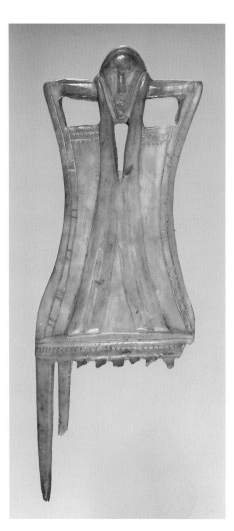

THULE ARTIST

<div align="right">Comb</div>

Thule period, 1000-1600; walrus-tusk ivory; 10.9 cm x 3.9 cm x 0.7 cm; Eskimo Museum, Churchill, Manitoba; Found by Levi Iluitok

About 1000 A.D., an incursion of aboriginal peoples from what is now Alaska crossed the Canadian Arctic as far east as Greenland, driving out the Dorset Culture and establishing the predecessors of today's Inuit. Named for the area in eastern Greenland where traces of its history were first identified, the Thule Culture is distinguished by its associations with the whale hunt. The stability of whaling encouraged the people to gather in permanent communities and provided

them with the time required to create small objects from ivory tusk or sea-mammal tooth. With the evolution of sharper and more sophisticated tools, objects such as swimming figures resembling birds, spirits and humans were frequently incised with drill holes or refined geometric patterning along the edges, revealing the dexterity of the carver.

This small ivory comb was found at Isortuk, Pelly Bay, in Nunavut. It depicts the head and elon-

gated torso of a figure on which the artist has repeated the curved shape of the comb on the interior, adding tusk-shaped elements in relief that climb to frame the delicate face. The comb was probably made for personal use. Due to the proliferation of ivory objects ascribed to women, such as pendants, needles and needle cases, it has been suggested that the Thule Culture associated women with the sea and sea-mammal hunting.

306

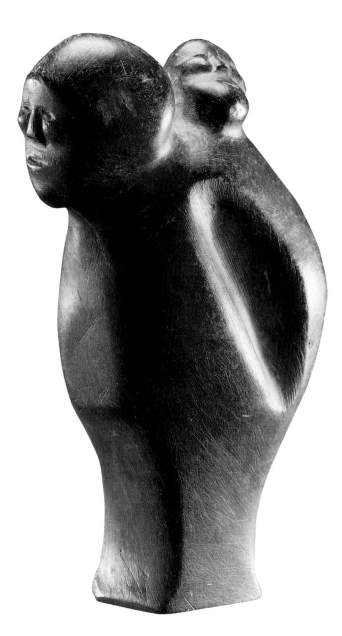

Mother and Child

John TIKTAK

c. 1970-1975; black stone; 23.2 cm x 14.8 cm x 7.5 cm; Art Gallery of Ontario; Gift of Samuel and Esther Sarick; Photo by Carlo Catenazzi/AGO (1916-1981)

In John Tiktak's *Mother and Child*, the mother stands patiently, solemnly staring ahead as her child peers up to the sky and the world beyond, his arms dissolving in a grasp around her neck, secure in the carrying pouch of the mother's *amautiq*. Together, their bodies create a single vessel-like shape, differentiated only by their heads and the elliptical indentation, expressing the Inuit concept of *amariik*—the linking of mother and child as a natural union.

Tiktak was greatly devoted to his mother, and following her death in 1962, the subject of the mother and child became a dominant theme of his sculpture. With an elemental simplicity that is characteristic of his work, Tiktak reduced forms to their essentials, summarizing the emotional and spiritual intensity of the relationship. In the words of writer Robert Williamson, "Few who work in stone in all the world can claim such purity, such quiet strength, such cool and lovely lines, such simple, straight humanity."

Born at a camp near Whale Cove, on the west coast of Hudson Bay, Tiktak lived as a hunter until 1958, when he moved to Rankin Inlet to work in the burgeoning nickel mine. In 1959, his leg was crushed in a mining accident, and by the early 1960s, he had embraced carving as his profession. "I do not think out what I will do," he said. "My thought comes out while I work. My work expresses my thought."

Joanne TOD

Having Fun?/The Time of Our Lives

(1953-)

1984; oil on canvas; 199 cm x 199 cm each; National Gallery of Canada

In *Having Fun?/The Time of Our Lives*, shrewd, colourful realism combines with large scale to produce paintings whose sensuous magnetism momentarily camouflages the critical edge of the contrasts between the "high" world of classical ballet and the "low" entertainment of popular culture. On the left, a ballet dancer *en pointe* enacts a prettified ritual of romantic pursuit. Smiling gleefully, she raises her arms in helpless delight as the male dancer effortlessly reels her in on a pink satin ribbon, gesturing with bravado. On the right, the toned brown body of the solitary night-club dancer turns away from us, facing her audience, assertively swinging her hips to the music. The proximity of the smiling blonde-haired woman elegantly attired in black contrasts strikingly with the dancer, while the mostly male onlookers display mixed reactions, from amusement to indifference.

Inspired by mass-media advertising, Joanne Tod presents a modern allegory questioning ideas of hierarchy, racism and consumerism in contemporary society. As she has said, "I want to acknowledge through my work that power relationships are interesting to examine but not necessarily to emulate…It is my intention to offer logical, though sometimes unorthodox, possibilities to the viewer as a critical analysis of the issues which affect society." A Montreal native, Tod graduated from the Ontario College of Art in 1974.

The Ice Cone, Montmorency Falls

Robert Clow TODD

c. 1840-1850; oil on canvas; 51.2 cm x 68.1 cm; Art Gallery of Ontario; Photo by Carlo Catenazzi/AGO

(c. 1809-1866)

When the cold winter temperatures had frozen the rivers and brought snow to cover the ice cone of Montmorency Falls near Quebec City, those with leisure time flocked to the site to enjoy the play afforded by winter. Since the late 18th century, the Montmorency sugarloaf had been a favourite subject for artists, who were captivated as much by its pristine beauty as by the demand of the British garrison class for paintings depicting popular excursion spots.

This work is typical of the many versions of the subject by Robert Todd, an Englishman who immigrated to Canada in 1834. Serving as a backdrop to an array of seasonal activities, the path to the ice cone is sprinkled with assorted sleighs, dogs and groups of chatting spectators. The barren white foreground is dominated by the dark profile of a team of horses pulling an elegant sleigh driven by a man sitting on a lion's skin. Behind them, other sleighs wait, and to the

left, one with prancing horses carries visitors closer to the frozen falls, where miniature figures frolic.

The attention to minute detail, the subtle tonal transitions and the overall precision with which this work was painted all attest to Todd's penchant for careful observation and to the meticulousness characteristic of his training as a decorative artist and sign painter. Research has shown that Todd painted backgrounds first, adding figures pertinent to the commission later.

Fernand TOUPIN

Surface with Directing Red

(1930-)

1956; oil on Masonite; 107 cm x 65 cm; The Montreal Museum of Fine Arts;
Purchase, Volunteer Association of the MMFA; Photo by Brian Merrett/MMFA

During the artistic revolution in Montreal in the 1940s and 1950s, some artists opposed the spontaneous gestural approach to art that was advocated by the artists associated with Paul-Émile Borduas and the Automatistes. Rather, they favoured a more rational ordered view, inspired by the grids and flat planes seen in the work of Dutch artist Piet Mondrian. Although Fernand Toupin, Louis Belzile, Jean-Paul Jérôme and Rodolphe de Repentigny admired the contribution

of the Automatistes, they were opposed to paintings that "read" as landscapes. Calling themselves the Plasticiens, these artists sought to liberate painting from its narrative function and to create works that would be independent objects. In their Plasticien manifesto of 1955, they pronounced their dedication to "plastic values: tone, texture, forms, lines and the final unity between these elements. These elements are valid in and of themselves."

Toupin, who had studied with Jérôme from 1949 to 1953, produced unconventionally shaped canvases, allowing the internal forms of the composition to define the shape of the picture instead of beginning with a predetermined framework. Here, predominantly red and blue stripes fill overlapping geometric shapes, establishing a dynamic pattern that resists ready reference to material reality and asserts the idea of the painting as an autonomous object.

Gong-88 Claude TOUSIGNANT

1967; acrylic on canvas; Diam.: 223.5 cm; Art Gallery of Ontario; Gift of the McLean Foundation, 1967; © Claude Tousignant, 2000 (1932-)

As early as 1959, Claude Tousignant was clear about his intentions: "What I want to do is to objectify painting, to bring it to its source, there where only painting remains…there where painting is only feeling." His journey toward a simplification of form with an emphasis on the dynamics of colour began when he studied with Gordon Webber at the School of Design in Montreal from 1948 to 1952. It continued throughout the 1950s, as he followed in the footsteps of the first Plasticiens, who sought a rational geometric approach to abstraction. By then, Tousignant was producing canvases of radical simplicity, sometimes with just two colours, flatly painted and divided by hard, clean edges.

In 1962, the work of American artist Barnett Newman convinced Tousignant of his mission to create art with a minimum of means. While the shape of the circle began to appear in his compositions of the early 1960s, only in 1965 did the painting itself become circular in format. Tousignant then embarked on a series of works resembling targets, composed of several concentric bands of colour resonating with optical dynamism. In *Gong-88*, we are dazzled by the optical vibrations of hot and cold colours that create a feeling of chromatic spinning, expanding and contracting much like the sounds of a gong reverberating from the centre with repetitions of varying intensities.

311

Harold TOWN

<div style="text-align: right">*Music Behind*</div>

(1924-1990)

1958-1959; collage of Masonite, T.V. back panel with plastic component, cardboard container, straws, labels, stamps and envelope, music sheets, fan, razor; 103.2 cm x 102.5 cm; National Gallery of Canada

In 1953, Harold Town joined with 10 other painters from his hometown of Toronto to organize the first exhibition of Painters Eleven, an expression of solidarity in support of abstract art by artists determined to fight Toronto's isolation from international modernism. In the same year, Town won worldwide acclaim for his innovative "single autographic prints," a series of monoprints (single and unique images) overprinted with a variety of colours and enhanced by col-

lage, a technique that thematically and metaphorically would thread through his entire oeuvre.

Time has not tempered the audacity of *Music Behind*. Emulating the example of Picasso and Georges Braque, who in 1911 attached fragments of newspaper and other printed material to their Cubist paintings, Town embraced the art of collage with his characteristic impudence, imagination and sense of humour. Beneath the dribbled application of primary colours that allude

to Mondrian in their quasi-gridlike delineation and to American abstractionists in their dripped abandon, Town attached an array of found materials. Bottle labels, bus tickets and sheet music combine with three-dimensional objects, creating a sculptural relief. Most striking is the use of the back of an old TV set with its protruding plastic cone, given to him by Albert Franck, a Toronto painter who was an early supporter of Painters Eleven. The art of collage in *Music Behind*,

Toy Horse #3

1978; ink and watercolour on paper; 76.2 cm x 55.9 cm; Private Collection

with its punning title, was also, in the words of Town, "the one medium most suited to the age of conspicuous waste, and it's marvellous to think of the garbage of our age becoming the art of our time."

In keeping with his profound admiration for Picasso, Town did not restrict his expression to a single style, technique or subject matter. Throughout his diverse production of paintings, sculptures, portraits, murals, collages and illustrations, there was no linear progression or evolution but, rather, a constant fluctuation between subjects and media, as he pushed the limits of every theme and technique he confronted.

Town's drawing talents, evident in his early endeavours as an illustrator for magazines such as *Maclean's* and *Mayfair*, continued unabated through the stylistic diversity of his prolific career. In 1976, the chance purchase of a toy horse in a local antique store inspired the production of over 800 drawings, all of which exemplified Town's expert versatility in creating seemingly endless transformations of a single subject. In *Toy Horse #3*, the horse is typically presented in profile, its dark head an element of quiet against the riot of pattern and decoration that animates its body. The assortment of wheels on three of the four legs evokes notions of the Trojan Horse, outfitted here with armour derived from Town's unremitting infatuation with the unlikely amalgamations of collage.

TSIMSHIAN ARTIST

Naxnóx, Mask Representing Woman

19th century; wood, abalone shell and paint; 22.5 cm x 20.8 cm x 11.3 cm;
McMichael Canadian Art Collection; Photo by Trevor Mills/VAG

The Tsimshian Nation ("people of the Skeena") has been established since 3000 B.C. south of the Skeena River in British Columbia. In the oral traditions of these people, the cosmos was defined as a place inhabited by magical forces and spirits. In gatherings that involved singing, dancing and other ritualistic ceremonies, masks gave visual form to these powers, rendering the spirits of the sky, the sea, the human world and the spirit world perceptible and confirming the Tsimshian's relationship to the universe.

The masks used in the dance are dramatizations of spirit beings and depict a variety of human vices and virtues and social groups, such as the young and the old. They were also sometimes portraits of individuals. While many masks made after 1820 were created for commercial trade with the Europeans, this mask of a woman seems to have been made for native ceremonial use and is typical of the sculptural naturalism characteristic of Tsimshian carving. Indeed, with her delicately carved aquiline nose, forthright gaze, gently parted lips and cool, serene expression, she seems to embody the spirit of equanimity.

Carved in the 19th century, when the intrusion of the Europeans had begun to disrupt native life and spiritual practice, the mask endures as an innocent expression of optimism in the tide of oppression that would soon come.

Chilkat Blanket

<div align="right">

TSIMSHIAN ARTIST

</div>

before 1874; mountain goat wool and cedar bark; 78.5 cm x 159.0 cm (without fringe);
Canadian Museum of Civilization, image #S92-4374

According to Tsimshian legend, the Chilkat blanket, or *gwushalait*, originated following an encounter between Raven and GonAqAdḛ́t, a tribal god/spirit who was wearing a Chilkat blanket that he later gave Raven for the women to unravel and copy. The genesis of the Chilkat blanket, named for the Tlingit tribe that later produced many of these ceremonial robes, is attributed to the Tsimshian weavers who knew of the utility of the yellow cedar in making clothing. The inner bark, beaten

until soft, formed a thread or cord that could be woven into capes, skirts and blankets. The warp yarn was made of a double strand of twisted cedar bark covered with mountain goat wool, and the weft was of wool.

It took the women about six months to weave a blanket based on designs painted on pattern boards by the men. Although most designs are arranged in three fields, this one features only two: the large horizontal grid of animal faces and spirits and the lower section

that resembles an elongated "diving whale" pattern with eyes and nose holes. The black, yellow and white colours of this blanket are typical, while the red is less common. Most designs are abstract versions of crest animals and so would confirm the ancestry of the wearer. Symbolic of rank and nobility, robes were worn on special occasions. They were sometimes used as burial shrouds. The blankets, designed and commissioned as works of art, were valued as family heirlooms.

Mark TUNGILIK

(1913-1986)

c. 1982; grey-green stone, ivory, baleen, copper, black pigment; 18.1 cm x 33.6 cm x 10.3 cm;
Art Gallery of Ontario; Gift of Samuel and Esther Sarick; Photo by Carlo Catenazzi/AGO

Scene

Gradually emerging from the sides and top of the green stone arch, a polar bear on the left and a muskox on the right creep up and face each other as spirit helpers in the hunt. A hunter and a range of exquisitely carved animals—the wished-for catch—are depicted in an arc beneath them, while below, on terra firma, hunters return with their bounty to a winter camp scene defined by a miniature sled and a snow house. Using ivory and the green stone from his local

area near Kugaaruk in Pelly Bay, Mark Tungilik constructs a microcosm of Inuit life on the land, emphasizing the dependence on animals for survival and the faith in the spirit world to assist in the hunt.

Tungilik began carving in the 1930s, while living in the Kitikmeot region of the central Arctic. Established as a fertile whaling ground since the late 19th century, the area thus provided a plentiful supply of ivory to Inuit artists, who created carvings to trade

with whalers and explorers. The practice continued in the 20th century and was encouraged by Roman Catholic missionaries, who sought ivory carvings of Christian subjects. Tungilik, for example, carved a small bust of Christ wearing a crown of thorns. In the 1940s, Tungilik moved to Repulse Bay, where he excelled in the production of miniature carvings of figures in landscape settings that maintain high standards of realism on a scale much smaller than what we see here.

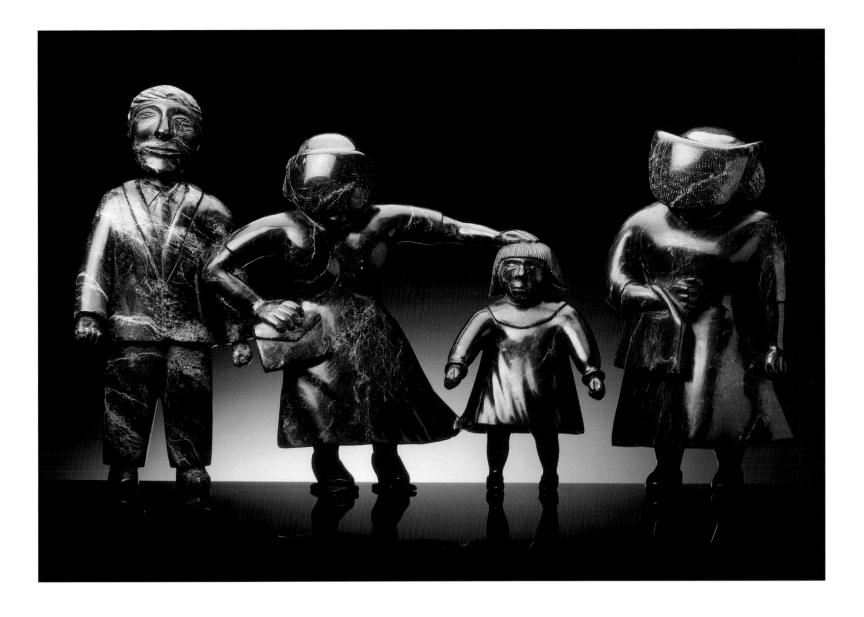

This Has Touched My Life

Ovilu TUNNILLIE

1991-1992; dark green stone; man: 47.0 cm x 22.5 cm x 13.5 cm; woman and child: 42.0 cm x 48.5 cm x 26.5 cm; woman: 42.5 cm x 23.5 cm x 18.0 cm; Canadian Museum of Civilization, image #S99-54

(1949-)

In the dark green serpentine stone of her native Baffin Island, Ovilu Tunnillie gives sculptural form to her childhood memories. In the late 1950s, Tunnillie, like many Inuit, was sent south for tuberculosis treatment. Of special interest to her were the people in strange clothes, women wearing hats and veils and carrying purses, apparel utterly unfamiliar to her. "I really looked at how they were dressed," she recalled, "and having seen them like this has been the most

memorable for me…I wonder sometimes if they were ashamed of their faces." Here, the child Ovilu stands bewildered, flanked by masked creatures whose feminine attire and stocky proportions suggest bodyguards rather than helpers. These masks appear to be decorative, but for Tunnillie, they may also have recalled the protective face coverings people wore to shield them from tuberculosis.

Returning home, Tunnillie admired her father's carv-

ings and was attracted to the "beauty and shapes of the rocks." In 1969, she married and settled in Cape Dorset, and by 1972, she had begun to carve in earnest, delighted to be able to sell her work and provide for her family. Tunnillie is recognized as an innovative and imaginative sculptor. Skiers and football players as well as traditional subjects of Inuit legend and wildlife populate her sculptures, whose forms she enhances by experimenting with materials such as quartz and white marble.

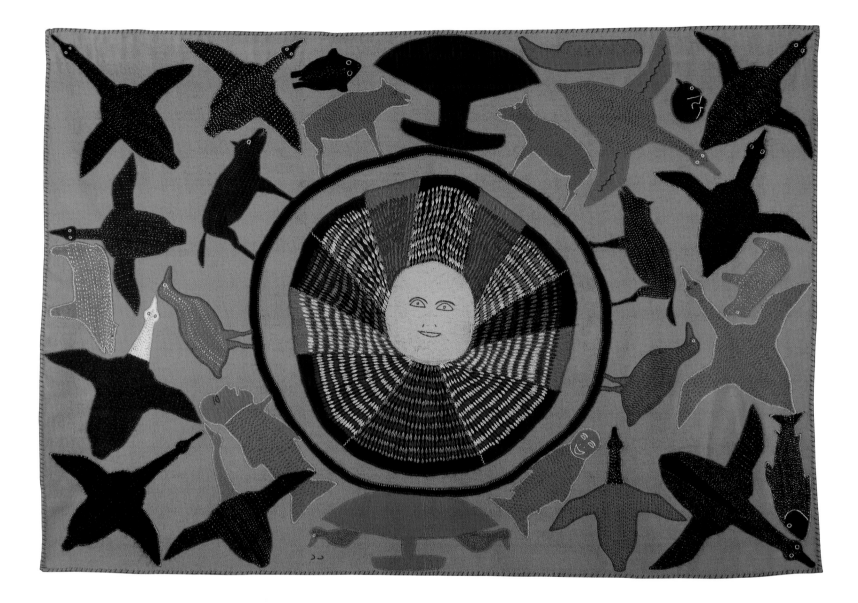

Marion TUU'LUUQ

Sun Woman

(1910-)

1975; duffle, felt, embroidery floss, thread; 127 cm x 183 cm; Art Gallery of Ontario; Gift of the Klamer Family, 1978

In the centre of Marion Tuu'luuq's *Sun Woman*, the flesh-coloured face evokes the Inuit legend in which the sun is a woman, the spiritual giver of life. Elaborately stitched geometric shapes radiate from her head and, in their embroidered intricacy, recall the beadwork collars made by Tuu'luuq and other Inuit women in the Baker Lake community in the late 1960s. The *ulu*, or large fan-shaped knives used by the women to scrape skins, emphasize the importance of women in

the community. The knives touch the circle on opposite sides, while the proximity of animals, birds and transformed creatures asserts the interconnectedness of humans and animals in Inuit life.

Drawing on the extensive sewing skills she had developed decorating caribou clothing while living on the land in the Back River area northwest of Baker Lake, Tuu'luuq used small, precise stitches and contrasting colours of thread to attach the crea-

tures in the Sun Woman's solar system. The inventiveness and variety of the stitches are like brushwork, embellishing the surfaces and suggesting the diverse textures of nature, such as the feathers on birds and the scales on fish.

Just as her husband Luke Anguhadluq frequently rotated his paper while he was drawing, Tuu'luuq likewise appears here to have rotated the felt when doing her stitchwork.

318

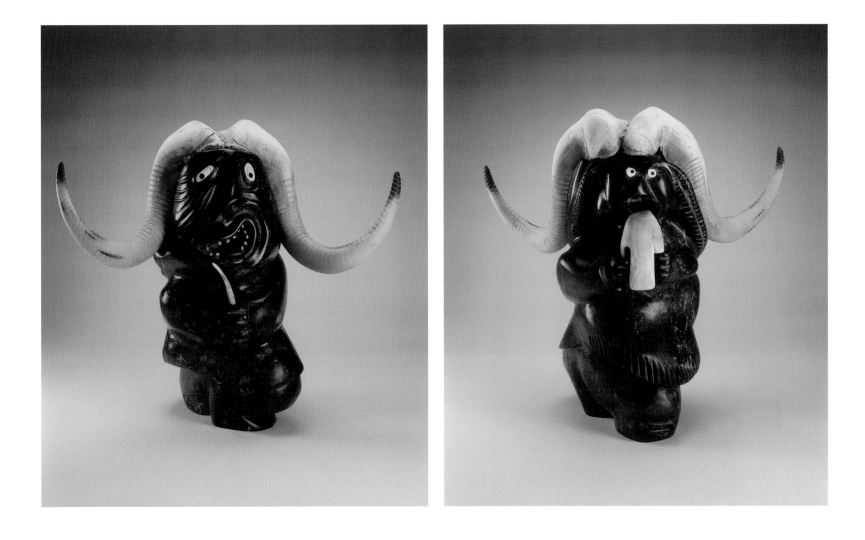

Inukpajuaq (Giant)

Judas ULLULAQ

1987; dark green stone, muskox horn, ivory, bone, sinew; 56.0 cm x 61.3 cm x 37.0 cm;
National Gallery of Canada; Gift of the Government of the Northwest Territories, 1989

(1937-1999)

This large, expressive two-sided sculpture illustrates the transformation of a female shaman into a muskox. While a shaman might wear a crown of muskox horns to attract the animal, the device is used in this Judas Ullulaq sculpture with contrasting effects.

On one side, the horns jut out aggressively, flanking the large head and crooked glare of the Inukpajuaq, a helping spirit in her transformation to a muskox and a source of strength for a successful hunt.

On the opposite side, the horns sweep back like a graceful headdress, and the shaman's inlaid ivory eyes stare out as she happily devours the profits of the hunt.

Ullulaq lived a nomadic existence in the Kitikmeot region of the central Arctic, moving to Taloyoak in the late 1960s and later to Gjoa Haven, on King William Island. Like other artists of the region—notably his nephew Karoo Ashevak, whose work and inclination toward humorous exaggeration he greatly

admired—Ullulaq focused his carvings on shamanic rituals and scenes from everyday life. Unlike Karoo, however, Ullulaq preferred stone over whalebone.

"Sometimes, it is very difficult to decide what I am going to make out of the stone," he said. "I think about legends and stories and tales of what people did in the past…It depends on the shape and size of the stone, on the colour and also on the quality of the stone."

319

Tony URQUHART

Along the Road

(1934-)

1975; wood, porcelain, glazed ceramic, Plexiglas, glass, dried flower stems; H: 147 cm with pedestal;
Art Gallery of Ontario; Purchased with assistance from Wintario, 1979; Photo by Larry Ostrom/AGO

Tony Urquhart began his career as a painter, and in the late 1950s, he produced abstract work whose gestural shapes and ethereal spaces suggested the mysteries of life and death. Seeking to prolong the viewing time of a work of art, he began in 1965 to make paintings on boxes, which required the viewer to move around. In 1967, he extended this process by creating sculptures that opened and closed, demanding the viewer's participation. The boxes were also inspired by Urquhart's ad-miration for the small medieval altarpieces with hinged side panels that he had seen during his European travels.

Despite the first impression of a functional object —a smooth, grey box on a simply turned leg—*Along the Road* is cut by an irregular segment that, when opened, reveals an organic shape suggesting a rock or some ancient decayed material. On the opposite side, miniature Palladian windows can be extended and allude to classical architecture and the possibility of other views. While Urquhart allows that *Along the Road* has its literal side, offering an encounter with objects or vistas one might see along a country road, the relationship among the elements remains ambiguous. A tension exists between the constructed and the organic elements, a dichotomy which evokes, as the artist has said, "the strong suspicion that nature, not man, is getting the upper hand." In the mid-1950s, Urquhart studied at the Albright Art School in Buffalo and at Yale University.

320

Sculpture No. I

Armand VAILLANCOURT

c. 1959-1961; welded steel; 47 cm x 225 cm x 25 cm; National Gallery of Canada

(1932-)

Jagged pieces of scrap metal, cut and welded into sharp angular and gently rounded shapes, are assembled in a coarse arrangement that evokes the rhythm of a mysterious calligraphy. Challenging the traditional notions of sculpture as something that is static, monolithic and vertical, Armand Vaillancourt turns convention on its head with this work, presenting a piece that is open and energetic, suspended from wires, rather than set on a base, and horizon-

tal, thus free of figurative associations. In creating the sculpture, Vaillancourt was emulating the work of Spaniards Julio González and Pablo Picasso, who had similarly explored new methods of making sculptures with welded steel in the 1930s, as well as the abstract metal sculptures of David Smith, an American whose work Vaillancourt had seen in the mid-1950s.

Vaillancourt studied at the École des beaux-arts in Montreal and attracted public attention in 1954 with

a two-year project that involved the sculpting of a tree scheduled to be cut down on Durocher Street. Carved *in situ* in front of passersby, the work launched Vaillancourt's reputation as a social activist as much as an innovative artist and blazed the trail for his future experiments using chain saws and fire for his wooden sculptures. A commissioned work refused upon completion, *Sculpture No. 1* took first prize at The Montreal Museum of Fine Arts spring exhibition in 1961.

John VANDERPANT

Tracks

(1884-1939)

1934; silver-bromide print on wove paper; 35.0 cm x 27.2 cm;
Vancouver Art Gallery Acquisition Fund VAG 90.68.41; Photo by Teresa Healey

John Vanderpant here presents a view high above a railroad, where the graceful linear cadence of ribbons of steel evokes a silvery silence far removed from the toils of human labour. As an artist who had immigrated to Canada from the Netherlands in 1911 and had settled in Vancouver in 1919, Vanderpant kept his photographic eye on the international scene. His early work embodied the soft-focus style of the pictorialists, but by the 1920s, Vanderpant had become caught up in the philosophy of the *Neue Sachlichkeit* (New Objectivity) movement, which favoured eccentric perspectives and exploited the abstract formal patterns that exist in nature and the built environment. Vanderpant's photographs expressed a utopian vision that celebrated the advancements of modern engineering. In the linear complexity of metal bridges and fire escapes and the enduring elegance of the columnar grain elevators, Vanderpant saw the potential, as he wrote in 1935, for "a composition aiming at the lasting characteristics of beauty."

Despite his national and international success throughout the 1920s and 1930s, Vanderpant suffered hardship during the Depression and, in 1934, was forced to sell the family home and live above his Robson Street gallery. In the serene timelessness of his art, however, Vanderpant sought to evoke spiritual states beyond the finite materiality of the world.

Facing Extinction Renée VAN HALM

1985-1986; oil on canvas mounted on wood construction; 2.7 m x 6.1 m x 1.4 m; National Gallery of Canada (1949-)

Approaching Renée Van Halm's large installation, we hover with uncertainty between the illusion of deep space in the painting and the material reality of the side wings and floor elements that jut into our space. When we look into the dark concavity of the empty stadium, the impression of overwhelming gloom is countered by the panorama of a seascape. While its colour and animated brush strokes lend a note of optimism, the work remains overpowered by the ominous staticism of the architecture. A disembodied beach scene in the foreground presents a tangle of driftwood ready to engulf us between the proscenium walls of this imaginary theatre. We wait in suspense for the next act, convinced by the sombre tones and isolation of the solitary portrait on the left that we are braving a mysterious sorrow.

In the early 1980s, Van Halm began making installations inspired by depictions of architecture in Italian Renaissance paintings, interested, as she has said, in "the psychological dimension of space...[and] that quality of absence or anticipation." These themes continued to preoccupy her in the mid-1980s as she focused on the "social symbolism of contemporary architecture" and, in particular, on the 1936 Olympic Stadium in Berlin, with all "its negative connotations of power and racial supremacy."

Van Halm was born in Amsterdam, the Netherlands, and graduated from the Vancouver School of Art (1975) and from Concordia University (1977).

Frederick H. VARLEY

The Cloud, Red Mountain

(1881-1969) c. 1928; oil on canvas; 86.8 cm x 102.2 cm; Art Gallery of Ontario; Bequest of Charles S. Band, 1970; Photo by Larry Ostrom/AGO

In *The Cloud, Red Mountain*, vibrant warm light illuminates the profile of the earth-red mountains, casting a rich mosaic up through a sky the colour of gemstones. In its lapis-blue ceiling, carved white clouds reflect the light in the sky and float like a magical presence free of terrestrial gravity. Writing years later of his passion for the West Coast landscape, Fred Varley said, "British Columbia is heaven…It trembles within me and pains me with its wonder as, when

a child, I first awakened to the song of the earth."

Varley, like his colleague Arthur Lismer, was a native of Sheffield, England, and studied there and in Antwerp, Belgium, before immigrating to Canada in 1912. Through Lismer, he found work at the commercial art companies of Grip Limited and, later, Rous and Mann, where he met Tom Thomson and the artists who would subsequently form the Group of Seven. While he was excited by his first sketching trip

to Algonquin Park with Thomson, Lismer and A.Y. Jackson, Varley did not at that time embrace landscape painting with the zeal of the others. In fact, he was more fixed on establishing his career as a portraitist, and following his experience as a war artist, he returned to Toronto and secured commissions from Vincent Massey and other members of the Toronto art establishment. Only during Varley's 10-year sojourn in Vancouver, where he moved in 1926 to

324

Vera

1931; oil on canvas; 61.0 cm x 50.6 cm; National Gallery of Canada; Vincent Massey Bequest, 1968; Reproduced courtesy The Estate of Kathleen G. McKay

accept a teaching position at the Vancouver School of Decorative and Applied Arts, did the magnificent scale of the mountains, beaches and vast skies inspire an exploration of landscape painting.

Although the Vancouver years were fraught with financial difficulties for Varley, they were also a time of joy and artistic growth. His friendships with artist Jock Macdonald and photographer John Vanderpant deepened his interest in spiritual theories of creativity whose seeds had been sown in Toronto through his contact with Lawren Harris. In the portrait *Vera*, we see the evidence of Varley's exploration of theories of colour associated with his interests in Eastern mysticism and his beliefs about the symbolic function of colour. Vera gazes from the canvas with a dreamy expression and a gentle smile that are enhanced by the spontaneous brushwork and imaginative use of colour. The blue-mauve palette on the left side gives way on the right to one that is darker and greener. In Varley's world, green and blue evoked spirituality, and pale violet, beauty. In using these colours to portray Vera, Varley expressed his feelings for his former student, now an intimate and spiritual comrade. In 1936, he wrote, "The artist's job is to unlock fetters and release spirit, to tear to pieces and re-create so forcefully that…the imagination of the onlooker is awakened and completes within himself the work of art."

325

Bill VAZAN

<div style="text-align: right">Event, Horizon</div>

(1933-)

1989-1991; engraved granite; 176 cm x 160 cm x 108 cm; Musée du Québec; Photo by Patrick Altman/MQ

Since the 1970s, Bill Vazan has left his mark on the land, at home and abroad, drawing on the history of particular sites. He has lifted turf, built water channels, repositioned rice stalks, made tracks in the sand and arranged wood and rock to create patterns of calligraphic beauty that are both ritualistic and enigmatic. "Instead of encouraging the fragmentation of life and thought that largely characterizes contemporary society," he said, "my work reconnects [the] individual, society and nature."

Time compresses before us as the clearly ancient granite boulder *Event, Horizon* comes alive with incised abstract markings that evoke aboriginal petroglyphs as well as the cosmic patterns proposed by contemporary physics to understand the workings of the universe. Consistent with his interest in archaeology and historic sites, Vazan alludes to the magic and symbolism of archaic rock carvings in our eternal struggle to grasp the mystery and power of nature. Anthropologist Paul

Heyer has noted, "As an artist cosmographer, Vazan is concerned with a human-centred universe. He tries to signify, bestow meaning on, situations where land, sea and sky can be reexperienced as primal orienting forces." Echoing the process of ancestral stone carvers who used stone to erode the Earth's hard crust, Vazan uses a sandblaster. For Vazan, the horizon is limitless and the incised rock a gesture to reunite contemporary life with primordial time and to share in the persistence of nature.

Zacharie Vincent and His Son Cyprien

Zacharie VINCENT

c. 1845; oil on canvas; 48.5 cm x 41.2 cm; Musée du Québec; Photo by Patrick Altman/MQ

(1815-1886)

Born in a Huron village near Loretteville, Quebec, Zacharie Vincent—also called Telari-o-lin (Huron for unmixed or undivided)—claimed to be the last pure-blooded Huron. Here, he appears stern and stoic. Wearing an orange shirt decorated with trade silver and a wampum across his chest, he is accompanied by his young son Cyprien, who is dressed in complementary green. Both carry traditional native weapons—a tomahawk and a bow and arrow. Vincent is known to

have painted about 12 self-portraits that document his ageing appearance. Among the earliest of these portraits, this one is distinguished by the simplicity of Vincent's dress and by the fact that it is the only work which includes Cyprien, the eldest of his four children. Although Vincent painted other scenes of traditional Huron life, such as camping, canoeing and snowshoe making, the self-portraits are by far his strongest work and were perhaps a way for him to

perpetuate the image of his race in the face of the Huron's assimilation by European culture.

The occasion of having his portrait painted in 1838 by eminent Quebec artist Antoine Plamondon is believed to have inspired Vincent to take up the brush himself. His celebrity as the subject of Plamondon's prizewinning portrait was furthered two years later with the publication of the poem *The Last Huron* by renowned Québecois poet François-Xavier Garneau.

Horatio WALKER

(1858-1938)

1900; oil on canvas; 153.0 cm x 193.4 cm; Musée du Québec; Photo by Jean-Guy Kérouac/MQ

Horatio Walker's glorification of the hardships of agricultural life is made even more dramatic by the size of this painting, whose large scale overwhelms the viewer. We observe this scene as from a low vantage point, with the fields elevated above us and the yoke of oxen advancing like a dark primeval force as the young herdsman raises his stick. Behind, the farmer bends low to direct the plough. Creating an almost religious aura, the rising sun casts beautiful slivers of light on the heaving sides of the animals and along the curving back and legs of the boy. Silhouetted against the brightening sky, his open hand and commanding gesture are both ethereal and powerful in their masterful authority over nature.

At the turn of the 20th century, Walker was on his way to becoming the most celebrated Canadian-born painter of the time, and his work was well represented in American museum collections. Although he spent his winters in New York City, he summered on Île d'Orléans, east of Quebec City, where he continued to be enchanted by the daily rituals of the agricultural community. There, as he said, he tried "to paint the poetry, the easy joys and the hard daily work of rural life." His love for this subject was fuelled by the example of 19th-century French painter Jean-François Millet, whose sympathetic renderings of peasant life Walker greatly admired.

The Goat

Jeff WALL

1989; cibachrome transparency, fluorescent light, aluminum display case; 229 cm x 309 cm; Art Gallery of Ontario; Photo by Carlo Catenazzi/AGO

(1946-)

Since the late 1970s, Jeff Wall has embraced the technology of advertising, using large-scale cibachrome transparencies backlit by fluorescent tubes and encased in metal boxes to evoke the illusionary space and suspended narratives of traditional oil painting. Wall stages the light effects and arranges the characters with the deliberation of a theatrical director, hiring actors to perform in arrested scenes of everyday life. The images' large scale creates a cinematic impact, yielding what Wall has called "a simultaneous recovery of film and painting."

In *The Goat*, four children taunt a fifth, who stands awkwardly in his pale blue shirt and black pants, mocked by an impish child who beckons to the "goat" with his fingers held up like horns. Even the logo "Converse" printed on the boy's pants is symbolic of opposition. Emulating the shallow space and dramatic lighting of Baroque painting, Wall focuses on "the small gestures." He explained: "They are physically smaller than those of older art, more condensed, meaner. Their smallness, however, corresponds to our increased means of magnification in making and displaying images."

Born in Vancouver, Wall studied at the University of British Columbia (1964-70) and later at the Courtauld Institute of Art in London, England. As art historian Scott Watson has remarked, "[Wall] unerringly focuses on alienation, revealing the operation of abstract universals in individual lived moments."

Ian WALLACE

At the Crosswalk

(1943-) 1988; acrylic on canvas and black-and-white photographs laminated on canvas; 243.4 cm x 486.2 cm; National Gallery of Canada

The deep perspective of a city street where a man on one corner faces a woman on another is interrupted by minimalist red and black paintings that together symbolize the oppositions and tensions between modes of representation in 20th-century art. Speaking of the juxtaposition implicit in the photographic image and abstract art, Ian Wallace said, "I am attempting to position the photographic image, which is loaded with specific references to reality, common experience and the human subject, in re-lation to the ideal space of painting in its purest state as the horizon of art…By traversing the space of this ideal with the gestural mark of the photographic image of the individual in the street, I am attempting to inscribe across the surface of modernist counter-representation a reminder of the modernity of the social subject."

Wallace was born in England and graduated from the University of British Columbia in 1968. As one of the leading Vancouver photo-based conceptual artists, he has explored minimalist art and large-format photography associated with mass-media advertising and the cinema. Since 1973 and his first large-scale photo mural, *The Melancholy of the Street*, Wallace has probed the ruptures in communication central to the late-20th-century urban malaise. Art historian Scott Watson observed: "For Wallace, pessimistic but romantic potentiality is the intersection, whether he finds it on the street or in the space between pictures on museum walls."

The Doll's Room Esther WARKOV

1980-1981; oil on canvas; 183.3 cm x 198.5 cm; Collection of the Winnipeg Art Gallery; (1941-)
Anonymous gift; Photo by Ernest Mayer/WAG

In *The Doll's Room*, the doll, animals and nature are rendered with a crisp realism that belies the dreamlike gathering. The doll herself is the giant hostess, while domestic, wild and exotic animals assemble in close proximity, staring out at us with indifference. Spatial incongruities abound in the juxtaposition of a deep background landscape, which also reappears through the open cupboards that harbour yet more animals. The three canvases provide an image that is simultaneously unified and divided, destabilizing the perception of space where the doll and sheep advance into our space. The red-brown palette, brightened by golden tones and off-whites, suggests an inner world through which the colours of external reality cannot penetrate.

"What I am really trying to do," explained Esther Warkov, "is create an interesting fantasy world of human emotions, which is something a lot of the Surrealists did, like Max Ernst, but a more gentle, human sort of thing." To devise her paintings, Warkov borrows from old books and magazines, presenting personal and collective "half-forgotten memories," perhaps alluding in *The Doll's Room* to lost innocence and an idyllic time when humanity lived in harmony with nature.

A native of Winnipeg, Warkov studied under Ivan Eyre at the University of Manitoba from 1958 to 1961 and, since then, has exhibited widely both nationally and internationally.

331

The Kitchen Sink

Margaret WATKINS The Kitchen Sink

(1884-1969) c. 1919; palladium print; 21.3 cm x 16.4 cm; National Gallery of Canada

The unlikely subject of unwashed dishes becomes a symphony of shapes and shadows, where plays of light create silvery tones and abstract rhythms. The linear curve of the kettle spout, like the head of a curious snake, directs our gaze to the pattern of circles and rounded shapes of the objects in the sink, also echoed by the tubular tap and the shadows. When Margaret Watkins exhibited this work in 1921 at the Pictorial Photographers of America in New York

City, some critics were baffled by the notion that domestic disarray was an appropriate subject for art. Others cheered, recognizing Watkins' devotion to the principles of modern art. "The 'objects' are not supposed to have any interest in themselves," she wrote, "[but are] merely contributing to the design."

Watkins, a native of Hamilton, Ontario, began her studies in 1914 in New York City at the Clarence H. White School of Photography, a leading centre for

modernist photography, where her innovations with the medium soon earned her a teaching position. By the 1920s, she was exhibiting her work in the United States and abroad, drawing critical acclaim for the poetry of her eccentric subject matter. Following a tour of the Soviet Union and Europe in 1931, Watkins' visit to Scotland and subsequent care of ailing relatives there so detained her that it marked the end of her promising artistic career.

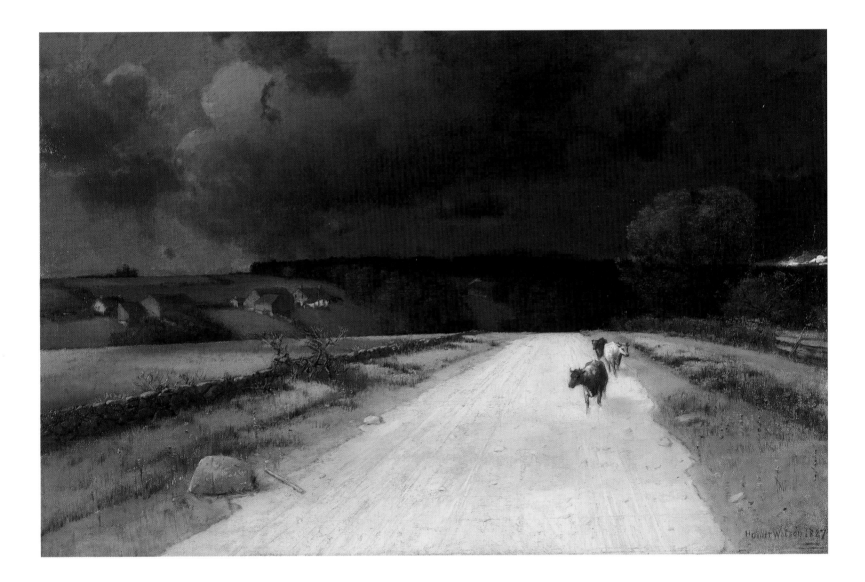

Before the Storm

Homer WATSON

1887; oil on canvas; 61.4 cm x 91.5 cm; Art Gallery of Windsor; Memorial Bequest of Mr. and Mrs. G. Hudson Strickland, 1982, 1990

(1855-1936)

As purple-grey storm clouds roll forward and throw ominous shadows across the lush green land, three stray cows wander along a sun-bleached road, oblivious to the menacing skies overhead. In the left corner, a stick by the side of the road adds an element of suspense and suggests the quick departure of the cowherd. Homer Watson took pride in this work, as he wrote in a letter, "Have finished up that white road and dark sky affair, and it is my best so far."

A native of Doon, a village near Kitchener, Ontario, Watson was largely self-taught. In 1874, he studied briefly with John A. Fraser in Toronto and, in 1876, travelled to New York City. There, he admired the work of American artist George Inness, whose landscape paintings combined an attention to detail with a romantic feeling. Returning to Canada, Watson garnered instant fame in 1878 when his painting *The Pioneer Mill* was purchased as a gift for Queen Victoria.

When Oscar Wilde visited Toronto in 1882, he dubbed Watson "the Canadian Constable"—a compliment that led Watson to spend three years in England in the late 1880s studying Britain's painters. This awareness would later compromise his originality. When Watson returned to Doon, however, he recognized that his homeland offered "ample material to fix, in some degree, the infinite beauties that emanate from the mysteries of land and sky."

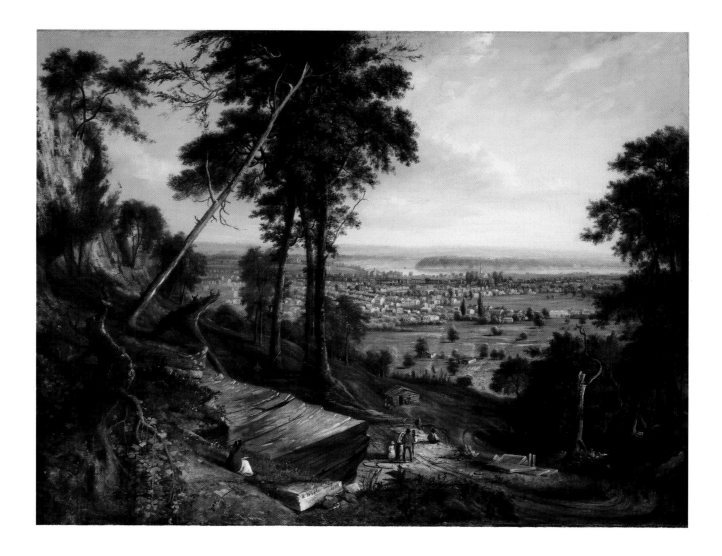

Robert R. WHALE

View of Hamilton

(1805-1887)

1853; oil on canvas; 90.6 cm x 120.8 cm; National Gallery of Canada

The city of Hamilton, located at the head of Lake Ontario, had long been established as a hub for milling and transportation before it boomed in the 1830s with an influx of immigrants from the British Isles and with an improved canal system that increased water traffic. Certainly from the point of view of English-born artist Robert Whale, who settled in Burford—a village near Brantford, Canada West—in 1852, this capitalization of natural resources was something to be celebrated in the progress-seeking Victorian era.

Here, our view from the escarpment is framed by jutting rocks and a newly logged forest that affirm the difficult reality faced by settlers. Taking the winding path past a group of people, we traverse farmland before encountering the edge of town, where domesticated nature gives way to tidy rows of houses soon to be dwarfed by burgeoning industrialization in the rapidly expanding city.

As one of the first professional artists working in southern Ontario in the mid-19th century, Whale eagerly exhibited at the annual provincial agricultural fairs. There, amidst displays of fruit, furniture, needlework and livestock, he won numerous awards and attracted future commissions. Although he did portraits for an increasingly prosperous clientele, he is best known for his panoramic views of Dundas and Hamilton and for his many paintings of trains.

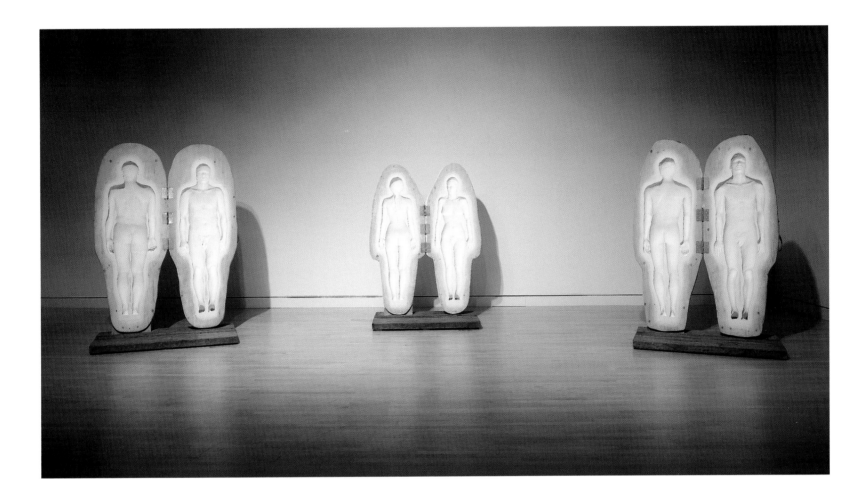

September 1975

Colette WHITEN

1975; plaster, burlap, wood, rope, fibreglass, metal and paint; each figure: approx. 220 cm x 150 cm x 84 cm; National Gallery of Canada (1945-)

In a gallery, three life-sized casts of a woman and two men—the artist and two friends—greet us with their ethereal presence. Although the figures are clearly concave, with the imprints of their individuality pressed into the plaster and wooden cases, the light effects compel the recessions to be read as volume and the bodies as convex, thus creating an ambiguity of both absence and presence. The mummylike shells suggest death, while the pristine whiteness of the plaster conjures

notions of the egg, containing and protecting a life therein. The work's dualities resonate across the ages, evoking the eternal cycles of life and death, the fragility of existence and the ephemerality of perception. Inspired in 1975 by the sight of her fresh footprints in the snow, Colette Whiten recalled, "Looking at the impressions…I felt a strong sense of space. I wanted to capture that in my art…I wanted the silence, the heaviness of neutrality."

The British-born Whiten graduated from the Ontario College of Art in 1972. In the late 1980s and the 1990s, she abandoned her plaster sculpture and embraced petit-point needlework and later beadwork, exploring mass-media imagery and traditional male/female power relationships. Contrasting public and political themes with personal and domestic techniques, Whiten continues to pose the materiality of representation against the fleetingness of time and being.

335

Irene F. WHITTOME

The White Museum II

(1942-)

1975; mixed media; each box: 219.1 cm x 25.4 cm x 15.8 cm; Art Gallery of Ontario;
Purchased with funds from the Estates of Frances Loring and Florence Wyle, 1988; Photo by William Wilson/AGO

In constructing the works for her White Museum series, Irene F. Whittome consciously and uncritically embraced a particular view of the museum: as a place of collections from disparate sources, as an environment for the presentation of objects removed from their original function for the purposes of conservation and display and as a system of classification for objects where private or ritualistic expression is made public. In *The White Museum II*, 14 tall, narrow boxes display totemlike elements that are wrapped in cotton thread, string and other materials. They are compartmentalized in painted white containers, and their repetitive wrapping suggests objects from an anthropological collection whose origins and purpose remain enigmatic. The word "white" in the title refers to the colour of the boxes and the dominant tones of the objects, whose pristine appearance echoes the museological obsession with sanitation.

Whittome, born in Vancouver, graduated in 1963 from the Vancouver School of Art, where she studied with Jack Shadbolt. From 1965 to 1968, she attended the L'Atelier Hayter in Paris and specialized in printmaking, later settling in Montreal. At the Documenta V in Kassel, Germany, in 1972, Claes Oldenburg's *Mouse Museum and Ray Gun Wing* and Marcel Broodthaers' conceptual *Musée d'art moderne* inspired Whittome's exploration of fictionalized museum displays, a theme she has continued to investigate throughout her career.

Reason over Passion

Joyce WIELAND

1968; quilted cotton; 256.5 cm x 302.3 cm; National Gallery of Canada; © The Estate of Joyce Wieland

(1931-1998)

The multi-talented Joyce Wieland, already renowned by the mid-1960s as a painter, sculptor, printmaker and filmmaker, turned her hand to quilting while living in New York City. There, in reaction to the male-dominated art scene, she embraced what she termed "the whole feminist thing" and, at the same time, developed a fervent interest in Canadian history and politics. These pursuits came together in a series of quilts that celebrated her ardent patriotism. Her purpose in making quilts was, she said, "to elevate and honour craft, to join women together and make them proud of what they had done."

The words "reason over passion" come from a 1968 statement by newly elected Prime Minister Pierre Elliott Trudeau, who had spoken about the need to place reason over passion in government. Here, Wieland's playful use of colourful letters—hot reds, warm oranges and soft pinks—seems at odds with the seriousness of the message. The little hearts sprinkled almost frivolously around the border add an element of gaiety which suggests the vivid possibility that passion may, in fact, dominate reason. The quilt is a study in contrasts: between the political and the domestic and between the notions of reason and passion themselves—polarities and tensions that permeated Wieland's entire career as an artist, along with her desire "to give the people of Canada a sense of themselves."

Elizabeth Wyn WOOD

Northern Island

(1903-1966)

1927; tin on black glass; 20.5 cm x 37.7 cm x 20.8 cm; Base: 2.0 cm x 71.0 cm x 40.5 cm; National Gallery of Canada;
Bequest of Mrs. J. P. Barwick (from the Douglas M. Duncan Collection), 1985; Estate of Elizabeth Wyn Wood and Emanuel Hahn

In cast tin and black glass, the rugged landscape and gale-swept waters of Georgian Bay are made still, silent and sleek in this sculpture by Elizabeth Wyn Wood. A tree, bent by the wind, curls against the smooth, curving forms of rocks, casting a polished reflection into the shiny liquid blackness of the glass. Wyn Wood admired the streamlined beauty of the car, airplane and ocean liner and embraced materials usually associated with transportation and industry

and with the Art Deco movement of the 1920s. "Sculpture," she wrote, "must combine an absolute honesty to the spirit of its own day with a timeless and universal quality."

One of a series of island sculptures produced by Wyn Wood in the late 1920s, *Northern Island* marks her most innovative contribution to the history of Canadian sculpture. She was declared the "Lawren Harris of sculpture" in the press for her exploration of a dis-

tinctive Canadian subject in simplified form. Like her husband Emanuel Hahn, Wyn Wood also pursued a career as a sculptor of monuments, and in 1934, she was commissioned to execute her largest work, the Welland-Crowland War Memorial. In the 1930s and 1940s, her sculpture was dominated by images of strong, heroic women as workers, and in the 1950s, she produced official portraits of such prominent individuals as King George VI and Stephen Leacock.

The Rimmer

Florence WYLE

c. 1918-1919; bronze; H: 85.5 cm ; © Canadian War Museum/8257

(1881-1968)

With a black patina covering his sturdy bronze figure, Florence Wyle's subject evokes the grime and soot of a Canadian First World War munitions factory. Using the round form of the wheel rim as an anchor, the young man leans slightly to the left, grasping the fruits of his toils. While his lithe body is clothed in protective factory garb, the musculature of his neck, shoulders and arms convinces us of his able strength and demonstrates the thorough knowledge of human anatomy

that Wyle acquired during her premedical training.

Born and educated in the United States, Wyle and her lifelong partner Frances Loring settled in Toronto in 1913. They were commissioned in 1918 by the Canadian War Memorials Fund to produce bronze sculptures of the various types of female munitions-factory workers. Wyle introduced the idea of including men, because "they [are] so wonderfully sculptural." The figures were well received and opened the

door to a series of subsequent commissions. Between the two World Wars, Wyle and Loring actively campaigned to raise the profile of sculpture in Canada, and along with Elizabeth Wyn Wood, Emanuel Hahn and Henri Hébert, they founded the Sculptors' Society of Canada in 1928. For the next 20 years, Wyle concentrated on designing fountains for private gardens, executing portraits and continuing her study of the female nude.

Lawrence Paul YUXWELUPTUN

Scorched Earth, Clear-Cut Logging on Native Sovereign Lands, Shaman Coming to Fix

(1957-)

1991; acrylic on canvas; 196.6 cm x 276.5 cm; National Gallery of Canada

In the foreground of a surreal wasteland, a red shaman with a desperate expression stands alongside severed logs and brandishes the image of an angry spirit to protest the annihilation of the land behind him. The shaman's grief pervades the painting. A masklike form on the beach emits tears, and in the distance, a blue figure riding the dinosaur's tail gazes at the sun, weeping in sympathy. Borrowing the shapes and curving lines of traditional West Coast art, Lawrence Paul

Yuxweluptun uses acidic colour and distortion to create a landscape estranged and alienated from nature. The thin flatness of the forms evokes the dripping clocks of Salvador Dali's *The Persistence of Memory* and alludes to the artist's lament for a time past, before the exploitation of the land by industry.

"I am concerned with the colonial mentality that is directly responsible for the killing of wolves, buffalo [and] whales," said Yuxweluptun. "How do you

paint a land claim?…Is it necessary to totally butcher all of this land?…All the money in the bank cannot buy or magically bring back a dead biosystem…Painting is a form of political activism, a way to exercise my inherent right, my right to authority, my freedom." Yuxweluptun was born in Kamloops, British Columbia, of parents whose ancestors were Okanagan and Coast Salish hunters and whose political advocacy was inspirational.

340

Yukon

Tim ZUCK

1994; oil on panel; 53 cm x 79 cm; McMichael Canadian Art Collection

(1947-)

In Tim Zuck's paintings of figures, still lifes and landscapes, the subjects hover with a material reality, exuding a calm indifference to the chaos of life. They are typically centred in the middle of the canvas and meticulously rendered, their small formats affording a quiet majesty that transcends the ordinariness of their subject. In *Yukon*, Zuck distils the real-life experience of observing a floatplane land on the cool grey northern waters, posing its elegant red geometry against the open water and distant hills. The splashdown is hushed and controlled, causing a horizontal wave that is echoed in the thrust of the wings. Zuck's process is equally methodical: He took about 200 photographs of the airplane, realizing that time and weather would forbid a careful study of the moment.

Despite his devotion to the physical world, Zuck, a native of Erie, Pennsylvania, remains an abstract artist, focused on the formal qualities of objects. "I see life as extremely tenuous, though we all make believe that it's solid and reliable," he said. "I see art, along with humour and philosophy, as a window through which we can suddenly view the world in a different way. It questions the structures, it throws us for a loop, it challenges us, it provides no answer, and I like that."

Zuck studied at the Nova Scotia College of Art and Design, Halifax (1971) and at the California Institute of the Arts, in Valencia.

341

ACKNOWLEDGMENTS

A book of this scope could not have been written without the assistance of a great many people. A warm thanks goes to Lionel Koffler, Publisher, Firefly Books, whose idea it was to take an alphabetical approach to an introduction to Canadian art, inviting unexpected juxtapositions of artists as a refreshing means to disrupt staid historical trajectories and the predictability of a linear progression. Hearty thanks are also due the many living artists who took an interest in the book, offering valuable suggestions and insights into their creative expression.

For their kind help in the daunting task of selecting only 300 artists from the tens of thousands who have contributed to this country's rich artistic heritage, my gratitude to James Borcoman, Curator Emeritus, National Gallery of Canada; Viviane Gray, Curator of Indian Art, Indian Affairs and Northern Development; Ingo Hessel, artist and Inuit art writer; Charles C. Hill, Curator of Canadian Art, and Christine Lalonde, Assistant Curator Inuit Art, both of the National Gallery of Canada; Joanne Lamoureux, art historian and professor, Université de Montréal; Denise Leclerc, Associate Curator of Modern Canadian Art, National Gallery of Canada; Gerald McMaster, Curator of Contemporary Indian Art, Canadian Museum of Civilization; Joyce Millar, art historian; and Janice Seline, Assistant Curator of Contemporary Art, and Ann Thomas, Curator of Photographs, both of the National Gallery of Canada.

For their generous agreement to review selected texts and offer beneficial remarks in their areas of expertise, I would like to recognize, in particular, James Borcoman, Gerald McMaster, Christine Lalonde and Marie Routledge, Curator of Inuit Art, National Gallery of Canada.

In my travels and research, many people associated with public collections across the country amiably assisted me in viewing works and obtaining reproductions. Beginning in Newfoundland, I would like to thank Elaine Anton, Newfoundland Museum; Ned Pratt, photographer; and Brian Murphy, Art Gallery of Newfoundland and Labrador. In Nova Scotia, Geri Nolan Hilfiker, Art Gallery of Nova Scotia; in New Brunswick, Rachel Brodie, Beaverbrook Art Gallery. In the province of Quebec, Lise Nadeau and Nathalie Thibault, Musée du Québec; Christine Turgeon, Musée des Ursulines; Monique Gauthier, Musée d'art contemporain de Montréal; Jean-Pierre Labiau and Marie-Claude Saia, Montreal Museum of Fine Arts; Morgan Baillargeon, Louis Campeau, Judy Hall, Isabelle Poulin, Leslie Tepper and Judy Thompson, Canadian Museum of Civilization; and Tom Sawyer and John Bell, Department of Canadian Heritage. In Ontario, Judy Harris, Woodland Cultural Centre, Brantford; Tobi Bruce and Christine Braun, Art Gallery of Hamilton; Gerry Loveys, McMaster Museum of Art; Linda Morita, McMichael Canadian Art Collection, Kleinburg; Barry Fair, London Regional Art and Historical Museums; and Joan Murray and Linda Jansma, McLaughlin Art Gallery, Oshawa. In Ottawa, Ian Wainwright, Canadian Conservation Institute; Sue Lagassi, Canadian Museum of Contemporary Photography; Raven Amiro and France Duhamel, National Gallery of Canada; Eva Major-Marothy and Jill Delaney, National Archives of Canada; Anna Hudson, Faye Van Horne and Felicia Cukier, Art Gallery of Ontario, Toronto; Judith Schwartz, The Justina M. Barnicke Gallery, Hart House, University of Toronto; and Janine Butler, Art Gallery of Windsor. In Manitoba, Anneke Shea Harrison, Winnipeg Art Gallery. In Saskatchewan, Bruce Anderson, MacKenzie Art Gallery, Regina. In Alberta, Kirsten Evenden, Glenbow Museum, Calgary; and Bruce Dunbar, Edmonton Art Gallery. In British Columbia, Ann Pollock, Vancouver Art Gallery; Jennifer Webb, Museum of Anthropology, University of British Columbia; and Grant Keddie and Dan Savard, Royal British Columbia Museum, Victoria. To these and any others whose names I may have inadvertently omitted, my sincere thanks.

I am deeply indebted to the Firefly team whose hard work and steady commitment made this book a reality. Many thanks to Michael Worek, Associate Publisher, and his assistant Karen Lathe, whose dedication and cheerful persistence in obtaining images and clearing copyrights was matched only by her good humour in negotiating the labyrinths of the art world. To designer Janice McLean, my gratitude for her tireless eye and attention to detail in delivering a handsome book and maintaining high standards of quality for the reproduction of the images. To Tracy Read, my patient and good-humoured editor, for her wisdom, tenacity and sympathetic support, a heartfelt thanks. Copy editor Susan Dickinson is to be congratulated for her exacting review of my texts. Thanks also to proofreader Catherine DeLury. I take full responsibility for any oversights or errors that may have escaped their scrutiny.

My parents, family and friends, near and far, merit special thanks for their constancy and warm encouragement over the many months this book occupied my life and kept me from their company. Particular thanks are also due Barbara Dytnerska, whose sound advice and listening ear were of great solace throughout. On the home front, to Howard Duncan, my devoted first reader, immeasurable thanks for his unwavering support, thoughtful criticism and equanimity, and to David and Caroline, my appreciation for their kind understanding. Lastly, my greatest appreciation is reserved for my children, Andrew and Martha, whose sweet patience and loving support were more than any mother could have asked for.

GLOSSARY Selected Art Terms and Movements

The artists cited below are *examples only* and do not represent an all-inclusive list of artists associated with the particular styles, groups or movements.

ABSTRACT EXPRESSIONISM: A manner of painting associated with abstract artists who worked in New York City in the 1940s and 1950s that explores gestural and geometric abstraction to express feelings, ideas and inner realities. These artists were also influenced by Surrealist theories of automatism and by the writings of Freud and his followers, both of which led to a visual expression of the subconscious. See: Bush, Cahen, Luke, Ronald, Town

ABSTRACTION: A term that has several meanings depending on the degree to which the representation of an object is distanced from nature. It can be art that minimizes—abstracts, reduces, takes away—a reflection of the world as we see it, and it can also be art which is nonobjective, that is, art which has no relationship to objects in nature. It consists of a visual language that focuses on the elements of art (colour, line, shape and texture) for its expressive message.

ACADEMY: A term derived from Plato's Academy in Athens which came to be applied to art schools in 16th-century Italy—and, later, in France and throughout the rest of Europe—that provided art training based on the classical art of Greece and Rome. This training emphasized the methodical study of the human figure, from the plaster cast to the live model, nude and draped. State academies also upheld a hierarchy of subjects in art, esteeming historical, biblical and mythological subjects over portraits, landscapes, still lifes and genre paintings (scenes of everyday life). In Paris in 1795, the École des

beaux-arts was established as the leader of official art schools, and it upheld the traditions of the earlier Académie royale de peinture et de sculpture, founded in 1648. The private academies, such as Julian and Colarossi, that were frequented by Canadian artists in the 19th century were informal art schools where students had access to models and benefited from the twice weekly criticism by resident senior artists.

ART BRUT: A term introduced by French artist Jean Dubuffet, who admired the visual expression of people considered "outsiders"—those who were often marginalized by society for reasons of mental health. Art brut artists created for their own pleasure, without concern for financial return or the glamour of the art market. See: Dallaire

ART DECO: A style of decoration popular in Europe and North America in the 1920s and 1930s that embodied a glorified image of the machine age and was characterized by an aesthetic arrangement of line and streamlined geometric shapes.

AUTOMATISTES: A group of Montreal abstract artists active from the early 1940s to the early 1950s that was led by Paul-Émile Borduas. They subscribed to Surrealist theories of automatism, which led the artist to work "automatically," inspired by dreams and the subconscious. In 1948, they published their manifesto, *Refus global* (*Total Refusal*), a call for freedom of expression during the oppressive Church-dominated Duplessis regime. See: Barbeau, Borduas, Ferron, Gauvreau, Leduc, Riopelle, Sullivan

BAROQUE: From the Italian *baròcco*, meaning irregular, a term generally used

to describe a style of art that developed in Italy in the 17th century. In painting, it is usually characterized by extravagant gesture, dramatic lighting and a calculated theatricality designed to involve the emotions of the beholder. In sculpture and architecture, elaborate form is often balanced and symmetrical.

BEAVER HALL (HILL) GROUP: A short-lived (1920-21) predominantly female group of artists who shared studio space on Beaver Square in Montreal. They were encouraged by A.Y. Jackson, who saw their aims as similar to those of the Group of Seven, and their works were included in many of the Group's shows, although, in fact, their strength was in figurative painting, particularly by the women artists. See: Coonan, Heward, Holgate, Newton, Savage

CANADIAN GROUP OF PAINTERS: The success and exclusive membership of the Group of Seven led to complaints by artists and the press that the larger Canadian art scene was not being recognized. After the opening of the last Group of Seven exhibition in 1931, A.Y. Jackson proposed that the Group of Seven should expand. Two years later, a wide representation of artists from across the country collaborated to form the first exhibition of the Canadian Group of Painters. Despite its acknowledgment of modern trends and of subjects other than landscape, this new group continued to bear the imprint of the Group of Seven. It disbanded in 1945. See: Brooker, Comfort, Humphrey, McKague Housser, McLaughlin, Schaefer

CLASSICISM: A term used in broad and diverse ways to refer to art influenced by the principles of design found in the art of ancient Greece and Rome, consisting generally of elegance, balance

and restraint. Classicism can also refer to qualities of harmony and simplicity and can be applied to art completely independent of antique influences.

COLLAGE: From the French *coller*, meaning to glue or to paste, collage was first embraced by Georges Braque and Pablo Picasso in 1909 as a method by which real objects and assorted pieces of paper or materials were affixed to the surface of their Cubist artworks. See: Town

CONCEPTUAL ART: A type of art in which the idea or concept behind the work is more important than the work's visual aesthetics. It developed in the 1960s in the United States as a reaction against the excessive commercialization of the art world and was inspired by the innovations of French artist Marcel Duchamp, who in 1913 presented his "readymades"—mass-produced objects selected arbitrarily and displayed as art—declaring that if the artist deemed it art, then it was, by virtue of his decision.

CONTEMPORARY ARTS SOCIETY: Founded by John Lyman in 1939 as a means for bringing together young Montreal artists opposed to the conservatism in Canadian art and committed to modernist trends inspired by early-20th-century French painting. Members also objected to the domination of the Group of Seven. In 1938, Lyman wrote, "The real Canadian scene is in the consciousness of Canadian painters, whatever the object of their thought." See: Lyman, Pellan, Roberts, M. Scott

CUBISM: A revolutionary style of painting initiated by Georges Braque and Pablo Picasso, working together around 1908, in which they abandoned

GLOSSARY

the traditional one-point perspective and rendered the three-dimensional forms of nature through a system of geometric shapes and planes that brought together different points of view simultaneously, thus creating a fragmented vision of nature. The term was first used in the press by French critic Louis Vauxcelles to describe a 1908 painting by Braque. See: Archambault, Munn, Pellan, Town

DADA: From the French word for hobbyhorse, this was an anarchistic movement born from the despondency and disillusionment of European artists following the First World War. It was founded in Zurich in 1915 by a group of artists and writers who championed an irrational and nihilistic approach to art fuelled by accident and chance. Their aim was to shock and disturb. See: Curnoe

DIPTYCH: A picture comprising two parts featured side by side and sometimes hinged together. See: Tod

EXPRESSIONISM: A term used to describe the distortion or exaggeration of naturalistic form for the purposes of subjective, emotional expression. In a general sense, it can be used to identify the art of any period when the forms of nature have been disturbingly caricatured or overstated. It can also refer to the German movement that occurred from about 1905 to 1930, when artists used violent colours and aggressive shapes to reflect the fear and anxiety resulting from political upheaval and social unrest. Expressionism was censored by the Nazis in 1933. See: Bates, Breeze

FAUVISM: A term meaning "wild beasts," assigned by French critic Louis Vauxcelles to describe works exhibited in Paris at the 1905 Salon d'automne,

which featured paintings composed of a daring non-naturalistic use of colour and bold brushwork. Henri Matisse, its foremost proponent, insisted, "The chief aim of colour should be to serve expression as well as possible." As a movement, it was short-lived but influential, especially for the German expressionists.

GENRE PAINTING: An art-historical idiom used to describe works that feature scenes from everyday life, especially domestic subjects. See: Krieghoff, Kurelek, Raphael

GROUP OF SEVEN: A group of Toronto-based artists who were devoted to the Canadian wilderness as their primary subject and who saw in it an expression of national spirit and identity. The members held their first exhibition at the Art Gallery of Toronto in 1920 and disbanded in 1931, expanding their membership later to form the Canadian Group of Painters. See: Carmichael, Casson, Harris, Jackson, Johnston, Lismer, MacDonald, Thomson, Varley

IMPRESSIONISM: A term assigned to the painting style of a group of highly individual French artists working after 1860. They generally preferred to paint *en plein air*, directly from nature, capturing the fleeting effects of light and colour. In their first exhibition, held in 1874, Claude Monet's painting *Impression—Sunrise* led journalist Louis Leroy to name the whole group "Impressionists." See: Cullen, Lyall, McNicoll, Suzor-Coté

INSTALLATION ART: A hybrid form of art that evolved in the 1970s in which artists construct environments consisting of objects and sometimes technology, offering the viewer an experience that is spatial and experiential. Initially, works were site-specific (cre-

ated for a particular place), but later, the term was also applied to large works that combine painting, sculpture and other media and occupy the space of the viewer. See: Frenkel, General Idea, Van Halm

LUMINISM: A term used to describe mid-19th-century landscape painting, romantic in tone, that featured highly finished depictions of nature, focusing on the sublimity of light and space. See: L. O'Brien

MAIL ART: A movement started in the 1950s by American artist Ray Johnson, who created a network in which artists exchanged various kinds of ephemera, such as postcards and collages, through the mail. They adopted aliases, made rubber stamps, embraced xeroxing as a way to make art and created image archives, all of which intentionally subverted the gallery systems. See: Metcalfe

NEOCLASSICISM: A style popular in late-18th- and early-19th-century European art that emulated the heroism and grandeur associated with ancient Greece and Rome. Although the style embraced considerable variation, it was generally characterized by a feeling of equilibrium, linear simplicity, grace and restrained, harmonious colouring. See: Baillairgé, Berczi, Berthon, Bourassa, Plamondon

OP ART: An abbreviation of the term "Optical Art," it was a type of abstract art popular in the 1960s that featured exaggerated chromatic and linear contrasts, usually in geometric configurations, to create an optical experience of a pulsating or vibrating image and the illusion of movement on the surface of the canvas. See: Barbeau

PAINTERS ELEVEN: A group of 11 Toronto artists devoted to abstract art who gathered together in 1953 and held their first exhibition under the name of Painters Eleven in 1954. Despite their personal clashes and fragmented, highly individual approaches to abstraction, the members continued to exhibit together until 1960, by which time they had accomplished their aim to create recognition and respect for abstract art in Toronto. See: Bush, Cahen, Luke, Macdonald, Ronald, Town

PERFORMANCE ART: An informal and contrived theatrical presentation that incorporates music, movement and visual art. It is rooted in the "Happening" popular in the 1960s, where artists acted out (sometimes outrageous) events or ideas with a degree of spontaneity (sometimes with audience participation) and uncertainty about how the event would end. Although initially focused on the impermanence of the act, it became popular to document the performance with photography and video, endowing it with perpetuity. See: Metcalfe

PLASTICIENS: A group of four Montreal abstract artists (Rodolphe de Repentigny, Louis Belzile, Jean-Paul Jérôme and Fernand Toupin) who, in 1955, issued their manifesto declaring their allegiance to a rational approach to abstraction inspired by the geometric purity of the work of Piet Mondrian. These artists were important precursors of younger artists such as Gaucher, Molinari and Tousignant. See: Toupin

POP ART: A term used by British art critic Lawrence Alloway to describe an art movement inspired by advertising and popular culture that flourished in Britain in the mid-1950s and in the United States in the 1960s. As a reaction to the inwardness and hermetic in-

dividualism of the abstract expressionists, pop artists embraced representational imagery inspired by consumer culture and mass media. See: Breeze, Curnoe, Thauberger

POST-IMPRESSIONISM: A term introduced by British art critic Roger Fry to describe the work of such artists as Cézanne, Gauguin and Van Gogh, who came after the Impressionists and who transformed the loose, light-filled brush stroke into more formally structured and expressive painting. See: Morrice

PRECISIONISM: A movement in American painting that began around 1915 and continued throughout the 1920s, in which smooth lines, geometric shapes, clear, bright colours and a refined, precise technique were used to render an idealized view of the urban and industrial landscape. See: FitzGerald, M. Scott

PRE-RAPHAELITE BROTHERHOOD: The name assumed by a short-lived group (1848-53) of young British painters who opposed the values of the Industrial Revolution and academic art and were attracted to the simplicity and earnestness of early Italian art before the time of Renaissance artist Raphael. See: Hime

PRISME D'YEUX: In early 1948 and in opposition to Paul-Émile Borduas' interpretation of automatism, as well as his domination of the Contemporary Arts Society, Alfred Pellan and other artists broke away from the group and formed Prisme d'yeux (Prism of the Eyes). In their manifesto, they declared their aim to "seek a painting liberated from all contingencies of time and place, from all restrictive ideology." See: Bellefleur, Pellan, Roberts

PROFESSIONAL NATIVE INDIAN ARTISTS INCORPORATED: A group of seven native artists, including Daphne Odjig, Alex Janvier and others, who were displeased with the federal government's efforts to promote native art. In 1974, they founded a formal organization in an effort to develop a marketing and exhibiting plan involving established galleries and to encourage art and art scholarships in the native communities. By 1975, the group had disbanded. See: Janvier, Odjig

PURISM: A style invented around 1918 by French artist Amédée Ozenfant and architect Le Corbusier, both of whom admired the rationality and precision of machines and proposed an aesthetic based on clean lines, restrained colours and the removal of everything extraneous. See: Binning

REALISM: A term used generally to imply fidelity to the world of appearances, incorporating an intention to depict objects accurately and objectively.

REFUS GLOBAL: A manifesto inspired by the liberal attitudes of Surrealism and automatism and signed in 1948 by Paul-Émile Borduas and fellow artists to protest the artistic, political and social oppression in postwar Quebec society. They called for a "resplendent anarchy" exemplified by their emotionally charged abstract paintings. See: Barbeau, Borduas, Ferron, Gauvreau, Leduc, Riopelle, Sullivan

REGINA FIVE: A name given to the five abstract artists affiliated with the University of Saskatchewan, Regina, who participated in the so-named 1961 exhibition circulated by the National Gallery of Canada. Diverse in their backgrounds and philosophies, they shared an interest in strong central im-

ages and allover compositions and were encouraged in their artistic endeavours by American Barnett Newman, who led the Emma Lake workshop in 1959. See: Bloore, McKay

ROMANTICISM: A movement that developed in Europe in the late 18th and early 19th centuries whose chief proponents were J.M.W. Turner in England and Delacroix and Géricault in France. In contrast to the structure and restraint in the work of their earlier neoclassical predecessors, they used colour and light for dramatic and emotional effects. See: Field, L. O'Brien

ROYAL CANADIAN ACADEMY OF ARTS: In Ottawa, in March 1880, the Marquis of Lorne, then Governor General of Canada, presided over the first exhibition of the Royal Canadian Academy of Arts. Seeking to create a foundation upon which the arts in Canada would flourish, the Marquis also recommended that the artists who were elected to the new Academy should donate a work which would establish a collection for the National Gallery of Canada, also founded that year. The first president of the Academy was Lucius O'Brien. Artists continued to donate diploma works until 1976. See: Comfort, O'Brien, Schreiber

SCULPTORS' SOCIETY OF CANADA: Dissatisfied with the representation of sculpture in Canada by societies such as the Royal Canadian Academy of Arts, Frances Loring, Florence Wyle, Henri Hébert, Alfred Howell, Emanuel Hahn and Elizabeth Wyn Wood founded the Sculptors' Society of Canada in 1928 to foster the "encouragement, improvement and cultivation of the art of sculpture." See: Hahn, Loring, Wood, Wyle

SURREALISM: In 1924, French poet André Breton issued his Surrealist manifesto proposing that the source of artistic inspiration lay in the subconscious and dreams. For the circle of Canadian writers and artists around Paul-Émile Borduas, this highly influential document led to an exploration of Surrealism, described by Breton as "pure psychic automatism, by which it is intended to express verbally, in writing or in any other way, the true process of thought…free from the exercise of reason and every aesthetic or moral preoccupation." See: Archambault, Borduas, Daudelin, Pellan

TRIPTYCH: A picture or carving comprising three parts featured side by side and sometimes hinged together, designed so that the two lateral elements fold over to cover the central one. This format was often used in Europe in medieval times for portable altarpieces. See: Binning, Cardinal-Schubert

TROMPE L'OEIL: A French term meaning "to trick or fool the eye," used in reference to carefully painted depictions of objects whose fidelity to detail leads viewers to believe that they are looking at an actual object rather than an illusion.

WESTERN FRONT: An innovative artist-run centre with an international reputation, founded in Vancouver in 1973 by Eric Metcalfe, Kate Craig, Michael Morris and others, which promoted collaborations among artists in the production of conceptual, performance and video art. See: Metcalfe

347

FURTHER READING

There exist hundreds of books and countless articles in periodicals devoted to Canadian, Inuit and native art. Information about most of the artists featured in this book can be found there. For Inuit and native art, there are, in addition, numerous publications in the subject areas of art, anthropology and ethnography that focus on specific regions and linguistic groups and offer extensive in-depth information. Rather than providing an exhaustive list, I submit instead a number of selected publications for the exploration of Canadian art in general, as well as useful texts in particular areas.

CANADIAN ART GENERAL

Béland, Mario, ed., *Painting in Quebec, 1820-1850: New Views, New Perspectives*, Musée du Québec, Quebec, 1992.

Bell, Michael, *Image of Canada*, Public Archives of Canada, Ottawa, 1972.

———, *Painters in a New Land*, McClelland & Stewart, Toronto, 1973.

Harper, J. Russell, *Early Painters and Engravers in Canada*, University of Toronto Press, Toronto, 1970.

———, *Painting in Canada: A History*. 2nd ed., University of Toronto Press, Toronto, 1977.

Hill, Charles C., *Canadian Painting in the Thirties*, National Gallery of Canada, Ottawa, 1975.

———, *The Group of Seven: Art for a Nation*, National Gallery of Canada, Ottawa, 1995.

Lord, Barry, *The History of Painting in Canada: Toward a People's Art*, NC Press, Toronto, 1974.

Reid, Dennis, *A Concise History of Canadian Painting*, Oxford University Press, Toronto, 1973.

———, *"Our Own Country Canada," Being an Account of the National Aspirations of the Principal Landscape Artists in Montreal and Toronto, 1860-90*, National Gallery of Canada, Ottawa, 1979.

Villeneuve, René, *Baroque to Neoclassical: Sculpture in Quebec*, National Gallery of Canada, Ottawa, 1997.

CANADIAN WOMEN ARTISTS

Farr, Dorothy, and Natalie Luckyj, *From Women's Eyes: Women Painters in Canada*, Agnes Etherington Art Centre, Kingston, Ontario, 1975.

Graham, Mayo, *Some Canadian Women Artists*, National Gallery of Canada, Ottawa, 1975.

Luckyj, Natalie, *Visions and Victories: 10 Canadian Women Artists, 1914-1945*, London Regional Art Gallery, London, Ontario, 1983.

Tippett, Maria, *By a Lady: Celebrating Three Centuries of Art by Canadian Women*, Penguin, Toronto, 1992.

MODERN AND CONTEMPORARY ART

Bradley, Jessica, and Diana Nemiroff, *Songs of Experience*, National Gallery of Canada, Ottawa, 1986.

Burnett, David, and Marilyn Schiff, *Contemporary Canadian Art*, Hurtig, Edmonton, 1983.

Davis, Ann, *Frontiers of Our Dreams: Quebec Painting in the 1940s and 1950s*, Winnipeg Art Gallery, Winnipeg, 1979.

Ellenwood, Ray, *Egregore: A History of the Montreal Automatist Movement*, Exile Editions, Toronto, 1992.

Fenton, Terry, and Karen Wilkin, *Modern Painting in Canada*, Hurtig, Edmonton, 1978.

Five Painters from Regina, National Gallery of Canada, Ottawa, 1961.

Leclerc, Denise, *The Crisis of Abstraction in Canada: The 1950s*, National Gallery of Canada, Ottawa, 1993.

Nemiroff, Diana, *Canadian Biennial of Contemporary Art*, National Gallery of Canada, Ottawa, 1989.

Pluralities/1980/Pluralités, National Gallery of Canada, Ottawa, 1980.

Pontbriand, Chantal, *The Historical Ruse: Art in Montreal*, The Power Plant, Toronto, 1988.

Varley, Christopher, *The Contemporary Arts Society, Montreal, 1939-1948*, Edmonton Art Gallery, Edmonton, 1980.

Visions: Contemporary Art in Canada, Douglas & McIntyre, Vancouver, 1983.

INUIT ART HISTORICAL, MODERN AND CONTEMPORARY

Blodgett, Jean, *The Coming and Going of the Shaman: Eskimo Shamanism and Art*, Winnipeg Art Gallery, Winnipeg, 1979.

———, *Eskimo Narrative*, Winnipeg Art Gallery, Winnipeg, 1979.

———, *Grasp Tight the Old Ways: Selections from the Klamer Family Collection of Inuit Art*, Art Gallery of Ontario, Toronto, 1983.

——— and Susan Gustavison, *Northern Rock: Contemporary Inuit Stone Sculpture*, McMichael Canadian Art Collection, Kleinburg, Ontario, 1999.

Driscoll, Bernadette, *The Inuit Amautiq: I Like My Hood To Be Full*, Winnipeg Art Gallery, Winnipeg, 1980.

———, *Uumajut: Animal Imagery in Inuit Art*, Winnipeg Art Gallery, Winnipeg, 1985.

"The Eskimo World," *artscanada*, December/January 1971/1972, vol. 28, no. 6.

Hessel, Ingo, *Inuit Art: An Introduction*, Douglas & McIntyre, Vancouver, 1998.

Houston, Alma, ed., *Inuit Art: An Anthology*, Watson & Dwyer, Winnipeg, 1988.

In the Shadow of the Sun: Perspectives on Contemporary Native Art, Canadian Museum of Civilization, Hull, 1993.

The Inuit Print, National Museum of Man, Ottawa, 1977.

Jackson, Marion, and Judith Nasby, *Contemporary Inuit Drawings*, Macdonald Stewart Art Centre, Guelph, Ontario, 1987.

Leroux, Odette, Marion E. Jackson and Minnie Aodla Freeman, eds., *Inuit Women Artists: Voices from Cape Dorset*, Chronicle Books, San Francisco, 1996.

McGhee, Robert, *Ancient People of the Arctic*, University of British Columbia Press, Vancouver, 1996.

———, *Canadian Arctic Prehistory*, Canadian Museum of Civilization, Hull, 1990.

Routledge, Marie, *Inuit Art in the 1970s*, Agnes Etherington Art Centre, Kingston, Ontario, 1979.

Seidelman, Harold, and James Turner, *The Inuit Imagination*, Douglas & McIntyre, Vancouver, 1993.

Swinton, George, *Sculpture of the Inuit*, McClelland & Stewart, Toronto, 1992.

Wight, Darlene, *The First Passionate Collector: The Ian Lindsay Collection of Inuit Art*, Winnipeg Art Gallery, Winnipeg, 1991.

Zepp, Norman, *Pure Vision: The Keewatin Spirit*, Norman MacKenzie Art Gallery, Regina, 1986.

NATIVE ART HISTORICAL, MODERN AND CONTEMPORARY

Bebbington, Judy, *Quillwork of the Plains*, Glenbow Museum, Calgary, 1982.

Berlo, Janet C., and Ruth B. Phillips, *Native North American Art*, Oxford University Press, New York, 1998.

Brownstone, Arni, *War Paint: Blackfoot and Sarcee Painted Buffalo Robes in the Royal Ontario Museum*, Royal Ontario Museum, Toronto, 1993.

Burnham, Dorothy K., *To Please the Caribou*, Royal Ontario Museum, Toronto, 1992.

Ewers, J.C., *Plains Indian Sculpture*, Smithsonian Institution Press, Washington, D.C., 1986.

Hall, Judy, Leslie Tepper and Judy Thompson, *Threads of the Land: Clothing Traditions from Three Indigenous Cultures*, Canadian Museum of Civilization, Hull, 1994.

Harrison, Julia, et al., *The Spirit Sings: Artistic Traditions of Canada's First Peoples*, McClelland & Stewart, Toronto, 1987.

Hill, Beth and Ray, *Indian Petroglyphs of the Pacific Northwest*, Hancock House, Saanichton, British Columbia, 1974.

Holm, Bill, *The Box of Daylight: Northwest Coast Indian Art*, Seattle Art Museum and University of Washington Press, Seattle, 1984.

In the Shadow of the Sun: Perspectives on Contemporary Native Art, Canadian Museum of Civilization, Hull, 1993.

McLuhan, Elizabeth, and Tom Hill, *Norval Morrisseau and the Emergence of the Image Makers*, Methuen, Toronto, 1984.

McMaster, Gerald, and Lee-Ann Martin, eds., *Indigena: Contemporary Native Perspectives*, Douglas & McIntyre, Vancouver, 1992.

McNair, Peter, Robert Joseph and Bruce Grenville, *Down from the Shimmering Sky*, Douglas & McIntyre, Vancouver, 1998.

———, Alan L. Hoover and Kevin Neary, *The Legacy: Continuing Traditions of Canadian Northwest Coast Indian Art*, British Columbia Provincial Museum, Victoria, 1980.

Nemiroff, Diana, Robert Houle and Charlotte Townsend-Gault, *Land Spirit Power: First Nations at the National Gallery of Canada*, National Gallery of Canada, Ottawa, 1992.

Sheehan, Carol, *Pipes that Won't Smoke; Coals that Won't Burn: Haida Sculpture in Argillite*, Glenbow Museum, Calgary, 1981.

Taylor, Colin F., *Buckskin and Buffalo: The Artistry of the Plains Indians*, Rizzoli, New York, 1998.

Thompson, Judy, *From the Land: Two Hundred Years of Dene Clothing*, Canadian Museum of Civilization, Hull, 1994.

Whitehead, Ruth Holmes, *Micmac Quillwork*, Nova Scotia Museum, Halifax, 1980.

PHOTOGRAPHY

Borcoman, James, *Magicians of Light: Photographs from the Collection of the National Gallery of Canada*, National Gallery of Canada, Ottawa, 1993.

Greenhill, Ralph, and Andrew Birrell, *Canadian Photography, 1839-1920*, Coach House Press, Toronto, 1979.

Koltun, Lily, ed., *Private Realms of Light: Amateur Photography in Canada, 1839-1940*, Fitzhenry & Whiteside, Markham, Ontario, 1984.

Langford, Martha, *Beau: A Reflection on the Nature of Beauty in Photography*, Canadian Museum of Contemporary Photography, Ottawa, 1992.

———, *Contemporary Canadian Photography from the Collection of the National Film Board*, Hurtig, Edmonton, 1984.

Thomas, Ann W., *Fact and Fiction: Canadian Painting and Photography, 1860-1900*, McCord Museum of Canadian History, Montreal, 1987.

TITLE INDEX

TITLE INDEX

ART GALLERY OF
GREATER VICTORIA
1040 Moss Street
Victoria, BC V8V 4P1
Telephone: 250-384-4101

ART GALLERY OF HAMILTON
123 King Street W
Hamilton, ON L8P 4S8
Telephone: 905-527-6610

ART GALLERY OF
NEWFOUNDLAND
AND LABRADOR
Box 4200
323 Prince Philip Drive
St. John's, NF A1C 5S7
Telephone: 709-737-8210
Fax: 709-737-2007

ART GALLERY OF NOVA SCOTIA
1723 Hollis Street
Box 2262
Halifax, NS B3J 3C8
Telephone: 902-424-8457
Fax: 902-424-0750

ART GALLERY OF ONTARIO
317 Dundas Street W
Toronto, ON M5T 1G4
Telephone: 416-979-6660

ART GALLERY OF WINDSOR
Devonshire Mall
3100 Howard Avenue
Windsor, ON N8X 3Y8
Telephone: 519-969-4494
Fax: 519-969-3732

BEAVERBROOK ART GALLERY
703 Queen Street
Box 605
Fredericton, NB E3B 5A6
Telephone: 506-458-2021

CANADIAN CENTRE FOR
ARCHITECTURE
1920, rue Baile
Montreal, QC H3H 2S6
Telephone: 514-939-7000
Fax: 514-939-7020

CANADIAN CONSERVATION
INSTITUTE
1030 Innes Road
Ottawa, ON K1A 0M5
Telephone: 613-998-3721

CANADIAN MUSEUM
OF CIVILIZATION
100 rue Laurier, CP 3100
succursale B
Hull, QC J8X 4H2
Telephone: 819-776-8177
Fax: 819-776-8491

CANADIAN MUSEUM
OF CONTEMPORARY
PHOTOGRAPHY
1 Rideau Canal
Box 465
Station A
Ottawa, ON K1N 9N6
Telephone: 613-990-8261
Fax: 613-990-6542

CANADIAN WAR MUSEUM
330 Sussex Drive
Ottawa, ON K1A 0M8
Telephone: 819-776-8655
Fax: 819-776-8657

COLLECTION DES URSULINES
DE QUÉBEC
2 rue du Parloir, CP 760 H.V.
Quebec, QC G1R 4T1
Telephone: 418-694-0694

EDMONTON
ART GALLERY
2 Sir Winston Churchill Square
Edmonton, AB T5J 2C1
Telephone: 780-422-6223

ESKIMO MUSEUM
Box 10
Churchill, MB R0B 0E0
Telephone: 204-675-2030
Fax: 204-675-2140
GLENBOW MUSEUM
130–9th Avenue SE
Calgary, AB T2G 0P3
Telephone: 403-268-4100
Fax: 403-265-9769

HART HOUSE ART GALLERY
University of Toronto
Toronto, ON M5S 3H3

INDIAN ART CENTRE
10 Wellington, Room 928
Hull, ON J8X 4B3
Telephone: 819-997-8310

LONDON REGIONAL ART
AND HISTORICAL MUSEUMS
412 Ridout Street N
London, ON N6A 5H4
Telephone: 519-672-4580

MACKENZIE ART GALLERY
3475 Albert Street
Regina, SK S4S 6X6
Telephone: 306-522-4242

MCCORD MUSEUM
OF CANADIAN HISTORY
690 Sherbrooke Street W
Montreal, QC H3A 1E9
514-398-7100

MCMASTER MUSEUM OF ART
Alvin A. Lee Building
University Avenue
McMaster University
1280 Main Street W
Hamilton, ON L8S 4L6
Telephone: 905-525-9140

MCMICHAEL CANADIAN
ART COLLECTION
10365 Islington Avenue
Kleinburg, ON L0J 1C0
Telephone: 905-893-1121

MENDEL ART GALLERY
AND CIVIC CONSERVATORY
950 Spadina Crescent E
Box 569
Saskatoon, SK S7K 3L6
Telephone: 306-975-8054

MONTREAL MUSEUM
OF FINE ARTS
CP 3000 succursale H
2189 rue Bishop
Montreal, QC H3G 2T9
Telephone: 514-285-1600
Fax: 514-285-4041

MUSÉE D'ART CONTEMPORAIN
DE MONTRÉAL
185, rue Ste-Catherine Ouest
Montreal, QC H2K 3X5
Telephone: 514-847-6226
Fax: 514-847-6292

MUSÉE DU QUÉBEC
Parc des Champs-de-Bataille
Quebec, QC GIR 5H3
Telephone: 418-644-6460
Fax: 418-646-1664

MUSEUM OF ANTHROPOLOGY
AT THE UNIVERSITY OF
BRITISH COLUMBIA
6393 NW Marine Drive
Vancouver, BC V6T 1Z2
Telephone: 604-822-5087

NATIONAL ARCHIVES
OF CANADA
395 Wellington Street
Ottawa, ON KIA 0N4
Telephone: 613-992-8188

NATIONAL GALLERY
OF CANADA
Box 427, Station A
380 Sussex Drive
Ottawa, ON KIN 9N4
Telephone: 1-800-319-2787
Fax: 613-993-4385

NEWFOUNDLAND MUSEUM
Box 8700
St. John's, NF AIB 4J6
Telephone: 709-729-2451
Fax: 709-729-2179

OTTAWA ART GALLERY
2 Daly Avenue
Ottawa, ON KIN 6E2
Telephone: 613-233-8699
Fax: 613-569-7660

ROYAL BRITISH
COLUMBIA MUSEUM
Box 9815
Station Provincial Government
675 Belleville Street
Victoria, BC V8W 9W2
Telephone: 250-387-3701

ROYAL ONTARIO MUSEUM
100 Queen's Park
Toronto, ON M5S 2C6
Telephone: 416-586-5590
Fax: 416-586-5668

VANCOUVER ART GALLERY
750 Hornby Street
Vancouver, BC V6Z 2H7
Telephone: 604-662-4700
Fax: 604-682-1086

WINNIPEG ART GALLERY
300 Memorial Boulevard
Winnipeg, MB R3C 1V1
Telephone: 204-786-6641
Fax: 204-788-4998

WOODLAND CULTURAL
CENTRE
Box 1506
184 Mohawk Street
Brantford, ON N3T 5V6
Telephone: 519-759-2650